CW00952368

Chikankari

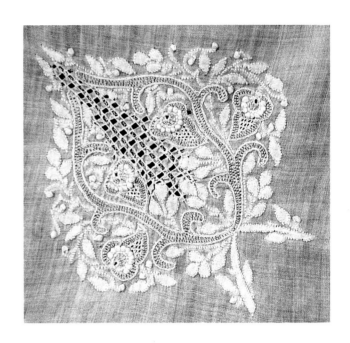

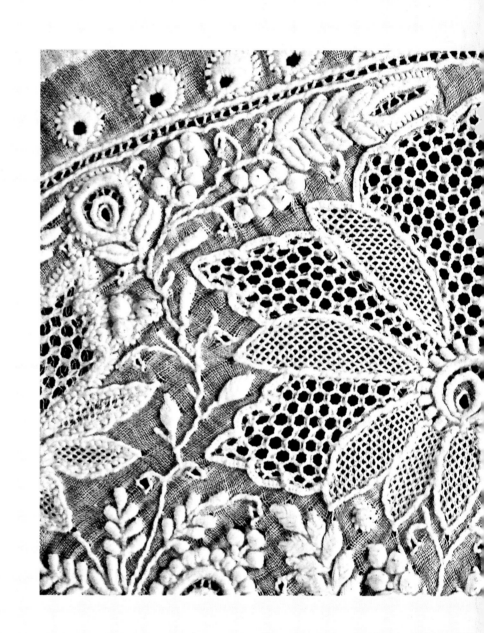

Chikankari
A Lucknawi Tradition

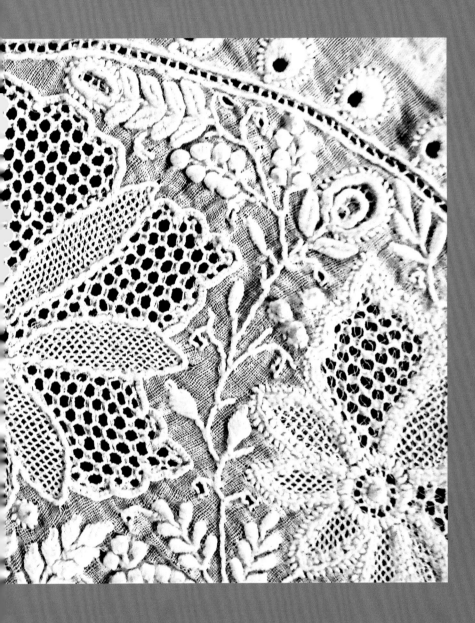

PAOLA MANFREDI

NIYOGI
BOOKS

Published by
NIYOGI BOOKS
D-78, Okhla Industrial Area, Phase-I
New Delhi-110 020, INDIA
Tel: 91-11-26816301, 49327000
Fax: 91-11-26810483, 26813830
Email: niyogibooks@gmail.com
Website: www.niyogibooksindia.com

Text ©: Paola Manfredi
Images ©: Paola Manfredi

Editing and Design: Malini Saigal

ISBN: 978-93-85285-53-0
Publication: 2017

All rights are reserved. No part of this publication may be reproduced or transmitted in any form or by any means,
electronic or mechanical, including photocopying, recording or by any information storage and retrieval system without
prior written permission and consent of the publisher.

Printed at Niyogi Offset Pvt. Ltd., New Delhi, India

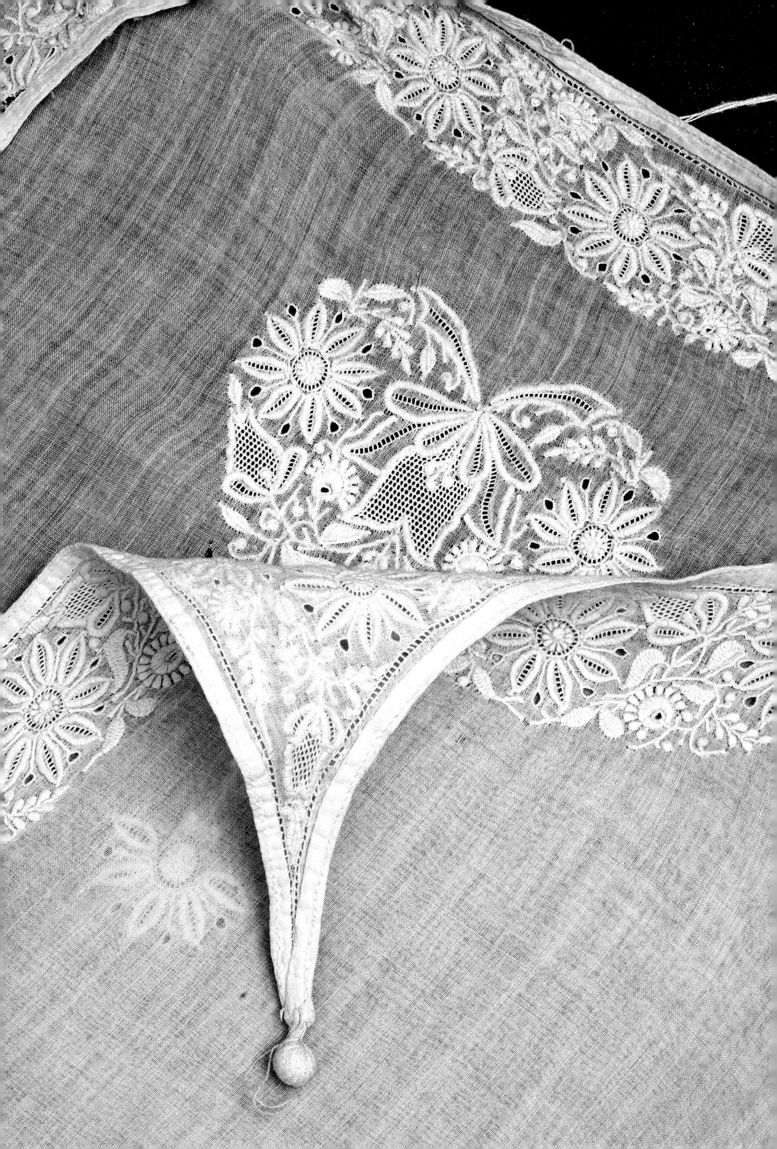

CONTENTS

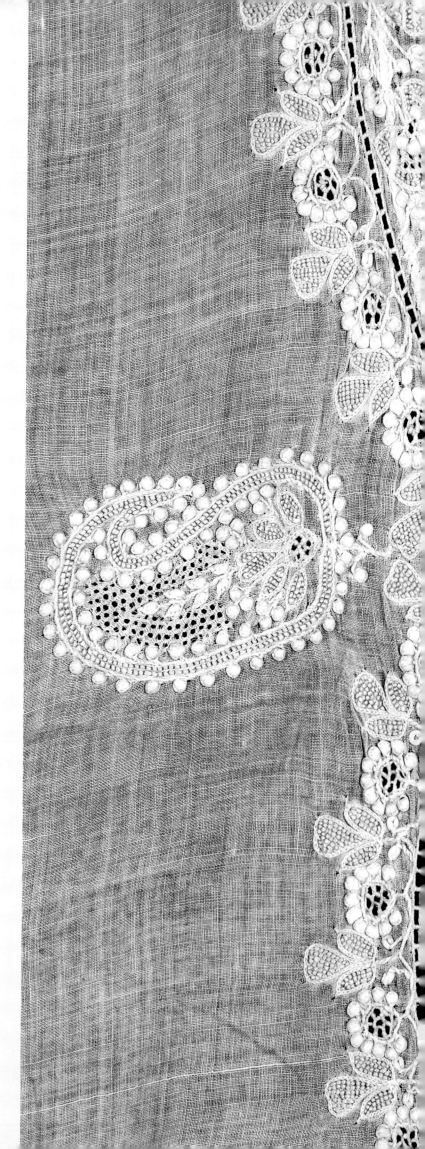

HALF TITLE: Sampler of jali or open work by master craftman Ayub Khan

TITLE PAGE: Detail of sampler SEWA collection, Lucknow

*PREVIOUS PAGE: Kurta, Lucknow, late 19th century
Weavers Studio Resource Center Archive, Kolkata*

*RIGHT: Choga: detail of the front buttoned with ghundi and tukuma
Cotton, chikan embroidery with cotton and silk (muga or tussar), Lucknow, probably 19th century
Crafts Museum, Delhi, Acc. No. 64/3084*

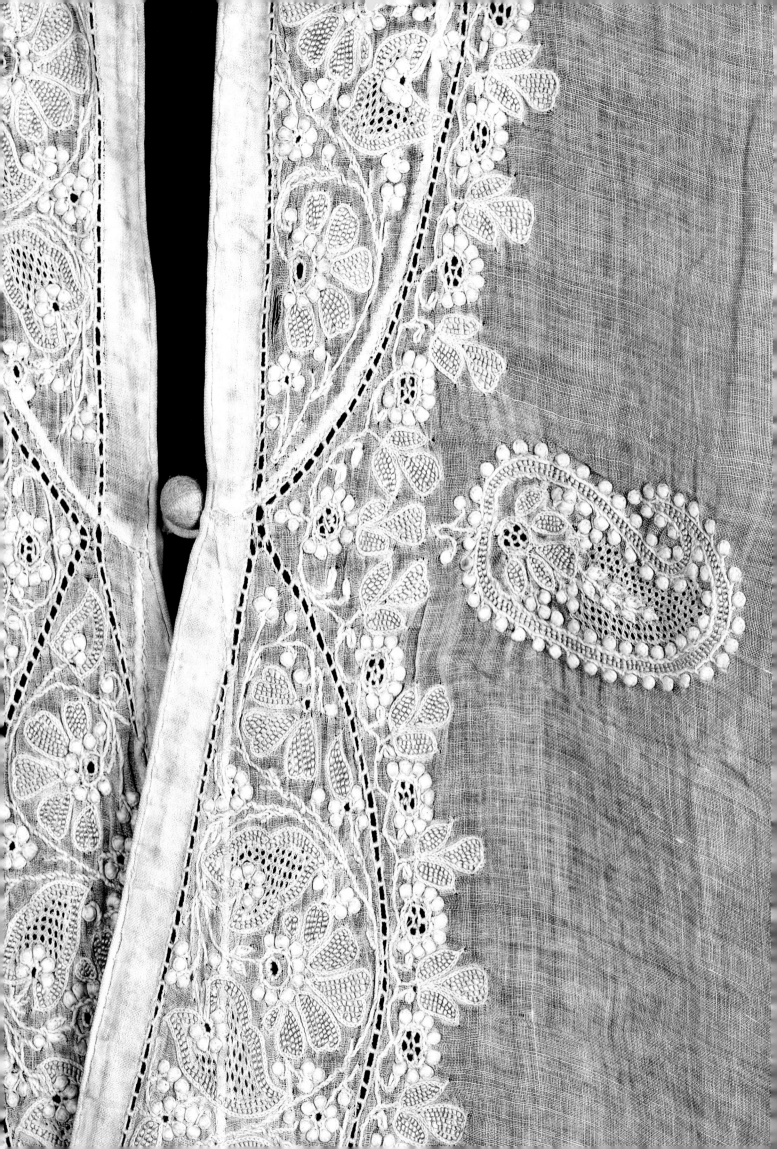

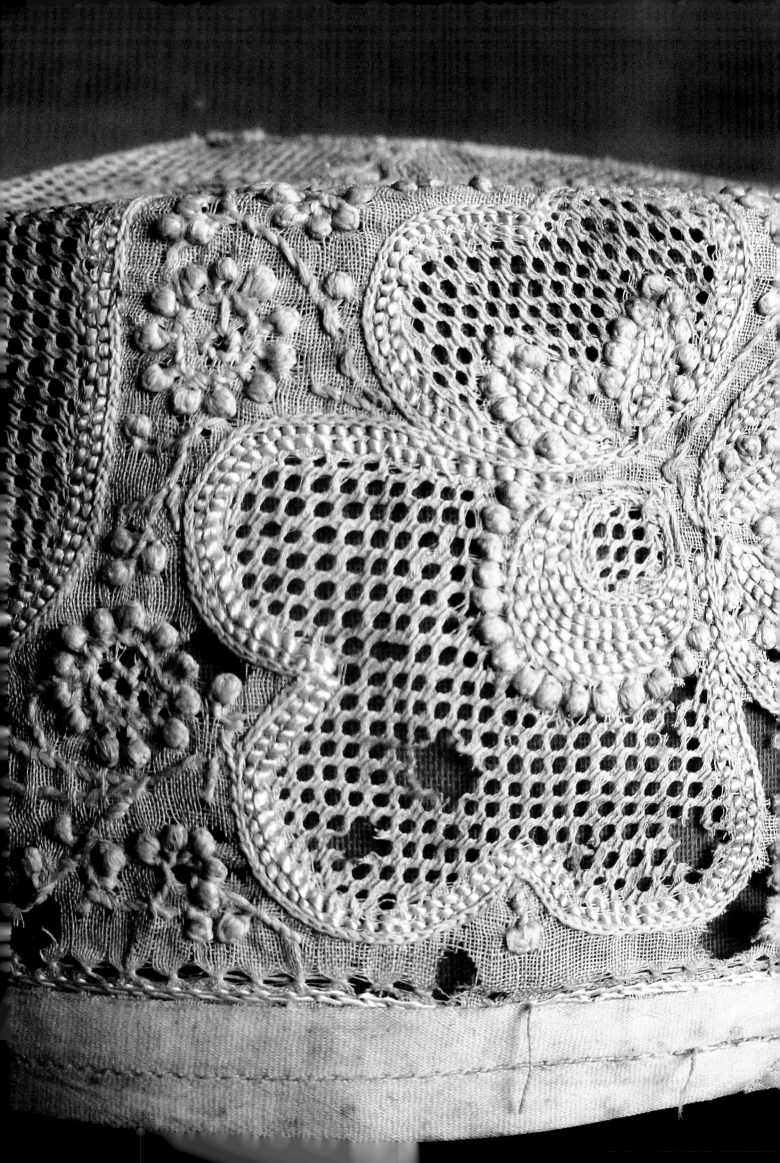

FOREWORD

Paola Manfredi's research on Chikankari is an in-depth study of its origins, its historical past, its socio-cultural significance, the range of motifs and their symbolic meaning, as well the socio-economic aspects. Paola has been working for more than thirty years with traditional craftspeople, often in rural areas, to develop high quality textiles and handcrafted products , combining active interventions with research and scholarly approach. She reinterprets local traditions, techniques, skills, aesthetics and historic decorative vocabulary absorbing them in her designs and enhancing the current productions, with emphasis on the quality of every aspects of the finished product.

In her writing, she emphasizes on the complexity and ingenuity of the varying techniques, which result in the uniqueness of the embroidery and she emphasize on the importance to document traditional skills and artifacts, as they reflect the often extraordinary traditional knowledge of the artisans, knowledge and skills that are now fast disappearing with a consequent great loss for humanity's immeasurable and diversified heritage. Traditional crafts are deeply connected with the specificity of their environment, thus becoming involved in conservation issues is part of the process of strengthening traditional practices and reviving fragile crafts industries.

White on white embroidery has a delicacy, which makes the wearer look very elegant. Few realize that the art of chikan work is not only in the embroidery, but in the creation of the apparel. The seams are artistically worked into a continuous floral motif. The edges of the angarkhas and kurtas are edged with embroidery. The shoulders are also worked with intricate embroidery. The back of the neck has a leaf of the pan, the tree of life, or the mango pattern. The finished garment is structured and has a form, which flows over the body.

Paola became a designer consultant with SEWA-Lucknow, an NGO, on few projects of chikankari in the mid-90s. SEWA-Lucknow started chikankari embroidery production in 1984 aiming at breaking the stronghold of middleman and ensuring fair wages to craftswomen. The embroidery was done by the veiled women of Muslim households. Since they had no possibility of having access to the market, the traders paid them very poor wages. The system also was such that it made it impossible for new entrants to enter the market. SEWA-Lucknow began with developing direct access to markets, upgrading artisans skills and reviving and revitalizing the old traditions, so it could reach its original level of refinement.

Chikankari, which involves very minute intricate white embroidery on finely woven white muslin, has a long and rich history, as its exquisite craftsmanship reached unsurpassed heights in the 18th and 19th centuries. Paola's revival of the designs of the past and the intricate techniques created a rich range of products using the traditional line production. She organized a few exhibitions for SEWA-Lucknow in Milan.

Her 30 years of work in Chikankari has now culminated in a publication, which is one of a detailed study, the like of which has not been done before. It also has a rich collection of illustrations, which she has collected from Museums the world over and private collections. The detailed description of the techniques where most of the 72 stitches are explained is an extraordinary repository of technical know how. She has not neglected to collect the local terminology, which is most important and is often neglected by many Indian scholars. This book will not only help to preserve knowledge of the finest techniques of chikankari and help the designers and producers to maintain the old traditions.

Jasleen Dhamija
New Delhi, 2015

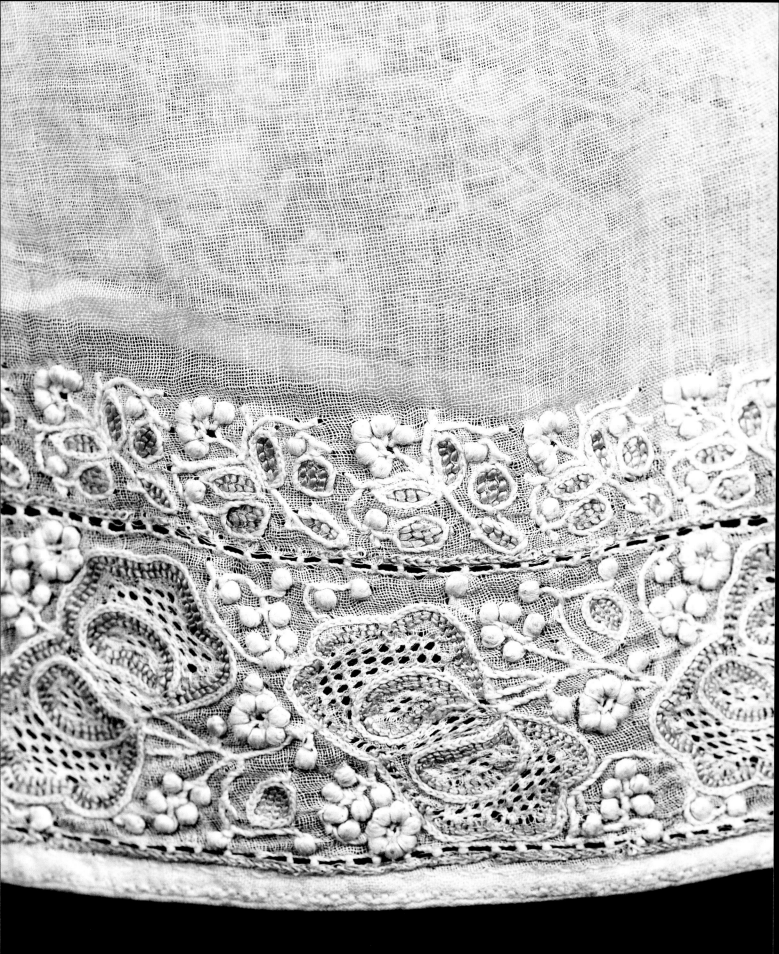

Introduction

Chikankari is reputed to be among the finest traditional embroideries from India, typical of Lucknow, once the capital of the vast and rich dominions of the state of Awadh. With the gradual decline of Mughal authority in the second half of the 18th century, the Nawabs of Awadh established their independence from the Delhi court. They gave credence to the legendary extravagances of oriental monarchies, shaping their own aesthetic and style, and redefining the concept of court splendour and royal patronage. From the late 18th and up to the middle of the 19th century, Lucknow attracted artists, artisans, musicians, chefs and literary figures, all seeking royal favour. This influx contributed to Lucknow's glowing reputation for beautiful Urdu poetry and literature, for classical music and dance, for fairs and grand Muharram processions. Lucknawi lifestyle came to define class, taste, manners and culture.

A variety of arts and crafts, in particular embroideries of several kinds, flourished in this atmosphere of wealth and sophistication. The *karkhanas*, or royal workshops, produced exquisite works of *zardozi*, *ari* and *kamdani* embroideries with gold and silver threads on silks, velvets and fine muslins. Chikan embroidery, although it developed towards the end of the Nawabi era, is often taken to epitomize the best and ultimate refinement of Nawabi and Lucknawi culture. 'Classical' chikankari is intricate, yet delicate, white embroidery on very fine white muslin, wherein different stitches create myriads of subtle combinations and textures.

In spite of its celebrated, almost iconic status in Lucknow, chikan embroidery has hardly ever been the focus of in depth research or descriptive works. The earliest detailed account, which has been the reference for most subsequent writings, is by George Watt in *Indian Art at Delhi*, published in 1903. In the early 1960s, Jasleen Dhamija contributed an article with invaluable personal testimonies from master craftsmen. Sheila Paine's small book titled *Chikan Embroidery: the Floral Whitework of India,* written in the early 1980s, remains the main reference on the subject to this day. Clare Wilkinson-Weber's *Embroidering Lives: Women's Work and Skill in the Lucknow Embroidery Industry* (1999), focused on the chikan craftswomen from a feminist perspective, and is the most in depth and informative academic study on this craft. Veena Singh's *Romancing with Chikankari* attempted to fill a gap on the subject at a local level.

There are also a few short essays on chikan which were for the most part published before the ubiquity of the internet and are scattered in different publications and magazines, many of which are now unavailable or out of print. The more accessible and informative ones have been written, among other authors, by Laila Tyabji, Ruth Chakravarty, Tereza Kuldova, Clare Wilkinson-Weber and myself.

In the early 1990s I was invited by Laila Tyabji to document chikan embroidery at SEWA-Lucknow for Dastkar's project to create handbooks on Indian embroideries' traditions for craftspeople. At that time I was already involved with designing and producing white on white hand embroideries (*ari* work mainly) with an Indian master craftsman, the late Salim Khan. My specific knowledge of chikan embroidery was very limited and consisted for the most part, of the works and pioneering efforts by SEWA-Lucknow in the middle 1980s to revive fine craftsmanship in chikankari. In those years, the chikan work available in the marketplace was of rather average quality and consisted mainly of shadow work, one of the less complex stitches in chikan.

The paucity of written references and documentation led me to look for actual old pieces in Indian museums. This was also disheartening, as in most cases I was unable to go past the

Choga, detail of the border
Lucknow, probably late 19th
century; cotton, embroidery with
cotton and silk (muga or tussar)
Crafts Museum, Delhi
Acc. No. 7/5213

intricacies of bureaucratic procedures to access the reserve collections. However, the State Museum and Crafts Museum in Lucknow, the Indian Museum in Kolkata and the Crafts Museum in Delhi have been very generous in making accessible their chikankari 'treasures' over the years, despite the intrinsic fragility of the antique pieces in their collections. Private collectors, antique textiles dealers, and museums abroad particularly the Victoria and Albert Museum in London, the Royal Museum in Edinburgh, the A.E.D.T.A (whose collections were later bequeathed to the Oriental Arts Museum, Musée Guimet in Paris) have also been most helpful.

Despite the various private initiatives and government schemes to revive chikan embroidery, and to address the problems of the sector, mainly abysmal low wages and health related issues afflicting the craftsperson involved in it, there is no proper documentation, and almost no samples are visible or accessible. I find myself often wondering how can there be a 'revival' of this craft if no older references and samples are made available to the craftspeople, to inspire them or against which to evaluate their work? The 'revival' has been dependent for the most part on memories, on the oral and practical transmission of the craft by a few master craftspeople or their apprentices who belong to recognized lineages of masters in Lucknow. Recognized by State or National Crafts Awards, these master craftspersons became certified teachers in Government sponsored chikan training programs.

In over two decades of involvement with this craft, I have hardly ever seen any archival or old sample easily available to the craftspeople for reference. There are many reasons for this. One is, of course, economic as to mark a good piece 'not for sale' but for reference is to freeze the investment incurred in its making, which is generally too onerous on a craftsperson or even on a small organization. The few exceptions were samples pieces created expressly for government crafts awards, kept as testimony of the superior craftsmanship running within the family or the organization.

But we do have wooden blocks with their coded graphic vocabulary used for tracing / transferring the motifs on the fabric are the tangible aids, and these retain a memory of the craft. Broken or worn out, the most popular designs on these blocks have been carved again and again, some apparently since the 19th century and early 20th century.

It became an obsession of mine to share with the craftswomen at SEWA-Lucknow either old pieces that occasionally a generous and trusting owner would lend me, or visual documents of fine chikan craftsmanship collected in the most disparate situations across the world. This book is the outcome of that 'obsession'. Its scope has evolved over time, eventually devolving into a less ambitious project than I had originally intended. I know I have just managed to scratch the surface of the story of this craft and its protagonists, with this compilation of existing old records. Yet I hope this will advance further studies on chikankari, both in the embroidery and in the art of dressmaking. I would like to stress here that it is precisely the way in which the art of embroidery and the art of dressmaking fused together in such subtle aesthetics, that generated chikankari's enduring fame. Chikan embroidery, no matter how beautifully executed, is only one aspect of the story and is incomplete by itself.

My search for old pieces met with a number of obstacles along the way. I found that the fragility of the cloth had often reduced surviving glorious robes to tatters. While pieces in public collections were often out of reach, those in private collections took time to access, necessitating the establishment of trusting relationships to enable the sharing of family heirlooms, especially if the pieces were not in pristine condition. Such torn pieces, constituting

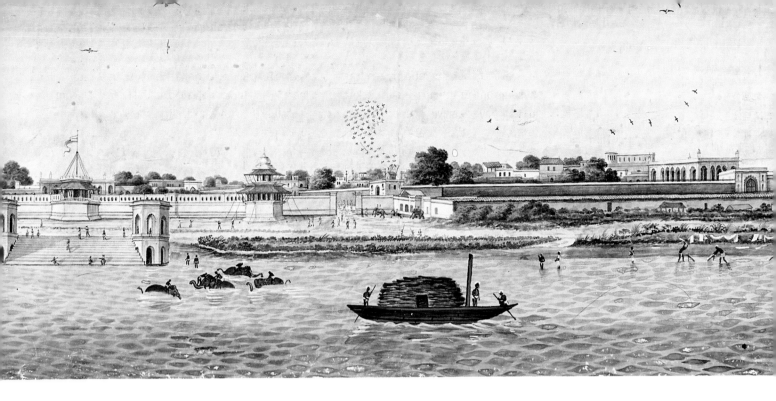

View from the Gomti river (detail)
Lucknow, 1826, watercolor on
paper, 31 x 610 cm (full roll)
Yale Center for British Art,
BA-ORB-3427397-0002-DSP

parts of intimate family stories, were often too private, too precious, to be shared with a stranger. I am deeply grateful to those, who overcoming their initial hesitation and shyness, allowed me to look at their chikankari treasures.

Unfortunately some of these contexts were not conducive to taking good quality photos in ideal conditions. The samples were often torn, creased, spotted or unclean, yellowed with time or simply too fragile to handle directly. Of course their value lay in the affection and memory of the relative that they had belonged to. But not all were damaged—some were so immaculate and exquisite that they took my breath away, made me wonder about the life and stories of the anonymous artists of the past who made them.

This book is not an academic research, nor is it a social or economic essay on the chikan industry in Lucknow today. These would have required different scholarly approaches. It has evolved into a personal journey in search of that 'mythical' chikan embroidery, that mesmerizing visual experience, now frustratingly elusive, stored away in private and public collections in India and across the world.

Describing the present day production system to illustrate the possible way in which the antique pieces might have been manufactured can be, understandably, objectionable. However old records narrate processes and situations strikingly similar to the ones artisans face nowadays.

Although it is almost impossible to date any of the pieces presented in the book, the older pieces might not be older than the mid or latter part of the 19th century or early 20th century, a time when some major changes in the production system had occurred. The pieces presented in this book are generally assumed to be chikankari from Lucknow, unless otherwise stated, but for some of them this origin might still be a question mark.

I collected information from various sources, mainly practitioners, artisans, entrepreneurs, and from the memories of the owners of old pieces, besides also my own personal involvement and experience with this craft. Unfortunately many gaps and inconsistencies

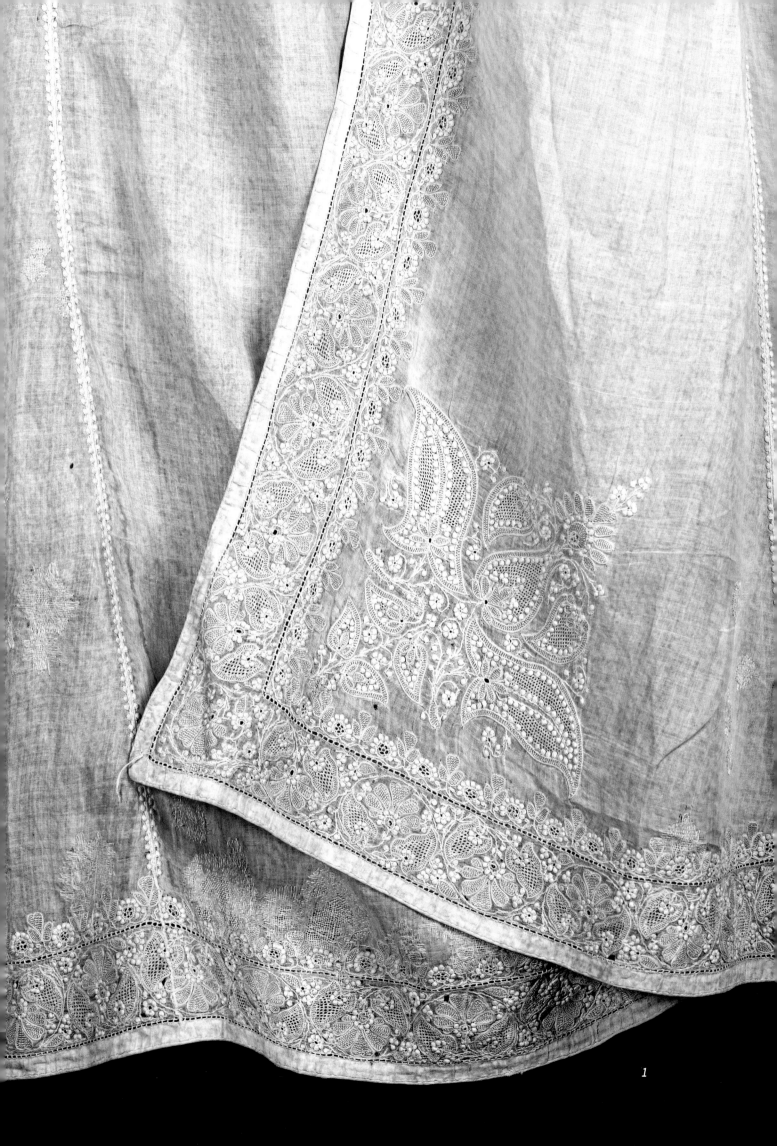

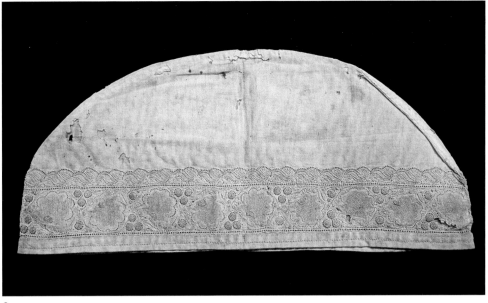

2

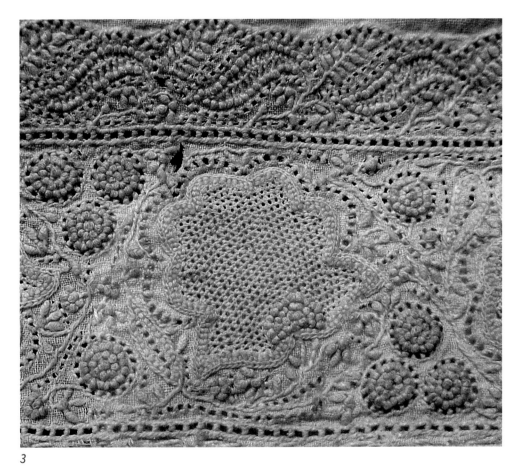

3

1 Choga, corner motif detail
Cotton cloth, cotton and silk
embroidery (muga or tussar),
Lucknow, probably late 19th
century, Crafts Museum, Delhi,
Acc. No. 64/3084

2 Dopalli topi, two panels cap
stitched at the top
Cotton, Lucknow, 19th century
Chote Bharany's Collection,
New Delhi

3 Dopalli topi, enlarged detail of
the border
The tiny leaves of the upper border
are worked in different ways: ghas
patti, phanda and dhaniya patti.
Cotton , Lucknow, 19th century
Chote Bharany's Collection,
New Delhi

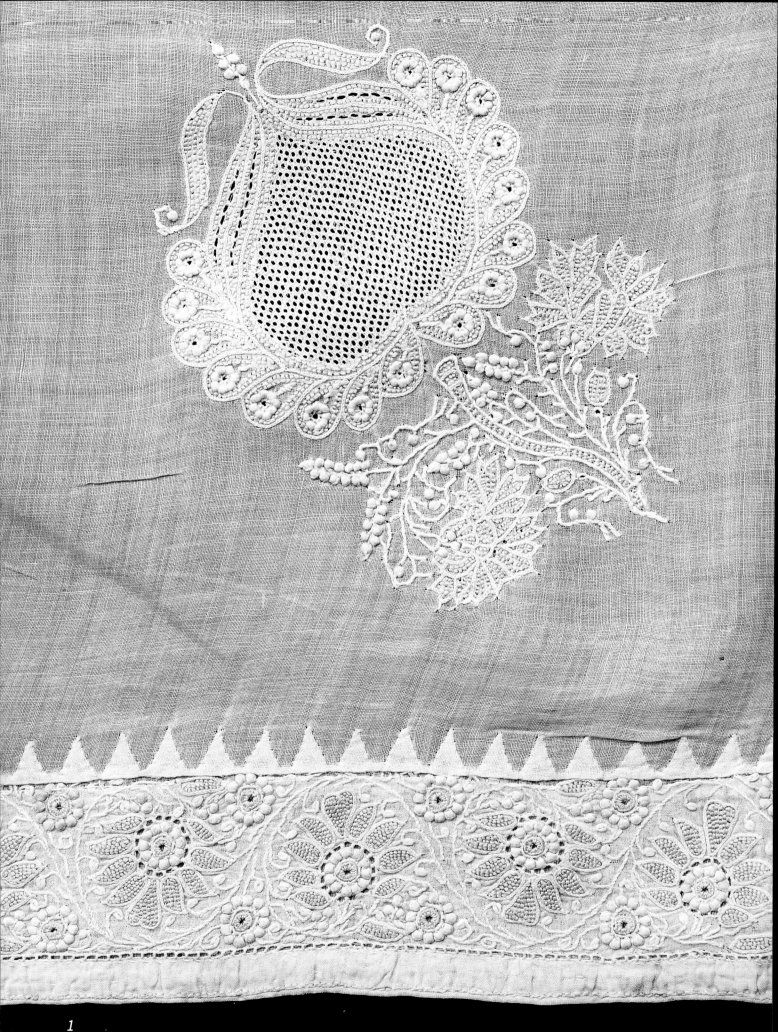

1

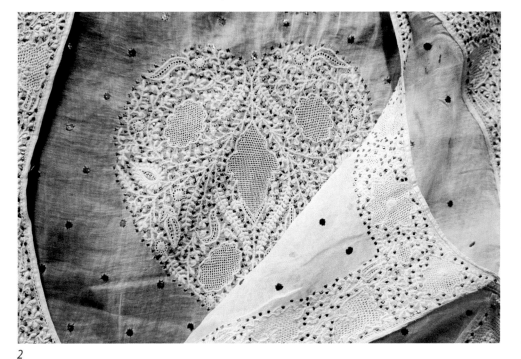

2

1 Choga detail
An unusual flower as a lower
corner motif and an attached
border with jawa, the tiny
triangular hemming seam.
Cotton, chikan embroidery with
cotton and silk thread, Lucknow,
late 19th century, Rajasthan
Fabrics and Arts Collection, Jaipur

2 Short top, with angarkha's
pattern, detail
Silk cloth with chikan embroidery
in cotton, kamdani work with
silver wire (badla)
Lucknow, late 19th–early 20th
century, Crafts Museum, Delhi,
Acc. No. 7/5212

still remain to be addressed. I have tried to touch upon the vast spectrum of themes and issues connected with past and present chikan embroidery, but many of them could not be explored in all their complexities. The focus also eventually narrowed down to chikankari embroideries produced for local elites, arbitrarily disregarding what appears to have been chikan embroidery produced for export and for Western-styled dresses, the reason being that no matter how good the latter productions, the quality of their work cannot compare with the finesse of the former.

I have also tried to highlight details of the costumes, which together with embroidery ornamentation created a particular look and defined a style, reflecting the identity, taste and lifestyle of its patronage. It is surprising that there has not been more specialized and technical attention to the evolution of the styles and patterns of Indian 'haute couture' costumes in general and to the ones embroidered with chikan. I am not only referring to the embroiderers but also to the designers, the masters and the tailors. Generally clubbed together under broad costume categories, the subtle variants in the cutting and assembling of different parts of the costumes have gone by and large unspecified. There are very few works on historical Indian costumes and they often fail to satisfy ones' curiosity on the elaborate technical knowledge and skills of the makers.

Chikankari has been regarded as an exquisite tradition, yet at the same time, it has also been looked down as a minor needlecraft perhaps not fully worthy of the attention of refined scholarship on 'authentic' Indian textiles. This book attempts to redress this perception and to make a few hidden treasures visible and available for further research, reference and visual delight. Perhaps this book encourage fortunate owners to look into their chests and trunks and bring back to light some more of these exquisite creations.

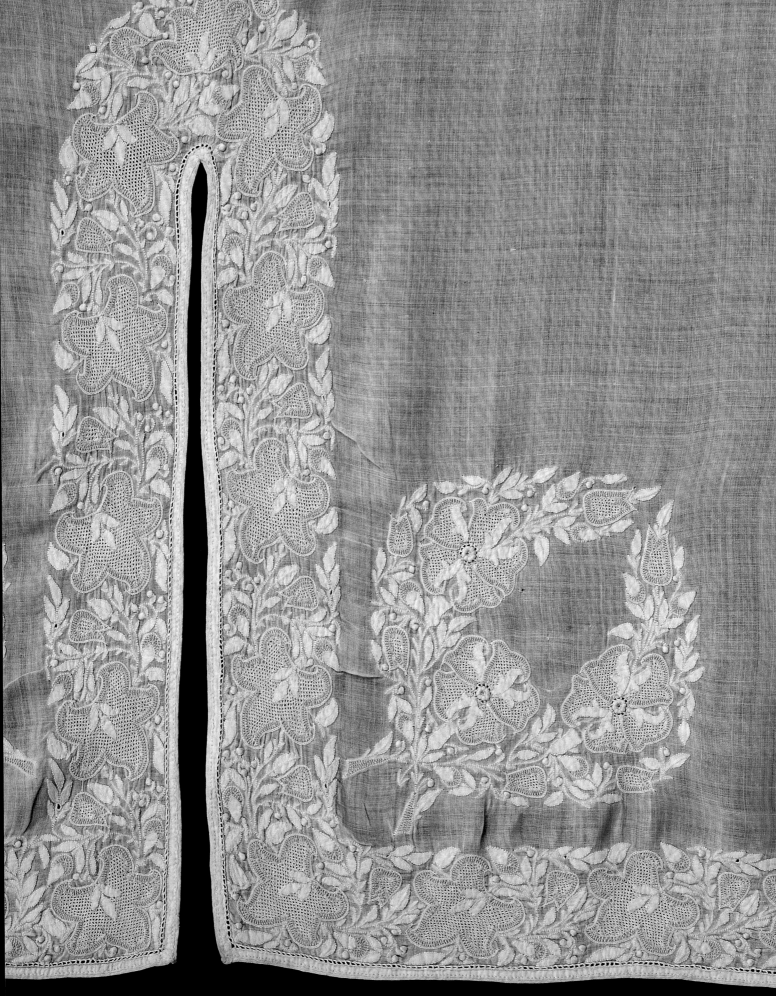

Lucknawi chikan embroidery has been described in many ways during the last two centuries. Most writers strive to find appropriate words to convey its ethereal essence the delicacy and lightness of pattern, the minuteness of the stiches, and yet the rich textures, lights and shadows of the whole. In 1903, George Watt [1] wrote: "Lucknow chikan work [...] is the most artistic and most delicate form of what may be called the purely indigenous needlework of India."[2] Kamladevi Chattopadhaya, the impressive figure behind the renaissance of Indian handicraft and handlooms in independent India, writing in 1965 described it as a "very subtle and suggestive white stitches on white,"[3] while Laila Tyabji, CEO of Dastkar, the well-known organization for crafts and craftspeople, feels that chikan is "like a dragonfly's wing, its white-on-white gossamer textures reflect the light and shade of her [*the artisan*] life — its beauty and its fragile, transient nature."[4] Even more poetic are the words of Amita Walia: "The magic of chikankari or the white-on-white embroidery of Lucknow reflects the splendour of Indian craft as pure moonlight resplendent in all its beauty."[5]

When I myself first saw an old, embroidered angarkha in the late '80s I was mesmerized by the minuteness and utter simplicity of the exquisite embroidery, and by the perfection of the craftmanship involved. The understated aesthetic of that piece, and other similar works that I started to search for became my own yardstick to assess 'true' Lucknawi chikan. But is it possible to define 'true' chikan? Is it a needlework technique and a particular combination of stitches? It is a specific decorative vocabulary? Is it a certain quality of execution and technique? Is it the rhythm of a traditional production process?

Any attempt to define chikan embroidery in the contemporary context seems to highlight its contrary nature too. Moreover, the above ethereal descriptions often appear incongruous for the sparsely worked and shabby, or thick and bold commercial productions. According to past aesthetics the finest embroidery would ornate the garments in subtle ways, ultimate luxury being defined not by quantity but by the flawless workmanship and inconspicuous miniature-style and minimalism of the stiches. "*Lightness of touch*" was the essence of the elaborate Lucknawi courtesy and, we could say, of some exquisite chikan embroideries of former times. Chikan used to be white on white embroidery executed with minute stitches on translucent fine cotton muslins. Quite the opposite of the aesthetic of today's chikan which favours lavishness of craftsmanship, whether grossly or very finely executed, in any colour and on any kind of fabric: cotton, silk or synthetic textiles, on thin or thick weaves, on plain or printed materials. Today chikan can be bulky with thick threads and slack and long stitches or very fine, delicate with intricate textures for few elite niche markets—in either case, Lucknawi chikan will always evoke images of insubstantial, evanescent and delicately flowered muslins.

A Question of Identity
Different definitions at different points in time reflect changes in patronage, taste and styles as well as changes in the organization of the production of this industry. They also indicate that chikan is a symbolically charged craft, embodying different things to its varied stake holders.

Most definitions of Luchnawi chikan emphasise ideal concepts rather than being the description of the actual needle-craft, especially in the contemporary context. The emphatic nuance in chikan writing may derive from its association with the 'erstwhile fairytale wealth' [6] and the extravagant but highly refined lifestyle [7] of Nawabs and Maharajas. Interestingly though it is "considered an embodiment of the royal city of Lucknow, chikankari has its origins in the Mughal courts. Created in the harems for the use of kings, it is now accessible to the common man."[8]

Kurta, side slit and corner motif
Cotton fabric with cotton and
silk embroidery (muga or tussar)
Lucknow, late 19th–early 20th
century, Rajasthan Fabrics and
Arts Collection, Jaipur

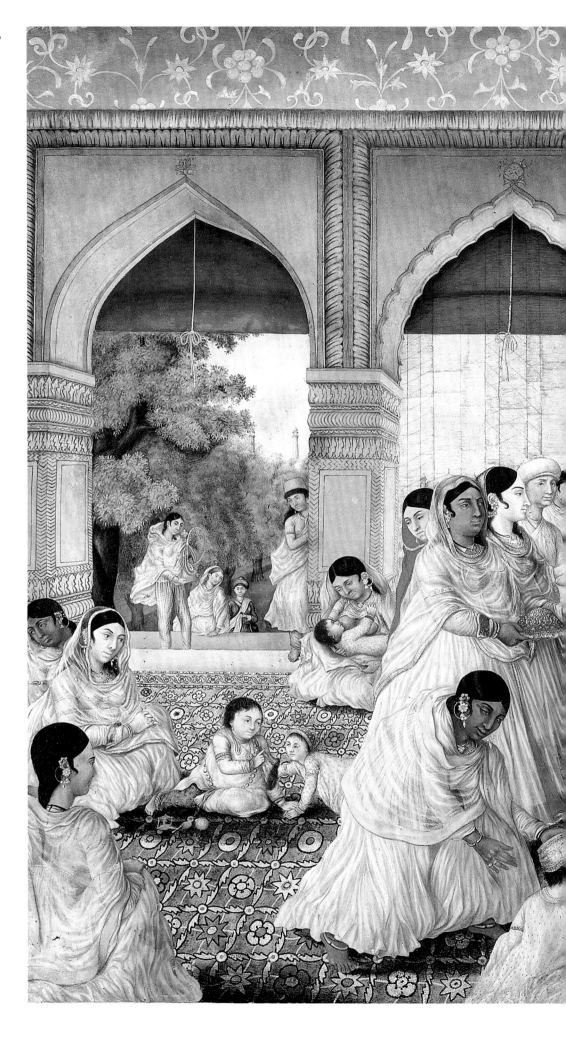

Noblewomen playing chess in the zenana at the Oudh court. Attributed to Nevasi Lal, Lucknow, c. 1790–1800, opaque watercolor and gold on paper, 47 x 62 cm, Musée National des Arts Asiatiques, Paris, Acc. No. MA12112

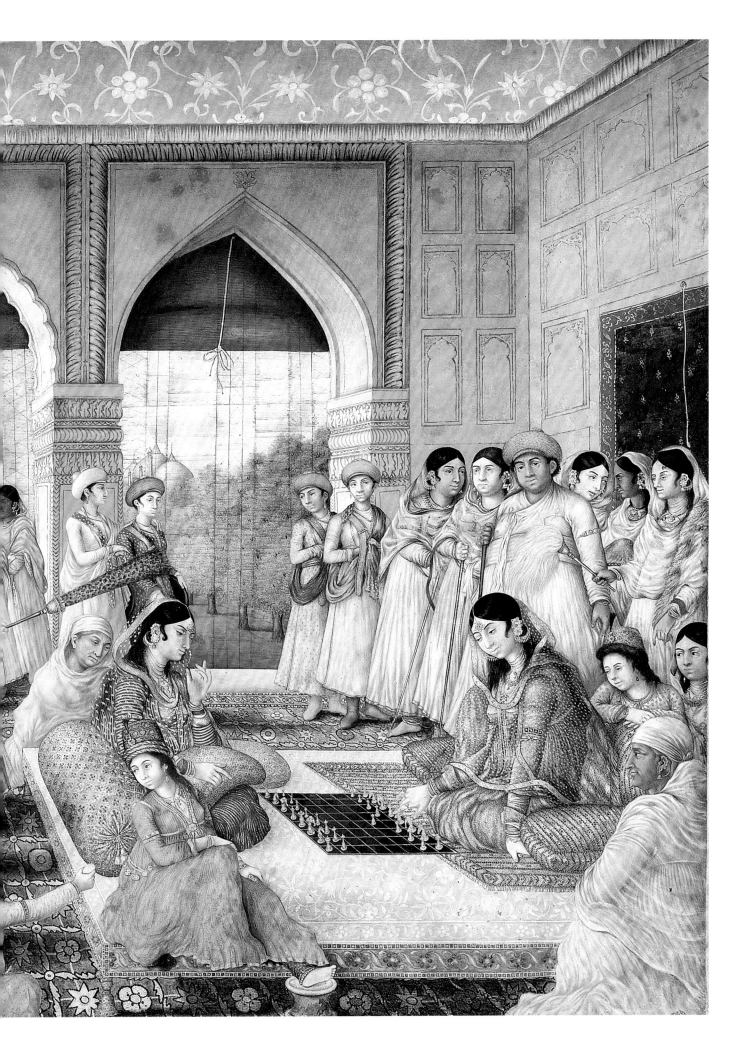

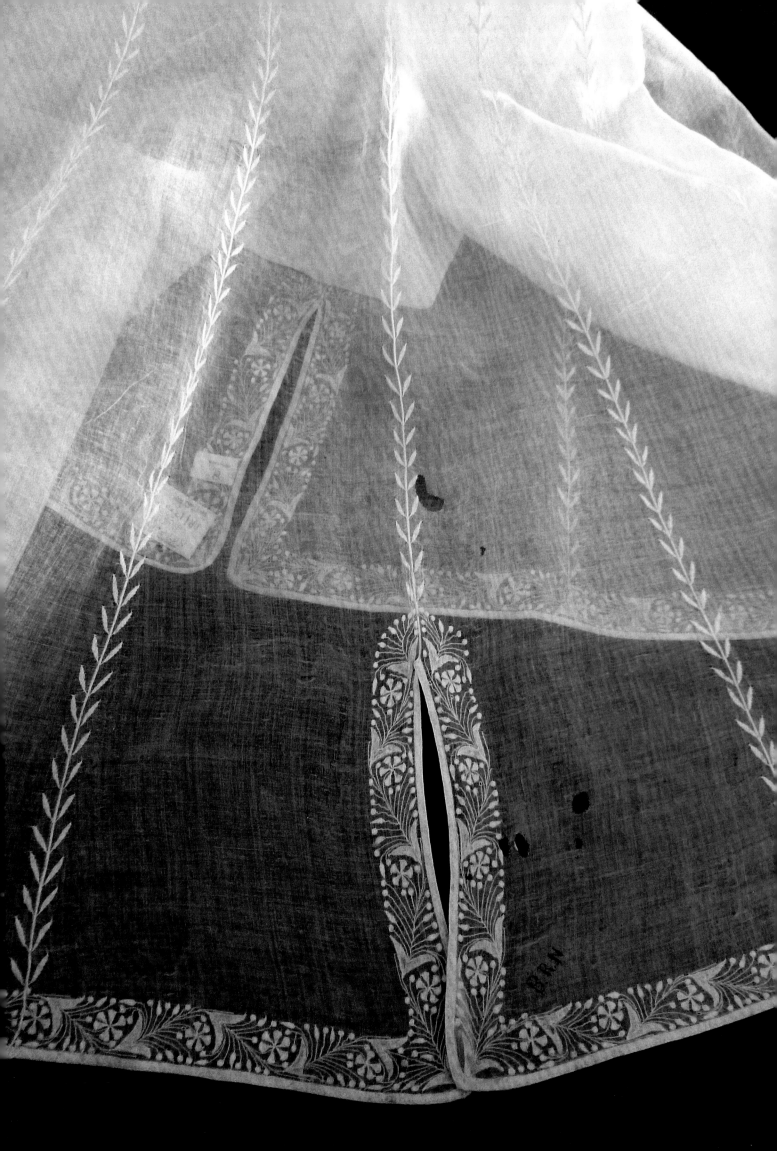

Tereza Kulkova, an anthropologist who did extensive research on the subject, defines identities: "Chikan stems from this idealized period of local past and today has turned into a literally living material proof of the imagined presence of the past. It has a specific symbolic value of its own; it is not just a souvenir par excellence from Lucknow, but first and foremost a materialization of the discursive representations of the city. This material thing, this embroidery, gives the city its identity and it also projects its identity onto the wearer of Chikan. Chikan is associated with wealth, style and taste, extravaganza, finesse, delicacy, but even honor, respect and power."[9]

Furthermore the production of chikan embroidery, in which different religious, craft and social communities are bound in a system of interdependency has played "a significant role in the sustenance of the relaxed relationships"[10] and ensured great stability of the composite social fabric.

Gender Narratives
Chikan is also a 'gender' sensitive craft,[11] as seen in the different theories about the origins of this industry and the history, development and organization of the production process.

If on one hand chikankari is related to the legendary luxury of the court, on the other hand, it is associated with poverty and unscrupulous exploitation of poor women in rural areas, who have limited opportunities for earning a livelihood, being unskilled and confined within the domestic space. They were, and often still are, paid a pittance for their work. A similar system of production seems to have existed in earlier times as well, as some accounts describe destitute women and very young children working for miserable wages to produce these quintessential luxury products. Probably the earliest mention of hand embroidery commercially made in Lucknow is Mrs Meer Hassan Ali's writing, and it is particularly interesting as it refers to impoverished, high status Muslim women who have to work for a living: "The young ladies themselves are satisfied in procuring a scanty subsistence by the labour of their hands. I have known them to be employed in working the jaullie[12] for courties[13] which, after six days' close application, at the utmost could not realize three shillings each; yet I never saw them other than contented, happy, and cheerful, a family of love, and patterns of sincere piety."[14]

There is a gender polarity in the perception of the quality of work made by male and female artisans, the extent of decline depending on the context of the narrative. A statement repeated often enough to have become an almost unquestioned fact, is that in the old days chikan was a male craft and therefore the quality of craftsmanship was far superior! The reason for this was that the system of production in royal or private *kharkanas* and the consequent patronage bestowed by refined and discerning clients on the talented (male) artisans were great incentives and the rewards, not only in economic terms but also in the appreciation and respect for their talents and skills fostered the craft.

While there are records of male embroiderers who produced very fine chikan embroidery, there are also records of equally talented ladies, whose contribution is generally minimized, if not totally ignored, as these records were more part of oral histories than of written documents. But literature does mention the feminine presence in the chikankari industry in Lucknow as early as the beginning of 19th century.

Gender differences also appear in the 'myths of origin' of chikan. The feminine versions of chikankari's origin states how the Mughal empresses Nur Jahan and at times Mumtaz Mahal,

Light muslin kurta with khatao (applique) embroidery
Lucknow, late 19th–early 20th century, Silver and Art Palace, Textiles' Collection, Jaipur

NEXT PAGE
New Year Tribute
Attributed to Nidha Mal.
Provincial Studio of Oudh, c.1760-1764, watercolour, 31.5 x 44.4 cm
Chester Beatty Library, Dublin.
Acc. n. CBL In 69.5

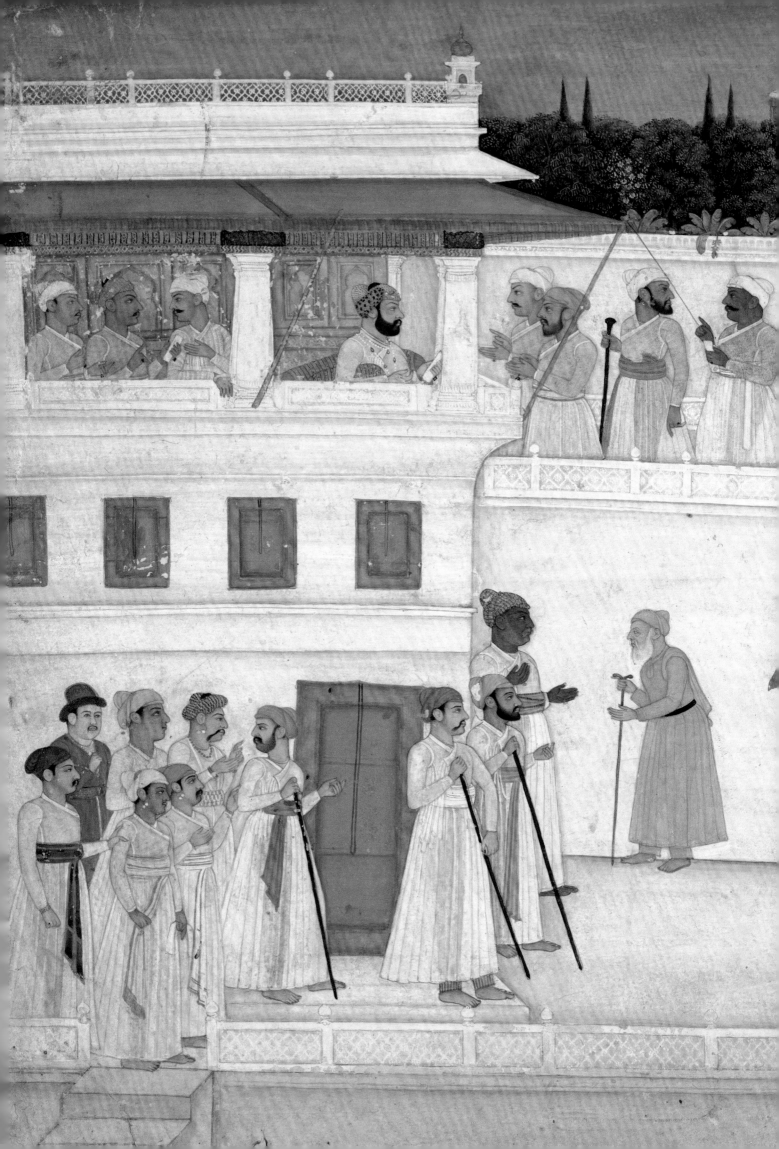

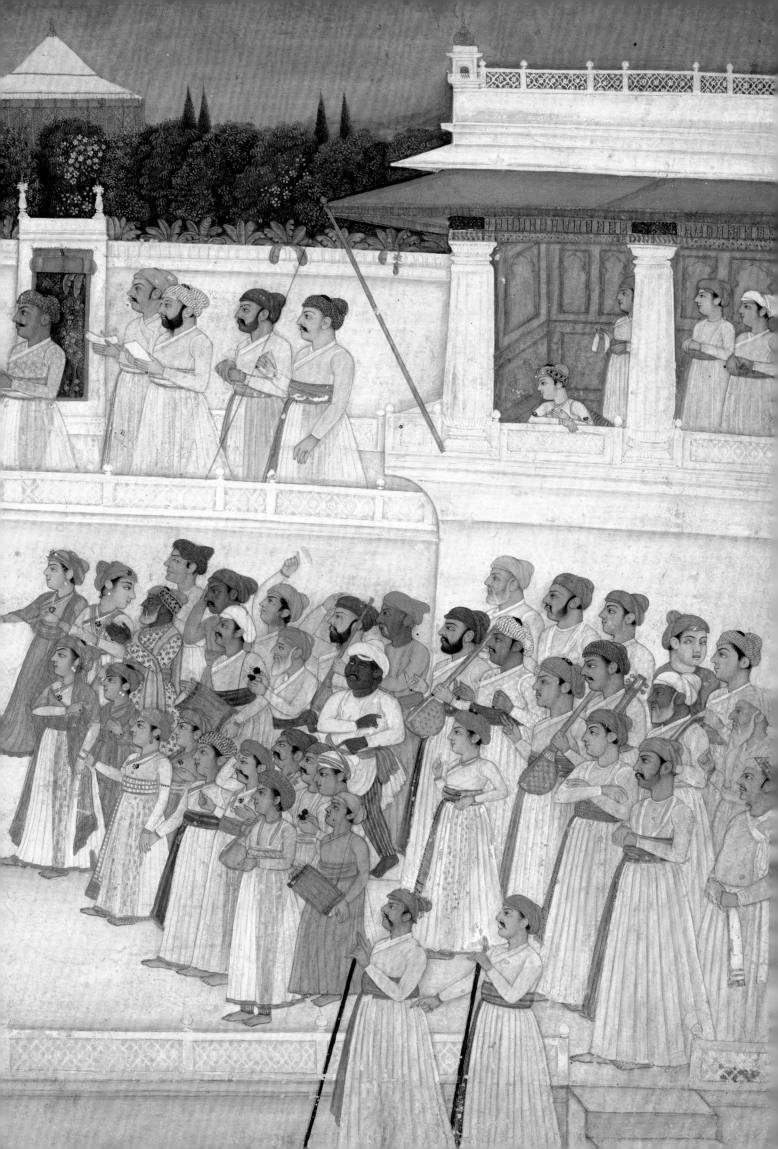

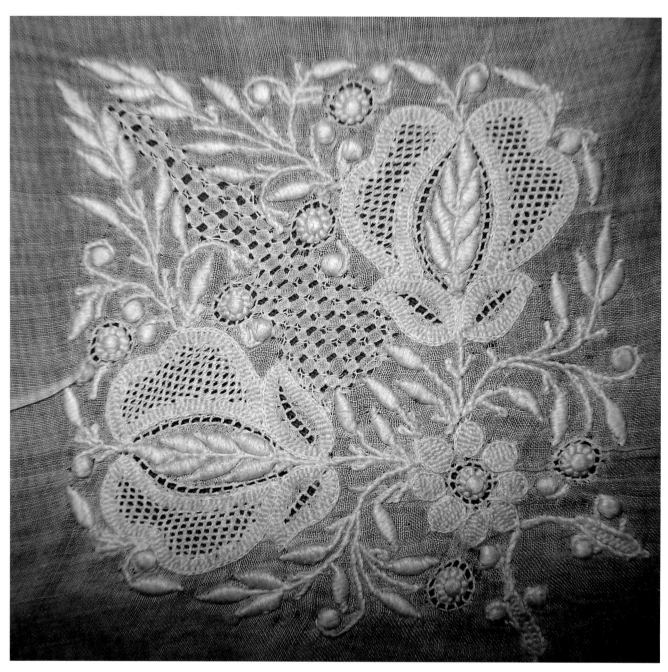

*Angarkha, detail of lower corner
motif, worked in dorukha or
reversible chikan*
*Cotton cloth, cotton embroidery,
Lucknow, mid-late 19th century
Nawab Jafar Mir Abdullah's
collection, Lucknow*

renowned for their refined aesthetic and Persian cultural background, initiated this tradition by commissioning master craftsmen to transfer and interpret the decorative elements found on Isfahan mosques and palaces onto delicate stitchery.

In another female-oriented story, the credit for introducing the art of chikan embroidery to Lucknow goes to an anonymous princess from Murshidabad. Being bored with the indolent lifestyle of the zenana and to attract the attention of the Nawab, this noble lady embroidered a very beautiful cap on delicate muslin for him. Soon, the other ladies, jealous of her success in attracting the attention of the Nawab, also took up the art of embroidery.

Chikan thus became an ideal feminine occupation and an expression of feminine artistic accomplishment. Hand embroidery was part of the upbringing of well-educated Muslim girls, who were encouraged to spend time in more meaningful ways than just sit idle in the zenana ."[15] "A delicate chikan cap took up to a year to make…"[16] and the skill of embroidery embodied artistry, sophistication, love and devotion.

The notion of occupying leisure time with chikan embroidery is so deeply rooted that even today the time spent by female artisans on embroidering is often referred to as their 'free time'. One could say that with what they earn for their work… it should be rephrased as 'working for free'. It is also difficult to not link persistent exploitative practices with the enduring perception that chikan embroidery is and should not be expensive, as it is made during the spare time of poor women, who are not used to much and so happy with little.

Both feminine narratives endorse a noble lineage for chikan, and also explain how the fashion for delicate embroidered muslins began, and eventually spilled over into the royal *kharkanas*, where male master artisans took over the production of these exquisite craftworks. The story of the Murshidabad princess also points to a Bengali origin, which is accepted by most scholars, but it is not common in Lucknow. The 'masculine narrative' of the origin of Lucknawi chikan tells of a wandering saint who taught this fine craftsmanship to Ustad Mohammad Shair Khan, an ancestor of Fiaz Khan, the first recipient of the Mastercraftsman award in the early '60s. Fiaz Khan's superior embroideries are still remembered and celebrated. The wandering saint later disappeared and "*chikankars believe that he was sent by God himself.*" Jasleen Dhamija was told that the Mazar (tomb) of Ustad Mohammad Shair Khan is visited by the chikankari workers even today.[17]

Over the past two centuries, Lucknawi chikan has evolved several distinct forms. These incude the sophisticated costumes for the elites of the past, the embroidered goods for export to the West during colonial times, the cheap productions for the vast Indian and international markets, and the redefined, sophisticated chikan embroidery for the contemporary high fashion luxury market. There is little resemblance in look, style and price tag and yet unmistakably, all these categories are Lucknawi chikan. Perhaps the most satisfactory definition of chikan today would be "any cotton embroidered article that comes from Lucknow. The Lucknow origin is the strongest and simplest element in the definition."[18]

I once asked the CEO of an old firm producing chikan in great quantities for the local and export market why the cheapest workmanship is called chikan since this undervalues the better quality products. His candid reply was that "if I don't call it chikan, I will not be able to sell it!" Not everyone in Lucknow would agree with this approach. There are a few entrepreneurs and organizations struggling to reconcile fine quality and workmanship typical

of the past with equitable wages for the craftswomen and the sustainability of their business in a highly competitive market. They have to fight against the general perception that chikan is an inexpensive product, no matter how fine the work might be.

Quite by chance, I came upon a woven label stapled to a piece in the Crafts Museum, Delhi. Probably dating to the 1960s, it reads 'UP Govt Quality Certification Mark', pointing to some form of officially certified quality control in the past which does not exist any longer. Unfortunately we haven't succeeded in getting more information about it.

In 2008, a group of entrepreneurs and NGOs[19] registered 'Chikankari from Lucknow' under the Geographical Indication (GI) law. This was done in an effort to define standards of quality and to expose spurious products, as GI law derives from an international agreement that aims at protecting and certifying the authenticity of a product from specific areas, guaranteeing that it is "made according to traditional methods, or enjoy a certain reputation." [20]

Notes

1 George Watt was part of the Indian Government Service and he was appointed to various important governmental posts, including Scientific Assistant Secretary, Government of India (1881), Reporter to Government of India on Economic Products (1887–1903) and Director of the Indian Art Exhibition, Delhi (1902–1903). For this exhibition, Watt produced a catalogue of the objects on display with a discussion concerning where, how and by whom the various groups of objects were made. In the catalogue there are numerous pages dedicated to the range of Indian textiles available at the turn of the century, including decorative needlework forms. [http://stories.rbge.org.uk/archives/11686].

2 G. Watt, *Indian Art at Delhi 1903: Being the Official Catalogue of the Delhi Exhibition 1902–1903*, reprinted in Delhi, 1987:399.

3 K. Chattopadhyaya, 'Origin and development of embroidery in our land' in Marg : *Textiles and Embroideries of India*, 1965: 8.

4 Laila Tyabji, 'Chikan' in *Namaste*,1997.

5 Amita Walia 'Moonlght on white: Imperial Embroidery' in *Embroidery in Asia: Sui Dhaga*. Delhi, 2010:5.

6 Sheila Paine, *Chikan Embroidery: The Floral Whitework of India,* 1989:18.

7 G. Watt, *Indian Art at Delhi,* 1903, reprinted in Delhi, 1987.

8 Ruth Chakravarty, 'The Story of Chikan' in *Embroidery in Asia: Sui Dhaga*, Delhi, 2010:29.

9 T. Kulkova, 'A Commodity as a Window into Complexity: The Chikan Embroidery of India and the Intertwined Social Life of Things and People', 2010.

10 Ibid

11 see C. M. Wilkinson-Weber, *Embroidering Lives*, New York, 1999:22.

12 Jali, netting.

13 Courti-Kurti, a part of the female dress.

14 Meer Hassan Ali, *Observations On The Mussulmauns Of India : Descriptive of Their Manners, Customs, Habits and Religious Opinions Made During a Twelve Years' Residence in Their Immediate Society*, letter, 1832.

15 as depicted in 'Noblewomen playing chess', *c.* 1780–1800, India, Uttar Pradesh, Lucknow.

16 A.H. Sharar, *The Last Phase of an Oriental Culture,* 1975:17.

17 J. Dhamija, 'Chikankari', *Textiles and Embroideries of India*, Marg, 1965.

18 C. Wilkinson-Weber, 1999:4.

19 Applicants: 1. Shri Markandey Singh, Special Secretary, Small Scale Industry & Managing Director, U. P. Export Corporation Ltd; 2. Shri Anil K Singh, Chief Executive, Network of Entrepreneurship & Economic Development (NEED); 3. Shri Anshu Mali Tandon, Secretary, Lucknow Chikan Handicraft Association; 4. Shri Indra Bhushan, Secretary, Shilp Sadhana.

20 http://lucknowchikan-gi.webs.com

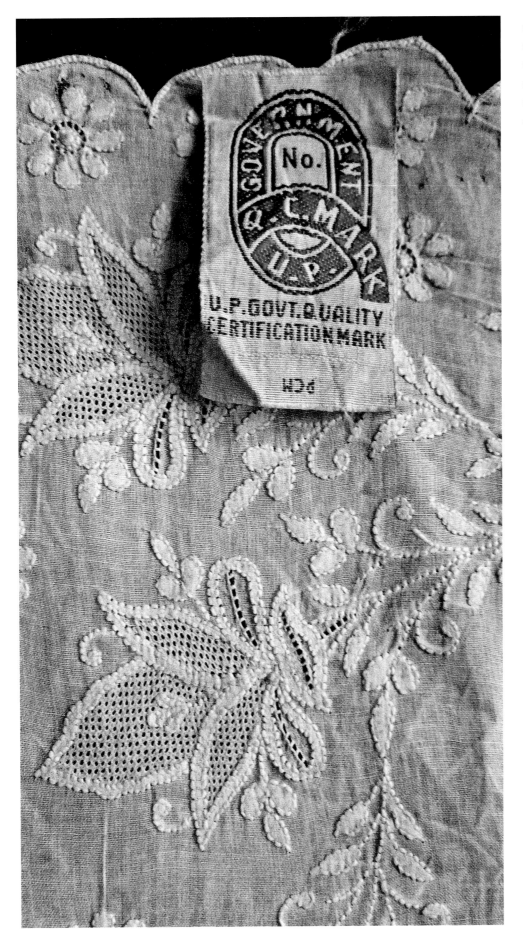

Cotton table cover with Uttar Pradesh Government Quality Certification Mark
Mid-20th century, Crafts Museum, Delhi
Acc. No. QM6/4QM4/92/66/140

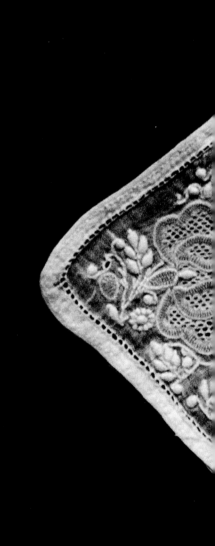

CHAPTER 2

A History of Chikankari

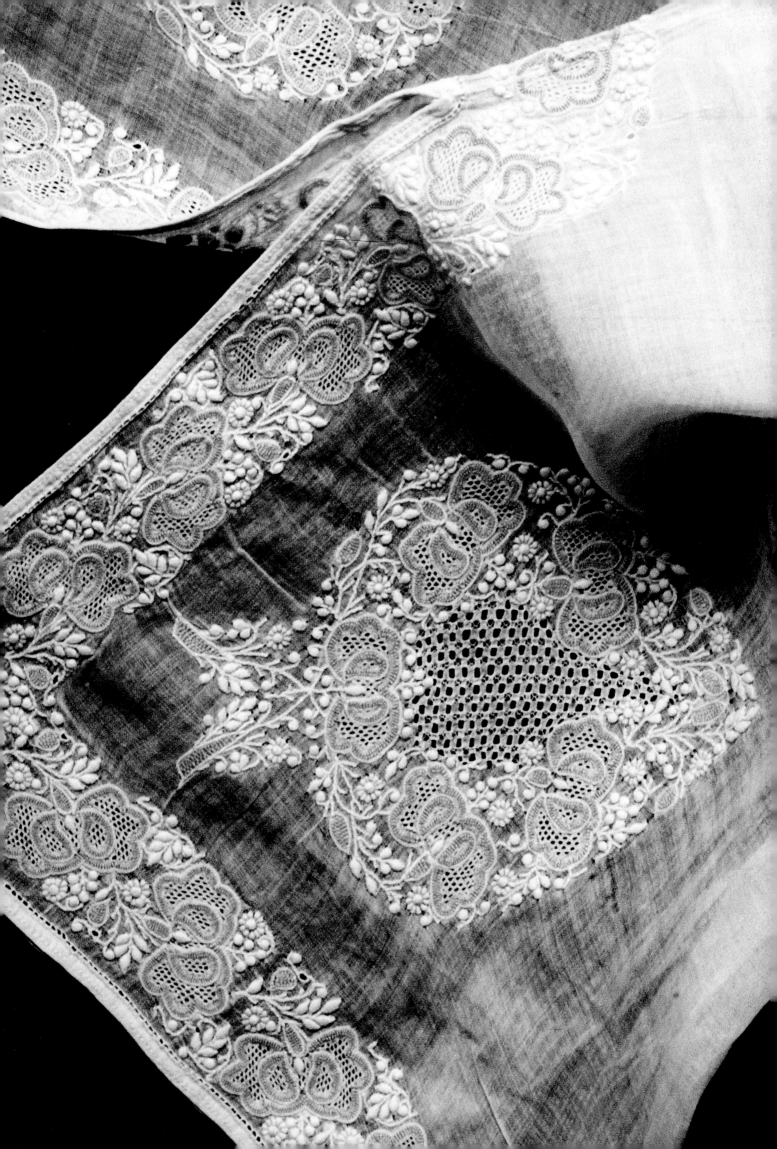

The origin and development of chikan embroidery is largely based on conjectural narratives in literature. However dissimilar, these stories are accepted by their respective proponents as conclusive and they are authenticated by repetition, particularly in Lucknow, to the point that questioning them would sound either utterly discourteous or abysmally ignorant. There are basically two stances: a popular view in Lucknow that favours the Persian origin of chikan embroidery through the patronage of the Mughal empresses, and a scholarly view which points to a Bengal origin. These two main narratives, though they might appear distant, are not necessarily mutually exclusive, and they also have some converging features.

A Look at Etymology

Although it seems established that the word 'chikan' derives from the Persian language, its application to a particular embroidery form seems to be more complex. From old records it appears that the word 'chikan' was applied to embroideries made in different places, each having developed its own particular style.

Many 'chikan' embroideries

A few monographs on Indian textiles intended as trade inventories and some detailed catalogues of colonial exhibitions dated 19th and early 20th centuries, specifically mention chikan embroidery, but this name appears to be used for a variety of different needle works.[2] In fact, the word chikan is used for a category of embroidered fabrics made in different part of the Indian subcontinent: Dacca in Bengal (today Bangladesh); Quetta in Balochistan and Peshawar (today Pakistan); Bhopal; Madras (now Chennai); Delhi, and Lucknow.

Sheila Paine, an expert on traditional embroidery wrote a small book, Chikan Embroidery: the Floral Whitework of India*, in the early 1980s. This book remains the main reference on the subject to this day. In it she discusses in great details the etymology of the word 'chikan'*

The Indian name for chikan embroidery is 'chikankari'; 'chikan' is a Persian word, 'kari' is Hindi for work. Persian was the court language of India, introduced by the Mughals, who came from Central Asia and ruled Northern India from 1530 until their empire declined in the mid-eighteenth century with the growing power of the British. Persian names were commonly used in their courts, even provincial ones.

Dehkhoda's Persian dictionary, compiled in 1950s and 1960s, quotes the definition of chikan given in earlier dictionaries. The oldest of these is Burhan's classical dictionary of 1651, which describes it as "a kind of embroidery with gold thread...Quilting." Later dictionaries give "embroidery with gold thread," "embroidery in various kind of silk on garments and other items." There is no mention of white, or of cotton, or of flowers. The usual Persian word for 'embroidery' is *naksh*, familiar in Europe from the embroidered trouser legs of Persian costume marketed under this name in Europe in the 1840s when Persian women began to adopt western-style dress and sold their old costumes.

Two poets are quoted by Dehkhoda: Radi al-Din Nishaburi, writing in the 12th century and Kamal al-Din Ismail, writing in the 13th. Both use the word chikan as a metaphor for 'needle'.

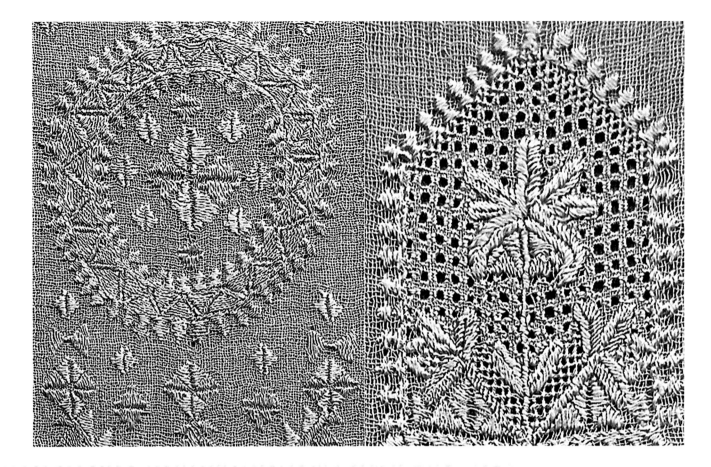

ABOVE: Silk embroidery on cotton
Persian, 19th century

PREVIOUS PAGE: Choga
Slit, border and corner motif
Lucknow, 19th century, cotton
muslin with cotton and silk
embroidery, 170 x 125 cm
Crafts Museum, New Delhi,
Acc. No. 7/5213

'Needle' is commonly *sozan* in Persian, from which is derived *suzani*, the embroidered hangings and bedspreads of the Uzbeks of Central Asia. The first appearance of the word chikan in India is in John Richardson's Persian/English dictionary published in Calcutta in 1806. This defines chikan or chikin as "a kind of cloth worked with the needle in flowers." The 1852 Steingass revision of Richardson, combined with Johnson's Persian/Arabic/English dictionary, adds "and gold" to this definition. Modern Hindi dictionaries give 'embroidered fine muslin' as the meaning of chikan. The word is used in the province of Orissa in eastern India to mean chain stitch. This is the stitch normally used to outline appliqued motifs on the ceremonial umbrellas and banners of that region. It is always in white.

A related term is 'chikandoz', which in Peshawar means colourless embroidery. Here, and in Quetta and Bhopal, the technique is simple quilting and backstitch and it is not considered chikan work, though quilting was included in the definition of 1651. Chikandoz was also the name given in the nineteenth century to some embroiderers in western India, notably the silk workers of Surat and some towns in Sind. The only Persian word with an associated sound from which chikan may derive is 'chick' or 'chiq', defined by Yule's glossary of colloquial Anglo-Indian as a "bamboo screen blind." John Fryer used this word on his voyage of 1672–81 when describing the women of Bombay [...] There is a strong affinity in the patterns of chikan embroidery and those of the window screens that protects Muslim women from public gaze. The Hindi name for these decorated screens, *jali*, is given to the pulled-thread stitches of chikan.[1]

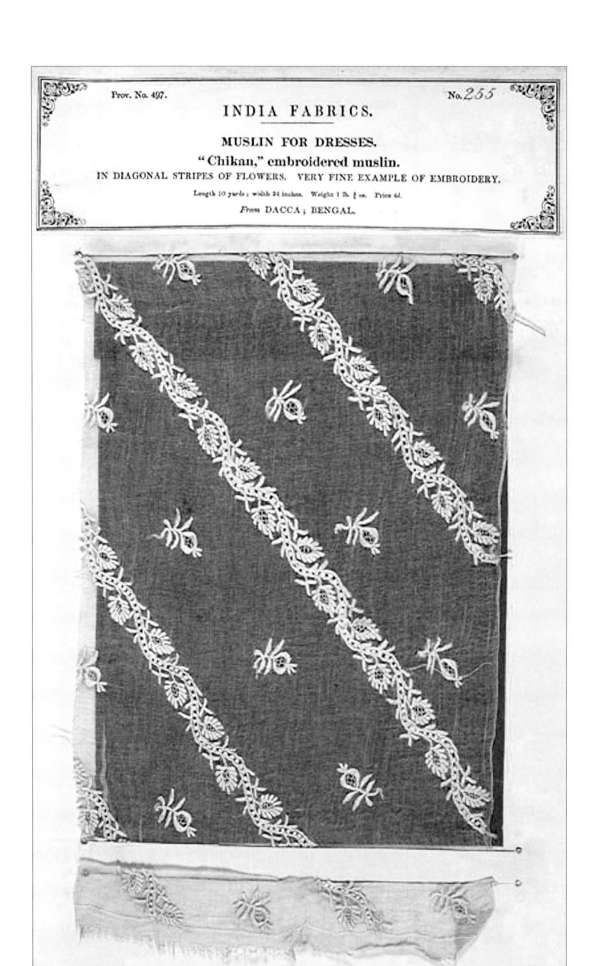

INDIA FABRICS.

MUSLIN FOR DRESSES.

"Chikan," embroidered muslin.

IN DIAGONAL STRIPES OF FLOWERS.　VERY FINE EXAMPLE OF EMBROIDERY.

Length 10 yards ; width 34 inches.　Weight 1 lb. ½ oz.　Price 4l.

From DACCA ; BENGAL.

All the embroideries called chikan must have shared some similarities, perhaps the white-on-white work or the satin stitch or the open work. As specific samples have not survived, except a few from Dacca that have been clearly identified, it is difficult to know what kind of chikan embroidery was made in these different places and what it looked like. The embroidered muslins from Dacca are visible in the collections of the Victoria & Albert Museum in London.

On most trade records and exhibition catalogues of the19th century, the origin of chikan and particularly the one which further developed in the Lucknawi style is stated to have originated in Bengal. Could there be a Persian origin for Lucknawi chikankari? According to some scholars, this is improbable as the white-work embroideries made in Persia are based on counted threads techniques, their look is more geometric, and the open works are based on drawn out threads. On the other hand, Lucknawi chikankari is characterised by flowers and meandering stems, and the delicate open works or *jali*. The latter are a distinctive feature of chikan, and although they look very similar to the Persian ones, yet technically, they are executed in a different way, without pulling out any thread from the background fabric.

"White work was indeed also made in Persia, in the technique known as filo tirato. This means that the threads are drawn out of the fabric rather than teased apart as in chikan. Removing threads in this manner automatically gives straight lines rather than curves. Patterns therefore tend to be geometric and not floral and surviving Persian white-work of the 19th century is of crosses, squares and diagonals filled with intricate detailing. It is not like chikan."[6]

It is, however, generally acknowledged that the white needlework traditions that spread all over Europe since early Renaissance period, in different styles and at different times probably came from Middle East or from Asia.

J. Forbes Watson, Reporter on the Products of India for the Secretary of State and Director of the Indian Museum since 1858, was the editor of the monumental collection of 18 volumes on *The Textiles Manufactures of India* published in 1866 containing over 700 specimens of textiles to show British manufacturers the types of fabrics made in South Asia. He stated that:
"In the first part of Table-I we have specimens of cotton embroidery on muslin, known under the name of Chikan work, termed also Chikan-Kari or Chikan-doze. It includes a great variety of figured or flowered work on muslin for gowns, scarfs, etc...it also comprises a variety of net-work, which is formed by breaking down the texture of the cloth with the needle, and converting it in open meshes. According to Taylor, Mahomeddan dresses are frequently ornamented in this manner; and he adds that there are about thirty variety of this kind of work, of which the Tarter and Sumoonderlah are considered the principal. It is said that the business of Chikan-kari embroidery affords employment to a considerable number of men and women in the town of Dacca."[3]

In Table-I under 'chikan', he listed:
"Phool Kari: A striped muslin embroidered with sprigs of flowers from Gwalior, Diagonal stripes of flowers in white cotton with intervening smaller sprigs from Dacca, Plain muslin embroidered with large flower sprig from Dacca, Vine leaf and grape pattern with intervening double rows of flower sprigs from Dacca, Flower sprigs in diagonal order from Dacca, Bootee. Plain muslin with needle-worked spots in crimson from Dacca."[4]

Swatch No. 255 from 'The Textiles Manufactures of India' compiled by John Forbes Watson published by the India Office in 1866
Cotton muslin with cotton embroidery, Dacca, mid-19th century, Victoria and Albert Museum, London

Bed cover, corded quilting
Late 19th-early 20th century, cotton, embroidered and quilted, Rajasthan Fabrics and Arts Collection, Jaipur

Excerpt from 'Chikan work and Drawn Stitch or White Embroidery on Cotton , Silk, etc. Washing Embroideries', *from the catalogue of the Indian Art Exhibition at Delhi, 1903, by George Watt*

This may be briefly described as a form of embroidery done on some white washing material such as calico, muslin, linen or silk. There are various methods and stitches, shortly to be described, that are more or less characteristic, but the most frequent is the ordinary satin stitch combined with a form of button-holing.

The great centres of this form of embroidery are Calcutta, Dacca, Lucknow, Peshawar, Madras, Bhopal and Quetta. In Madras, silk is the material most generally employed and the form of needlework there practised is almost exclusively satin-stitch, though the so-called drawn work and one or two of the special stitches that characterise the chikan work of Northern India are to some extent adopted. Accordingly, Madras silk embroideries are not usually classed as forms of chikan work but are placed along with the satin-stitch embroideries generally.

So again the exceedingly beautiful but imperfectly known white embroidery of Baluchistan has never before been assigned its true place, namely, along with the chikan work of Eastern Bengal and Lucknow. It differs, however, very materially from all the others and stands out by itself as constituting a class of work that calls for separate recognition. It is double satin stitch but the patterns are very quaint and aboriginal. So again the Bhopal white work is a form of silk embroidery in satin stitch a quilting embroidery in which very frequently a padding of some coloured material is employed which shows faintly through the sewing thus producing a most graceful and highly artistic effect. A similar form of padded or quilted embroidery is met with in Quetta.

The needlework of this Division may be usefully referred to three great sections: 1st: Chikan work proper; 2nd : White satin stitch; 3rd : Kamdani or gold embroidery on white cloth.

1st: Chikan work proper. For this purpose it seems desirable to give the position of importance to that of Lucknow, though in historic sequence it is probable that the craft originated in Eastern Bengal and was only carried to Lucknow during the period of luxury and extravagance that characterised the latter term of the Court of Oudh. The Kings of Oudh attracted to their capital many of the famous craftsmen of India, hence Lucknow, to this day, has a larger range of artistic workers than are to be found in almost any other town of India. Lucknow chikan work is perhaps the most remarkable of these crafts as it is the most artistic and most delicate form of what may be called the purely indigenous needlework of India.[5]

Megasthenes (*c.* 350–290 BC) was the Selucid Greek ambassador from Seleucus I Nicator to the court of Chandragupta Maurya in Pataliputra (modern day Patna in Bihar). In an account of his travels *Indika*, he states: "Their robes are worked in gold, and ornamented with precious stones, and they wear also flowered garments made of the finest muslin." In another fragment, he again specified, "...thus they dress in muslin, wear the turban, use perfumes array themselves in garments dyed of bright colours."[7]

An extremely rare and ancient terracotta has been excavated at Chandraketugarh in West Bengal, dated to around 400 BC and probably contemporaneous with Megasthene's travels. It depicts a richly ornamented woman, a Devi or a noblewoman, wearing the finest muslin dotted with small flower motifs similar to the kind that will appear much later in chikan embroidery.

According to other authors, chikankari already existed in the 7th century AD. As writes Kamladevi Chattopadhyaya: "Very subtle and suggestive white stitches on white is what is known as chikan work. It has been dated back to King Harsha's time who is said to have had a liking for white muslin garments embroidered with patterns but no colour, no ornamentation, nothing spectacular to embellish it."[8] The frescoes at Ajanta, dated to around 5th and 7th centuries, are considered by some authors as showing early depictions of chikan embroidery.[9]

Embroidered light muslin was highly appreciated at the Mughal court. Sir Thomas Roe was the first English ambassador to the Mughal Court from 1615–1618. In his correspondence, he mentions that the Empress Nur Jahan had a preference for rich textiles, tapestries and fine embroideries. These could thus be offered as precious gifts to gain, through her good will, access to the Emperor to obtain trading rights, or be sold to the local elites at good profits.

According to Laila Tyabji, who has played an important role in the revival of high quality designs for chikan embroidery in Lucknow in the mid 1980s and who is herself an accomplished embroiderer: "Chikankari stems from the white-on-white embroidery of Shiraz and came to India as part of the cultural baggage of the Persian nobles at the Mughal Court…,"[10] and she specifically links it to Nur Jahan, Jahangir's beloved queen. Nur Jahan belonged to a Persian family where customarily girls would learn to master needlework from a young age. At the time of her first marriage to Sher Afghan, Nur Jahan lived in Dacca and it is quite possible that she became acquainted with the finest muslins,

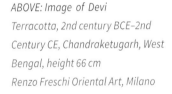

*ABOVE: Image of Devi
Terracotta, 2nd century BCE–2nd
Century CE, Chandraketugarh, West
Bengal, height 66 cm
Renzo Freschi Oriental Art, Milano*

*BELOW: Detail of Devi
Small flowers motifs on the draping
of the light muslin*

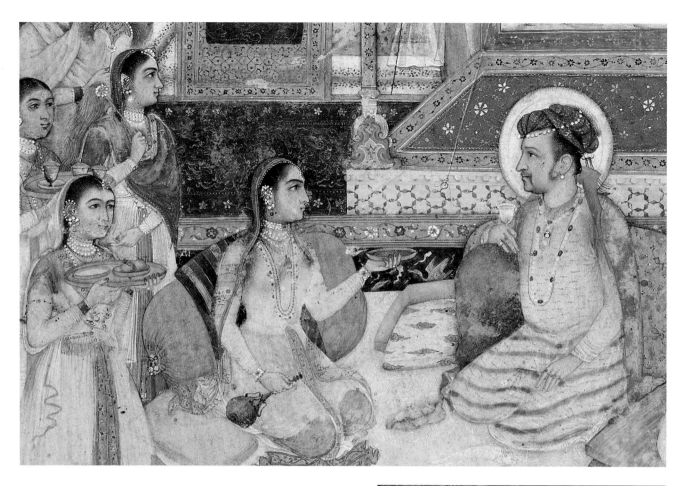

Jahangir and Prince Khurram being
entertained by Nur Jahan
North India, c. 1640–50; opaque
watercolor, ink and gold on paper,
25.2 x 14.2 cm
Freer Gallery of Art, Smithsonian
Institution, Washington, D.C.,
Acc. No. F1907.258, gift of Charles
Lang Freer

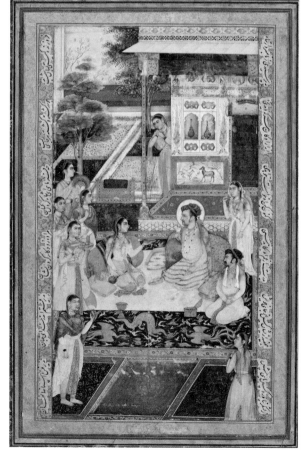

maybe also the embroidered ones which were made for export. Special workshops in Dacca were engaged in producing the finest muslins exclusively for the Mughal court and Nur Jahan is credited "with the introduction of many innovative things, and most of them are associated with textile and couture culture...with the sanctioning and designing of many dresses during her time, mostly brocaded and lace decorations. The most famous of these garments was probably the Nur Mahali which was essentially men's wear!"[12] Also well-known was the *dudami* or flowered muslin.

From Chikankari : White on White: Stitches and Shadows *by Laila Tyabji*

How chikan originated, even what its name means is, appropriately enough, an equal mystery. There are those who would have it that—like everything else in the Universe from space satellites and Jesus Christ to the more obscure sexual acrobatics—it was all written down in the Vedas. D.N. Saraf in his book on Indian crafts cites travelers to the court of Harshavardhana of Kanauj referring to delicate muslin draperies embellished with motifs worn by the royal harem. But these could have as well have been woven as embroidered. Folklore and ones wilder jingoist fantasies apart, historical research supported by the ancestral memories of master craftsmen, seems to suggest that chikankari stems from the white-on-white embroidery of Shiraz and came to India as part of the cultural baggage of the Persian nobles at the Mughal Court, along with kalamkari textile painting, silk carpets, blue tile work and pietra dura. Twelfth-century Persian poets were already using the word chikan as a metaphor for needle. Though Shirazi embroidery is done on coarse unbleached linen, its repertoire of pulled, drawn thread, knotted, chain and overlaid stitches is strikingly similar to those in the chikankari tradition. Legend says it was Empress Nur Jehan, a noted aesthete and embroiderer, who, while making an Eid cap for her husband , the Emperor Jehangir, conceived the idea of using the fine white cotton mull for which Indian weavers were famous, as a base for her stitchery.

Be that as it may, it is well authenticated that the Mughal Court adored and patronized chikan embroidery and gave it its own distinctive character and design identity. Chikan was used for everything—from turbans and veils to angarkhas, chogas and palace interiors. The Imperial Mughal manuscript copy of the Padshanama...has a beautiful detail of a many arched balcony curtained with flowing, sheer white-on-white draperies with delicate floral motifs, which could well be chikan. The cool understated refinement of chikan suited the sophisticated elegance of the Mughals—just as it did the searing heat of an Indian summer. The floral jaals, rosettes and paisleys that remain a part of the chikan tradition today are a legacy of their style and imagery—unchanged though occasionally distorted—through the years.

Chikan, as Bernier, the 16th-century French doctor and traveler reminds us, is ephemeral. He had a keen eye for the finer details of both Indian women and Indian textiles. He described the court ladies drawers, "enriched with fine needle embroidery ... "so fine and delicate that...they last only one night, even though they are often worth ten or twelve crowns..." The under-drawers and over-gowns are gone but their stylized, exquisite motifs have come down to us, preserved through the wooden printing blocks with which chikan motifs are transferred onto cloth for embroidery. Converted today into 20th century three-dimension by the laboring hands of women, working in situations and surroundings not much changed from their 16th-century sisters.[11]

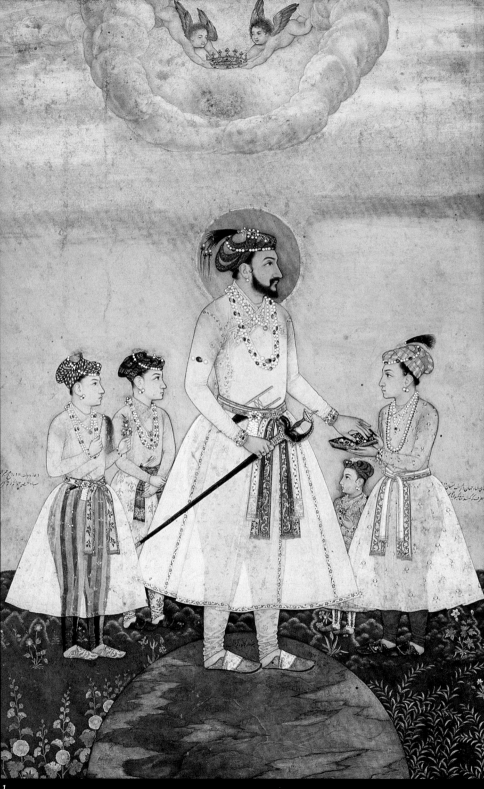

1 Shah Jahan on the globe with his children
Balchand, c.1596–1640 , 23.2 x 14.9 cm, Chester Beatty Library, Dublin
Acc. n. CBL In 7A.10

2 Contemporary daraz seam with small flower motif
Cotton, Lucknow, 2015

1

J. Taylor, in 1840, wrote:

"The Empress Noor Jehan greatly encouraged the manufactures of the country and under her patronage the Dacca muslins acquired great celebrity. They became at this time, the fashionable dress of the Omrah at the Imperial and Vice-regal Courts of Hindostan, while the finer fabrics, so exquisitely delicate, as to be styled in the figurative language of the East 'webs of woven wind', 'abroan' or running water, or 'shubnem' or morning dew, were exclusively appropriated to adorn the inmates of the seraglios."

Jahangir's period is considered to be a time of great changes in fashion and particularly for the preference of fine muslins from Bengal in royal apparel. Many travellers noticed the white costumes worn at court, and that the cloth was so diaphanous that the skin could be seen through the fabric. Visual records of antique Indian miniature paintings and of portraits by Western artists active in India during the 18th and 19th centuries are invaluable, detailed documents of the prevailing court fashions. Costumes made of white, translucent, fine muslins are remarkably frequent; the translucency appears to vary according to the rank of the wearer. The higher the status, the thinner the robe. Frequently the muslin *jama* worn by the emperors is so transparent as to be almost invisible.

Occasionally, hints of ornamentation are visible on the white sheer muslins, in colours or gold, or in white. It is, however, difficult to say if the decoration is woven or embroidered: is it *jamdani* weaving, gold printing or chikan embroidery?[13]

In a remarkable painting by Balchand (*c.* 1627–29), the Mughal Emperor Shah Jahan and his sons are wearing the finest muslin *jama*. The ornamentation on Shah Jahan's *jama* is particularly intriguing, for the seams joining the panels of the skirt of his *jama* look very similar to a kind of seam, the *phool ka daraz*, which is typical, albeit rare, on costumes embroidered with chikankari[14] in Lucknow. A similar coat (or is it the same passed on from father to son?) is worn by the Emperor Jahangir in an earlier portrait by Bichitr dated 1620.

After the decline of the Mughal court in Delhi, other Indian courts, particularly the court of Oudh, continued to favour the finest of *jamdani* or flowered muslins[15] made in Dacca with the legendary, hand-spun cotton thread. This was indeed a very rare commodity as "to procure country thread of a certain quality is a task attended with considerable labour and expense; it

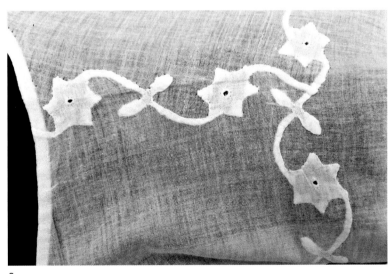

2

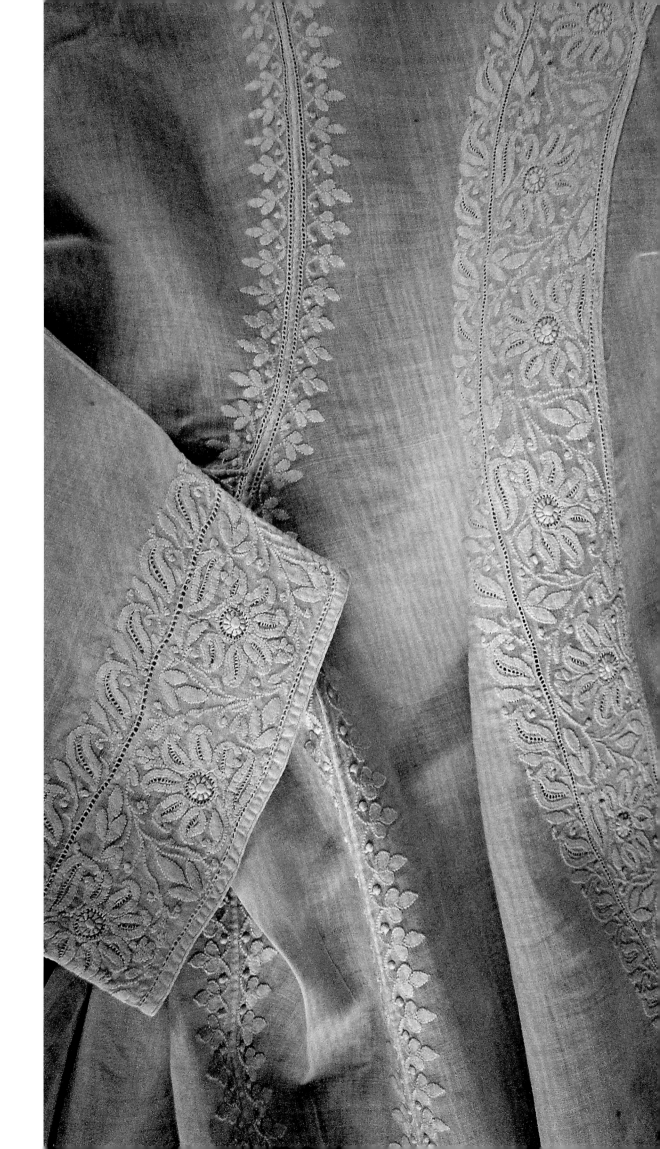

can only be done by visiting the different marts in the district, and it is estimated that two-thirds of the time occupied in preparing the fine muslins, are spent in searching for thread suited for the manufacture."[16] The Nawabs of Oudh supported the development of very fine *jamdani* weaving in their state, particularly famous were the ones from Tanda, Jais and Faizabad.

Angarkha
Late 19th–early 20th century,
cotton with cotton embroidery
Private Collection

The Bengal Roots

Since ancient times, Bengal has been known for the production of very fine muslins. These are documented in Latin literature as textiles "highly prized by the ladies of Imperial Rome in the days of its luxury and refinement." They were exported to the Red Sea ports of Aden and Jeddah, from where they were forwarded further afield.

During the 12th–13th centuries Arab merchants established in the Dacca region traded in embroidered textiles called *kashida*. These were large square cotton scarves with dense floral motifs made with muga or tussar silks. They were exported to Middle Eastern markets. In 1840 James Taylor, a civil surgeon, surveyed the conditions of Bengal population in *A Sketch of the Topography and Statistics of Dacca.* He wrote:

> "They have the pattern of the flower that is to be worked, stamped upon them with a red dye by a class of workmen called "Cheepigurs" after which they are distributed to the embroiderers in the town, by persons (Oastagars and Oostanees), who contract with the merchants for the work, and who supply the embroiderers with silk and an occasional advance of money...The principal embroiderers are Mussulmaun women of the lower classes, and the wives of Doobees, who devote the time they can spare from their usual domestic duties, in thus earning a little money for themselves and families. Embroidery appears to be a favorite occupation among all ranks and classes of Mussulmaun women. Formerly, when there was a greater demand for Khasseida cloths of different kinds, than there is at present, females of the first families in the place were in the habit of employing their leisure hours in this way, and I believe it is no unusual thing in Turkey in the present day, for ladies of distinction, including even those of the Sultan's seraglio, to send embroidered work to the Beresteens of Constantinople, for sale...About 20,000 pieces of Khasseidas are annually worked here, and are sent to Persia, Egypt, and Turkey, where they are chiefly used as turbans."[17]

It is interesting to note that the technical process of stamping the motifs to be embroidered described here is similar to the one recorded in Lucknow.

European trading companies arrived in India in the 16th and 17th centuries looking mainly for textiles, an essential commodity in the international spice and slave trade. Over the next few centuries, the diversity and fine craftsmanship of Indian textiles—printed, painted, embroidered or woven—triggered intense and prolific exchanges at creative and decorative levels. It also prompted a competitive race in Europe to manufacture textiles as varied and as fine as the Indian ones, the negative consequences of which led to the annihilation of the Indian handloom industry particularly in Bengal.

The Indian craftsmen were reputed to be extremely dexterous and meticulous, painstakingly making by hand "with a greater perfection and beauty"[18] exquisite products, highly coveted in Europe, at comparatively much lower prices. Samples books, patterns and designs of all kind, suiting Western tastes and changing fashions, were dispatched to India, to be reproduced or exotically interpreted in prints, weaves and embroideries.

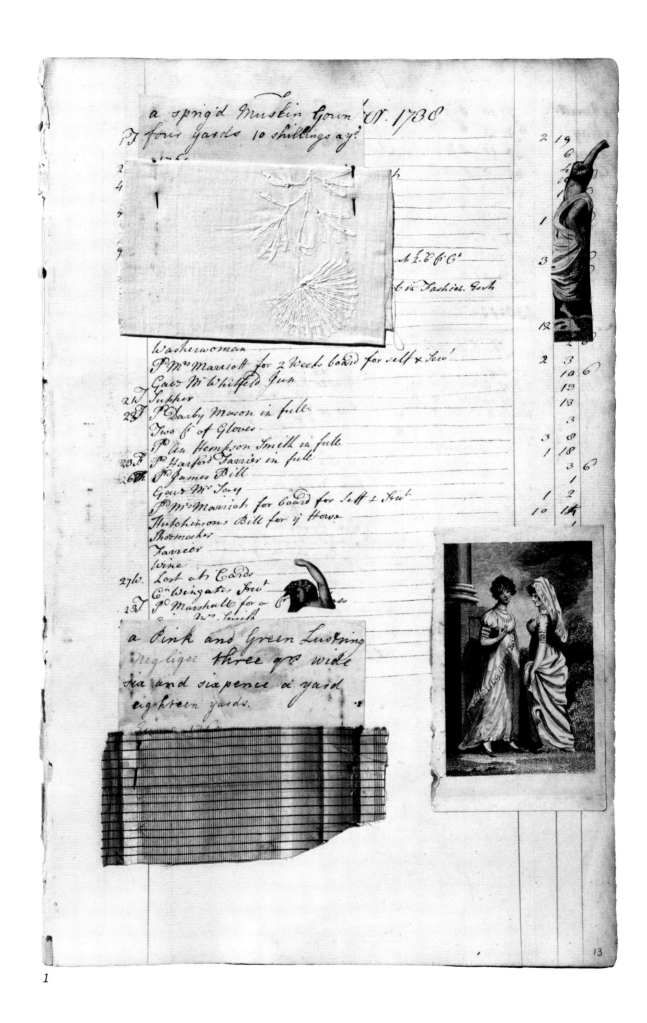

a sprig'd Muslin Gown N.° 1738

P.ᵈ four yards 10 shillings a yᵈ 2 | 19

Washerwoman 2 | 3
P.ᵈ M.ʳˢ Marriott for 2 Weeks board for self & Serv.ᵗ 10 | 6
Gav.ᵈ M.ʳ Whitfeld Jun 13
21.ᵗ Supper 13
22.ᵗ P.ᵈ Darby Mason in full 3
Two p.ʳ of Gloves 3 | 8
P.ᵈ An Hempson Smith in full 1 | 18
23.ᶠ P.ᵈ Harford Farrier in full 3 | 6
26.ᵗʰ P.ᵈ James Bill 1
Gav.ᵈ M.ʳ Jay 1 | 2
P.ᵈ M.ʳˢ Marriott for board for Self & Serv.ᵗ 10 | 14
Hutchinsons Bill for y.ᵉ Horse
Shoemaker
Farrier
Wine
27.ʷ Lost at Cards
C.ᵗ Wingate Sto.ᵗ
28.ᵗ P.ᵈ Marshall for a
M.ʳˢ Smith

a Pink and Green Lustring
Negligee three q.ʳˢ wide
six and sixpence a yard
eighteen yards.

13

1

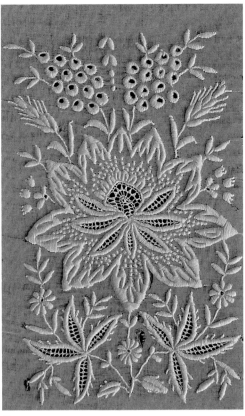

1 White floral embroidery on muslin
From an album of swatches compiled by Barbara Johnson (1746–1823), possibly Bengal, 18th century, Victoria & Album Museum, London, Acc. No. T.219-1973/2006BH4159

2 Swatch of a flower sprig from the Svecia shipwreck
Cotton embroidery, tepchi stitch on cotton, Bengal, 18th century

3 European white on white embroidery
Cotton muslin with cotton embroidery, possibly Ayrshire, early 19th century, 12 x 23 cm
Author's Collection

2 3

Chikan embroidery on the legendary fine muslins from Dacca was among the articles in great demand and exported from Bengal since the second half of the 17th century. Shiela Paine writes:

> "Records of the mercantile companies give a factual account of the textile traded from Bengal. Orders for the year 1681, for example, included "500 mulmuls with fine needlework flowers wrought with white, the flowers to be about 3 or 4 inches asunder and neat." Though referred to as needle work, the spacing of the flowers indicates that this could perhaps be jamdani weaving. It is however clear that fine white cottons with repeat motifs of isolated flowers worked in white thread were of the textiles exported to Europe from Bengal."[19]

Two fabric swatches from the mid-eighteenth century show 'flowered muslins' from Bengal embroidered in *tepchi* stitch, one of the stitches typical of Lucknawi chikan. One swatch was recovered from the Svecia, a Swedish cargo ship wrecked in 1739 [20] and has embroidered carnation flowers. The other fragment is from a book of swatches dated to the middle of 18th century and has a carnation flower with leafy stems. [21]

> "Bengal also had a most delicate, almost shadowy stitch termed chikankari, probably because of a resemblance to chikan work…The chikankari was done with white cotton thread to create an effect of light and shadow on fine muslins. There is every reason to presume that this embroidery tended to pattern itself on the finely woven jamdani with its very delicate designs, creating variations of textures and patterns of white on white." [22]

The craze for sheer muslins, plain, patterned on the loom or embellished with the needle, spread all over Europe and in America specially towards the end of the 18th century, culminating with the fashion of 'Empire' and 'Regency' styles.

1 Angarkha detail
Embroidery in diagonal stripes
with tepchi stitch,cotton muslin
with cotton embroidery, northern
India, possibly Lucknow
Rajasthan Fabrics and Arts
Collection, Jaipur

2 Jamdani
Diagonal stripes or tercha
design, cotton muslin, Dacca
(Bangladesh), 19th century
Rajasthan Fabrics and Arts
Collection, Jaipur

3 Picchwai painting
The ornamented muslin is the
backdrop of the deity,
Tapi Collection, India,
Acc. No. Tapi 04-146.

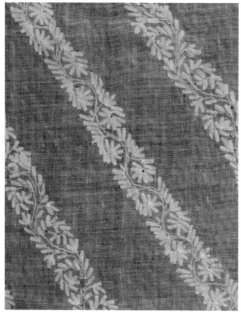

1

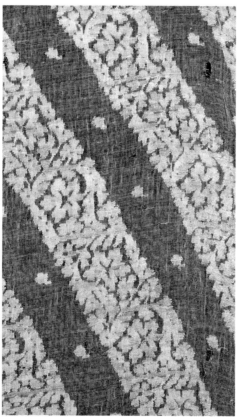

2

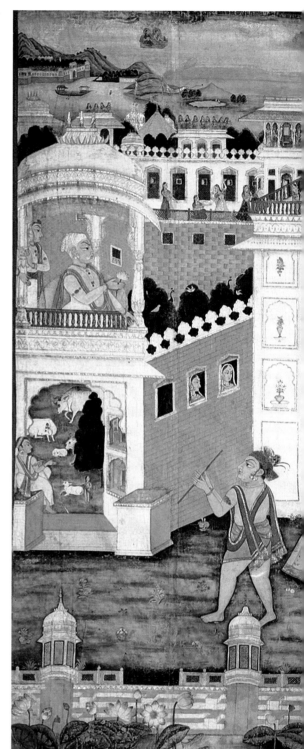

3

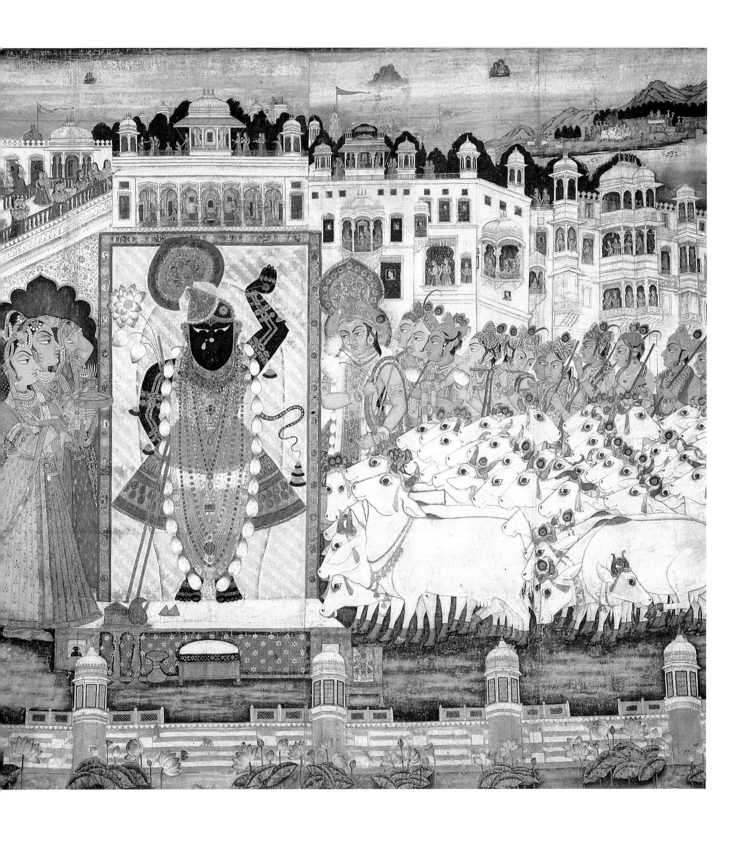

The art of fine embroidery was also a necessary accomplishment for girls of both affluent and poor backgrounds in the West. It was considered a must to keep girls occupied in industrious activities like embroidery work, the practice of which would nurture 'good virtues' and foster another valued feminine feature such as artistic sensibility.

Different variations of fine whitework embroidery developed all over Europe and in America in the 18th century, like the Dresden embroidery in Germany or the Ayrshire embroidery in Scotland. Both styles share many similarities with chikan embroidery. Known especially for open work and filling stitches, they were "done on the finest of linen and cotton fabrics, in a variety of complex pulled and drawn thread designs as well as solid and outline stitches." [23]

The colonial literature quoted earlier and textile historians believe that chikan embroidery began to be produced in Dacca as a faster and less expensive imitation of *jamdani* muslins, with the "same technique of thick soft white cotton upon fine cloth, much of the production being piece-goods for costume clearly derived from the woven type, though the motifs have greater freedom of design."[24] In the contemporary records, Dacca appears to have been a very busy and industrious textile hub. J. Taylor writes that:

"The art of embroidering is most extensively practised here, especially by the Mussulmans, who display in the use of the needle, a dexterity fully equal to that exhibited by the Hindoos in their labours at the spindle and the loom [...] The flowering of muslin dresses is performed by a set of embroiderers called " Chuckendose" and the embroidering of muslins, scarfs and shawls with silk by workmen called " Zurdose." The latter description of work is highly esteemed in Europe, and is in a much more flourishing condition, than any other kind of manufacture here. The scarfs and shawls are imported from Calcutta[25] and are worked to order chiefly for transmission to England. This year about 1000 have been manufactured, and a few I believe for her Majesty."[26]

From the early 1800s the production of fine muslins in Bengal declined rapidly as the British textiles industry succeeded in the manufacture of mechanically competitive products. Taylor notes that: "The exports of muslins to England in 1787 amounted in value to 30 lacs of rupees. In 1807 they were only 8 ½ lacs, in 1813 they had decreased to 3 1/2 lacs, and in 1817 they altogether ceased and the Commercial Residency was abolished."[27] Export of muslins from India stopped, and from 1821 fine yarns and muslins cloth, later including even machine made 'jamdani', were imported from Britain into India in ever increasing quantities. During the 1830's the trade of *kashida* embroideries, which were worn as turbans by the Turkish and Egyptian armies, also declined rapidly as army uniforms were changed.

The dramatic drop in muslin manufacture and embroidery industry combined with political instability and natural disasters also caused decrease in the population of Dacca. Taylor noted that in "In 1800 the inhabitants were 200,000, but now they do not amount to more than 68,038 in number, according to the census of 1838."[28]

However, the court of Awadh grew in fame and splendour from the second half of the 18th century. It replaced the Mughal court as patron of the arts, including the finest of textile crafts. Excellent *jamdanis* were produced in Faizabad, Jais and Tanda. It is therefore quite possible that the loss of job opportunities in Bengal and the demand for accomplished craftsmen to support the lavish and luxurious lifestyle of the ruling elite in Lucknow induced craftsmen

to migrate to workshops where there would be a demand for their sophisticated skills. Scholars therefore believe that chikan embroidery in Lucknow came from the muslin, *jamdani* and chikan craftsmanship in Bengal, which in turn had absorbed styles and taste of the international markets that they had been supplying .

The Move to Lucknow

Craftsperson and local traders in Lucknow do not accept, generally, the assumption of Bengal origin of chikankari and narrate different stories, emphasizing the royal lineage and particularly its association with the refined lifestyle characteristic of Awadhi society.

> *"Chikan is casually assumed by many Lakhnawis both inside and outside the industry to have been one of the many craft specialities that blossomed under the nawabs. Some sources even make deliberate reference to Asaf ud-Dawlah himself as an early patron."*[29]

In reality, there isn't any definitive evidence to support or to challenge the argument regarding any special patronage accorded to chikan embroidery by the Nawabs of Awadh. It is intriguing that a contemporary writer like Abdul Halim Sharar describing in great detail the culture, fashion and lifestyle during the Nawabi era makes only casual mentions of chikan embroidery.[30]

Today, chikan embroidery in Lucknow is a prosperous industry that connects a complex social fabric. As also noted, it is a rather sensitive concept in so far as it defines Lucknow's identity and its celebrated magnificent past, despite an admittedly much less glorious present. The mythical beauty of chikankari reflecting a era of graciousness helps to conceal the often sordid conditions in which most artisans live and work. Undoubtedly, the evocative association with royalty has become an effective marketing strategy and it is emphasized, however incongruously, even with regard to present day embroidery productions of inferior quality.

Insofar as the Lucknawi origin is concerned, there are two main stories, with individual variations and embellishments. They could also be considered as one narrative told from different perspectives. The most popular one credits the origin of the craft to the Mughal Empress Nur Jahan, who was of Persian lineage. As stated earlier, she is known to have been an educated and sophisticated patron of arts and crafts. The story goes like this: Nur Jahan was enchanted with the *jali* and delicate flowery designs from Isfahan, the Persian capital celebrated for the exquisite ornamentations on its buildings. Accordingly she ordered that these designs should be replicated on wooden blocks, printed on cloth and embroidered on the finest muslins. Nur Jahan was herself an accomplished embroiderer. In a variation of the same narrative the Mughal empress is Mumtaz Mahal, Nur Jahan's niece and the beloved wife of Shah Jahan, for whom was built the legendary Taj Mahal.

According to others, an anonymous princess from Murshidabad who was married to an equally unidentified Nawab of Awadh developed Lucknawi chikankari. She wished to attract the Nawab's attention and to escape the boredom of the harem, and so fashioned an exquisite embroidered cap on fine muslin as a present for her husand. The Nawab appreciated the gift, thus setting a fashion trend as well as triggering embroidery competitions among the other ladies of the zenana. Murshidabad, in Bengal, was indeed renowned for beautiful textiles and white embroideries on fine cloths.

Many craftspeople have a different story to tell. In the early 1960s, Jasleen Dhamija, a textile historian, interviewed Ustad Fiaz Khan, one of the best known chikan master-craftsmen of his time:

"Fiaz Khan, who is today one of the best craftsmen doing chikankari, tells the story that his family has been practising Chikankari for the last 200 years. The first person in his family to take this embroidery was Ustad Mohamad Shair Khan who was a peasant and tilled the ground near Lucknow. Fiaz Khan relates that a traveller while passing through the village in hot summer season asked for water from Ustad Muhammad Shahir Khan who taking pity on the plight of the traveller offered him milk and invited him to rest under the shade of his house before resuming his journey. The traveller was so pleased with his hospitality that he promised to teach him an art which will never allow him to go hungry. The traveller then trained Ustad Mohamad Shahir Khan in the art of chikankari. After his pupil has mastered the technique, the traveller disappeared. Chikankars believe that he was sent by the God himself, and that "Fiaz Khan's great-grand-son Fias Mohamad Khan was the apprentice of Ustad Mohamad Shair Khan. We were told that there is a Mazar (tomb) of Ustad Mohamad Shair Khan which is visited by the chikankari workers even today".

Other artisans believe that chikankari was introduced into Lucknow only in the 19th century through the court of Awadh.The manner in which it became popular and it was developed to such a fine technique, is told very simply by one of the local dealers in Lucknow:

"The Nawab of Oudh had a very large harem. A princess from household of Murshidabad was married to the Nawab of Oudh. The princess was a skilled seamstress and to escape from boredom of the harem took to embroidering a cap for the Nawab. With tiny stitches and variegated patterns she successfully embroidered a white cap working it richly with white thread on muslin cloth. Finally when it was ready, she sought permission to present it to the Nawab personally. The permission was granted and so was the private audience. The Nawab was so charmed by the gift and the giver that he started to single her out for his attentions. The other inmates of the harem jealously watched the favoured princess at work. Slowly they too started to work at different items trying to out-do each other in the fineness of their stitches and the delicacy of their patterns. Jealously guarding their work so that no one should know what they were preparing. Thus a great art was born out of the boredom of the harem and the desire to win the favours of the Nawab."

These are the two stories that are told by the master craftsmen and the traders. The traders might have romanticised his story for better sale whereas the worker's story might have become a myth while being retold over generations. The 'mazar' exists however and Shri Fiaz Khan's family records do make mention of Ustad Mohamad Shair Khan."[31]

The legends associated with the origin of chikan in Lucknow are woven together in narratives not necessarily congruent or factual; however these stories are certainly effective in carrying forward the chikan industry and maintaining its aura.[32]

Moving into the Modern Age

There are scanty references to chikan embroidery in contemporary literature from the 19th century onwards, other than in trade inventories and exhibition catalogues. Mrs. Meer Hassan Ali who lived in Lucknow from 1816 to 1828 is the author of *Observations on the Mussulmauns of India : Descriptive of Their Manners, Customs, Habits and Religious Opinions Made During a Twelve Years' Residence in their Immediate Society.* She mentions embroidery in Lucknow,

which can be assumed as a form of chikan embroidery, though she doesn't specifically name it. Talking about the educated daughters of an impoverished family she says "the young ladies themselves are satisfied in procuring a scanty subsistence by the labour of their hands. I have known them to be employed in working the jaullie[9] (netting) for courties [10] (a part of the female dress), which, after six days' close application, at the utmost could not realize three shillings each…" [33]

Abdul Halim Sharar (1860–1926) was born in Lucknow in a cultured family and grew up at the exiled court of the last Nawab of Awadh, Wajid Ali Shah, in Matya Burj in the suburbs of Calcutta (present day Kolkata). In his book *Guzishta Lucknow* he chronicled in great detail "the final example of oriental refinement and culture in India" when "old culture and social life reached its zenith." According to him, chikankari became fashionable in Lucknow only during the last phase of Nawabs' rule. Sharar's statement is a significant and reliable testimony. He is meticulous in his long descriptions of men's and ladies' dresses, winter and summer fashions, forms of pyjamas, headwear and footwear, and even if chikan is not always specifically mentioned, the ornamentations that the text sometime hints to, could well be chikan embroidery.

Referring to the evolution of men's dress, Sharar mentions that the angarkha was normally worn with a bodice underneath. However in Lucknow "the bodice was discarded and the exposure of the left side of the chest was not considered incorrect but attractive […] a shaluka, a waistcoat up to the neck, was worn in place of the bodice, with button in front. Buttons had just been introduced to India from Europe. Special styles were displayed in these waistcoats. People of taste wore tight waistcoats of muslins with embroidered patterns. Some people wore coloured waistcoats and the embroidery brought out the fine delicacy of the cloth." [34]

He further added that: "In the cold weather it was fashionable to wear over angarkha and chapkan the doshala, a shawl, such as used to be presented by the royal court as the khilat. Woollen scarves were also frequently worn…In the hot weather embroidered muslin scarves were worn, and these were part of the dress of all elegant people. They covered their heads with *chau goshia* topis of chikan work, their bodies with angarkhas, their legs with wide pyjamas, and over their shoulders they draped scarves of light muslin or tulle. This was the accepted fashion of the upper classes and elegant people of Lucknow." [35]

Chikan embroidery on thin muslin seems to have been used mainly for the decoration of caps: *chau goshia, panch gaushia* and *dopalli*, indispensable accessories of men's headgear. "Later, when chikan became popular, it was used for this purpose. A delicate chikan cap took up to a year to make and even the most ordinary ones cost anything from ten to twelve rupees." [36]

William Hoey was posted in Lucknow as a Licence Tax Commissioner and he extensively surveyed the various industries at that time. In *A Monograph on Trade and Manufactures in Northern India* dated 1880, he provides a detailed description of the chikan industry in Lucknow:

"There is one industry that has grown to great proportions in the last 20 years. It was almost unknown in the nawabi. It is chikan-dozi. The class of embroidery denominated chikan is in great demand and the export of it to Calcutta, Patna, Bombay, Hyderabad and other cities is an important trade. It is not easy to see why this industry has taken so fast an hold on Lucknow. But I might venture an explanation. When one wanders through the mohullas of the City where reduced Muhammadan family reside and where there are poor Hindu families who need to add to the scant subsistence afforded by a small shop or service, one sees women and even small

A Monograph on trade and Manufactures in North India. (American Methodist Press, 1880) by William Hoey

Chikanwala – Chikan is hand-flowered muslin and the chikan of Lucknow is in greater demands in all part of India. The most of this work is done on tanzeb, a kind of muslin of local manufacture, which is woven generally in webs of between 19 and 20 yards in length and 14 girahs[38] in breadth. The chikanwala who gives out material to the chikan-doz or embroiderer cut the web into two equal lengths, for the half web (about 9 ½ yards long) is the length that is used for doputtahs, and it is also convenient for cutting up to make angarkhas. Females generally cut the pieces in two parts, one being double of the other, and the short piece is cut in two in the length and the three pieces then formed are sewed together so as to make a doputtah half as wide again as the web. Thus a web 9 ¾ yards long and 14 girahs wide makes a doputtahs for females to wear 6 ¼ yards long 21 girahs wide. The same web might be cut in four angarkhas.

It is only when one wonders round the city enquiring into trade that one can get an idea of the extent to which the working of chikan is pushed. Little girls 5 or 6 years of age may be seen sitting at the doors houses near Chob Mandi busily moving their tiny fingers, over a piece of tanzeb and working butas and helping home by their earnings which are little enough, ony one paisa for 100 butas. It is by this early beginning that chikan workers attain the great skill they do in embroidery: but even when the greatest skill has been attained the wages paid to the chikandoz are but low. Take a piece of chikan 9 ¾ yards long worked in good style which sells for Rs 12. It is worked with diagonal bels about one inch wide at interval of about 3 inches, and in each intermediate space there are twelve butas worked. There are 560 yards of bel and 560 butas in the piece. The chikandoz has been paid only Rs 4, for all this work. The tanzeb has cost Rs 3-8. The thread delivered to the embroiderer was 14 lachhas which at 6 as. 6 pie per tola, cost 14 as. 6 pies. There is little silk spent in picking out the hearts of the flowers, and the silk and labour come to only 4 as. 6 pies. The stamping of the pattern by a chippi before giving out the web to the chikandoz cost only 4 as., and the charge of the dhobi for washing and stiffening when the web is returned by the chikandoz to the chikanwala is 4 as. Thus the whole cost of production is Rs 9-3 and the selling price is Rs 12. This gives a profit of 32 percent. This rate is high because the chikanwala has his capital sunk in the piece of web while it is in the hands of the embroiderers, and he has a brisk market for his goods only during the hot weather and rains.

The foregoing will serve as a sample of the rate of profit enjoyed by chikanwalas, and, as far as I can ascertain, this rate prevails whatever be the form of goods made up – whether rumals, doputtahs, bels, or chadars.

Chikan is largely exported from Lucknow to Agra in the N.-W., to Mirzapur, Patna and Calcutta in the East, and to Hyderabad, Dhakan. All this work is wrought by chikandozes who are given out work and paid by the piece and the wages paid are determined by the skill of the workman and the difficulty of the work. Among the best workers in Lucknow is a small settlement of Mahomedans on the north side of the river at Hasanganj and after them are the workmen employed by Ilahi Bakhsh, and Damodhar in the Chauk. Women of the Agarwala and Khattri castes are very clever needlewomen and embroider their own doputtahs. Some specimens of their workmanship are quite equal to anything turned out by skilled Mahomedan men, professional chikan-workers.[39]

*Embroidered collar for western
apparel
Cotton muslin with cotton
embroidery, Lucknow, early 20th
century, Crafts Museum, Delhi,
Acc. No. 92/7805/99*

*children busy with needle and muslin. Thus the labor at the manufacturer's command is cheap
and abundant. He is able to undersell those who go into the market from other places. This is
one reason why the chikan business has taken a deep root in Lucknow… As a domestic pursuit
chikan was always a favorite employment of the women of some casts."*[37]

It is interesting to highlight the different points made by Hoey in his statement: that chikan
industry was almost unknown during Nawabi times, although chikan embroidery did exist as "a
domestic pursuit" and was "always a favorite employment of the women of some casts"; that it
"has grown to great proportions in the last 20 years" placing its popularity from the 1860s, and
that the growth was made possible thanks to the abundance of cheap workforce constituted
mainly of impoverished families. According to this text the development of the chikan industry
in Lucknow seems to be linked more to the collapse of the courtly life and to the economic crisis
that followed the uprising of 1857 and the recapture and destruction of Lucknow by the British
in 1858, than to the patronage of the Awadhi court. This is in stark contrast to the prevailing
discourse which considers chikan craft as an epitome of the sophisticated refinement of the
Awadhi court. How does one reconcile these apparent contradictions?

An examination of old pieces possibly dating to the 19th and early 20th century reveals a striking
difference in the aesthetic and quality of craftsmanship between the costumes and other items
of apparel made for the sophisticated Indian patrons and items for western or westernized
markets. The latter included table cloths, doilies, shirtfront plastrons for insertion and collars.
There was extremely fine workmanship for the first and comparatively coarser work for the
latter. Conspicuous by their scarcity are antique pieces of feminine Indian apparel. Such a
noticeable difference in the quality of embroidery has persisted till today, through the ups and
down of chikan industry. It is basically the same craft, with common processes and stitches,
yet the pieces seem to belong to differing traditions and at times even techniques.

Wajid Ali Shah's exile to Calcutta and the exodus of the court and courtiers, the mutiny in
1857, the revengeful capture of Lucknow in 1858 by the British—all these had deeply affected
the old regime's economical, political and social order. The revenues of this once rich province
had to be restored, the loyalties of the landed gentry had to be secured. The British promoted
a policy of reconciliation with the nobility while awarding privileges to their loyal supporters.

1 Handkerchief with chikan border and initials
Cotton muslin with cotton embroidery, probably late 19th century, 41x40 cm, State Museum, Lucknow, Acc. no. 68.6.20

2 Silver and gold medals awarded to Kedar Nath Ram Nath for excellence in chikan embroidery at National and International Exhibitions
Late 19th century – early 20th century, courtesy P. Kohli, Lucknow
.

3 Poster of Coronation Exhibition held in London in 1911 in honor of King George V and Queen Mary
Courtesy P. Kohli, Lucknow

1

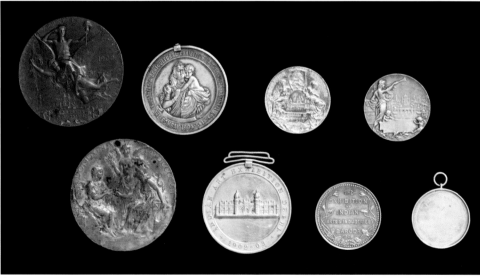

2

3

The British endorsed old rituals and symbols of power as a sign of continuity, like the splendid although less extravagant durbars, the exchanges of 'nazars' and 'killats' that combined "Western and Oriental effects." [40] The durbar began "the era of collaboration between the Lucknow elite and the British that continued uninterrupted,"[41] until the rise of the nationalist movement.

Continuity with the past was rooted also in the crafts and other traditional industries that had made Lucknow such a fashionable centre in North India. And while these industries were promoted and patronized by the old and new elites, the various traditional skills, products and process were also adapted to suit the commercial expansion towards new markets. The extremely fine chikankari, quintessential luxury product for an elite of patrons was copied and replicated at a much cheaper cost and relatively lesser quality for widespread commercialization. As already quoted above thanks to the "reduced Muhammadan family…and poor Hindu families who need to add to the scant subsistence afforded by a small shop or service…women and even small children busy with needle and muslin. Thus the labor at the manufacturer's command is cheap and abundant. He is able to undersell those who go into the market from other places"!

From G. Watt, Indian Arts at Delhi, *1903*

Awards for Division 41 : Chikan work
First prize with gold medal to Kedar Nath, Ram Nath of Lucknow for collection of chikan work.
First prize with silver medal to Daday Khan of Madras for a superb series of silk dress pieces embroidered in silk.
Second prize with silver medal to Sham Sunder and Ghazi Ram of Lucknow for a cotton sari.
Third prize with bronze medal to Alla Buksh Faiz Baksh of Lucknow for collection of chikan work.Commended for chikan embroidery: Mr. S. C. Pyne of Calcutta.
Commended for dress pieces: Ganga Pershad and Ganesh Pershad of Lucknow [44]

1

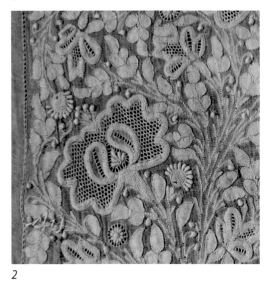

2

1 *Drawing/tracing for front yoke embroidery*
Pencil on paper, Lucknow, late 19th–early 20th
century, private collection

2 *Enlarged detail of embroidered yoke*
Muslin with cotton embroidery, Lucknow,
late 19th–early 20th century, Crafts Museum,
Delhi, Acc. No. 92/7805(21)

3 *Sample of front embroidered yoke, probably*
for a chapkan
Muslin with cotton embroidery
Lucknow, late 19th–early 20th century
Crafts Museum, New Delhi, Acc. No. 92/7805(21)

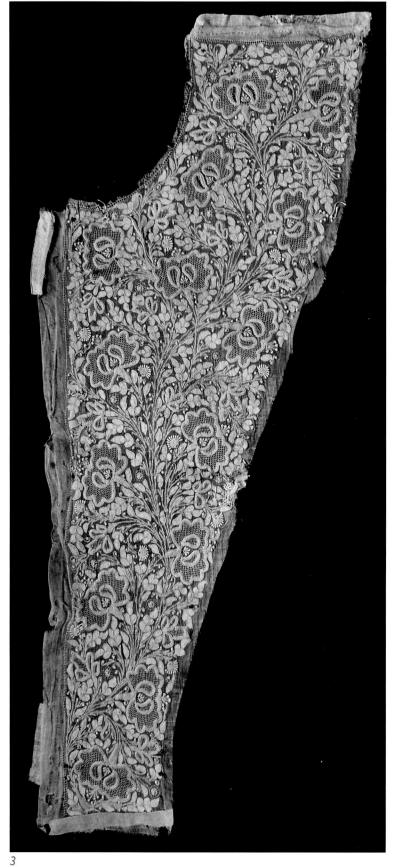

3

Towards the end 19th century chikan embroidery appears to have been a thriving business, as "rumals, doputtahs, bels (for insertion), chadars" were "in great demand in all parts of India" and they were "largely exported from Lucknow to Agra in the N-W, Mirzapur, Patna, and Calcutta in the East, Haiderabad and Dakhan."[42]

By the turn of the century, chikan embroidery in Lucknow had further grown in popularity. Sir George Watt, the Director of the *Indian Art Exhibition* in Delhi in 1903, wrote that "The Kings of Oudh attracted to their capital many of the famous craftsmen of India, hence Lucknow, to this day, has a larger range of artistic workers than are to be found in almost any other town of India. Lucknow chikan work is perhaps the most remarkable of these crafts as it is the most artistic and most delicate form of what might be called the purely indigenous needlework of India."[43]

A few names of producers of high quality chikan embroidery in Lucknow are mentioned in exhibition catalogues of the late 19th and early 20th centuries. Unfortunately the poor definition of the old photograph of these exhibits doesn't allow to fully assess the quality of work on these pieces. Some of those firms are still in business today, but what remains of the glory of the past, other than memories, certificates and medals, are a few small swatches of exquisite embroidery, collections of amazing old finely carved blocks and an extremely rare album of original drawings for chikan embroidery blocks. A beautiful piece of a sleeveless jacket in the former A.E.D.T.A.'s collection now at the Guimet Museum in Paris has been traced back to the firm of Kedar Nath & Ram Nath.

The Karkhanas

It is generally assumed that the system of karkhana, however exploitative it might have been, furthered a deep integration between design, artistry and craftsmanship, and the superior quality of the embroidery work.

> "According to the embroiderers Ayub Khan and Saliha Khatun, three to four male-run karkhanas filling orders directly for patrons were the primary source of chikan work in the first decade of the twentieth century and the place in which chikan in its finest form was developed."[47]

However, the karkhanas in Lucknow declined by the late 1920s and early 1930s, at the time of the great economic depression and the ensuing social upheaval. The dress style of the elites, particularly menswear changed dramatically with a fall in the demand for traditional formal wears like angarkhas, chapkans, achkans, on which the finest chikan embroideries were interpreted. This had important economic repercussions on this craft.

When the karkhana system disappeared, the shopkeepers took over the trade. The male embroiderers of chikan shifted to different roles and professions. A poorly paid, home-based feminine workforce became predominant in chikan industry. Among the reasons given by male master craftsmen was that there was a loss of appreciation for very fine chikankari and consequently also a loss of prestige associated with fine craftsmanship. The traders in chikan kept the wages down, pushing this craft to a subsidiary status.

Though sent into a steep decline, the fine art of chikankari did not die out completely, but continued along exclusive and privileged lines, maintained by rather well-kept secret family connections. Several people from elite classes still remember that in the 40s and 50s professional male chikankari workers would spend months in their family mansion in North

*Design impression from wooden
block and embroidered samples
swatches worked in khatao or
chikan appliqué*
*Muslin with cotton embroidery,
Lucknow late 19th-early 20th
century,Kedar Nath Ram Nath
chikan blocks' collection, Lucknow,
Courtesy P.Kohli and Crafts
Museum,Delhi, Acc. No. 92/7805
(94 & 95)*

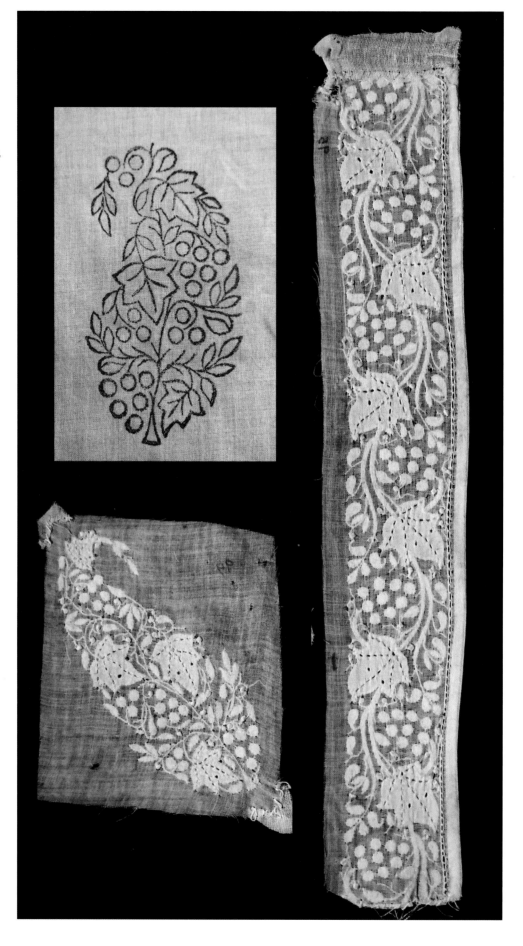

India to work on an 'annual' supply of chikan embroidered pieces for the entire family. Others stories narrate of direct uninterrupted connections since generations with the same family of chikan artisans, producing very fine and delicate embroideries for the old families.

A fairly recent anecdote gives an interesting insight into the history and personal nature of the relationship between master craftsmen and patron. A client had ordered some embroideries on behalf of one of her foreign acquaintances from the artisan whose family had been supplying her family with the most beautiful chikankari for generations. Upon requesting the artisan for an estimate of cost for the order, she received the dismayed reply that "if even people such as you begin asking for estimates, then there is no more hope [for traditional chikankari]."

In the decade following the tragedy of partition in 1947, many prominent muslim families left Lucknow and with their departure vanished an important segment of elite consumers. However, there was a corresponding influx of refugees into the city. Some of the refugee relief schemes, such as those where Kamaladevi Chattopadhyaya was involved, trained young girls in the art of chikankari as a source of income. A catalogue of chikan embroidery samples in the collections of the Victoria & Albert Museum in London, throws some insight into the situation of chikan industry in Lucknow in the 1950s.

The two volumes of swatches consist of numbered samples (1-399 and 400 to 791) interleaved with white and coloured tissue paper. The styles include traditional white work (white thread embroidery on white muslin), white work with some details outlined in coloured thread and white embroidery on coloured muslin.The work was produced by girls at the Lucknow Crafts Centre established by Paul Telco for the Uttar Pradesh administration to train partition refugees and other unemployed persons."Fine thread and muslin suitable for chikan embroidery was unobtainable in Lucknow at the time, but some of the samples show

A Description of Royal Karkhanas in Mughal India

Large halls are seen in many places, called Karkhanas[45]or workshops for the artisans. In one hall embroiderers are busily employed, superintended by a master. In another you see the goldsmiths; in a third, painters ; in a fourth, varnishers in lacquer-work; in a fifth, joiners, turners, tailors, and shoemakers ; in a sixth, manufacturers of silk, brocade, and those fine muslins of which are made turbans, girdles with golden flowers, and drawers worn by females, so delicately fine as frequently to wear out in one night. This article of dress, which lasts only a few hours, may cost ten or twelve crowns, and even more, when beautifully embroidered with needlework.

The artisans repair every morning to their respective Karkhanas, where they remain employed the whole day ; and in the evening return to their homes. In this quiet and regular manner their time glides away ; no one aspiring after any improvement in the condition of life wherein he happens to be born. The embroiderer brings up his son as an embroiderer, the son of a goldsmith becomes a goldsmith, and a physician of the city educates his son for a physician. No one marries but in his own trade or profession ; and this custom is observed almost as rigidly by Mahomedans as by the Gentiles, to whom it is expressly enjoined by their law. Many are the beautiful girls thus doomed to live singly, girls who might marry advantageously if their parents would connect them with a family less noble than their own.[46]

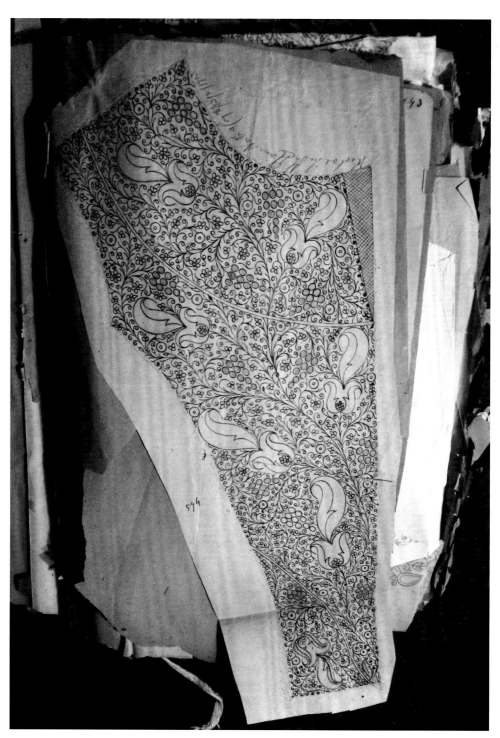

Design for chikan embroidery on front yoke for a chapkan or achkan
Inscribed 'Kedar Nath Ram Nath and Co, dt 12/2/1903', Album of Drawings and Designs for Chikan Embroidery, ink and pencil on paper, Lucknow, early 20th century
Private Collection.

a relatively high standard of execution, e.g. shadow-work and open-work in nos. 299–314 and 375–80. The project was soon abandoned because no market could be found at the time for chikan embroidery."[48]

The history of chikan embroidery between the 1950s and the 1980s is rather obscure. There is hardly any contemporary narrative except for references to its glorious past. The statement above, according to which "no market could be found at the time for chikan" is puzzling and lends itself to different interpretations. Which market does it refer to? The local elites that had left during partition? A local market that could not sustain the competition with more cheaply made chikan products? Changes in taste and fashion?

"According to chikan embroiderers, mahajan and Lacknawi laymen alike, the history of chikan, particularly since the mid-century, is essentially a story of inexorable decline."[49] This period coincided with "growing commercialization and cheapening of chikan" and corresponded with a shifting to the almost complete feminization of the embroidery stage.[50] The prevailing chikan available became almost exclusively *bakhia* work (shadow work), the quality ranging from the average to the cheap and shabby—to the point that *bakhia* work remained a synonym for chikan embroidery till not so long ago.

Even the local market for *dopalli* topis that had always been the items per excellence ornamented with very fine chikan embroidery eventually declined in the middle '80s. "The standard of work on these topis, even if no more than twenty years old, is far superior to what is considered good quality (if not the very best) murri work made today. One prominent mahajan said there was no present-day market for these kinds of caps, and a sizeable consignment of old caps that the shop could not sell had been packed up and dispatched for sale in Pakistan in the late 1970s."[51] Some people lamented that nowadays it is impossible to find "those exquisite embroidered caps"[52] that it was still possible to see, albeit rarely, in the '90s in the Chowk area. Few master craftsmen and fine workmanship nevertheless survived along private and privileged relationships with discerning customers, as we'll see in the following chapter.

The style of chikan stitchery available commercially in the early '80s in metro city like Delhi was almost exclusively shadow work executed at various levels of quality—the patterns filled with long and sparse stitches and a very shoddy look, however ornate the tracing. There were very few outlets in the central Connaught Place where if one was patient and lucky, it was possible to find something of higher quality and with bels worked with combinations of different embossed stitches, typical of old time chikankari. Invariably it was available on gents' kurtas and required a patient enduring of endless display of poor quality works before, if lucky, to see an acceptable good piece!

A New Lease of Life

In the middle of the 1980s an organization called Self Employed Women Association (SEWA) Lucknow, brought about dramatic changes in the chikan industry, both in the life of artisans and in the quality of chikan that became available.

SEWA-Lucknow was registered in 1984. "It came into existence following a study conducted by UNICEF and Literacy House, Lucknow in 1979 which revealed that the women and children working in the chikan industry were more cruelly exploited than in any other craft in the unorganized sector. To break out of the stranglehold of middlemen, they needed a viable and sustainable production system with direct access to ready markets. SEWA-Lucknow is a

Sample of Keiri
Cotton embroidery on silk,
Sewa-Lucknow, 2008

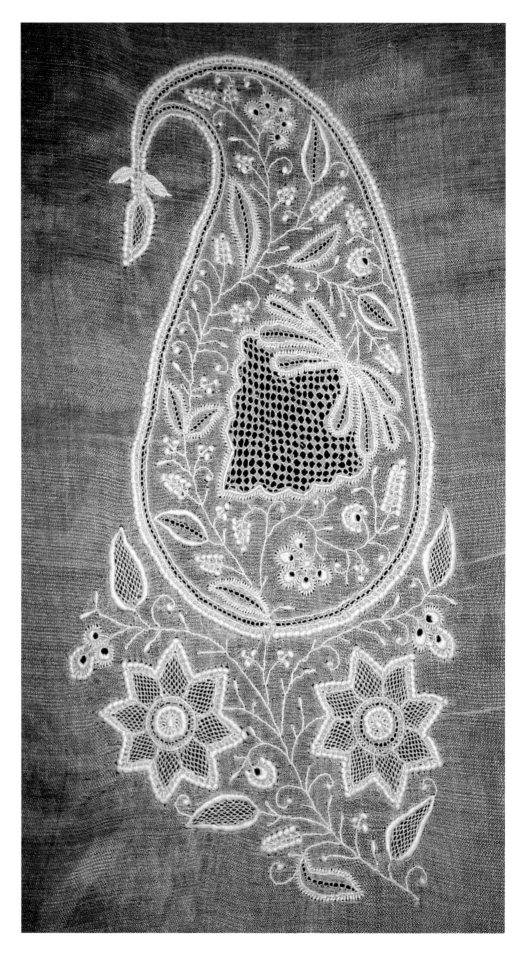

voluntary association of craftswomen who have come together in response to this need."[53]
It started with a small group of 31 artisans growing to 1000 in just few years and crossing
the figure of 7000 craftswomen members in 2014. Exhibitions and sales were held regularly,
initially in collaboration with Handicrafts Commission and Dastkar. The latter is a voluntary
crafts organization in Delhi, which has made vital marketing effort to promote SEWA products
and brought the handiwork of SEWA's members directly to buyers.

Initially SEWA was fiercely opposed by a few traders who saw in this organization a threat to
the system in place and the (exploitative) relationship with the home-based female workforce.
It is generally acknowledged in Lucknow that SEWA-Lucknow played a leading role in inspiring
other non-governmental organizations to take up the cause of chikankari.such as the Uttar
Pradesh Crafts Council headed by Sarla Sahni,[54] to take up chikan embroidery as an easily
accessible and low investment means to generate income opportunities and promote
economic and social development among the women from the most deprived sectors of the
society, both in peri-urban as well as in rural areas.

'Fair wages' for the chikan craftswomen and breaking the power of the middlemen have been
among the main objectives of the NGOs entering this trade, each developing its own approach
and solutions to these issues, with, admittedly, debatable results. 'Fair wages' is also the
problem many entrepreneurs and producers admit they are struggling with, sandwiched
between sustaining their business and satisfying a mass market of middle-level consumers
that does not accept high prices for chikan products, no matter how good the quality.

During our conversations with various people involved in different capacities in the chikan
industry, from the entrepreneurs themselves to the women artisans, the wages were
unanimously acknowledged to be low and even very low, especially in the rural areas. In 2012,
they were generally between 35 to 50 rupees per day for 4 to 6 hours work daily for 'standard'
quality commercial work. At the other end of the private sector spectrum some entrepreneurs
and designers have recreated forms of the ancient system of karkhanas by setting up
production centres where exclusive designs of consistently high quality are made for an
affluent clientele in the metropolitan cities of India. Unfortunately, there are also many other
entrepreneurs that take unscrupulous advantage of the expanded pool of available workforce
mainly in the rural areas around Lucknow and adjoining districts, often trained in only few
basic stitches.

The number of chikan embroiderers in Lucknow and in adjoining areas where this craft has
been promoted for income generation in the last twenty years has grown from few thousand
to a few hundred thousands craftswomen, all skill levels included.

Not all of SEWA-Lucknow's productions are of the highest workmanship as they have to
accommodate their growing members belonging to different skill levels. Still, the exquisite
works produced by a core group of accomplished craftswomen, under the excellence
craftsmanship of Nasreen Siddiqi[55] has certainly contributed to redefine chikankari since
the middle of the 1980s, when only rather cheap productions of shadow work and the basic
siddhaur jali were available. The early exhibitions in Delhi and Mumbai caused a sensation with
their range of beautifully embroidered and stylish pieces. All this plus a celebrated pioneering
collection of chikan embroidery on diaphanous silk organza designed by Ritu Kumar and
executed by SEWA's craftswomen played a major role in placing chikan at the centre stage of
the then emerging high fashion industry in India.

1 *In the late '80s Ritu Kumar was the first contemporary Indian designer to place chikankari on the haute couture ramp. Realized by Sewa-Lucknow.*

2 *An unconventional design for chikan embroidery by Rajesh Pratap Singh*

OVERLEAF
Sampler of different designs and stitches of chikan embroidery
Cotton embroidery on silk
SEWA-Lucknow, 2008

1

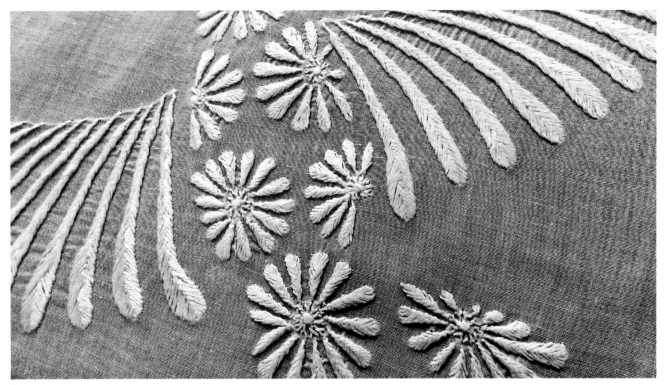

2

The challenge to firmly position chikan embroidery as couture apparel was taken up in the late 1980s by young designers Abu Jani and Sandeep Khosla. Their richly embroidered chikan kurtas and saris created a sumptuous, enduring white-on-white look. Their impeccably executed designs reflect the great skills of this tradition, even though antique chikankari craft was associated more to understatement than to opulence. Since then, high fashion chikankari has been endorsed by Bollywood stars and social celebrities, associated with the erstwhile splendour of Indian courts, and promoted by the descendants of local aristocracy like the princely families of Kotwara and Mahmudabad—all of which has contributed to the revival of fine workmanship and sophisticated artistry.

Over the last twenty years or so, many other designers have been working with this craft, far too many to be listed here. Most of them are developing designs within traditional patterns or more precisely within what it is perceived to be traditional. Rajesh Pratap Singh has been experimenting with chikan embroidery for many years, applying it to most unconventional designs and motifs and often taking this craft to its cutting edges limits.

On the wave of such successes, a huge market for chikan has developed catering to all means and tastes, both in India and abroad. This market has high, medium or low budget, and crude mass-produced chikan, often copying the styles and designs of most popular trend setter designers' brands. In fact, Lucknow has become a major hub for all sort of hand embroidery productions that are indistinctly grouped under 'chikan embroidery' label.

The number of chikan embroiderers was estimated to be around 40,000 in Lucknow and neighbouring districts in the mid-80s. They are now assessed at over 250,000 thousand, most of them home-based workers. The entire cycle of hand embroidered production is now estimated to sustain over a million people.

1 S. Paine, Chikan Embroidery, the Floral Whitework of India. Aylesbury. Shire publ. 1989:16-17.

2 Hoey, William. A Monograph on Trade and Manufactures in Northern India. 1880,.Watson, J. Forbes. Textile manufactures and the costumes of the people of India, London: 1866, reprint: Varanasi: Indological Book House, 1982. Watt, George. Indian Art at Delhi, 1903, Calcutta, 1903 (Reprint, Delhi: Motilal Banarsidass, 1987).

3 Forbes Watson, J. The Textiles and Manufacturers of India. 1866 reprinted in Varanasi, 1982:116.

4 Forbes Watson, J. The Textiles and Manufacturers of India. 1866:115.

5 Sir George Watt. Indian Arts at Delhi, 1903. Calcutta, 1903:398-399.

6 Sheila Paine. Chikan Embroidery. The Floral Whitework of India. Shire Publication, 1989:25-26.

7 Megasthenes-Indika. FRAGM. XXVII. Strab. XV. i. 53-56,-pp. 709-10. Of the Manners of the Indians.

8 K. Chattopadhyaya. Origin and development of embroidery in our land. Marg: Textiles and Embroideries of India, 1965:8.

9 Kalra, Jaspal. 2014. Kamala S. Dongerkery. The Romance of Indian Embroidery. Bombay: Thacker, n.d. K. Chattopadhyaya. Origin and development of embroidery in our land. In Marg : Textiles and Embroideries of India, 1965.

10 Laila Tyabji. Chikankari :White on White: Stitches and Shadows. In : Namaste Magazine February 1997.

11 Laila Tyabji 'Chikankari White on White: Stitches and Shadows' in Namaste Magazine , February 1997.

12 Das, Rajrupa. Mughalia Libaas :The trans migration of Central Asian fashion to the Indian sub continent in the 16th and 17th Century. Dissertation - MLitt Art History: Dress and Textile Histories, University of Glasgow. 2013.

13 "A Procession of Ghazi ud-Din Haider through Lucknow", ca.1820-1825 (painted). Museum number: IM.2:2-1909. IN: Archer, Mildred. Company Paintings Indian Paintings of the British period. Victoria and Albert Museum.

14 Balchand. Shah Jahan with his sons. C. 1627-29. Chester Beatty Library, Dublin.

15 James. Taylor. Sketches of the Statistics of Dacca. Calcutta: G.H. Huttmann, 1840: 164 173, 176.

16 J. Taylor, Id.: 172.

17 James Taylor. ibid 1840:177.

18 Watson, J. Forbes . The Textiles and Manufacturers of India. : 8.

19 S. Paine. Chikan Embroidery. The Floral Whitework of India. Shire Publication, 1989:20.

20 Cowan, Rex. Shipwreck, Dyestuffs and the India Trade. In: Crill, Rosemary Ed. Textiles from India: the Global Trade. Calcutta: Seagull Books, 2005:382.

21 Barbara Johnson's (1746-1823) samples book.

22 Kamaladevi Chatthopadyay. Origin and development of embroidery in our land. In Marg : Textiles and Embroideries of India, 1965:60.

23 http://thegoldenscissors.blogspot.in/2011/12/dresden-day.html

24 John Irwin and Margaret Hall. Indian Embroideries. Ahmedabad : Calico Museum, 1973:180 (Historic Textiles of India at the Calico Museum, Ahmedabad, vol. II).

25 During the years Taylor is referring to, muslins were imported into India from Britain.

26 J. Tailor . Id. 1840:176.

27 J. Tailor . Id. 1840: 365.

28 J.Tailor. Id. 1840: 306.

29 C. Wilkinson-Weber.Embroidering Lives.1999:15.

30 Sharar, Abdul Halim. Lucknow: The last phase of an oriental culture, Delhi: Oxford University Press, 1989.

31 J. Dhamija. Chikankari. In: Marg: Textiles and Embroideries of India, 1965:25.

32 However "There is seldom any reflection upon the fact that revival is geared to creating and satisfying a market, and that the women who are being trained to produce crafts for the market no longer embody the ideal of use-value production…" C. Wilkinson-Weber. "Women, Work and the Imagination of Craft" in: Contemporary South Asia. 13(3), (September 2004) 287–306.

33 Mrs Meer Hassan Ali. Observations On The Mussulmauns Of India : Descriptive of Their Manners, Customs, Habits and Religious Opinions Made During a Twelve Years' Residence in Their Immediate Society. London, 1832.

34 Abdul Halim Sharar. Lucknow: The Last Phase of an Oriental Culture. Delhi. OUP, 2001:170.

35 Abdul Halim Sharar. ibid 2001:178.

36 Abdul Halim Sharar, Id. 2001:172.

37 Hoey, William. A Monograph on Trade and Manufactures in Northern India. 1880:28.

38 A girah is a fraction more than an inch. In: Veena Talwar Oldenburg, ed. Shaam-e-Awadh. Delhi: Penguin 2007:122.

39 W. Hoey. A Monograph on trade and Manufactures in North India. American Methodist Press, 1880.

40 Oldenburg, V. Talwar . The Making of Colonial Lucknow: 1856-1877. 1984:249.

41 Oldenburg, V. Talwar . Id.:251.

42 W. Hoey. 1880:88.

43 G. Watts. 1903:399.

44 G. Watts. 1903:406.

45 (3) Karkhanas. In the palace of the Maharaja of Benares, at Ramnagar, may still be seen excellent examples of such ' palace workshops,' which have served not a little to maintain a high standard of workmanship, or many of the specialities of the district. See p. 228.

46 François Bernier. Travels in the Mughal Empire, 1656-1668.

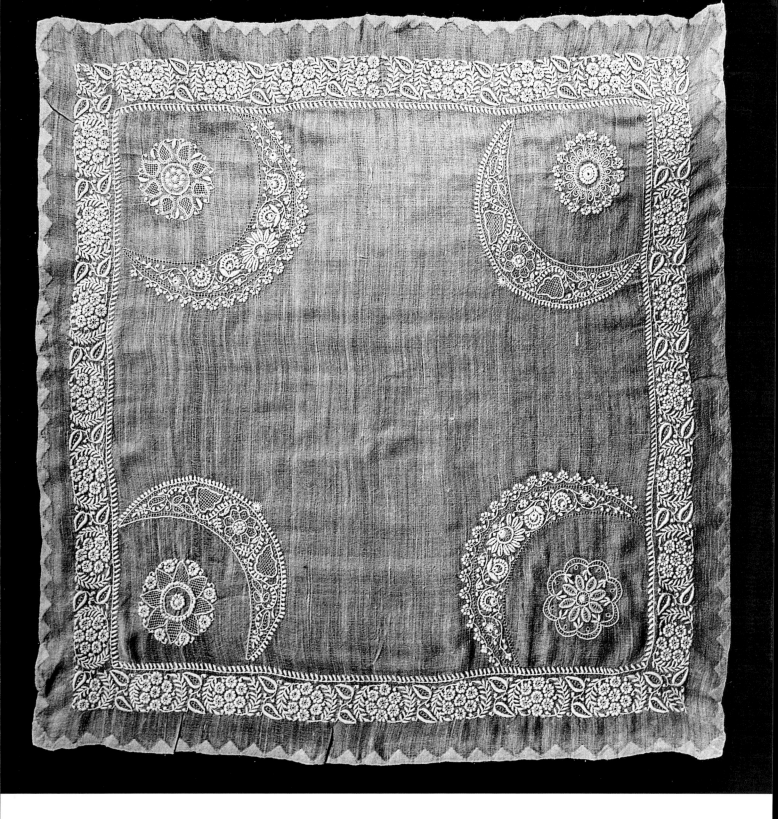

47 C. Wilkinson-Weber. ibid1999:18

48 V&A Museum, London: I S 51 & A-1968 -

49 C. Wilkinson-Weber. Embroidering lives. 1999:19

50 C. Wilkinson-Weber. ibid 1999:20

51 C. Wilkinson-Weber. ibid 1999:20

52 Personal communication by Mita Dass, producer and designer of
 chikan in Lucknow

53 SEWA presentation. Lucknow, 1991. See also : www.sewalucknow.org

54 "The U.P..Crafts Council under the inspiration of the late Ms. Sarla
 Sahni did great service to help the chikankar and give a promotional
 thrust to this craft. The history of the revival of chikankari would be
 incomplete without a reference to Ms.Sahni, who sought to change
 the lives of many chikanworkers." Ruth Chakravarty. A way of Life.
 EurIndia 2003:7

55 Like Rukshana, Nasreen Siddiqi, Nasreen … Just to mention a few.

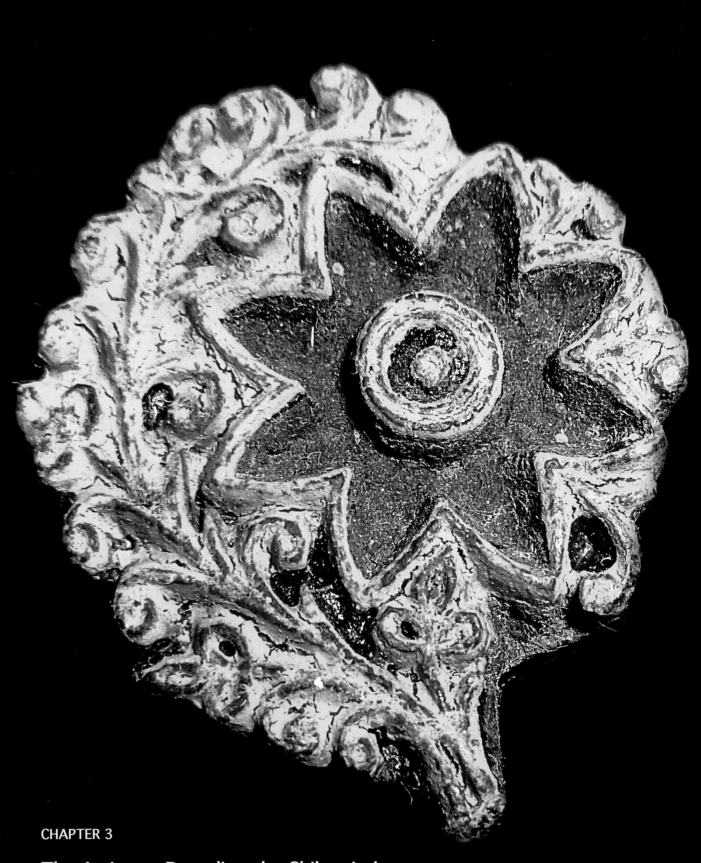

CHAPTER 3

The Artisans: Decoding the Chikan Industry

A distinctive feature of the chikan industry in Lucknow is its highly segmented and specialized nature, with a network of interdependent craftsperson organized in a spread-out production line—each stage being completed at different places by different artisans. It is dependent on smooth coordination of the various steps and on the liaison between the different actors and craftsperson involved in the process.

The process begins with the *mahajan*, the businessman or entrepreneur, who invests his capital in the preliminary steps of the production. He buys the fabric, gets it cut, stitched and printed with the tracings for the embroidery work. Then the *dalal* or *thekedar* (middleman or agent) distributes the work among the *karigars* (artisans), collects the finished pieces, delivers them back to the entrepreneur, receives the money and distributes the payments to the artisans for the work that they have done. More often than not the mahajan has no direct contacts with the *karigars*.

"The involvement of different actors from diverse places and social layers creates networks of interdependency that cut across the boundaries of class, religion, locality and gender"[1] and it has been studied as another distinctive feature of Lucknow which is the particularly "relaxed relationships" in the social domain, among all these different communities.

The exploitative and villain-like role of the middleman has been often highlighted though it is rather an essential role within this system to move the pieces around. The relationship that exists between the middleman and the artisans is more complex than generalisations can encompass as, "The ordinary chikan worker is homebound and shy, so the middle man is a vital link in the trade." Today, according to an estimate, not more than 10 per cent of workers deal with traders directly, particularly because the traders are too shrewd and calculating. The middleman, many of who are related to the workers, are in better position to tackle traders because they deal with number of them simultaneously. "If one of us disappoints them," says a trader in the Chowk, "they can always go to another one."[2]

Once the pieces are returned to the entrepreneur, they still have to be finished, sometimes with additional needlework, like the netting or *jali* or with *kamdani* embroidery, which is done by other specialized artisans. Then the pieces are passed on to the dhobis to be washed, starched and ironed. Eventually, they are ready for distribution and sale on the market.

Gender and Tasks

The different tasks in chikan industry are gender specific: men do the tailoring, printing and laundering, while embroidery is predominantly women's work. This is unlike the old days when the embroiderers were alleged to have been predominantly male and were reputed for doing the finest work. This gender division was never that rigid, particularly not in the last thirty years which have seem some changes such as the entry of NGOs to address the appalling conditions and exploitation of the home-based female chikan embroiders. This has led to many women becoming expert tailors and printers. Furthermore, activities such as washing and ironing done by the *dhobis* or washer-men, are often also done by the women of the family. To my knowledge no woman has set up independent printing or tailoring workshops, although there are many successful women entrepreneurs manufacturing chikan goods and female liaison agents or middle-women.

It is difficult, looking at a chikan embroidered piece, even a simple one, to imagine all the different hands it has passed through and all the craftspeople who have contributed their

Block with blue dye to print a buti or flower motif
Wood & blue dye, 6 x 5 cm
Kedar Nath Ram Nath, Lucknow

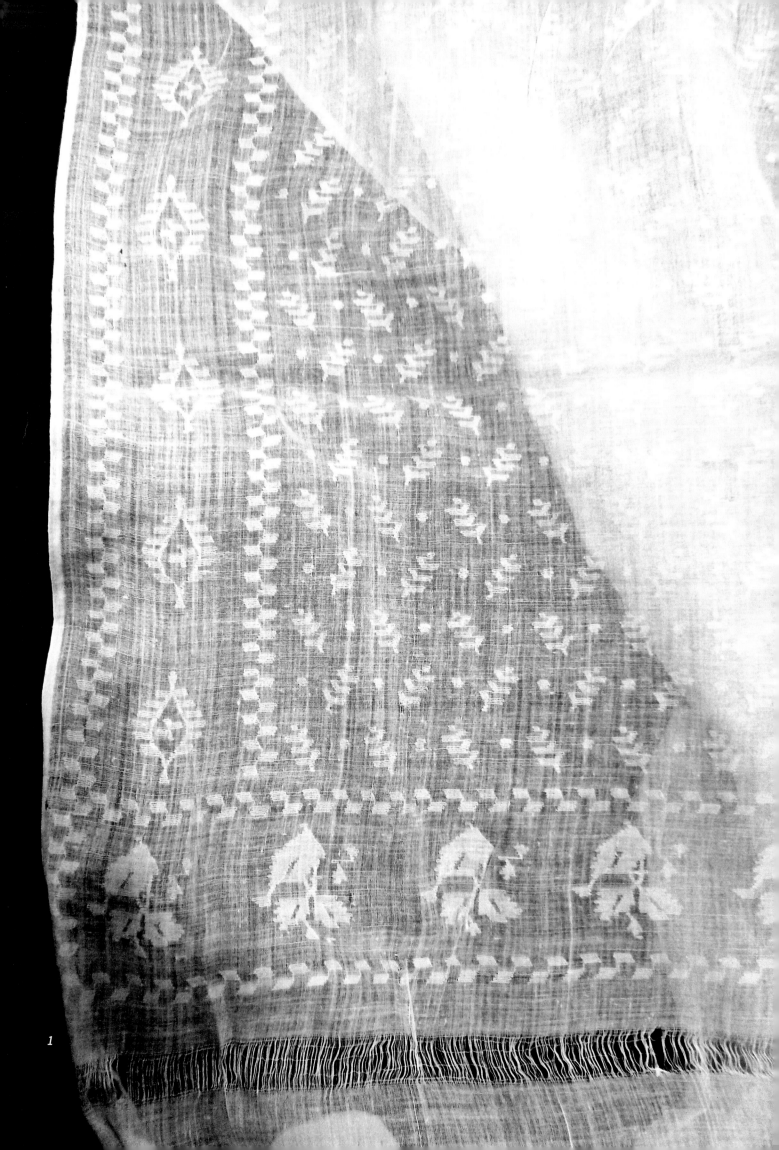

1

skill, their creativity and their hard work to make it. What is given here is a necessarily simplified description of the different steps and of the craftspeople's role and contribution to chikan production. These notes are based on the prevailing process though the the overall production process has remained consistent over time — from earlier accounts it appears that it has been in place since the 19th century! However a growing demand for mass-produced chikan embroidery goods for both national and export markets has made larger companies reorganize and rationalize some aspects of their production.

Weavers of Muslins

Varieties of high quality muslins were hand woven in various parts of India,[3] the most famous varieties being those produced in Bengal, in the areas around Dhaka. Fine muslins like *tanzeb* or *adhi* were produced in Lucknow and were among the preferred fabrics for chikan embroidery—*tanzeb* was particularly appreciated for loose summer shirts.[4]

2

1 Jamdani
A piece by Ali Ahmad, the
last weaver of fine jamdani in
Faizabad
Cotton muslin, Faizabad, 1958
Crafts Museum, Lucknow
Acc. N. B-6 SL-1 P-142

2 Angarkha (detail)
A jamdani woven with the royal
emblem of Wajid Ali Shah
Cotton, northern India, mid-19th
century, Weavers Studio Resource
Center Archive, Kolkata

In the 18th and 19th centuries the production of different qualities of fine muslins in the region was sustained by the demand of the Nawabs of Awadh and their courts. Exquisite *jamdani* was woven in Jais, Tanda and Faizabad and used for topi (*dopalli*) and *angarkhas* that were further ornamented with chikan embroidered trimmings. Particularly interesting are robes of fine *jamdani* ornamented with royal symbols of the Nawabs, especially the unique coat-of-arms of Wajid Ali Shah, which has two mermaids holding the crown and the banners of the king.

> *"Lucknow also makes large quantities of plain and striped, bleached and unbleached muslins, which are preferred to European cloths for purposes of chikan embroidery. They are also used by Indian gentlemen for turbans and summer shirts. Most of the Lucknow muslins are made at Mahmudnagar, and are known by the name of Sharbati, Malmal, Adhi, and Tarandam, striped ones are called Doria.*
>
> *Muslins with damasked patterns are made at Benares and Jais in the Rai Bareli District; those woven in the former place almost equal in delicacy fabrics of the same kind produced at Dacca. They are largely used in the manufacture of country caps.*
>
> *Muslins made at Jais had formerly a great reputation, but the industry has declined since the fall of the kingdom of Oudh. Good muslins were made at Tanda in the Faizabad District, and they had a great sale when Oudh had a court of its own."*[5]

Very fine *jamdani* was produced in this region until late 1950s. Mr. Ali Ahmad from Faizabad, who was awarded the master craftmanship award in 1958, was one of the last weavers in the area. The Crafts Museum in Lucknow has five samples of beautiful and fine quality *jamdani*.

The growing import into India of British machine made textiles from the second quarter of the 19th century led to the decline and eventual demise of the handloom muslin industry used in chikan embroidery. The imported varieties completely replaced the local muslins, although machine-made muslins could never equal the handwoven ones which were still regarded as best suited for the finest embroideries. By the turn of the 20th century, chikankari was made predominantly, if not exclusively, on mill-made cloth.

In 1880, William Hoey noted:

"There was some years ago a most extensive business in hand-loom weaving in Lucknow, but English goods are gradually pushing country fabrics out of the market and Jolahas (weavers) are emigrating from the city or seeking other occupations...The only cotton fabrics now woven are malmal, tanzeb, addhi, dhotar, jabdi and jamdani [...] The tanzeb and the malmal woven in Lucknow are the materials used for embroidery in chikan. The reason is that this class of fabric is soft and easily worked by the native embroiderers who do not stretch the fabric worked on a frame." [6]

Nowadays virtually all kind of cloths are used used for chikan embroidery. These include not only the traditional fine gossamer textures like *kota dorya* or *chanderi*, chiffons, georgette, *mulmul*, voile, organdy and lawns, but also several rather thick weaves in all sort of colours and materials, natural, synthetic or blends. In recent years there has been a revival, mainly in West Bengal, of fine handlooms like khadi and muslins of different varieties and counts. These exclusive fabrics are being used for sophisticated chikan production for luxury markets.

The Embroidery Process

The motifs for the embroidery are generally, although not exclusively, traced on stitched or 'half stitched' pieces. The reason is that the seams might also be part of the ornamentation and the chosen motifs for the embroidery have to be placed at specific points, usually defined by traditional compositional concepts. The following description of the process is based both on general observations of the industry in Lucknow and on specific experience at SEWA-Lucknow since the 1990s.

Masters and Tailors

The preliminary steps of chikan production involve the cutting and partial stitching of the pieces on which the tracings for the embroidery will be printed. These are men's professions and the master, who cuts the fabric, is often a 'free lancer' hired by the entrepreneur just for the time required to complete cutting the cloth according to the chosen pattern.

"Layers and layers of fabric are neatly stretched out on the clean floor and often without any frame of reference like a paper pattern or a tracing, masterji, crouched on his heels, one foot holding the thick layers of cloth in place, with his huge, heavy and sharp scissors, cuts into the thickness of the fabrics neatly and precisely, with brisk and vigorous dexterity." [7]

Traditionally the *darzi* (tailor) is a male artisan, generally paid a piece rate. He could be working from his own place, collecting or receiving the bundles of cut cloth from the entrepreneur, and bringing them back when completed, or be employed at the company's premises. Nowadays, machine stitching has also become a female activity in some organisations.

In earlier days the pieces were entirely stitched by hand, but sewing machines were introduced by the beginning of the 20th century. Today, the costumes are fully stitched by machine, but for finer quality productions the machine-made seams are finished as *turpai*, a self-bound seam achieved by rolling the inside fabric allowance together inwards, and hemming it very close to the seam. *Turpai* might be incredibly thin and on some old pieces, they appear as delicate lines on the transparent muslin, thus emphasizing the pattern and the design of the costume. *Turpai* seams are often the central spine for other graceful embellishments added by the embroiderers, such as *hathkati* or tiny leaves in appliqué work, shadow work, or lines of typical stitches such as

A Durzee
Solvyns Franz Balthazar
(1760–1824)
Musée National des Arts
Asiatiques, Paris
Acc. N. 03-017050/BG3686.2.17

phanda, *murri* or *dhanya patti*. On a few remarkable and rare pieces, the seams at the shoulders and at the sides, including the gusset, are executed with such sophisticated and subtle tailoring techniques that the seam itself becomes an ornamentation.

Unfortunately there isn't any documentation of these careful, perfectionist skills. The rare samples that occasionally emerge from private collections or museums display an unmatched delicate stitchery that testifies to the understated refinement and inconspicuous luxury of Lucknow.

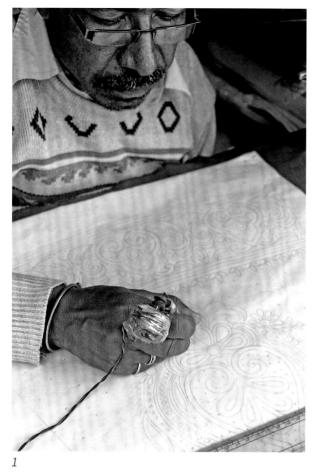

1

At a simpler technical level, handmade ornamented seams practiced on contemporary productions include *jawa* and *daraz*[8]. The *daraz* is a patterned joining seam that presents a neat and delicate finishing both on the right as well as on the reverse side. Technically speaking, the *jawa*, is not a seam, but it is a way of hemming with triangular or waving pattern, done with the fabric allowance. It is used as a decorative border or edging, often two panels finished with the *jawa* motif are joined together with the *jawa jali* stitch (faggoting stitch), that is a delicate open work in between the waving lines. *Turpai* does not require any special tracing, while *jawa* and *daraz* motifs have to be stamped on the 'half-stitched' cloth.

Unique to chikan craft is the tracing style of the wooden blocks that refers to a specific coded language understood by the embroiderers hinting at the overall style and at the choice of possible stitches best suited for the design. Another unique characteristic of the tracing coded lexicon is a variety of abstract signs for typical composite stitches like *kil, bijli, keher ki, kauri,* etc…

Draftsmen are found nside tiny little shops in areas beyond the Chowk, near the Dargah. They sit at small tables on which tracing paper is stretched, ready to draw the outlines of embroideries or they could be busy punching the translucent tracing paper with a

2

KEDAR NATH RAM NATH

A small suitcase, locked, in it a plastic bag with a neatly wrapped bundle of red cloth. I held my breath as the bundle was unwrapped and spread open on the table to reveal a thick worn out, leather bound file in the middle of fragments of brittle paper of the disintegrating pages. The hard cover too was damaged by bookworm bugs as was the drawing on the first page.

It was an album of thin paper pages on which were pasted drawings, made on thicker and stronger paper, similar to the ones used for miniature paintings, had been pasted. The supporting pages were in tatters, while the drawings were generally intact save for a few. The supporting paper was very fragile. Torn between the fear of causing further damage and the excited curiosity of looking further, I tried to be as gentle as possible.

I was elated. What I had suspected was true : these tracings were not the impression of chikan blocks, but the original drawings and I could recognize among them some designs I had seen still in use in different printing workshops. Some drawings had a stamp like a signature, a stylized heart with two letters - P and M. At the edge of some of the drawing sheets I noticed a small embossed dry stamp representing a tiny elephant with the howda and the

battery operated needle. These are the punched *khakhas* used mainly for *ari* and *zardosi* embroidery. The contribution of some artisans within chikan process is more 'visible' than that of others who are 'invisible' and anonymous. This is the case of the draftsman or the designer of the embroidery motifs, who might or might not be also the block maker. I have often wondered about their identity and by chance I saw some old photographs that led me to discover a remarkable collection of antique original drawings in an album belonging to the old firm Kedar Nath Ram Nath.

Block Makers & Printers

Rather unique to chikan embroidery is the method of transferring the embroidery motifs onto the cloth, it is done with carved wooden blocks made by the *thappakars* (block makers) while the transfer in other forms of embroidery is generally from *khakhas* or perforated tracings on paper.

The blocks are usually made of Indian rosewood called *Shisham (Dalbergia Sissoo)*, a hardwood that does not absorb water and is not attacked by termites. The wood should be well seasoned to avoid distortions or breaking. One side of the block is smoothened and painted with white *chuna* (lime) and the design to be chiselled out is drawn or transferred on it from a drawing on translucent paper. Then using a square wooden

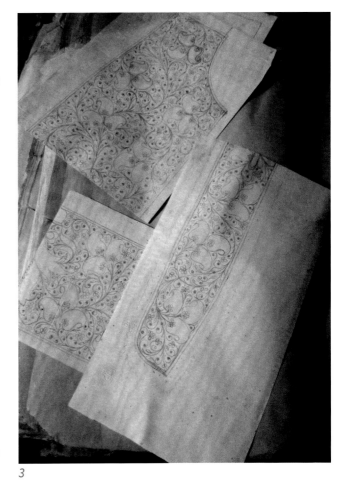

3

mahout. Delightful! A few drawings appeared to be dated: 1903, 1906, 1925, or with an undecipherable signature. The owner of this extraordinary document explained that during the time of his grandfather they used to employ a designer to draw the outlines of the blocks, but he could not remember his name.

The drawings were minutely drafted, very dense and yet very light. Page after page, there were sets of matching designs arranged within the various shapes for the different placements on the garment: there were borders with the matching front yoke, back paan motif, cuffs, the motif for the upper sleeves, the koni for the lower corners, the moon shaped kantha for the neck lines of angarkhas or Bangala kurtas. I noticed variations on the patterns of the front yoke of chapkans and achkans, sometime it ended pointed, sometime it finished about two inches broad at the waistline.

The drawings were amazing and beautiful; some very similar to the ones I had seen on costumes in museum collections, others had an early 20th century European flavor. There were collars for ladies' garments and motifs for table cloths and doilies. At times the owner of it remembered the names of old designs, like 'karela', 'gulab', … and commented on them, evoking bits of family and childhood anecdotes. His main concern now is to preserve such fragile and precious document, a special and unique testimony of Lucknawi art and craft history, to keep it safe for the future generations.

1 Artisan piercing a design for embroidery traced on paper Lucknow, 2014

2 Antique leather bound album with a unique collection of old paper drawings for chikan embroidery Private Collection

3 A design set for chikan embroidery These are patterns for the collar and front yoke, pencil on paper, Lucknow, late 19th–early 20th century Private Collection

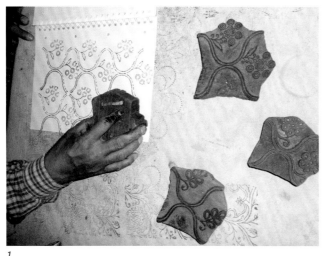

1

2

3

4

1 Muhammad Ali's printing workshop
*Experimenting with motifs, stamping them on paper to check and choose compositions
Lucknow, 2013*

2 The printers tray
*Note the lower bamboo mat on which various layers of fabrics are placed and are impregnated with the volatile ble dye
Lucknow, 2013*

3 ,4,5 & 6 Wooden blocks
A selection from different printing workshops, Lucknow, 2013

5

6

stick as a hammer and with a precision that defies imagination, the craftsmen carve the most intricate, large motifs or the most minuscule ones on tiny blocks. They use very simple tools that they make themselves, such as a hand drill and a few chisels of different sizes and shapes.

The block for chikan embroidery differ from the ones used for general printing, in that it is a flat piece of wood about 3 to 5 cm thick, engraved on one side without a handle on the top. Thus the size cannot be larger than what the hand can grip. However, the blocks for the larger motifs might sometimes have a handle. The description of the block makers in Lucknow in 1880 by William Hoey depicts a situation similar to the present day:

"The dies[10] are made of mango, shisham or ebony by carpenters, but carpenters who adopt the profession of die-cutters relinquish other work. The remuneration of die-cutters is regulated by the class of die cut:

1 – bel hashiya, for flowered borders, so cut that it can be used continuously 4as par die
2 – bel buti, single flower impressed by one stamp par die 4as par die
3 – bel haazi, flowered stripes used to print in long diagonal or transverse lines:
* also cut to be used continuously 8 to 12 par die*
4 – taharir, letters and quotations, also pictures and figures requiring use of
* successive dies Rs 2 to 4 par set of die*

A very skilled carpenter who works alone can earn about 8 as par diem by cutting dies in wood after defraying the cost of wood used. Qutb Ali of Chaupattiyan is an exceeding skilful die cutter and he can cut dies to print English or native patterns from a drawing or print or from the made-up materials."[11]

Many of the motifs we see today seem to have been inherited from old times and occasionally one finds discarded old blocks with designs noticed on antique embroidered pieces in museums or in private collections.[12] It is likely that typical motifs have been carved time and again as the blocks get damaged with use. The edges are particularly fragile and when they get worn out it becomes impossible to impress neat outlines for the embroiderers to follow.

Sometimes blocks with the same design occur in different printing workshops, which raises the issue of ownership of such designs. The printer or the entrepreneurs generally blame the 'notorious' unethical practices of block-makers, "who are untrustworthy to keep the designs exclusive, even when specifically directed to do so!"[13] On the other hand, the block makers , who are generally independent craftsmen, claim their share of the creative input into chikan embroidery by asserting ownership on the designs of the blocks.

To avoid having their own designs copied "all over town", some entrepreneurs and designers engage a block maker to work within their own premises so that the designs remain exclusive, as was the case with Kedar Nath Ram Nath. However, this is an expensive proposition today that only few can afford.

Despite the fact that the market is thriving these days, mass produced commercial work has no use for intricate blocks carved with very fine lines. "Block making is an endangered craft. These talented craftsmen, similar to so many other craftsperson in India, face the problem of situating themselves within the contemporary market economy."[14]

Printer's workshops are the most fascinating places. There is a typical smell of the mixture of gum and volatile dyes, quite overwhelming at first, but quickly forgotten in the anticipation of working on new design compositions. Even after so many years, I am always fascinated by the chaotic heaps of hundreds of wooden blocks on the floor, as only rarely are they neatly arranged on shelves. Plastic buckets or large reed baskets, like the ones used for vegetables, contain assorted sizes and styles of smaller blocks or the ones used for borders. The tiny little blocks used for miniature *butis* and specific stitches, fill up assorted containers which are piled up in different corners.

Looking for any particular design involves upturning the containers and scattering their contents on the floor, and then finding just the ones needed among the hundreds of small carved pieces of wood. A chikan block is a design unit by itself, or it can be used as part of more complex and ever changeable design composition. This system, unlike the tracings on the translucent paper with their set compositions, allows endless and instant combinations and permutations. It is a typical feature of the chikan embroidery process and it is a very ingenious and economical method to create innumerable designs with a relatively limited collection of tools.

Blocks are named according to their style and application:

- *Arka* a block used for borders with a design consisting of three smaller borders— generally the broader one is in the middle.
- *Kantha* the 'quarter moon block' with the shape for the typical neckline on *angarkha* or on Bangala kurtas. Its name derives from *kanth* (neck).
- *Bel* is a straight, single border, more or less wide, generally placed around the front opening of a kurta. *Bel* it is also the name used for the creeper designs used in oblique lines across *dupattas* and saris, or to fill or edge any other
- plain space.
- *Kat bel* is a border with a scalloped motif on one side; *kat* is also the name of the button hole stitch which is generally used as hemming. Some *bel* have on one or on both sides straight lines to make *hathkati* (*bel me hathkati milegi*)[15].
- *Koni* a block with a pointed motif which is placed at the corners of kurta.
- *Buti* a block of small motifs or small flower designs
- *Buta* a block with a large single motif, generally flowers and *keiri* (paisley) motif.

All the blocks with designs that have matching motifs for the different parts of the costume comprise a design set. These sets of several blocks mix and match the main motif, generally a particular shape of flower, often scaled in different sizes to be placed at specific emplacements or in a particular fashion. I have never seen the sets of matching blocks kept together and it is impressive how the printers can retrieve all of them from such messy, randomly placed stacks.

Blocks are broadly divided between the ones with motifs for *bhakia* (shadow work) and the ones for *murri-phanda*. The style of the chiselled designs is different and thus they give a clear indication of the kind of embroidery work possible. Within this broad distinction, the craftswoman can interpret the tracings in her own creative way. Looking at old and new blocks and comparing thin and thick outlines, I wondered about the correlation between the finesse of the carving and the quality of chikan embroidery. "To some extent it matters, but it entirely depends upon the *karigar*."[16] Blocks that are used for shadow work today were used in the past for *khatao* work, the fine appliqué work often seen on old pieces. However, the ultimate

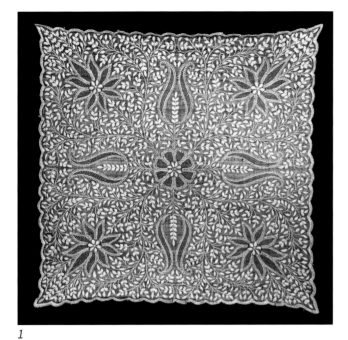
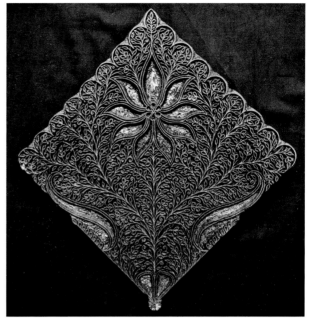

1 2

virtuosity of the craftsperson was to work in *khatao* the tiny motifs of densely designed blocks for *murri-phanda* work.

The design process at the workshop is a very interesting interaction between the printer and his customer, generally the entrepreneur or the designer. When I first began working with chikan, I wished I had catalogues of motifs, naively thinking that they would help in the selection of designs and to retrieve the chosen blocks. There were copybooks filled with stamped motifs, but they were not much help in selection of designs.

> *"In the early years of SEWA-Lucknow, somebody must have tried to introduce some system and order in the organization and the keeping of the blocks, many of them are still showing a code painted on the side, by filling large registers books with the designs stamped on the pages, often combining the matching borders and the main motifs, even suggesting possible combinations and designs. But I have never seen any of the craftswomen referring to these registers, gathering dust piled up in some corner of the printing room until the next designer, a chikan embroidery neophyte, will come and enthusiastically think that these registers would be of some help to explore the collection of hundreds of blocks and retrieve the preferred ones.*
>
> *How naïf! The best practical approach in the end for me has always been sitting on the floor, on a cushion or a bundle of cloth waiting to be printed solicitously pushed towards me by Kurshida or any of the other girls working in the printing section of SEWA, in the middle of the spread out blocks, the carved side face up, selecting first the main motif around which to develop the composition, then looking for the borders and other butis that would or could match the main motif. Once the set of blocks was finalized, I would sit often on the edge of the low table with the printer and together we would work out the spatial arrangements on the cloth".* [17]

But every printing workshop has its own system. What was true for me at SEWA-Lucknow, where the relationship has always been very warm and informal, feeling completely at home, might not always be true in other situations. Some workshops are very small and cramped with the low printing tables lined up one next to the other. On one side sits the printer and his tray; in front there is just enough space to accommodate the customer. Blocks are piled up in stacks in other

1 Chikankari cushion cover
Cotton embroidery on silk,
40 x 40 cm, Lucknow, 2014
Courtesy Mamta Varma, Bhairvi's
Chikan, Lucknow

2 Finely engraved wooden
block for chikan embroidery
20 x 20 cm, Lucknow, 2014
Kedar Nath Ram Nath collection

small and stuffy rooms or kept away in storage. Other workshops are spacious and very well organized, with the blocks neatly arranged and classified by size and style on metal shelves all around the walls. Designers are welcomed to chairs placed in front of the lower printing tables.

Working out the design is a joint process. Copybooks are opened, old compositions assessed and new ones suggested with different designs. The printer, who is fully aware of the location of the blocks, or understands which block could best interpret the designer's idea, retrieve the blocks and discusses or recommends possible combinations. Once the entire design is finalized, the blocks to be used are printed on the pages with annotations to guide the actual stamping on the cloth.

William Hoey's record of the *chhipi* or printers of cotton cloth in Lucknow in 1880 has many similarities with the way the work is carried out today:

"CHHIPI—This word has the exclusive meaning of cotton-printer or stamper. There are three different classes of cotton-printers who pass under this name but they all use similar dies.[18] […] The chhipi keeps at hand a large stock of dies (thappas) of various patterns and uses any pattern according to order. The first class of cotton printer is the stamper of real or imitation gold or silver leaf on coloured cotton fabrics for use in palki covers, purdah, lihafs, razais, toshaks &c. Lucknow manufactures of this class are almost all genuine…The process is simple but ingenious.

"The second Chhipi is the stamper of patterns on tanzeb, muslins etc., for chikan-workers. He uses the same wooden tappas as other chhipis and the coloured fluid which he uses is a thick solution of gheru or of mahawar (red colour extracted from lac). The rate of remuneration it will be seen, is very low when it is stated that a than for a dupattah 10 yards long and 40 girah wide is stamped for 2 as to 4 as, the chhipi supplying the colour. A chhipi of this class cannot be fairly charged with Licence Tax."[19]

The cost of printing a sari in 2012, depending on the complexity of the design, was between Rs 150 to 250. The printer usually works sitting on a cushion on the floor in front of a low table, which is rather small and yet wide enough for the printer's stretched arm to reach till the outer edge. The table top is padded with a few layers of fabric so as to facilitate the neat outlines of the impression. Next to the printer, there is a plastic tray with the dye. In the present context *gheru*, which is a brown-red clay, has been replaced by the *neel* or 'robin blue' powder, a synthetic fugitive indigo dye, generally used in low concentration as a whitener in laundry. On dark fabrics the printing is done with a light silver colour. Traces of *gheru* are sometimes still visible on old pieces below the embroidery.

The dyeing tray is a rectangular flat container, at the bottom of which is the *tatiya* (woven cane mat). This mat is covered with a 'blanket' consisting of six layers of cotton fabric and then a thicker cloth. The tray is freshly prepared every day although the mixture can be used for several days if properly preserved by covering with polythene. The dyeing mixture consists of *babul* [20] gum, dissolved in water[21] and *neel* powder.

New wooden blocks are soaked in oil for a few days before being used for the first time. After printing, used blocks have to be handled with great care for them to last a long time. They need to be brushed clean of the dry sediments of dye. The wood cannot be allowed to dry as it might then crack, so the blocks are greased before storing. When reused, they have to be soaked in water, so that they will take the dye evenly.

The carved side of the block is gently patted on the layers of impregnated fabrics of the dyeing tray and then carefully placed on the cloth stretched on the table. With the side of his hand the printer impresses a quick and heavy thump on it, leaving a neat contour on the fabric.

The half-stitched garments are printed with the motifs for the embroidery placed according to the traditional compositions or the requirement of the customer or, as many printers would claim, their own aesthetic and design sensibility. When I made an effort to simplify some compositions on traditional patterns like kurta by changing the placement of motifs or even removing some of them, the girls from the printing department in SEWA-Lucknow considered my interventions rather odd and 'incomplete'.

For commercial productions the stamping is done at full speed and admittedly not always with great accuracy. The fabric is often a little bit creased or crimped having already travelled and passed through many hands and then it is hastily pulled and flattened onto the printing table. The supposedly straight borders might bend upwards or downwards. The spacing and positioning of the motifs, especially if they are in the rather common diaper patterns,[22] across the plain field of *dupattas*, saris or on the front and back of the kurtas, are estimated by sight. However, in spite of the full speed rhythm at which they are stamped, the placement ends up being quite balanced.

Higher quality production works require the placement of the motifs to be more precise. Then the hands of the printer seem to dance across the plain field, fingers moving in gracious and rapid *mudras*, assessing placements and symmetries, creating imaginary diagrams and leaving a trail of perfectly arranged motifs. Designs that have to be symmetrically positioned are printed half on the right side of the thin cloth, while the mirroring side is stamped on the reverse and it shows through the light fabric. An elaborate design might require many different blocks.

From Male to Female *Karigar*s

Since the 1930s, male chikan embroiderers have progressively abandoned this craft or shifted to different roles within the trade, and chikan embroidery has became a predominantly feminine activity. This change has been attributed to various factors. The main reason is the transformation of the production system from the traditional *karkhanas* producing luxury goods for consumer elites, to a fragmented multi-stage process relying on home-based women workers.

Changing fashions is another factor. During the British Raj western menswear was adopted by the Indian elites. The shift from traditional fashion to the British style of clothing had various political and cultural implications, which have been analysed elsewhere in great detail.[23] The changes in dress style had an economic impact on traditional crafts. It caused a decline in demand for the highest quality chikankari best interpreted on traditional formal wear like *angarkhas*, *chapkans* and *achkans.* The loss of patronage by the discerning upper classes led to the loss of "respect and value for the fine master craftsmanship." Kurtas and *dopalli* topis never went out of fashion, but the *angarkha*, *achkan* and *chapkan* became progressively 'démodé', except perhaps in the private sphere where men's clothing would generally revert from the Western style to the more comfortable traditional wear.

> *"The symbolic value of western products was extremely high in this time as the British used their lifestyle and clothing to signify their racial superiority, modernity, refinement, masculinity and power over Indians. As a result, the period around the late nineteenth and early twentieth century saw elite and middle-class Indians caught in serious dilemmas with regards to the clothing choice and methods of self-presentation in public and private domains."[24]*

The male chikan professional embroiderers shifted towards other more lucrative jobs or to different roles in the chikan industry. Interestingly, the same hasn't happened for other forms of traditional embroidery like *ari*, *zardozi* or *kamdani*, that continue to be predominantly male professions, and Lucknow remains a renowned centre for all these needle-crafts. By the end of the 19th century, a form of chikan embroidery was produced in large quantities in Lucknow for the national and international markets. Many 'English goods' like table cloths and table linens, collars, yokes, and borders for insertions were produced for the western market. This style of chikan work shared the same technicalities and stitches but it had little in common with fine workmanship.

An intriguing question for which I have only conjectural answers is that there are comparatively many more surviving antique chikankari man's costumes than lady's wear. However, a cotton sari and 'dress pieces' are mentioned among the chikan works awarded prizes at the Delhi Exhibition in 1903.

A few male master embroiderers were still active during the 1950s and 1960s. They belonged to different lineages of master craftsmen who had supplied the finest chikankari to noble and affluent elites for generations. Even in those days, much as it is today, "not everyone could afford a piece from those masters!"[25]

Fyaz Khan and Hasan Mirza were the first recipients of national awards instituted by the Indian Government for excellence in craft and for contributing "not only to the preservation of rich and diverse craft heritage of the country, but also to the resurgence of handicrafts sector as a whole."[26] Their forefathers trained them, and in turn they trained their daughters and, more rarely nowadays, their sons in the family tradition of exquisite craftsmanship. Many have been recognized for the superior quality of their works and awarded National or State master craft awards or even the most prestigious Shilp Guru award. Among these are Ayub Khan, who is now an old man today who has lost his sight; Hasan Mirza's daughters, Akhtar Jahan, Rehana Begum, Nasim Bano; many other craftswomen like Saliha Khatun and Amna Khatun, Nur Jahan, Badar Anjuman, Rani Siddiqi, and Mrs Shahin, just to mention a few of a long list,[27] some of whom I was fortunate to meet. The award generally brought with it, along with the prestige and honour, a sum of money and the opportunity to hold training courses on chikan embroidery funded by the government.

The master craft awards, however bitterly criticized by many *karigars*[28], nevertheless succeeded in breaking the traditional anonymity of the artisans. Certainly not all craftsperson who deserved the top recognitions got them. Many could not sail through the bureaucratic processes, and thus there are many artisans doing excellent work who remain largely unidentified or are known only within the small circles of connoisseurs. Among these names are Rukhshana (who unfortunately is no more) and Nasreen Siddiqi, both from SEWA-Lucknow. Nasreen has trained and continues to teach groups of young women in the fine art of superb craftsmanship. Another laudable artisan whose work I was fortunate to see is Shakila from Bhairvi's Chikan. There are, of course, many more accomplished artisans that we have not had the opportunity to meet or to interact with as they are working in exclusive chikan embroidery centres jealously guarded by their patrons.

Even as a small niche of connoisseurs kept alive and unbroken the tenuous thread of fine chikan tradition, the commercial, mass-produced chikan took over the national and international markets with hand made products of varying quality from good or average quality to abysmally

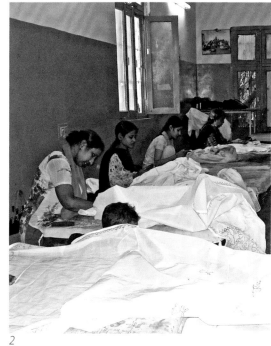

1

2

1 & 2 The ladies of the printing
unit at SEWA-Lucknow, 2007

low value. Unfortunately even this kind of work is extensively promoted as 'true chikan from Lucknow.' This is also the chikan industry that thrives on the exploitation of low-skilled female work-force from very poor backgrounds in the rural areas around Lucknow and the adjoining districts. This kind of chikan embroidery generally consists of roughly worked *bakhia* and, if any, *phanda* work made using a thread with so many strands of cotton that it takes just one fly of the needle to finish a coarse *phanda*. It is often also the only 'chikan' embroidery these female artisans are taught, or have ever known or seen.

Becoming a *Karigar*

The apprenticeship of the artisan starts at a young age, learning the basic skills while helping the elders within the family to complete orders. The transmission of the skill happens by demonstration, imitation, and with a lot of informal practice. However, there are also training courses imparted by experienced and skilled artisans through NGOs and government schemes.

From the artisans perspective, the main reason for chikan embroiderers to pursue their profession is either *shauq* (passion, interest) or *pareshani* (trouble, hardship). "*Shauq* is what stimulates the novice to hunger for knowledge, to find a master and to devote herself to learning the intricacies of chikan…On the other hand, *pareshani* lies behind the entry of most embroiderers into the contemporary chikan industry—the desperate search for money."[29]

Mrs Meer Hassan Ali, who lived in Lucknow for twelve years in the early 1800s, while talking about the well-educated daughters of a very good but impoverished Syaad family noted that "the young ladies themselves are satisfied in procuring a scanty subsistence by the labour of their hands. I have known them to be employed in working the jaullie [jali] (netting) for courties (part of the female dress), which, after six days' close application, at the utmost could not realize three shillings each; yet I never saw them other than contented, happy, and cheerful—a family of love, and patterns of sincere piety."[30] This is the first specific reference to chikan in Lucknow in contemporary literature, and highlights that poverty seems to have been a constant and common feature of female chikan embroiderers, as well as the fact that muslim ladies from well-to-do families learned embroidery as part of their education.

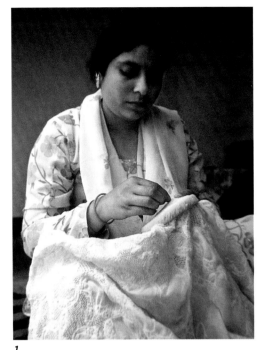

1

2

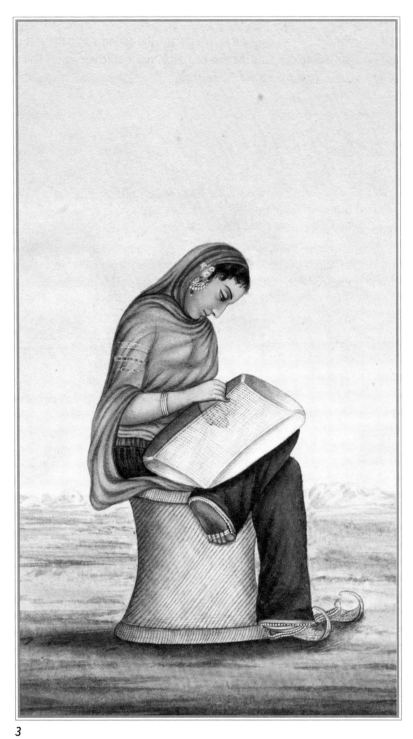

3

1 *Nasreen Siddiqi, master*
embroiderer at SEWA-Lucknow.
A most accomplished artist
of contemporary chikankari,
Lucknow, 2007

2 *Hand needle brand tag for*
chikan embroidery
State Museum, Lucknow,
Acc. N. 68.7.20

3 *An Embroideress*
Lucknow c.1815–1820
Watercolor on paper,22.5 X 15 cm
Victoria and Albert Museum,
London, Acc. N. AL.7970:25

This text is important also on two other accounts: it reveals that women were employed in chikan embroidery since early times, contrary to the notion that in the past only men were doing chikan embroidery and that women did intricate stitches like *jali*. William Hoey, describing chikan industry in 1880s, also observes that:

> "It is only when one wanders round the city enquiring about trade that one can get any idea of the extent to which the working of chikan is pushed. Little girls 5 or 6 years of age may be seen sitting at the doors of houses near Chob Mandi busily moving their tiny fingers, over a piece of tanzeb and working butas (flowers) and helping home by their earnings which are little enough, only one paisa for 100 butas. It is by this early beginning that chikan workers attain the great skill they do in embroidery: but even when the greatest skill has been attained the wages paid to the chikandoz are but low."[31]

But for the child labour described by Hoey, the situation hasn't really changed for thousand of chikan embroiderers from remote and poor rural areas. Many young girls today admit that they are doing chikan embroidery because they need to help their family or to save money for their own wedding, adding categorically that they'll stop working once they'll get married. Difficult not to sympathize with them as the vast majority of female chikan *karigar* are, as mentioned earlier, not only working for a pittance and therefore their hard work doesn't even provide for better living conditions but they also suffer from serious health problems linked with this profession.

On the other hand there are a few girls who find chikan embroidery a satisfying activity and they declare that, husband's family permitting, they are keen to continue even after their wedding, but most of the embroiderers state that they are doing such a laborious work only because their family depends on the income generated from it however meagre it might be. Others artisans, with probably less financial constraints, affirm that they only accept orders from private customers for fine quality work.

Interestingly, although chikan embroidery skills have been handed down from generation to generation, the embroiderers do not identify themselves as a specific artisan group like the *thappakar (*blockmakers), the *chapwala* or *chhipi (*printers), or the *dhobi* (washerman). Neither do they use the term *chikandoz*, that often appears in colonial literature for the 'embroiderer of chikan' to express a professional identity or a sense of belonging to a larger common interest group. For artisans who belong to organizations, such as SEWA-Lucknow, it is the strong connection with the organization which seems to forge their identity more than their profession. The term normally used is the generic *karigar* or artisan.

Embroidery Trails

Characteristic of chikan embroidery design and work are four constitutive elements.railing stems, flowers and leaves make three elements, all of which call for different stitches and textures. The *jali* or open work, generally placed inside the flower outline, is the fourth distinctive and essential component. The minimum requirements for a chikan embroidered piece, however cheaply made, are either a combination of shadow work with *jali*, or a mix of embossed stitches with *jali*.

The pieces are handed out to different artisans on the basis of the embroidery to be done, as some craftswomen are more skilled in certain stitchery than others. Some earlier narratives make a definite distinction between the embroiderers doing either 'flat' *bakhia* work or 'embossed' *murri-phanda*, implying a rather rigid segmentation of the work. However, it is not

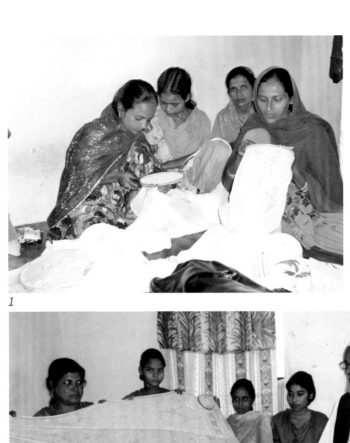

1

2

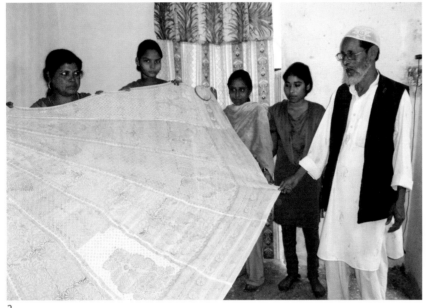

3

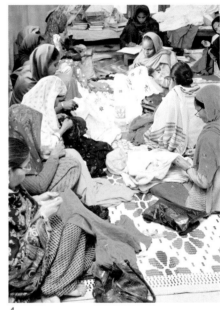

4

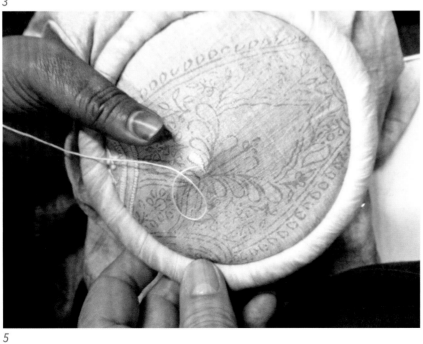

5

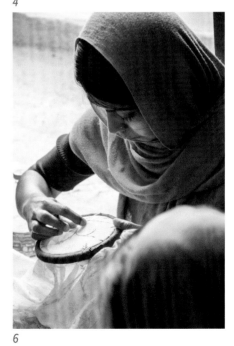

6

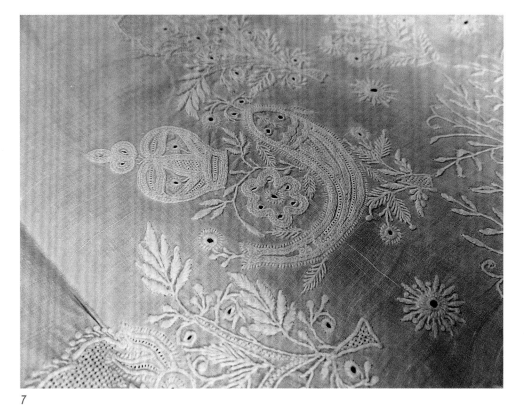

7

the case in the present context. What happens is that if the tracing requires a mix of *bakhia* and *murri-phanda* work, the *bakhia* would be done first, followed by the embossed stitches. Large pieces like saris are often embroidered by three or four artisans working together, each artisan putting in different stitches.

The pulled thread[32] work or *jali* is generally executed by skilled craftswomen who have specialized in it. The *jali* work fills the blank portions of the motif and adds the lattice textures so typical of chikan embroidery. There are many different kinds of *jali*. The *hathkati* is a single line of pulled thread work that can be executed in different visual combinations. The most common is the *siddhaul jali*.

The quality of the *jali* is gauged by the evenness and the fineness of the trellis produced by the fabric being pulled apart into thin lines: the embroidery thread should be almost invisible and the accuracy of counting warp and weft threads insures identical tiny holes forming a delicate net with different patterns. *Jali* work is rather strenuous on the eyes, especially when counting threads on fine muslin cloth. Often chikan embroiderers develop, among others health problems, serious vision diseases, and they may even become blind, like in the case of Ayub Khan.

Fine chikan is defined not just by displaying a vast repertoire of stitchery skill or by the evenness and accuracy of the work; equally important is the balance of the combination of stitches and the various textural effects. The tracings provide very specific indications of the kind of stitches that can be executed, but they also allow for individual interpretations and a range of choices within categories of stitches, flat or embossed. Most experienced artisans have submitted embroidered pieces for prestigious craft awards, in which they interpret the same motif several times, applying the entire vocabulary of chikan stitches, thus asserting their creative freedom over the constraints of the printed motif. For commercial productions, the sample reference of the required chikan stitchery is executed by one experienced embroiderer, trying out different textures till a final look

1 Women artisans
Women work together on chikan pieces at an embroidery centre, Lucknow 2013

2 Rehana Begum, National Craft Awardee and Mamta Varma, owner of Bharvi's Chikan
Lucknow, 2013

3 Shilp Guru Ayub Khan
Examining an intricate piece with with a group of ladies artisans at his embroidery centre, Lucknow, 2013

4 Embroidery is a group activity
Artisans at SEWA-Lucknow, 2007

5 &6 Close-up of chikan embroidery
Embroidery is a strenuous and laborious actvity for the artisans, often affecting their eyes and back SEWA-Lucknow, 2014

7 The fish and crown motif, emblem of the rulers of Awadh
Embroidery by master embroiderer Rehana Begum, Lucknow (Photo courtesy Rehana Begum)

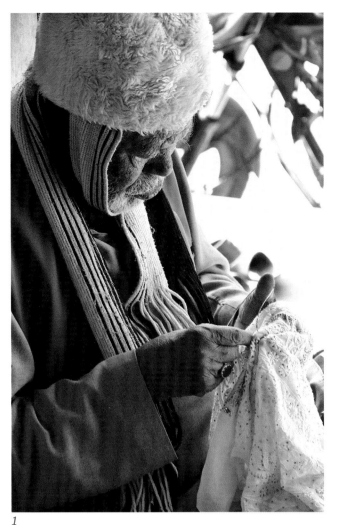

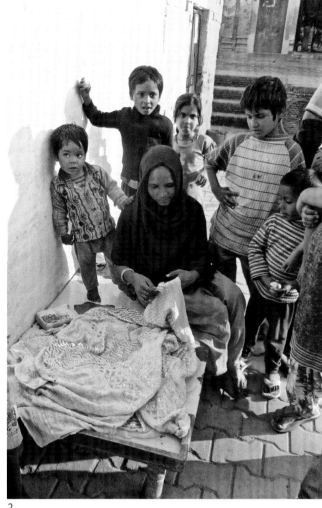

1

2

1 Kamdani embroidery
An artisan working in the old areas of Lucknow on a cold winter day, Lucknow, 2013

2 A lady adding kamdani on a chikan embroidered piece
Although kamdani is generally done by male artisans, ladies also are engaged in this craft.
Silk with cotton and metal wire (badla) embroidery, Lucknow, 2014

3 Detail of badla work
The badla wire is threaded and the larger dots executed on a sequin attached onto the cloth, Lucknow, 2014

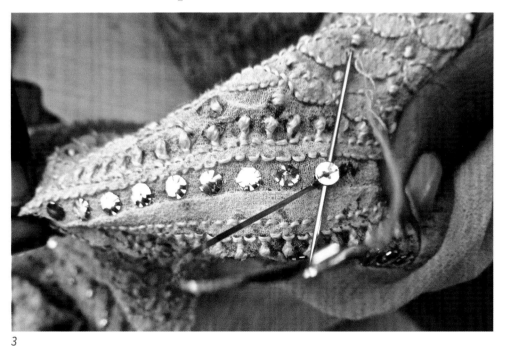

3

is approved. This master sample is then followed in the execution of the production pieces by the other *karigars*. Only the most common and easy stitches will be done on pieces to be quickly produced at low cost, but on more sophisticated designs, the creativity and aesthetic sense of the master embroiderers is highly valued and appreciated.

Bundles of stamped pieces are distributed to the *karigars* by their respective agents to be completed at home or at one of the 'production centres' dotting the suburbs of Lucknow or in the surrounding rural areas. 'Production centre' might suggest a workshop, but in reality it is often just a space or a room, within the home of one of the artisans of the group, in which small groups of women gather during the day to work together. The groups are small both because the actual space might just be a wooden platform as wide as a large *charpoi*, but also because "if they are too many women together they invariably end up in some quarrel!"[33] It could take anywhere between a few days to few months before the piece is completed and returned to the entrepreneur.

Once the chikan embroidery is finished, some pieces are further embellished with *badla* or *kamdani* work. This is a kind of embroidery executed with a thin flat metal wire. In the past the wire was silver or silver-gilt and unlike *zardozi*, it pierces through the fabric. *Kamdani* embroidery has a few stitches in common with chikan, including a *siddhaul jali*. It is believed to have originated in Lucknow and it is done by specialized *karigars*, predominately men, working in small workshops in the busy areas of old Lucknow. Women are also sometimes working in *kamdani* embroidery from their homes.

Most common embellishment with chikan embroidery is *mukaish* or *fardi,* which are sparse tiny glittering knots that add a subtle touch of lustre. However contemporary fashion trends for ever more lavish ornamentations have sensibly extended the portions embroidered with shining *badla* wire amidst chikan embroidery.

Badla work, according to Abdullah, the owner of one most reputed workshop in Lucknow, was fast declining till a few years back, partially because the flat thin silver or gold plated wire traditionally used in this embroidery had become far too expensive and difficult to obtain and the substitute cheap wires available "did not meet the clients' favours," The skilled craftspeople had also almost disappeared. The resurgence of this style of ornamentation is due, according to Abdullah, to various factors. Among these are the availability of new qualities of wires in a metal treated with an 'antique look,' and the recent fashion trends favouring a rich and opulent look. At Abdullah's his workshop, men both young and old, work in silence, concentrating fully on their work—in rather stark contrast to the chattering atmosphere prevalent in any of the women's production centres.

The Dhobis or Washermen
In their long journey through the production process, the chikan pieces pass through different stages and are being handled by many hands, sometime for months. By the time they reach the final stage, the white pieces are so dirty that it seems impossible they will ever achieve that immaculate look required by the customers or the shops.

> *"The delicate, pristine white-on-white shadow and shade of chikankari, the epitome of fastidious refinement and esoteric elegance emerging from these dim, dirty, tenement dwellings—children, chickens and goats squabbling, squealing and defecating in each corner, cooking pots smoking—is one of the miracles and mysteries of this fairly complex city."* [34]

1

3

2

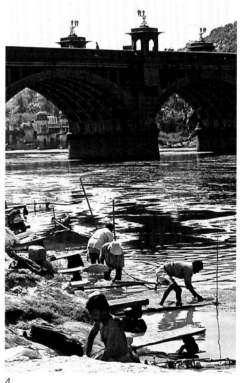

4

Chikan pieces being washed at the
banks of the Gomti river

1 Chikan embroidered pieces drying in the
sun at the river bank,Lucknow, 2007

2 Wooden plank used for washing,
Lucknow, 2013

3 Bundles of chikan embroidered cloths
being taken for washing to the dhobi
ghats, Lucknow, 2007

4 A view of the dhobi ghats, Lucknow 2007

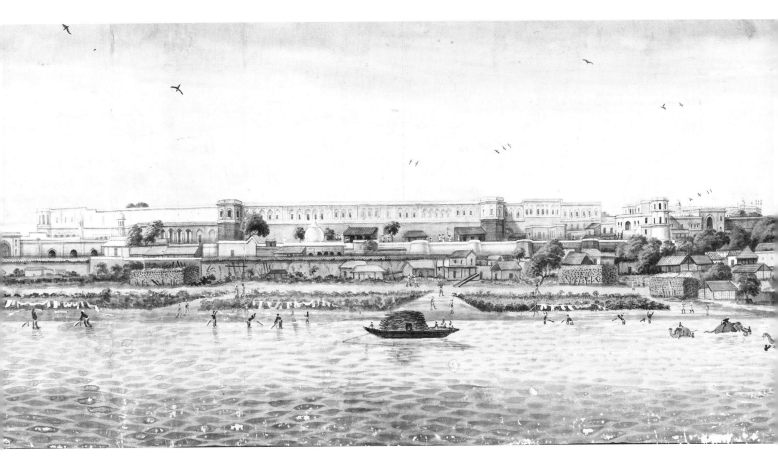

Lucknow view from the Gomti
A detail showing the dhobi
ghats in the early 19th century,
watercolor on paper,
Full roll 31 x 610 cm, Lucknow,
1826, Yale Center for British Art,
BA-ORB-3427397-0003-DSP

The magic rests with the dhobis. It is not unusual to cross the bridges of Lucknow and see the very picturesque and endless lines of washed chikan pieces drying in the sun. It is fascinating to watch the dhobis at work by the banks of the river, in front of the evocative skyline of cupolas, minarets and gardens, with the muffled yet incessant noise of traffic and honking of vehicles in the background. The scenery is peaceful: the slow flowing river, fishermen on their boat throwing nets, buffaloes cooling in the shallow waters. Standing in the water up to the waist, in front of wooden rugged planks, the dhobis work their magic and transform the dirtiest pieces into impeccable, almost pristine, white garments.

However, these romantic postcards have drawbacks too. The strong chemicals [35] are used nowadays to quickly clean the mass-produced embroideries of the tracing outlines and the dust and dirt accumulated during the entire production cycle. They are exceedingly damaging to the health of the dhobis, to the waters of the river and to the embroidered cloth itself. Till not long ago, the *"filthy crumpled rags stained with magenta"*[36] were first washed with soapy natural ingredients and then steamed overnight over a deep bowl of boiling water on a clay oven (*bhatt*).

"The top of the bowl is criss-crossed with sticks and on these the washer-man places a pile of the soaked embroideries. He then covers it with a plastic cloth and leaves it to steam all night. This removes the magenta dye…The next stage is done by the river … large holes dug along the banks are lined with plastic and filled with soapy water in which the embroideries are washed, sorted by colour. The soap is a dry acidic salt (rehu) extracted from the earth and in appearance like white sand. Then follows the spectacular pounding on the wash boards in the river."[37]

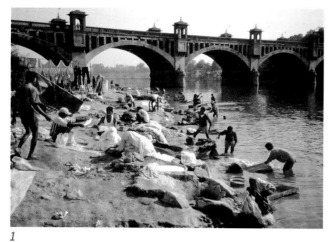

1

2

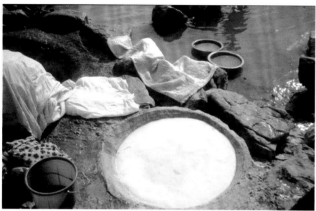

3

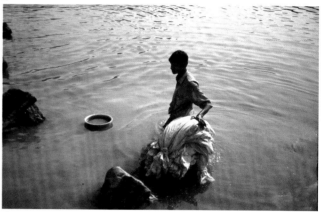

4

Dhobi ghats on the Gomti river

1 The Dhobi ghats are a hive of activity

2 Dhobis sorting the pieces,

3 Bleaching vats dug into the river bank

4 A dhobi rinsing a bundle of chikankari pieces in the river

5 Lines of washed clothes drying in the sun

5

Nowadays overnight steaming has been replaced with bleaching the pieces with chemical ingredients, in basins scooped out in the ground on the banks of the river, lined with plastic sheets. The pieces are then rinsed in the waters of the river.

Starching is the last processing stage of chikan after which the pieces are left to dry in the sun before ironing. "*The washer-men's womenfolk iron the embroideries with large heavy irons filled with glowing coals.*"[38] However it "*is not just women's involvement in supporting the economy of the household but an ironical fact that none of the male in the family are left with limbs that are strong enough to lift heavy weight, due to reaction of chemical on their skin and muscles.*"[40]

NOTES

1 Tereza Kuldova. "A commodity as a window into complexity: the chikan embroidery of India and the intertwined social life of things and people". 2010

2 Nirmal Mitra. "The chikan workers of Lucknow". Sunday Magazine, March, 1985

3 Ashmore, Sonia. *Muslins*. London 2012.

4 T. N. Mukharji. *Art Manufactures of India*. Calcutta.1888:322.

5 T. N. Mukharji. Ibid:321

6 W. Hoey. 1880:123-124

7 Personal notes at SEWA, 2004

8 For details on these seams, please refer to chapter 6.

9 Personal notes, Lucknow 2012

10 (MECH) : any of various tools or devises, originally cubical in form, for molding, stamping, cutting or shaping … http://www.yourdictionary.com/die

11 Hoey, W. *A Monograph on Trade and Manufactures in Northern India*". 1880:83

12 An interesting comment on this subject: Kuldova, Tereza "A chikan printing block and its story" at http://www.open.ac.uk/blogs/cim/?p=420

13 from personal conversations in Lucknow in 2012 with an entrepreneur.

14 "Wooden block making for hand printing in Pethapur, Gujarat" at www.craftrevival.org

15 in conversation with Muhammad Ali, printer in Lucknow.

16 From the field notebook – 5th November 2012

17 Personal notes, Lucknow 2005

18 Stamping 'Die' or 'dies' refers to any of various tools or devises, originally cubical in form, for molding, stamping, cutting or shaping

19 Hoey, W. 1880:82-84.

20 *Acacia nilotica.*

21 100 gr of gum in crystal form dissolved in 200 gr of water is generally the amount required for a day printing job.

22 a repeat pattern of squares (chequers), rectangles, or lozenges.

23 On this topic: Emma Tarlo. *Clothing Matters.* 1991. Arti Sandhu. *Indian Fashion*. Bloomsbury.

24 Arti Sandhu. *Indian Fashion*. Bloomsbury, 2015:27

25 From personal conversations with a descendant of an aristocratic Lucknow family.

26 [http://pib.nic.in/newsite/erelease.aspx?relid=67548]

27 the complete lists have become inaccessible in the concerned government offices.

28 the critiques pertained mainly to shady and corrupt practices.

29 For extensive discussion of these two concepts see C. M. Wilkinson-Weber, 1999:132-134

30 Mrs Meer Hassan Ali. *Observation on the Mussalmauns of India descriptive of their manners, customs, habits and religious opinions made during a twelve years residence in their immediate society.* 1832:letter 1. Second Edition, 1917.

31 Hoey, W. *A Monograph on Trade and Manufactures in Northern India*". 1880

32 Pulled Thread: When embroidery threads are stitched with tension to produce an open patterned lacy effect to the fabric. No fabric threads have been removed from the fabric.
 Drawn Thread: When fabric threads are removed from the fabric and then embroidery stitches are placed around the fabric thread grid to form an open lacy look. Tension is used 90% of the time. [http://www.jmddesigns.co.nz/tutorials/pulled_thread_tutorial.htm].

33 Personal communication.

34 Laila Taybji. "Hancrafting a culture". In : *Seminar Magazine*, n. 575. 2007.

35 "hydrochloric acid, bleaching powder, baking soda, caustic soda and washing soap"… "The chemicals also cause a havoc for aquatic life also as caustic soda (NaOH) and washing soap are highly alkaline effluents and lethal to all types of stream life, including bacteria. Excessive amount of nutrients change the algal community from one of great diversity of species to one of a few; the species which are eliminated are commonly those which form the food of the herbivorous animals which in turn feed the fishery resources of the area (Datta, Effect of Acquatic pollution on fish and fisheries. N.d.)". In: J. Kalra. Restoring the Essence of Heritage – Chikankari. New Delhi, 2013.

36 S. Paine. Chikan Embroidery : the Floral Whitework of India. Aylesbury: Shire Publ. 1989:54

37 S. Paine. 1989:54

38 S. Paine. 1989:54

39 J. Kalra. *Restoring the Essence of Heritage – Chikankari*. New Delhi, 2013.

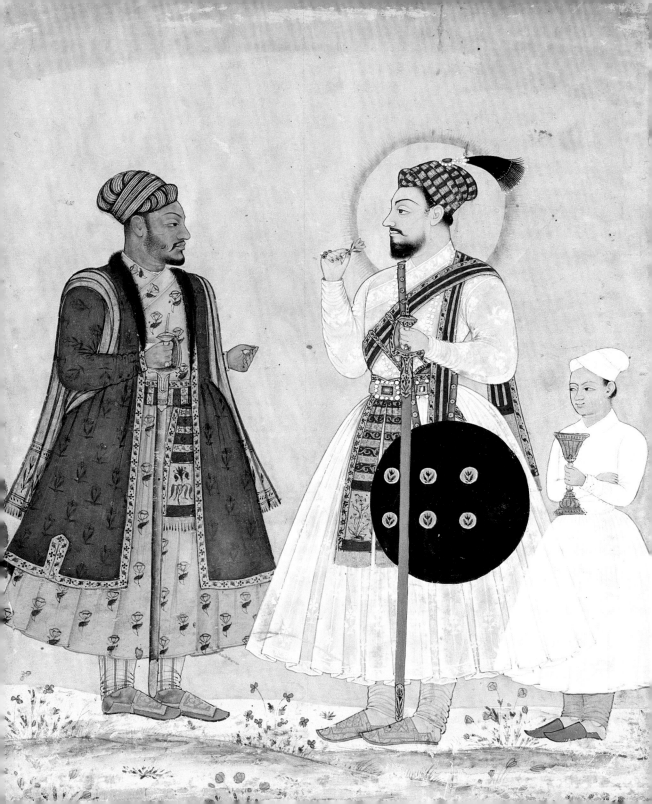

*T*his chapter is not a comprehensive essay on Indian costumes, or on the history of Awadhi fashion, as it examines and presents only those pieces from different private and public collections we have had access to. Many of these are family heirlooms, carefully preserved through generations despite conditions not always conducive to conservation. Indian weather is not merciful on delicate textiles and we are deeply grateful to their owners who have generously shared with us their treasures, overcoming initial hesitations for showing pieces in not so perfect conditions. The photography of the pieces therefore happened on different locations and we had to adjust to whichever conditions we were in, but we hope that the quality of the pieces presented will make up for the constraints of our search.

No samples of embroidered chikankari costumes exist prior to specimens that are probably dated from early-middle 19th century. Most of the costumes before the 18th century have been lost and "only in the Mughal-inspired courts that survived into the 19th century, like those at Lucknow and Murshidabad or, in a different degree, at Hyderabad, some costumes survived in their stores, but truly little is available for systematic study."[1]

Iklas Khan and Sultan Muhamad
Adil Shah of Bijapur
Watercolor on paper, Los Angeles
County Museum of Art,
Acc. No M.76.2.35.
From the Nasli and Alice
Heeramaneck's Collection

Historical Indian costumes have been usually described by their generic patterns focusing mainly on the textiles they were made of, with less attention on the details of the variations within a particular style or the technicalities of their embellishments and construction. The chikankari shown here has been made by hand from start to finish by experienced and accomplished dressmakers, and these haute couture costumes have many stories to tell. Unfortunately, many pieces will remain mysterious for ever. However even just observing the interpretations of the details in the ornamentation, the various cuts or the technical constructions has been an amazing journey of discovery and delight.

The quintessential delicacy of chikankari from Lucknow is rooted less in the embroidery itself and more on the perfectly harmonious ensemble of the various constitutive elements of these costumes. The embroidery is an integral part of it, but not necessarily the main one or one that would stand alone, with equal charm, without the other components. Chikankari from Lucknow was thus not just an added embroidered ornamentation, but a complex syntax of dressmaking, superbly mastered by specialized craftsmen. Chikankari produced for a demanding and fastidious Indian elite and chikan embroidery made for other markets like colonial elites and for export appear completely different both in aesthetic as well as in quality—so much so that one wonders if they coexisted in parallel, or if their production occurred at different periods. In today's context, the difference can compare to the distance between a haute couture garment and a prêt-à-porter or a cheap production one.

Most of the antique apparel that has survived is menswear. Very few womens garments such as dupattas, sari, sari borders and cholis have come to light, all of which are apparently of more recent origin than men's wear—some are estimated from the second quarter of the 20th century. Similarly only a handful of children's kurtas have emerged. These date to the 1950s, and most of them were rescued from becoming dusters only by chance.

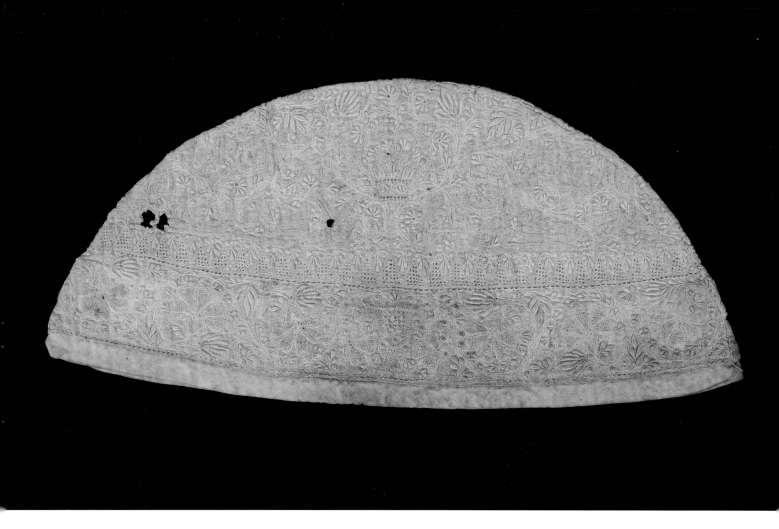

A rare dopalli cap
It is embroidered with a very
important prayer, 'Naad e Ali',
invoking help and protection.
Probably Lucknow 19th century,
cotton with cotton embroidery
Rajasthan Fabrics and Arts
Collection, Jaipur

The middle of 19th century marks a turning point in the history of Indian costumes. During the Mughal rule, formal wear among the elites had been dictated by strict court protocol. Fashion had remained relatively unchanged through the Mughal times, and most variations in styles and looks were generally minor changes on the basic same pattern.

> "At centres like Lucknow, however, a self conscious style was sought to be evolved, a certain dandyism taking over. It is not without reason that the 'bankas' of Lucknow, those elegant men whose lives revolved as it were around their appearance, are celebrated in the literature of the times. The old garments, the jama or the angarakha, the farji or fatuhi, the pyjama, the turban, underwent certain changes not always easy to date or describe; but the cuts and appearances were changed with careful look at the over-all effect of ensembles."[2]

A garment can only be appreciated by the way it fits when worn, looking at how it falls and how it drapes, and how it combines with other garments and accessories. These are all essential elements to understand the style and the life of a costume. "These dresses have to be seen worn and used for one to be able to take in their magic, for then alone do they begin to breathe a life of their own."[3] It is not possible to present these costumes in a living context. To make up for this drawback, this book emphasizes texture, the details of the pattern, and other embellishments.

A.H. Sharar gives an interesting glimpse of Lucknowi culture and lifestyle, capturing the fastidious attention that was paid to one's own apparel and image:

"In Lucknow [...] when a gentleman went out, he then dressed in chau goshia, a four cornered cap, fresh from the mould, an immaculately clean angarkha, which looked as though it had just come from the laundry and the hems and sleeves of which had just been crimped, wide linen or muslin pyjamas, a triangular scarf over the shoulders, a handkerchief and cane in hands, and Lucknow—made khurd nau, light, short-toed velvet shoes, on the feet...Many people took such care when going out that their clothes always looked freshly laundered, although they may not actually have been washed for months. The practice was to go out in the evening and stroll thorough the fashionable area of the Chauk market, taking great care not to let anything touch the clothes, even shying at one's own shadow. At night, on returning home the first thing that was done was to put the chau goshia on its mould and cover it with a cloth, then the angarkha, pyjamas and handkerchief were carefully folded with the scarf wrapped round them and put away...in this way expensive clothes, especially those made of shawl material, lasted four or five generations." [4]

British rule led to a slow change in fashion among the Indian elite, and then other sections of society. The first western elements to be incorporated into Indian formal wear were buttons and buttonholes, which replaced traditional string fastening system like on *jama* or the *ghundi* and *tukuma,* the cloth ball button and the string loop.

"When the poets of Delhi and Lucknow weave in reference to dresses in their elegant Urdu verses, they speak of this emphasis on new fashions, and observant writers with a descriptive bent of mind like Abdul Halim Sharar and Khawaja Hasan Nizami document much that was happening in the field of fashions in these parts. By and large, the list of the costumes in favor at the Oudh court reads as not being much different from that popular at Delhi in the 18th century, but the changes in the cut gave them another look. A new introduction was the kurta which was a modified version of the old nima or nimcha; but made of fine material and with a great deal of embroidery work in white on white, it acquired a presence of its own. Likewise the topi, dupalli as it was called, simply made but elegantly finished and sometime rakishly worn, was made of very light material. The upper garment, the angarakha, yielded in part to a chapkan which was a modification of what was also called a balabar, and came to be very widely adopted both by the upper classes and the men who worked as low officials or servants in the circles connected with the officers of the court or, in a fast changing context, were employed by the officers of the east India Company. The achkan and the shervani were other outer garments that came in, the latter especially popular at the Hyderabad court." [5]

Contemporary visual records, paintings or photographs, of possibly embroidered chikan costumes are very few. It is also quite difficult, despite the accurate detailing of the textile textures by the miniature painters, to differentiate between woven *jamdani* and embroidered chikan white works.

"Chuga was so much in fashion and demand that weavers of Dacca and Benares made chuga pieces, with butis or jal on the ground and pan, mukuta[6], kalanga or large jhar buta on the arms, back, front and konia in corners on daman. Banaras pieces were mostly brocade and those of Dacca in jamdani (flowered muslin). Designs for these chugas were carefully planned and gold butis or butas, with contrast colour outline, stand out beautifully on a white, red green or purple silk ground." [7]

1 On the road
Lucknow, 2013.

2 A dopalli cap with exquisite
embroidery
Lucknow, early 20th century,
cotton with cotton embroidery,
Rajasthan Fabrics and Arts
Collection, Jaipur

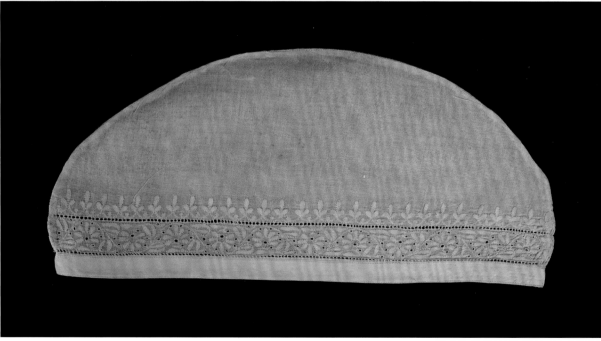

The use of topi or cap is documented at least since the 16th century, mentioned by Tulsidas in his *Ramacharitmanas*.[8] Topi are identified by the number of panels—two, four or five—used in the pattern. The topi became particularly popular in 19th century, being a light and beautifully ornate item. It used to be offered as a gift to the elders and to the rulers on festive occasions.[9] The *topiwallah* was:

> *"the maker of the ordinary skullcap, generally made of some light material, muslin or the like, and simply embroidered, which is worn by nearly every native of the East, Hindu or Mahommedan, either as a sole covering of the head or under the dopattah or amammah... There are three classes of topiwallahs: the manufacturer and wholesale vendor of the pairs of semicircular pieces of embroidered stuff not made up, which are required to make a topi, the wholesale vendor of made up topis, the retail vendor of made up topis."[10]*

Dopalri topi

The dopalri (two-panel or *dopalli*) was and is still a popular cap worn across the Lucknawi society, by both Muslims and Hindus, from princes to the humblest person, distinguished only by the fineness of the work on the border. It is supposed to have been introduced during the reign of Nazir-ud-Din Haidar[11] by a 'Delhi prince' who "was received with great honour by the court and the society. He wore a dopalri cap, which was made of two pieces of cloth to fit the head with a seam across the top. This cap was pleasing to most people for it was relatively simple and easy to produce. Many people adopted it. The prince came to be known as 'the prince of the dopalri cap'."[12]

The fashion of wearing dopalri spread beyond Lucknow. There are exquisite specimens among heirloom textiles of noble families from other states, as seen in Sangeet and Sidharth Dudhoria's collection in Kolkata, 'Kumar of Azimganj' (Bengal) or in the Sawai Man Singh II Museum in Jaipur which "boasts of having the largest collection of topis in India."[13]

The dopalri used to be embroidered onto an unstitched piece of fabric, with the two panels symmetrically mirroring each other. The borders were placed towards the centre of the square or rectangular piece of the fine muslin. A small gap separated the two panels to allow the margin for cutting them apart and for stitching a plain piping around the cap.

There are many samples of dopalri cap that have survived, as topis were carefully kept, even though they sustained more damage than any other item of clothing. There are variations in the quality of the muslin and the embroidery, but the workmanship on old samples is outstanding. A. H. Sharar wrote that it took six months to one year to make a cap, and the embroidery either entirely concealed the background fabric or was confined to just a decorated border. A few rare dopalris are so finely embroidered that the variety of stitches and textures can be fully appreciated only through a magnifying glass. The viewer is literally spellbound at the skill of the hands and eyes that produced such "invisible" masterpieces. These rare pieces seem to belong to a different level of art altogether. Were they commercially produced? Were they 'labours of love', or perhaps an expression of a state of deep meditation and devotion? For whom were they made—for the recipient of the cap or for the Almighty, or both?

One version of the origin of chikan in Lucknow mentions a princess from Murshidabad presenting a very fine cap to her husband, the Nawab. "With tiny stitches and variegated

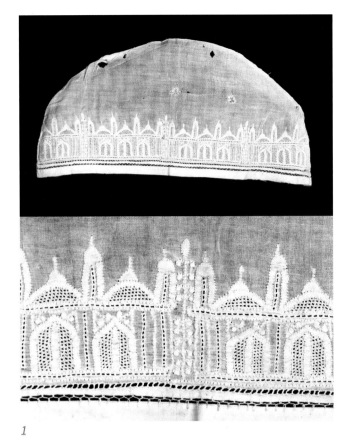

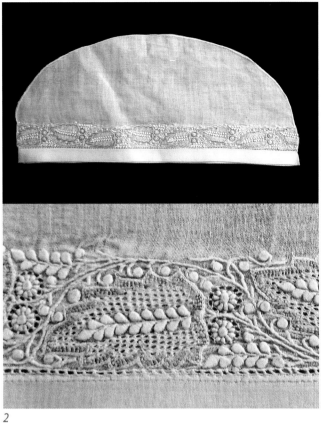

1

2

1 An unusual dopalli embroidered
with a skyline of masjids
*Probably Lucknow, late 19th
century, cotton with cotton
embroidery*
Private Collection, Delhi

2 Dopalli with a border of tendrils
and foliage
*Particularly fine phanda, gol
murri, jali and keel stitches.
Lucknow, late 19th century, cotton
with cotton and silk embroidery
Siddharth and Sangeeta
Dudhoria's Collection, Kolkata*

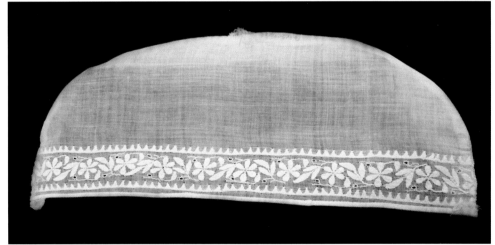

3

3 Dopalli with a floral border
worked in katao or appliquè
*Probably Lucknow, late 19th
century, cotton muslin
Crafts Museum, Delhi,
Acc. No. 92/7805(184)*

4 Dopalli cap with zardozi border
*Probably Lucknow, late 19th
century, cotton with zardozi
embroidery and sequins
Rajasthan Fabrics and Arts
Collection, Jaipur*

4

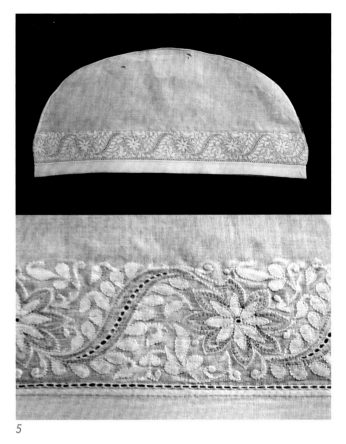

5

6

7

patterns she successfully embroidered a white cap, working it richly with cotton thread on muslin cloth. When it was finally ready she sought permission to present it to the Nawab at a private audience. The Nawab was so charmed by the gift and the giver that he started to single her out for his attentions."[14] Such accounts validate descriptions that at times might appear overstated.

The collections of dopalri that we have seen include a fully embroidered piece with calligraphic inscriptions. It has badly yellowed over time and it is difficult to clearly distinguish the motifs. The writing are the verses of an important and well-known prayer, Naad e Ali. Discernible on the same topi is the motif of a crown, in the typical Lucknawi shape.[15]

The embroidery on dopalri caps probably accounts for all the innumerable stitches that the craftspeople can experiment with in chikankari. The skill is truly amazing, particularly in the *jali* or open work. The virtuosity of the artisans was at its best on the borders. It is difficult to date the styles, although it can be assumed that they also followed changing fashions. The motifs on the borders on the topis sometimes match the borders on angarkhas and kurtas, suggesting that they might have been made as matching sets. It is a rather intriguing to find identical designs and workmanship on pieces now geographically distant. For instance, the border on a dopalri cap in a private collection in Kolkata is the same the same design and style of needlework as on an *achkan* in a museum collection in Delhi. Did they have a single owner? Were they actually made as a set or it is just similarity in design just a coincidence? Perhaps they come from a single workshop, or the same trader, or embroiderer.

5 Dopalli with bakhia or shadow work, back stitch, hathkati and phanda
Lucknow, late 19th or early 20th century, cotton with cotton and with silk embroidery
Rajasthan Fabrics and Arts Collection, Jaipur

6 Dopalli embroidered with chikan and kamdani embroidery
Probably Lucknow, late 19th or early 20th century, cotton with cotton thread and badla
Rajasthan Fabrics and Arts Collection, Jaipur

7 Dopalli topi with lace trimming
Probably Lucknow, late 19th century early 20th century, cotton with cotton embroidery
Crafts Museum, Delhi,
Acc. No. 92/7805 (161)

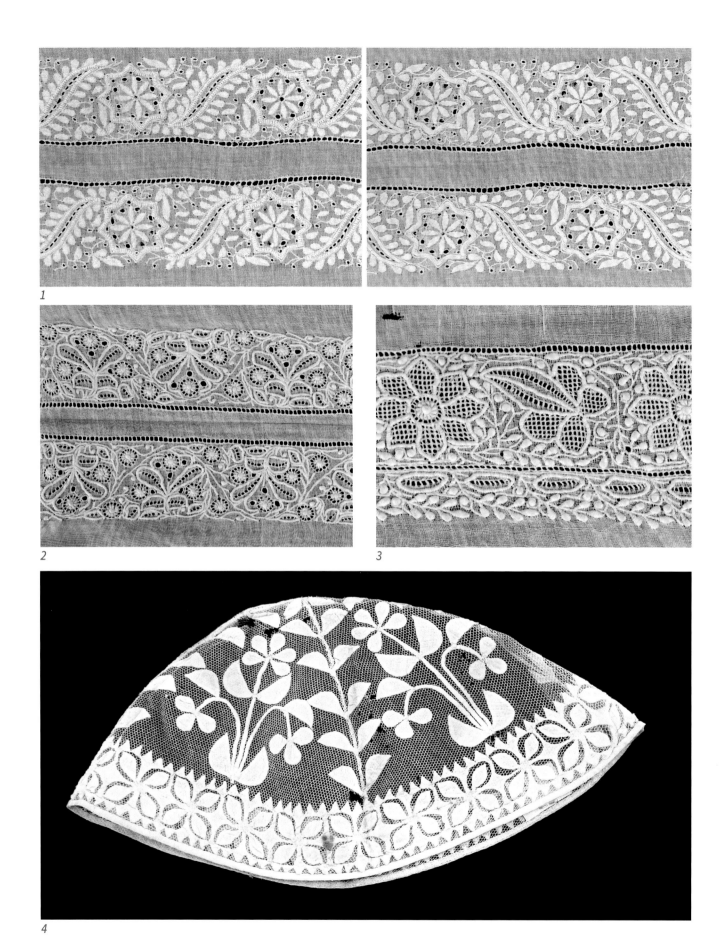

1

2

3

4

Chaugoshia

"In Lucknow [...] when a gentleman went out, he then dressed in chaugoshia, a four cornered cap, fresh from the mould, an immaculately clean angarkha, which looked as though it had just come from the laundry and the hems and sleves of which had just been crimped, wide linen or muslin pyjamas, a triangular scarf over the shoulders, a handkerchief and cane in hands, and Lucknow–made khurd nau, light, short-toed velvet shoes, on the feet."

Pagris (turbans) in a variety of fabrics, colours and sizes, and twisted and wrapped in hundreds of styles have traditionally been an essential accessory of male attire and an indication of the social status and identity of the wearer in India. It is important to remember that in the past clothing was not a matter of personal choice or preference but it was governed by specific and strict socio-political directives; in fact any change in style had to be sanctioned by the court.

"The court also allotted different forms of pagris to the various grades of employee [...] A white muslin pagri similar in appearance to the shimla was for the clerks. Court messengers wore red pagri. Attendants had white pagris on to which a tassel in gold and silver thread was attached in front on the right-hand side. The pagris of the palanquin bearers were like those of the messengers but had three silver fish stitches to the right-hand side..."[18]

Arabs and Persians, and initially the Mughals too, used to wear large turbans beneath which they wore a conical, pointed cap in the Turkish style. However during the Mughal era the large turbans became increasingly smaller and lighter, and the cap under the turbans when it didn't disappear altogether, became much lighter:

"Some wore no caps under their turbans and others wore extremely small ones of light material which could be blown away by a puff of wind. I am not certain what these caps were like but they probably resembled those worn by present Muslim patriarchs and religious mendicants, a strip of cloth about seven inches wide going around the head and sewn at the top."[19]

The chaugoshia cap consisting of four panels attached to a wide headband was among the headgears of the Mughal aristocracy. It was adopted in most of the regional courts like Awadh. According to contemporary records, the designs and shapes of headgears were frequently changed by the Nawabs with new models becoming fashionable and replacing old styles.

Panchgoshia

It is believed that in the 1830s the Nawab Nasir ud Din Haidar himself[20] designed the panchgoshia (five-panelled) cap, which soon became fashionable in Lucknow. According to Sharar, the wonderful chronicler of Lucknawi culture, the change to the panchgoshia was symbolic of a shift of religious allegiance from the four Caliphs to the five members of the Prophet's family, or in other words from the Sunni to the Shia tradition.

In the panchgoshia style "the long conical sections were joined together and attractive crescent-shape patterns were sewn at the rim. These crescents were made of cotton and were stitched on the inside of the fine muslin panels. They showed through the panels and gave the head-dress an elegant but simple appearance. This cap was so popular in Lucknow that it could be seen on the heads of all and most people gave up wearing pagris."[21]

1 Detail of unstitched dopalli Katao or appliqué embroidery with hul and hathkati stitches, seen from front (left) and reverse (right)
Probably Lucknow, late 19th century early 20th century
Cotton with cotton embroidery
Rajasthan Fabrics and Arts Collection, Jaipur

2 Detail of unstitched dopalli with balda, hathkati, phanda, hul and kil stitches
Probably Lucknow, late 19th or early 20th century, cotton with cotton embroidery
Rajasthan Fabrics and Arts Collection, Jaipur

3 Detail of an unstitched dopalli topi with balda, kil and jali work
Probably Lucknow, late 19th or early 20th century, cotton with cotton embroidery
Rajasthan Fabrics and Arts Collection, Jaipur

4 Chougoshia topi ornamented with cotton appliqué (patti ka kam) and cutwork embroideries on cotton
North India, 19th or early 20th century, cotton with cotton embroidery
Silver & Art Palace's Textiles Collection, Jaipur

1a and 1b Five panels or panchgoshia topi
Probably meant for the winter season it is worked with multicolour corded quilting embroidery and phanda, kat and jali stitches
It has two layers of cotton embroidered with cotton thread and corded quilting with wool,
North India, 19th or early 20th century,
Nawab Mir Jafar Abdullah's Collecton, Lucknow

2a & 2c Panchgoshia topi
A typical motif of stylized cypress tree concealing the seams of the panels and with floral crescents like a head garland
Lucknow, late 19th or early 20th century, two layers of muslin cotton with cotton thread embroidery
Crafts Museum, New Delhi
Acc. No. 71(6000)

2b Antique wood block impression on paper for a panel of a panchgoshia cap
Lucknow, late 19th or early 20th century
Sewa-Lucknow

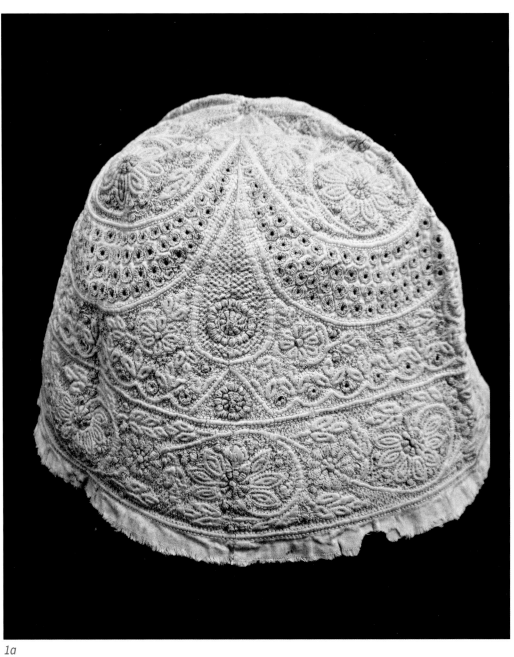

1a

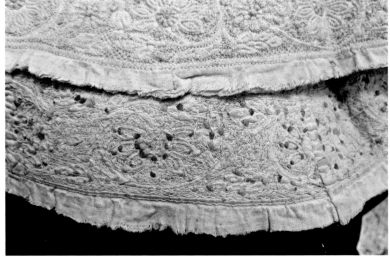

1b

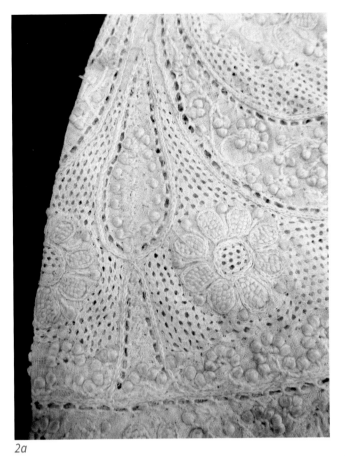

2a

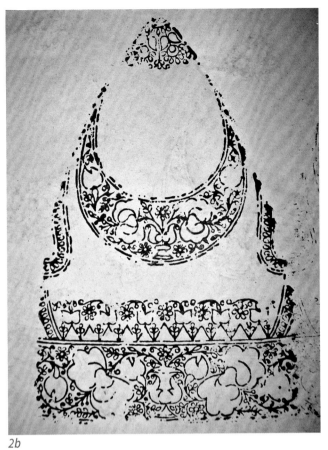

2b

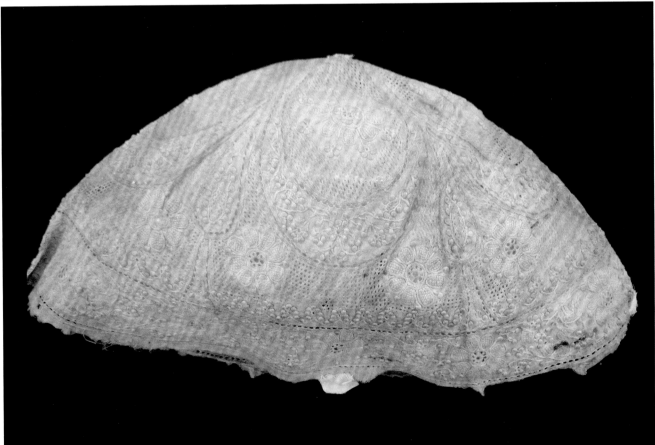

2c

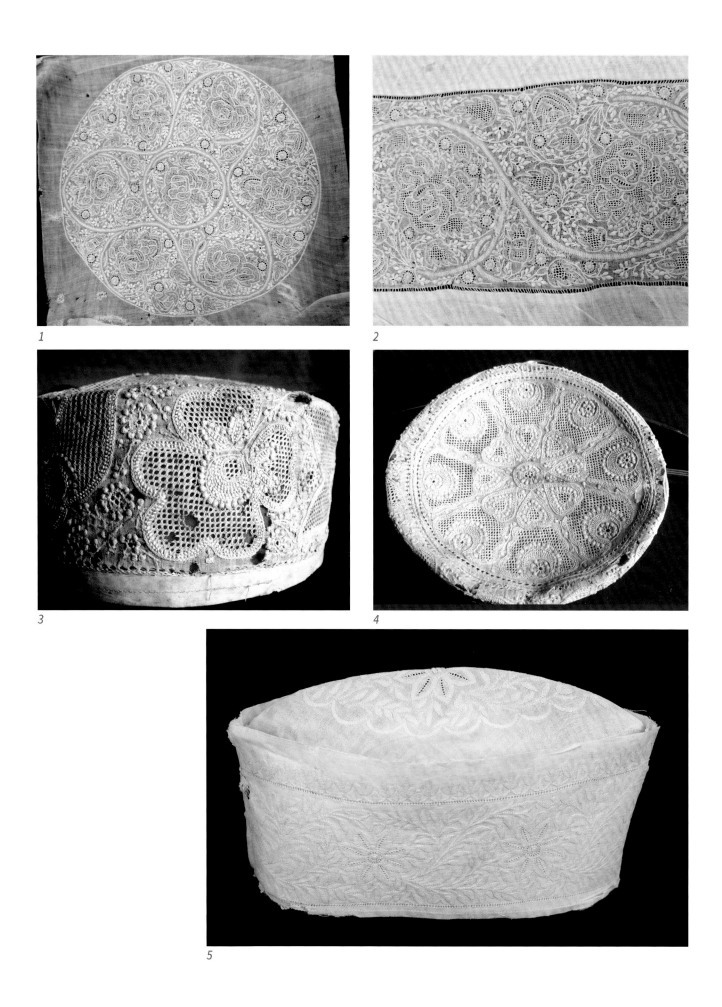

1

2

3

4

5

The panch goshia was developed in different styles, suitable for winter and summer:

"... a very attractive embroidered cap of the same type was created for the winter. The five panels were covered in thin muslin upon which gold and silver crescents and designs were stitched in different colours. In winter one saw no other covering on the heads of men of fashion. Later, when chikan became popular, it was used for this purpose...A delicate chikan cap took up to a year to make and even the most ordinary ones cost anything from ten to twelve rupees"[22]

Nawab Mir Jafar Abdullah had two old samples of panchgoshia which seem to correspond to this description. They had two layers of muslin fabric, the outer one being slightly thicker than the inner one. These pieces were embroidered with embossed chikan stitches and motifs, as well as with corded quilting work in two different colours, greenish blue and red which showed delicately through the outer fabric, slightly yellowed over time. Nawab Mir Jafar, drawing from his rich anecdotic repertoire, named this kind of workmanship as 'dogh' from a typical local culinary preparation which mixes creamy yogurt with chopped red tomatoes and green coriander leaves.[23] This kind of needlework work with corded filling is similar to the description of a quilting technique typical of Bhopal, quoted earlier from G. Watt.

The designs on panchgoshia seem to be characteristic, as seen on several old portraits. The five-crescent shape is like a scalloped garland adorning the crown of the head and small stylized cypress trees at the joining of the panels appear to be typical features, the cypress being worked in such a way as to conceal the joining seams.

A tambourine-shaped cap, called *mandel*[24], with a flat round top and a broad band circling the head, was adopted at the times of the Nawab Ghazi ud Din Haidar or Nazir ud Din Haidar, and it was usually embroidered in gold and silver.

"Rich men and the sons of Navabs adopted it and it acquired the distinction that no one was allowed to appear in the presence of the King or of princes without wearing either a turban or an embroidered mandel. In short the mandel gained access to the court".[25]

The State Museum in Lucknow has a very nice sample made with muslin and profusely embroidered with chikan work. It is quite rare to find such a complete piece. Most of the surviving samples are generally sets of unstitched pieces; a square muslin with an embroidered roundel for the top and a long embroidered band, with matching motifs.

Other Styles of Caps

"At the end of the monarchy a very small and narrow cap was developed from it which was pointed in front and behind. This was called the nukka dar cap."[26]

The cap known as the Gandhi cap, symbol of the freedom movement, was also sometime embroidered with delicate chikan work.

1 Unstitched piece for the round top of a mandel or tamburine cap Lucknow, late 19th century early 20th century, muslin with cotton and with silk embroidery. Crafts Museum, New Delhi. Acc. No. 67/4533

2 Unstitched embroidered piece for the head band of a mandel Lucknow, late 19th or early 20th century, muslin with cotton and with silk embroidery Crafts Museum, New Delhi. Acc. No. 67/4534

3 Mandel with chikankari embroidery Lucknow, 19th century, muslin with cotton and silk embroidery. State Museum, Lucknow

4 Mandel with chikankari embroidery Lucknow, 19th century, muslin with cotton and silk embroidery State Museum, Lucknow

5 A Gandhi cap Lucknow, 20th century, cotton with cotton embroidery Rajasthan Fabrics and Arts Collection, Jaipur

The origin of the angarkha is believed to "predate the advent of Islamic fashion by at least 1,000 years. Later evidence in paintings and sculptures suggests that, unlike the *jama*, which is of Central Asian origin, the garment evolved in a purely indigenous fashion. It remained popular throughout the country until well after the Mughal periods and it is still worn in some parts of rural India today"[27] The name derives from the Sanskrit '*angarakshak*' which means 'protector of the limbs'. By some interpretations, the typical front flap of this costume was made of hard-wearing material and it might have functioned as a protective shield in an ancient 'cavalry costume'.[28] The angarkha was a long man's tunic, to be worn on *paijama* trousers. It has long sleeves and a very typical round, oval or triangular front cut edged by *magaji* or piping. On some pieces the *magaji* is quite elaborate with a single or double *sinkia magaji* filled with different colours piping cords.

Within the round front cut, the bodice of the angarkha had an inner flap, called *purdah* (curtain), stitched from the neckline to the waist. On the side of the opening, the angarkha was fastened at the neck with *ghundi* and *tukuma* and at the waist with strings. The distinctive and consistent feature of this dress is the *purdah*. However, variations in the styles of the angarkha were related to geographical and fashion preferences, changing over times. The bodice is fitted and it is triangular gussets on the sides, delicately ornamented on several chikan pieces. The armhole is generally cut curved, the front opening is round-shaped in many different variations. The front inner panel might cover the chest completely, or leave a portion of it exposed. The front panels meet and fasten at the centre, or on the chest or lower down at the waist. One of the front panels crosses over the other that is fastened inside on one side.

The sleeves are rather fitted, generally long and tapering towards the wrist, to be worn in gentle wrinkled folds: "It was the custom that when angarkhas were delivered by the washer men, their edgings, tailpieces and sleeves were specially crimped and the marks of this crimping remained for a long time."[29] On different cut the sleeves ended with a long slit and thus hung loose showing the thin vest called *nima* made of plain muslin or *jamdani* that was worn under the angarkha. The length of the angarkha and the flare of the skirt varied: it might be with side pleats or gathers, or be just plain and rather fitted with or without *kali* (panels). On the lower part of the skirt, there are side slits that can be of different length, and sometimes there are also suspended pockets.

The angarkha was made in many styles, extremely elegant for formal wear or more simple probably for ordinary daily wear. It was made with precious silks and brocades, velvets, wools, padded with cotton and quilted, or with diaphanous jamdani, light mulmuls calicoes.As a ceremonial court dress, the angarkha was the epitome of elegance and refinement, and it was often embellished with elaborate embroideries. According to A. H. Sharar, the angarkha that was fashionable at the Mughal court in Delhi, had a hemline like that of a *qaba* and it was pleated on both sides like that of a *jama*."This was the old angarkha which was worn in Delhi… when it came to Lucknow it was made more close fitting. The body was also tightened, the pleats at the side disappeared entirely and the bottom were edged with lace… After the angarkha had been evolved in Delhi, the bodice was discarded and the exposure of the left side of the chest was not considered incorrect but attractive,"[30] as contemporary portraits show, among which the famous one of Wajid Ali Shah, the last exiled king of Awadh. "The angarkha survived in Lucknow as the dress of the law courts until the 1930s, when it was replaced by English legal costume."[31] The angarkha developed subsequently into the achkan.

Portrait of Panna Lal Mehta
He is wearing what appears to be a chikankari embroidered angarkha worn over a light vest called nima, made with a patterned muslin
Oil Painting by Raja Ravi Varma, 1901, 91.44 x 106.68 cm, Private Collection

1 Close up of a remarkable
chikankari paan motif which is
usually placed on the back.
Lucknow, 19th century
Muslin embroidered with cotton
and silk threads
Craft Museum, New Delhi,
Acc. No. 92/7804

2 On this angarkha the
chikankari embroidery is amazing
for its craftsmanship.The design
of the border on the front is gently
tapering towards the waist line.
The small pocket is outlined with
a narrow border and a single line
of hathkati or open work. The
turpai seam at the armholes is
ornamented with dense and yet
delicate embroidery.
Lucknow, 19th century
Muslin with cotton embroidery
and with silk embroidery.
Craft Museum, New Delhi,
 Acc. No. 92/7804

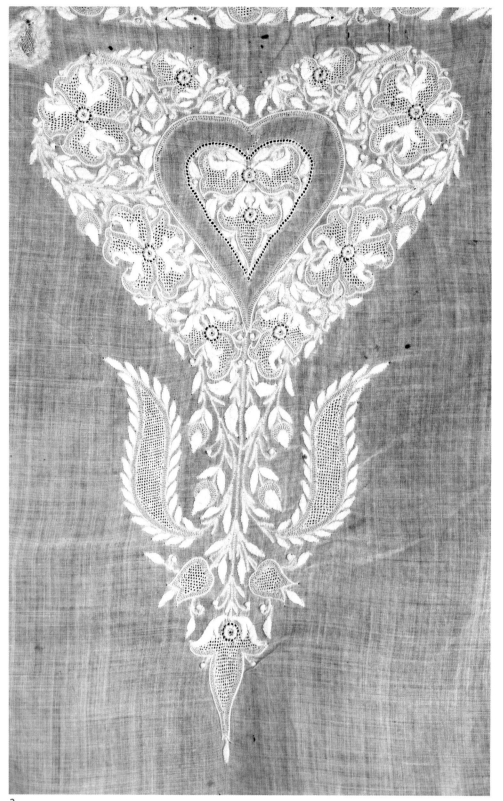

3

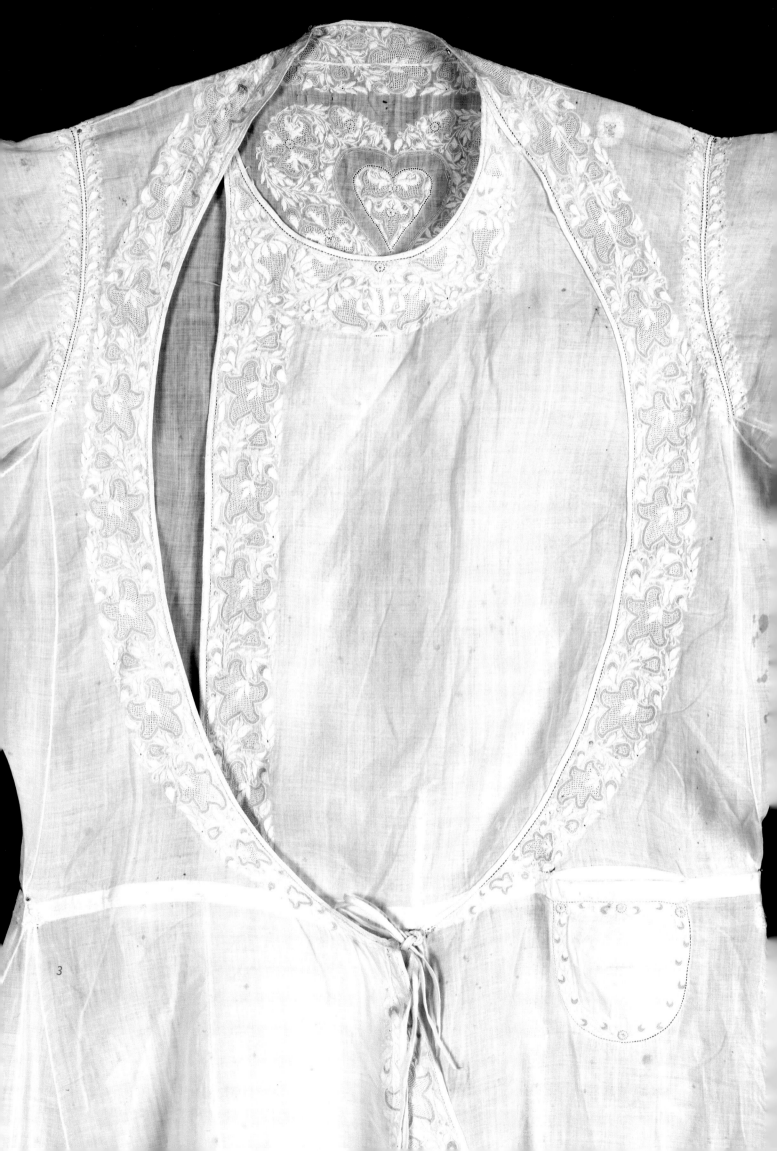

1 Fine appliqué work showing
through the diaphanous muslin.
Muslin with katao and cotton
embroidery, Munnu Kasliwal's
Collection, Gem Palace, Jaipur

2 Close up of katao or appliquè
work

3 A gossamer angarkha with hair-
thin turpai seams and a small
pocket at the waist.
The right side panel is overlapping
onto the front to be tied with a
tie-string on the left side. Muslin
with very fine appliquè work
edging the costume, Lucknow,
19th century, Munnu Kasliwal
Collection, Gem Palace, Jaipur

1

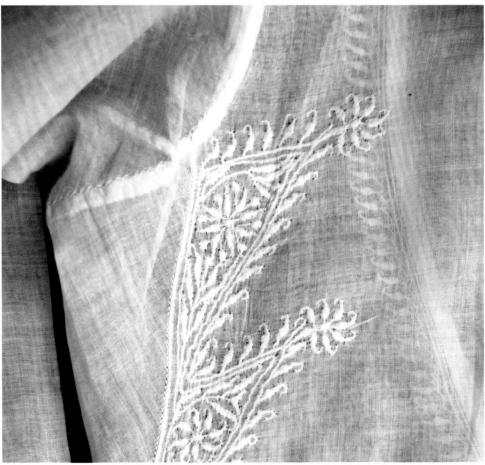

2

112

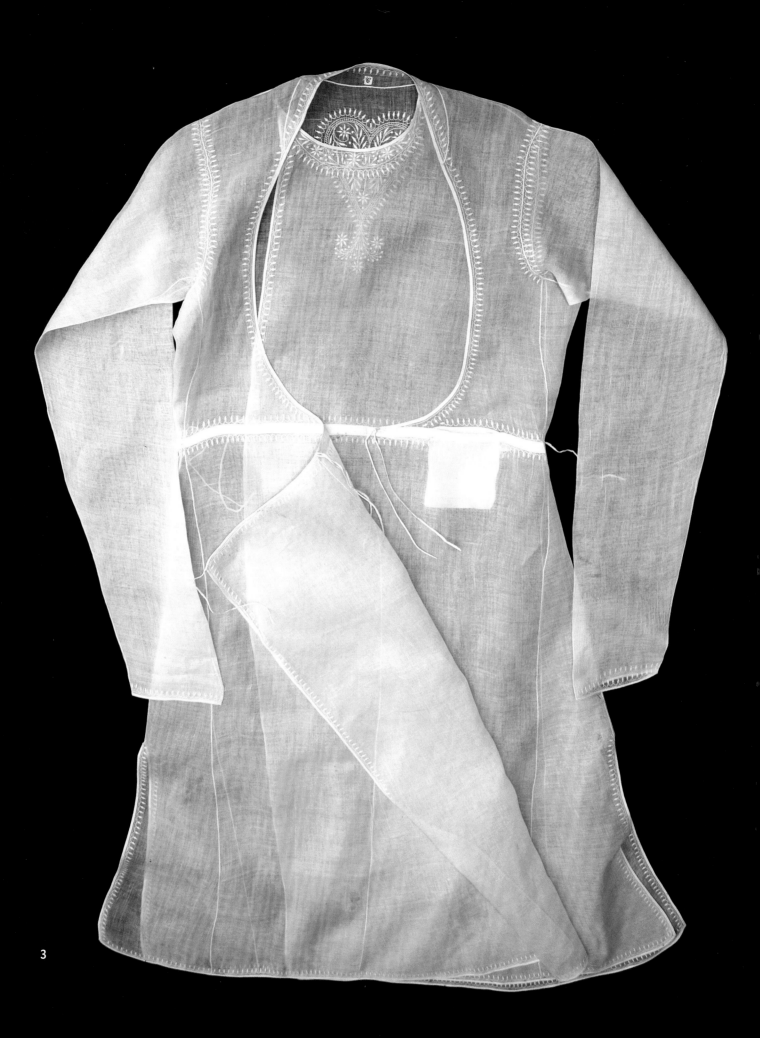

3

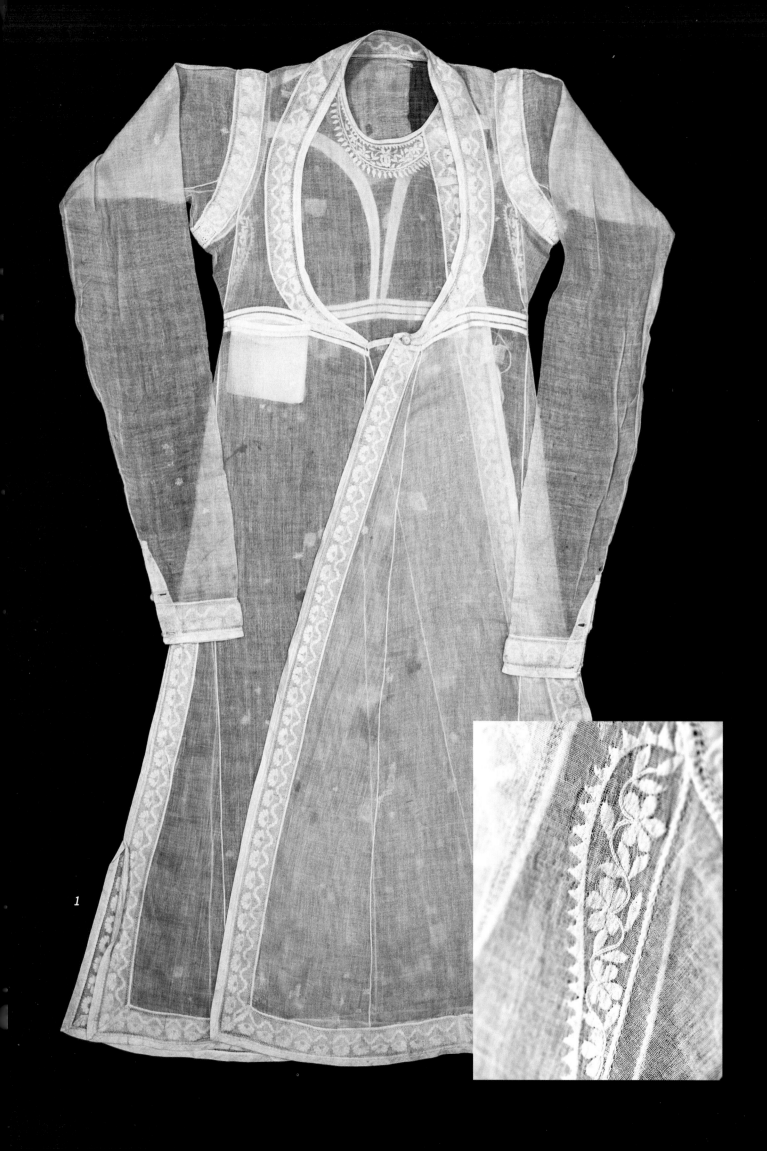

1

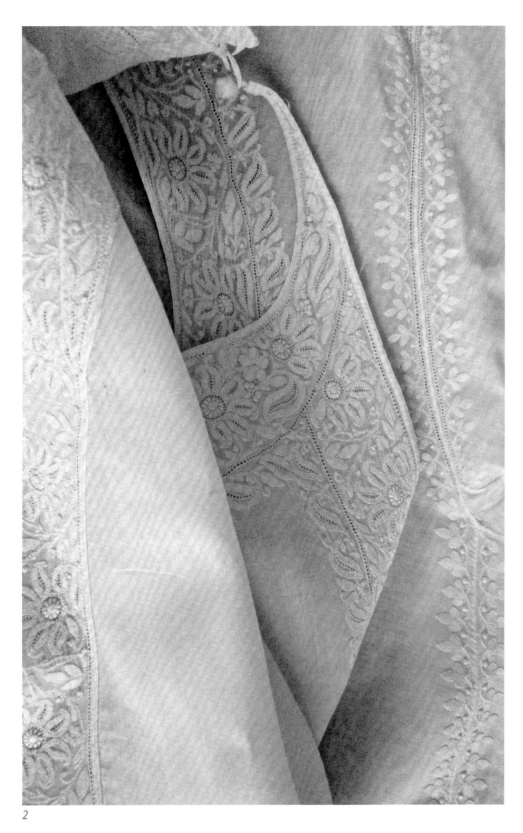

2

1 Angarkha of gossamer muslin
Edging all around and at the
armholes with a mechanically
embroidered ribbon simulating
the texture of chikan embroidery.
The more traditional tie strings
are replaced by a thread button
at the waist
Lucknow, late 19th or early 20th
century, muslin with cotton
appliquè ribbon and with katao
appliquè at the back
Nawab Mir Jafar Abdullah's
Collection, Lucknow

2 Angarakha detail
Fine shadow work with phanda,
kil and hathkati
Lucknow, late 19th or early 20th
century, muslin embroidered with
cotton thread
Author's Collection

115

1 Angarkha belonging to a member of erstwhile royal family of Lucknow
Remarkable chikankari ornamentation in dorukha style, 19th century, muslin with cotton embroidery
Nawab Mir Jafar Abdullah's Collection, Lucknow

2 Detail of above
Border and lower corner motifs
The quality of the embroidery is incomparable

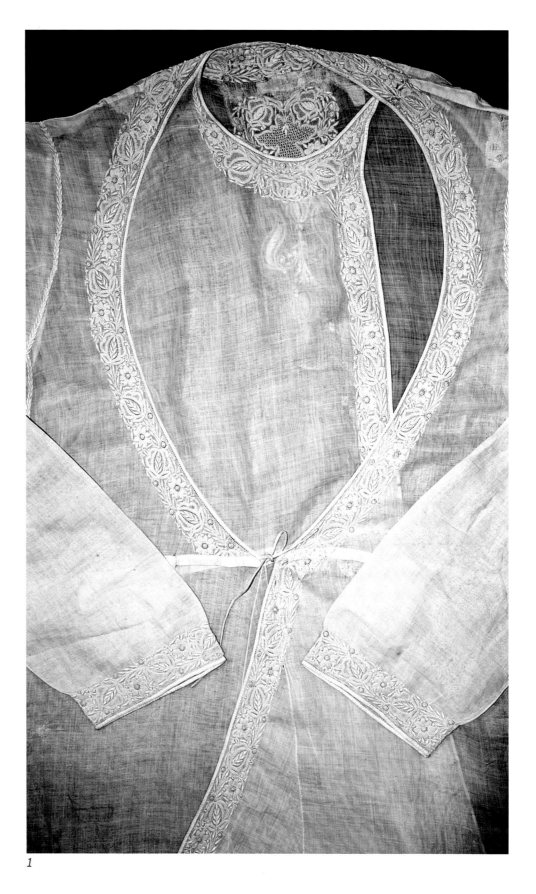

1

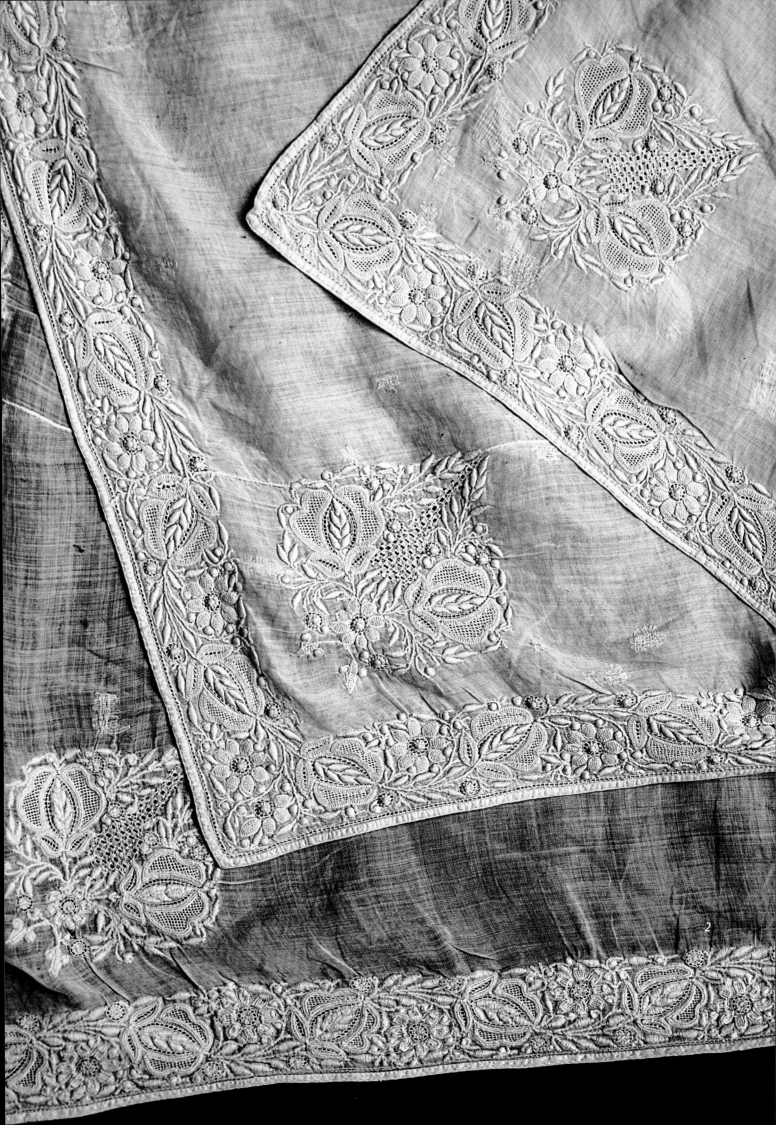

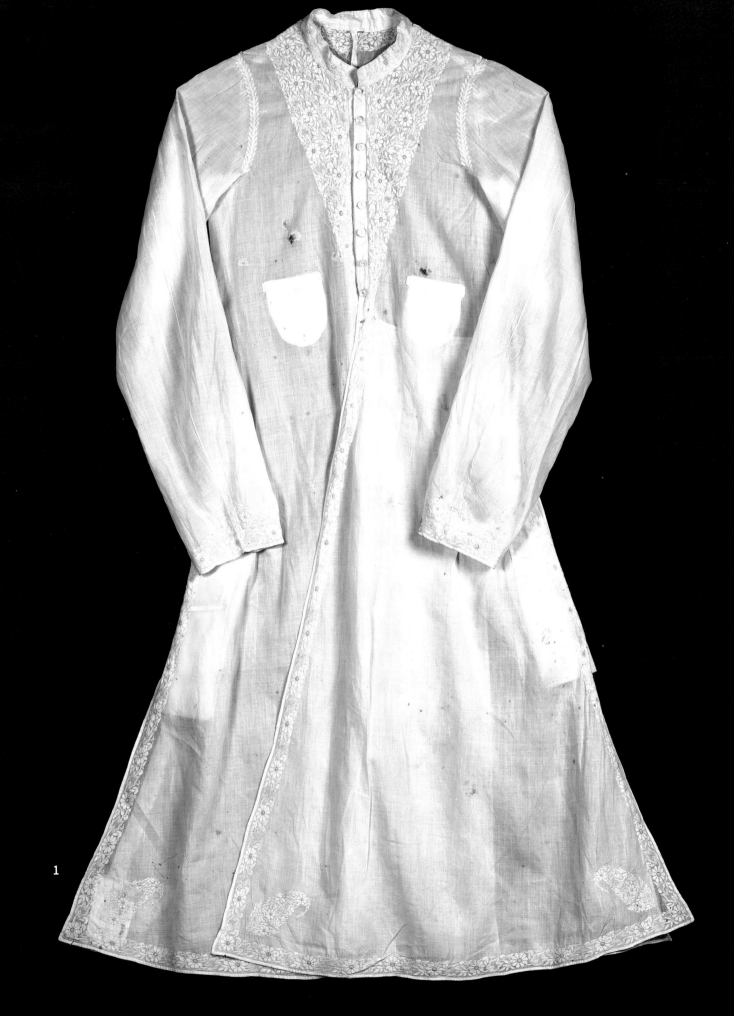

1

The chapkan is a 'fitted coat' which evolved in Lucknow in the second half of the19th century combining elements of the angarkha and Western style menswear. The most remarkable aspect of the chapkan was the introduction of the western style buttons and stitched buttonholes.

"In this form, the coat had a high waistline, and instead of tapes and stitches the insertion of the collar was fastened by buttons arranged in the form of a loop on the chest. The sleeves were in some cases too long or too tight for the arms and had to be gather up in dainty folds about the wrist or slit as far as the elbows with coquettish effect."[32]

In A.H. Sharar's description, the chapkan : "had a semi-circular jabot and lapels as the angarkha: The lapels were bow-shaped and sewn with buttons and there was an attractive bow-shaped ring of buttons near the neck. Like the *balabar*, it had a broad gusset fixed to the left side by buttons. This chapkan was made of wool or other thick cloth and was more suitable for winter wear; it was popular in the court."[33]

There are few specimens which are made with fine cotton muslin, certainly more suitable for the summer months. The lower portion of the chapkan was flared like on the angarkha, and one panel crossed over or under and it was fastened on the opposite side, either with tie-cords strings or in the *ghundi-tukuma* style . The achkan is a further development "on the lines of the chapkan and angarkha," it had a "coat collar which was opened in the centre and kept in position by the border hem."[34]

The coat had a straight cut and was open from top to bottom. It was fastened with buttons and had an extended panel on one side to be fastened inside on the opposite side 'to prevent the bottom of the garment from opening. The lower part of the achkan was exactly like that of the chapkan and angarkha and those who were fashion-minded had it edged with lace and embroidered.'[35]

The armhole is cut curved and the sleeves on the chapkan as well as on the achkan follows a western pattern, often in two pieces like on classic men's coats. On some pieces the loose fitting of the sleeves appears rather incongruous, as it doesn't really match the otherwise elegant tight fitted body of the costume. The achkan eventually evolved with few alterations into the shervani which "became so popular everywhere, including Lucknow, that it is now the national dress of all Hindus and Muslims in India."[36]

1 Chapkan
Front yoke, borders and small keiri at the lower corners ornamented with katao or appliquè work
Lucknow, late 19th or early 20th century, light cotton muslin with cotton embroidery
Crafts Museum New Delhi, Acc. No. 92/7804

2 Lower corner motif of a chapkan
Katao with hul, hathkati and kil

3 Drawing for a front yoke
Lucknow, late 19th or early 20th century, pencil on paper
Album of drawings for chikankari, Private Collection

2

3

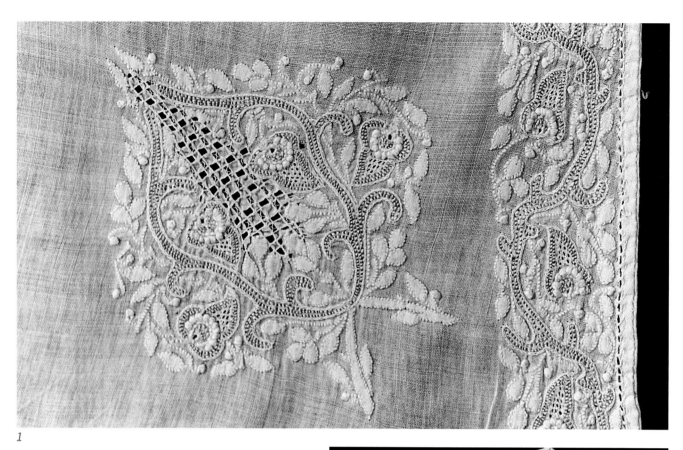

1

1 & 3 Close up of the chikankari
embroidery on achkan (1)
*White cotton thread and golden
silk thread. Bakhia, phanda, rahet
as filling stitch, janjira and jali
stitches.*
*Lucknow, late 19th century early
20th century*
*Nawab Mir Jafar Abdullah's
Collection, Lucknow*

2 Achkan
*Lucknow, late 19th or early 20th
century, cotton with cotton and
silk embroidery*
*Nawab Mir Jafar Abdullah's
Collection, Lucknow*

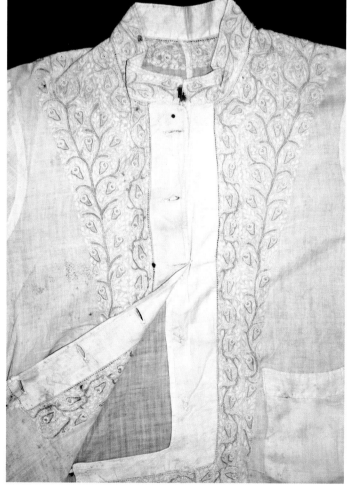

2

3

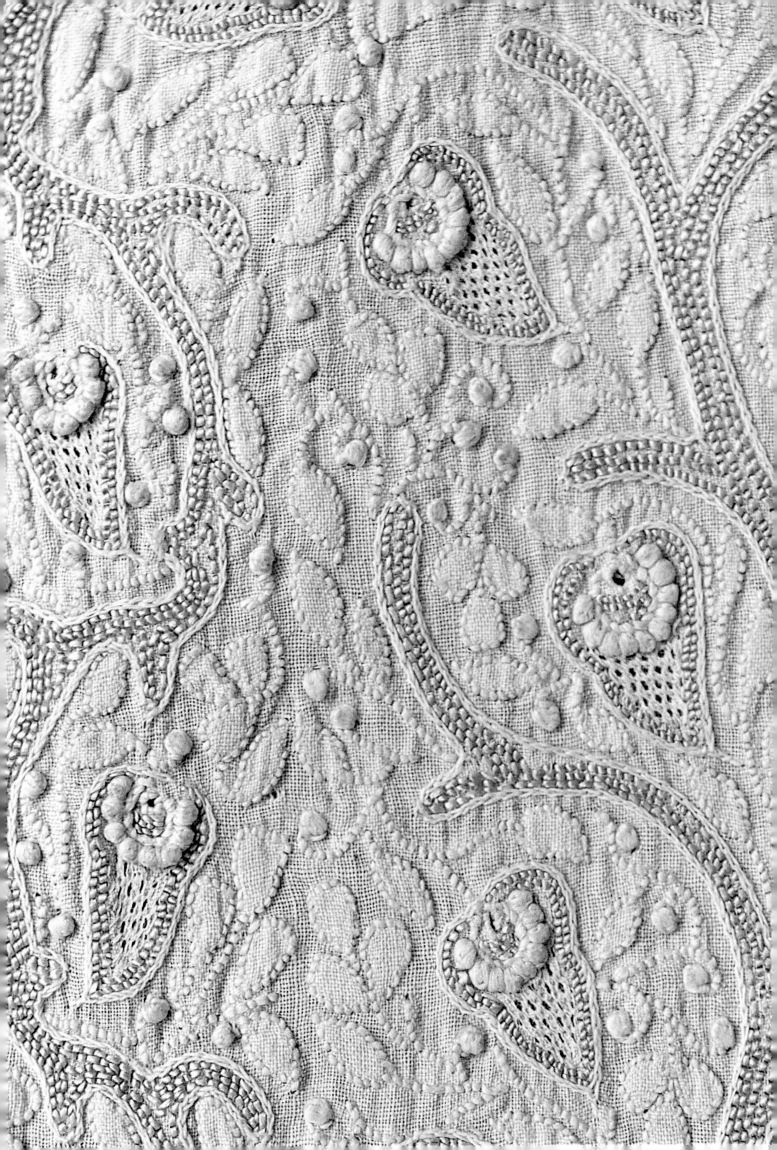

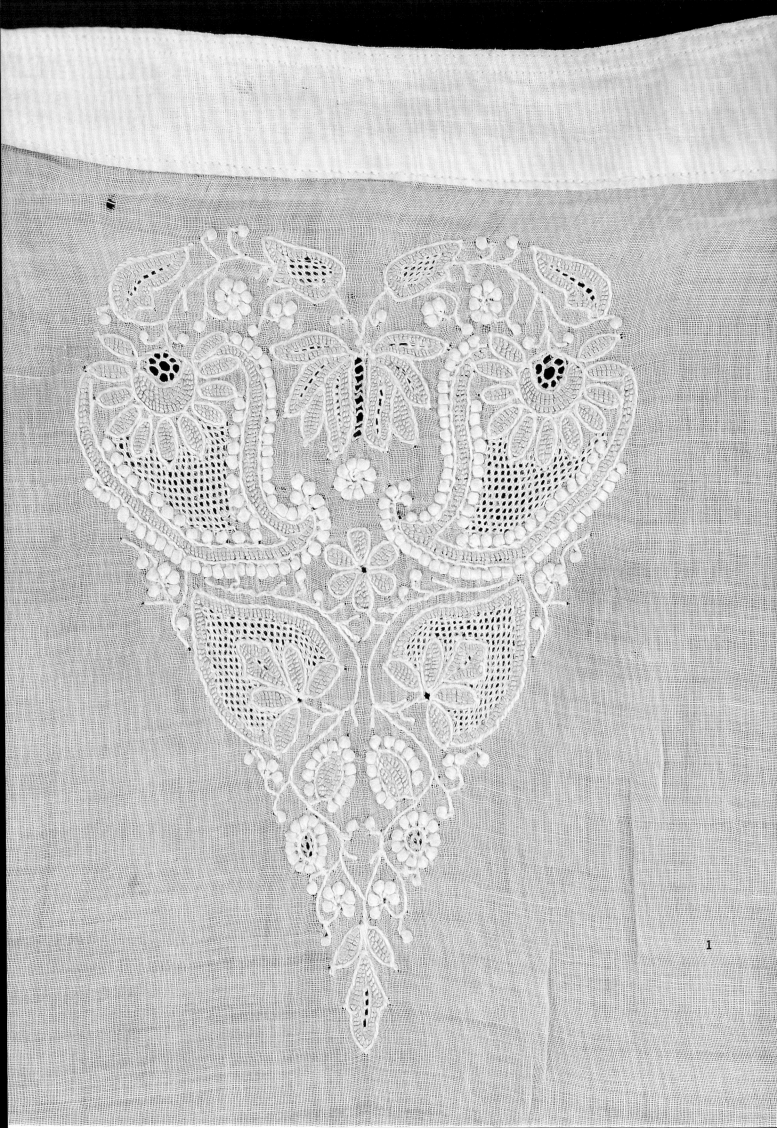

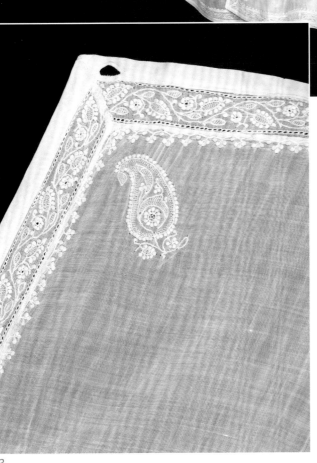

1 Paan leaf motif with an elongated shape at the back of a chapkan
Lucknow, late 19th or early 20th century, cotton with cotton and with silk embroidery
Rajasthan Fabrics and Arts Collection, Jaipur

2 Crossover front panel, fastened with a button at the waist line
Lucknow, late 19th or early 20th century, cotton with cotton and with silk embroidery
Rajasthan Fabrics and Arts Collection, Jaipur.

3 Front panel detail
Top corner with a small keiri motif. The embroidered border shows a joint at the corner. It might have been produced separately in a long strip and joined onto the garment
Lucknow, late 19th or early 20th century, cotton with cotton and with silk embroidery

3

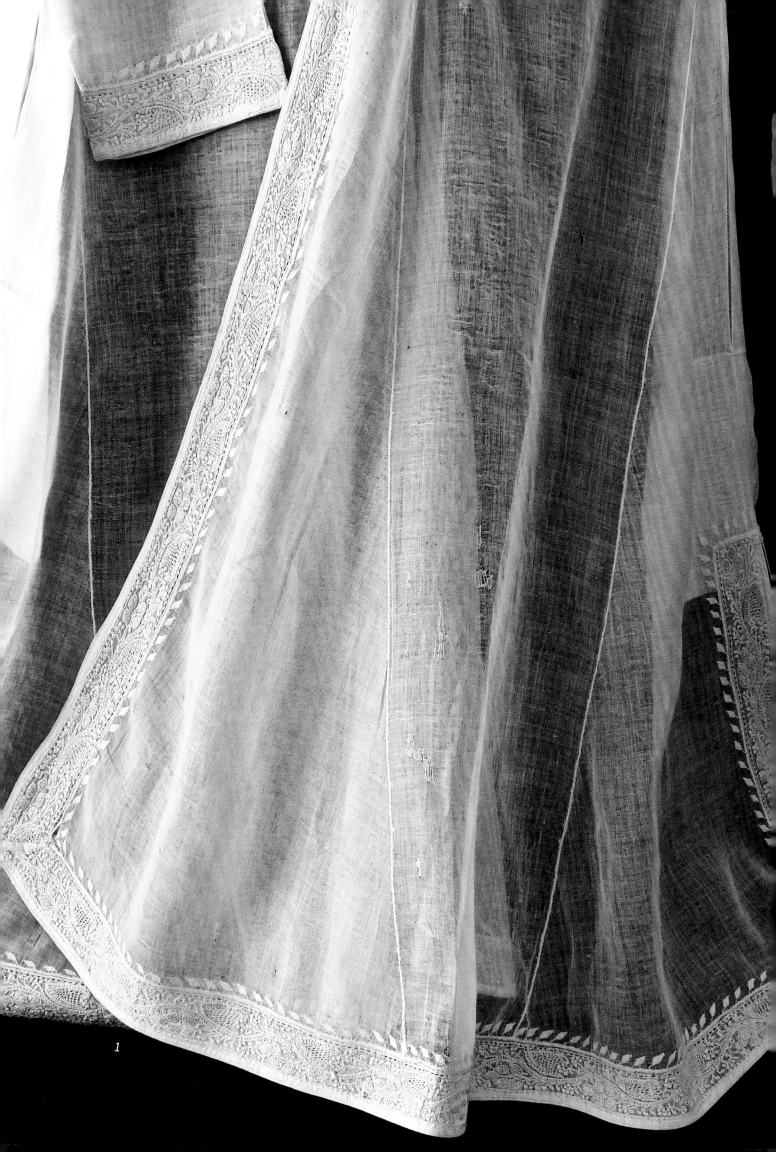

1

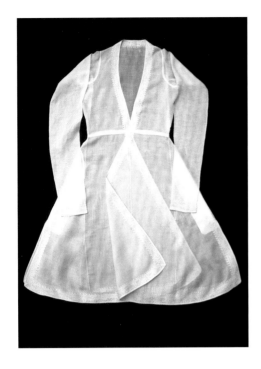

CHOGA

The name 'chogha' is said to be of Turkish origin[37] and it is a common garment throughout Central Asia. It is a loose, long-sleeved coat, open in the front with straight-cut panels.

In the Indian context, the choga has mainly been a ceremonial outer garment. During medieval times it was worn over angarkhi on formal occasions by the elite class.[38] It was usually made of precious textiles, like brocades or pashmina, elaborately decorated with sumptuous embroidery and trimmings.

The typical placement of embroidery motifs on the choga also reflects its Central Asian origin, where embroidery was considered to be a protective talisman. It is worked all around the openings: the borders, the sleeves and the pockets, these being the 'entry' points through which harmful forces could possibly attack the body. Moreover auspicious motifs are also placed in correspondence with the vulnerable points of the body like the front bodice, the shoulders and top of the arms, at the nape of the neck and at the back[39].

Likewise chikankari choga had an embroidered border all around of the edges, on the front opening, around the neck and it ornamented the hems and contoured the side slits. Embroidered corner motifs, *konia* were placed at the bottom both on the front and the back. Around the armholes, on the sleeve at the top and bottom, at the centre back there were embroidered floral compositions with matching the designs and workmanship of the border.

There are several variations to the choga's pattern: single straight front and back panel, or a wider coat with added flared *kali* inserted on the sides and/or at the centre front. The V-neck front opening might be either straight or oval shaped. The fastening might be on the chest or lower down at the waist. and it may be secured with one or two sets of *ghundi* and *tukuma*. On light muslin chogas, the meeting point of the front panels is often ornamented with mirroring *kairi*, or mango-shaped motif. The armhole is generally cut straight and rather deep with loose sleeves. A few samples have curved cut armholes. The gusset at the underarm is a common feature and it adds ease to an already loose outer garment. There were no suspended pockets on most of the samples that we saw.

Fine cotton chogas that have survived to these days are quite rare. The formal chogas embroidered with chikan are very elegant and display excellent workmanship, they are made with light fabrics, thin threadlike hand-stitched *turpai* and most amazing embroideries.

The catalogue of Costumes and Textiles in the Maharaja Sawai Man Singh II Museum in Jaipur lists four chogas from Lucknow, dated between 1830 to 1890. Their description mention interesting detail as conical trees on arms, back and daman, probably a stylized cypress, which unfortunately we could not see. They are dated 1870 and 1890 and it is specified that they were embroidered at Lucknow but tailored at Jaipur[40].

1 Diaphanous muslin choga
A separately embroidered border is attached onto the costume and further ornamented with a line of tiny leaves in katao. The hair-thin turpai seams are remarkable
Lucknow, late 19th or early 20th century, cotton muslin with cotton and silk embroidery
Olga Getto's Collection, Turin

2 Choga with an unusual fit
Unlike most chogas that are loose overcoats, this piece is body fitted. It is cut at the waistline and the lower skirt is flared, like an angarkha
Lucknow, late 19th or early 20th century, cotton muslin with cotton and silk embroidery
Olga Getto's Collection, Turin

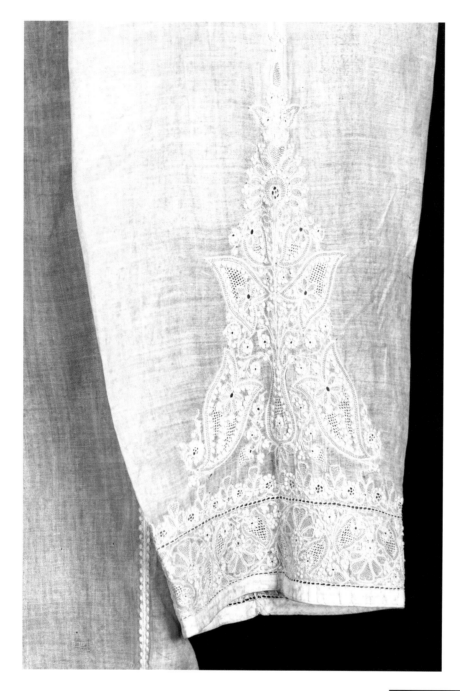

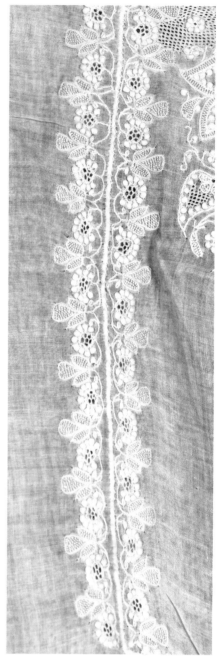

1 A classic choga
This elegant garment is very
well preserved and the quality
of the chikankari embroidery is
amazing. Classic in pattern, cut
and the placement of the motifs,
yet it shows unusual decorative
designs
Lucknow, late 19th or early 20th
century, cotton muslin with cotton
and silk embroidery
Crafts Museum New Delhi,
Acc. No. 64/3084

2 Close up of the composite
motif. The back of the choga is
worked mainly with small white
phanda and outlines of golden
silk, interspersed with jali and
open work
Lucknow, late 19th century early
20th century, cotton muslin with
cotton and silk embroidery
Crafts Museum, Delhi,
Acc. No. 64/3085

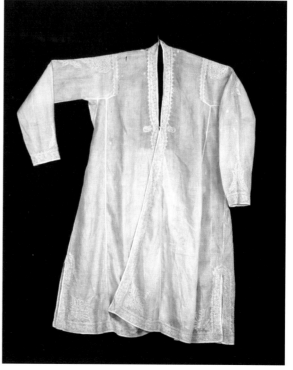

1

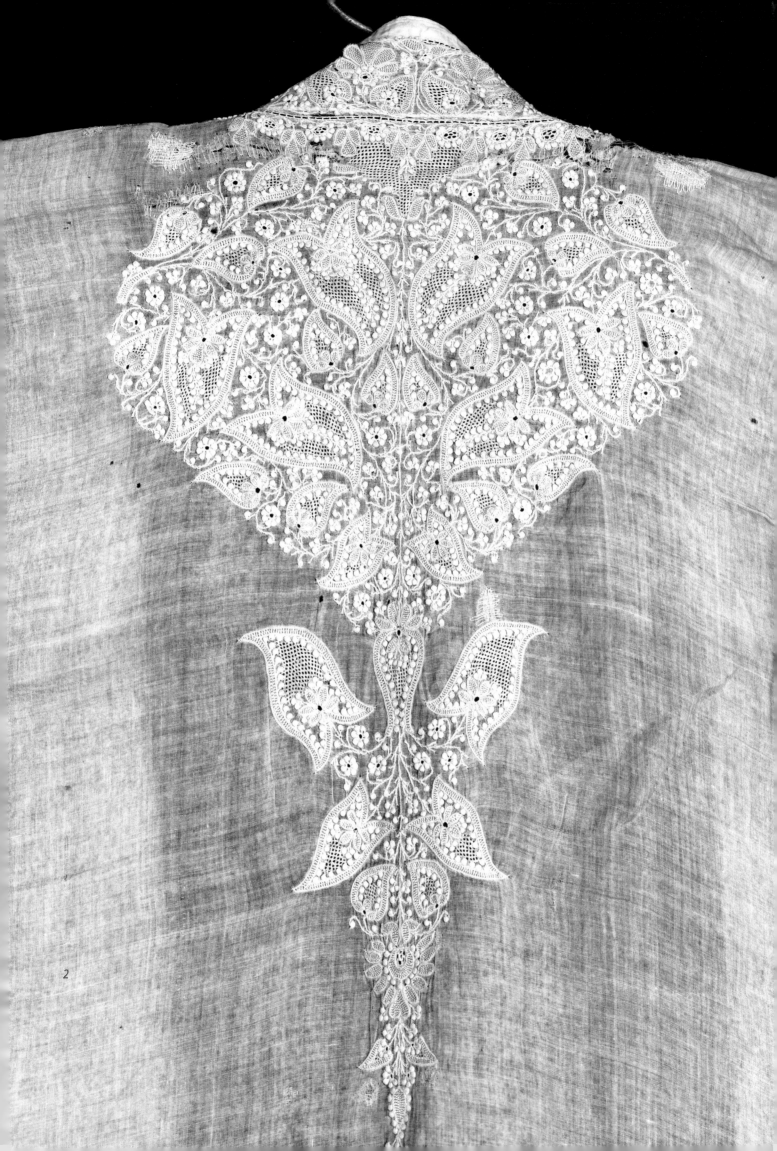

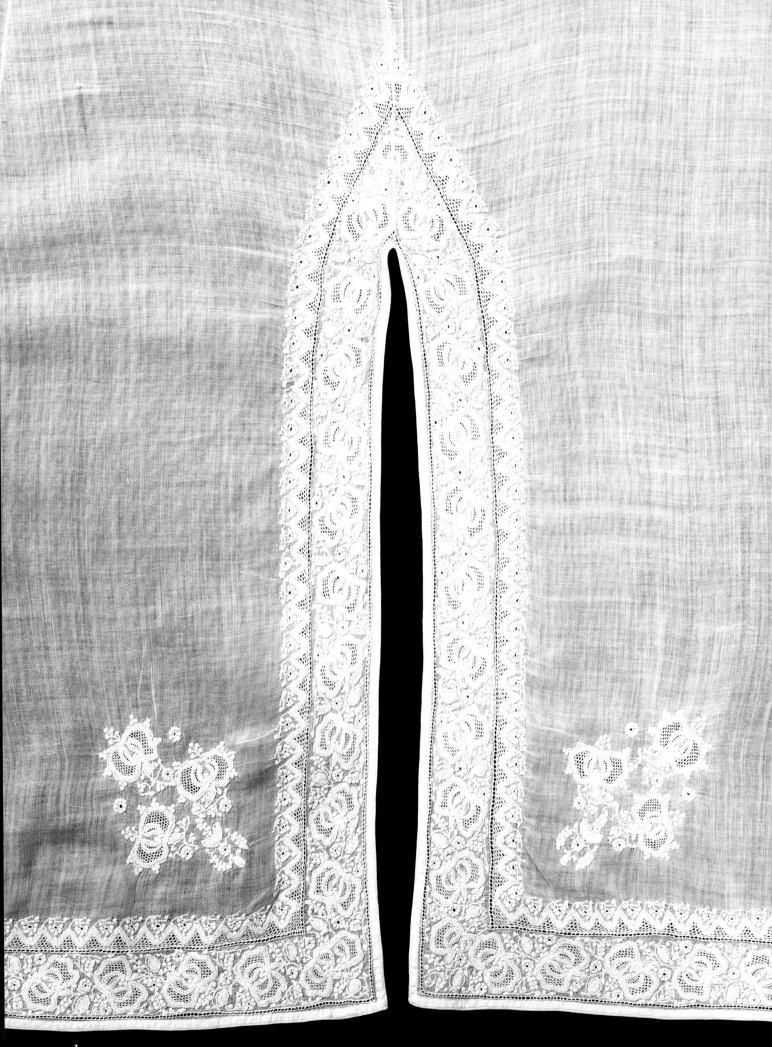

1

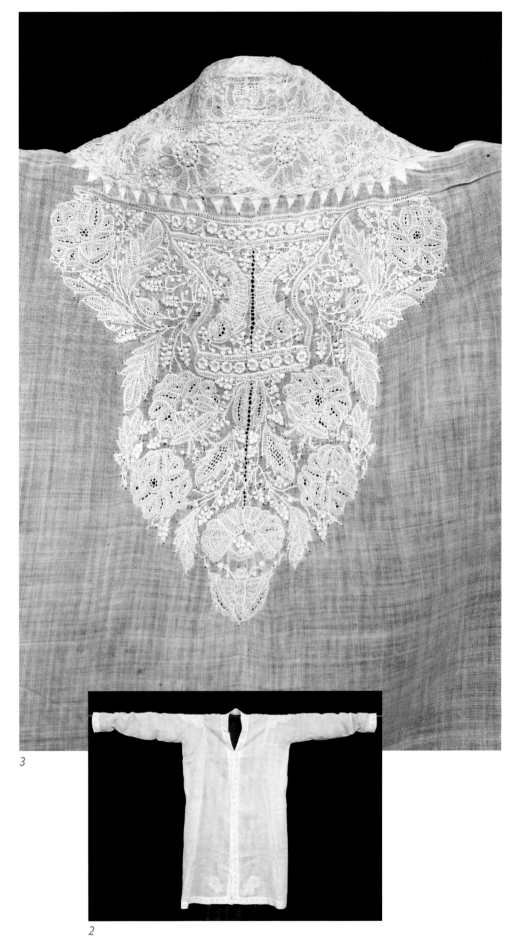

1 *Choga detail*
The corner flowers by the side slits match the design on the border. The jali or open work and the line of hathkati edging the border lighten an otherwise crowded composition
Lucknow, early 20th century, cotton muslin with cotton embroidery
Meenu and Romi Tholia Collection, Jaipur

2 *Straight cut choga*
It has a densely embroidered border

3 *Back design of choga*
The conventional triangular shape of the paan motif is composed by an inverted flower vase decorated with a pair of fish and a rich flower bouquet
Lucknow, early 20th century, cotton muslin with cotton embroidery
Rajasthan Fabrics and Arts Collection, Jaipur

3

2

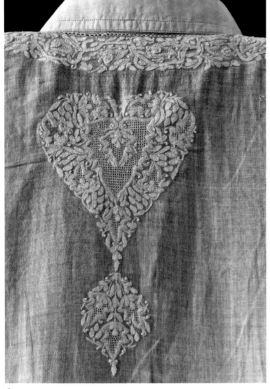

1

1 *Heart shaped paan leaf motif*
This motif on the back of the
choga is further embellished with
an hanging floral tassel
Lucknow, early 20th century,
cotton muslin with cotton
embroidery
Olga Getto's Collection, Turin

2 *Kurta with collar*
It is embellished with a bel or
creeper motif around the neck
and the front opening
Lucknow, early 20th century,
cotton muslin with cotton
embroidery
Olga Getto's Collection, Turin

3 *Embroidered cuff at the end of*
the gathered sleeves of the above
kurta
Lucknow, early 20th century
Cotton muslin with cotton
embroidery
Olga Getto's Collection, Turin

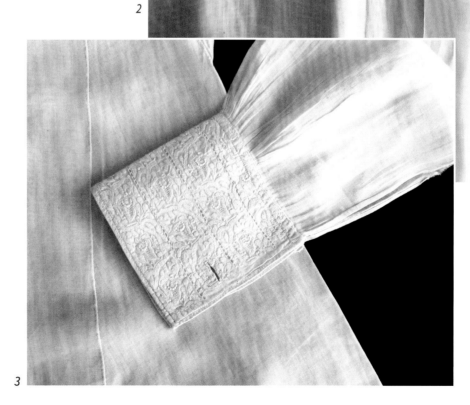

2

3

The kurta is a loose tunic, believed to have early origin as the word 'kurta' derives from the Sanskrit *'kurtak'* [41]. Its typical pattern of *kali* or panels (*kalidar* kurta) associates this garment to the traditional Central Asian costumes. According to some authors it is represented on ancient Buddhist sculptures, but others believe that it was actually introduced in India through Arab traders[42]. It was originally worn as an undergarment, but "turned into an article of great elegance worn in the Nawab circles of the 19th century Lucknow and attained simultaneously a measure of popularity in other centres like Delhi."[43]

An early mention of kurtis being embroidered in Lucknow is in the previously quoted Meer Hasan Ali's book written in the early 19th century: "I have known them to be employed in working the jaullie [netting] for courties [a part of the female dress], which, after six days' close application, at the utmost could not realize three shillings each"[44].

When the poets of Delhi and Lucknow weave in reference to dresses in their elegant Urdu verses, they speak of this emphasis on new fashions, and observant writers with a descriptive bent of mind like Abdul Halim Sharar and Khawaja Hasan Nizami document much that was happening in the field of fashions in these parts. By and large, the list of the costumes in favour at the Oudh court reads as not being much different from that popular at Delhi in the 18th century, but the changes in the cut gave them another look.

A new introduction was the kurta as a modified version of the old *nima* or *nimcha*. Made of fine material and with a great deal of embroidery work in whitework, it acquired a presence of its own. Likewise the topi, called dopalri, simply made but elegantly finished and sometime rakishly[45] worn, was made of very light material."[46]

The kurta is generally made up "of five different parts, known as : *asteen* or the sleeves, *daman* or the skirt, *kali* or the side pieces, *baghal* or the gussets under the armpits, and *gireban* or the collar.[47] However, this general basic pattern of the kurta is interpreted in endless ways. The front opening might vary in length and it can be in the centre or on the left or the right side of the neckline, on some other designs the front is closed and the openings are on the shoulders on both sides. The fastening at the front is secured with stitched buttons or more often with traditional removable kurta studs, while on the shoulders is the more common and traditional *ghundi-tukuma* style. The left or right opening follows the same principle as for *jama* or angarkha, on the right side for Muslims, on the left for Hindus.

The kurta might have a plain round neckline or a collar band. The armhole is generally cut straight with a gusset at the underarm on the *kali* kurtas , or it can be cut curved, particularly if the kurta has a collar band and no side panels. The sleeves are rather loose and quite long as they used to be worn delicately crimped with *entada* seeds.[48] The British influence affected also the style of the kurta, the shape of the collar changed and the sleeves were sometimes with gathered bottoms and cuffs. The length of the kurta could be anywhere between the hip and the knees. The side slits are also of various lengths with suspended pockets of different shapes and sizes, on one or on both sides. The hem might be more or less flared.The feminine version of the kurta follows the same basic structure and it is called kurti. It has many regional variations and the styles of the kurti have been more sensitive to the changing fashions.

1 *Kurta, ornamented side slit with*
border and corner motif or konia
Narrow sleeve end with matching
border
Lucknow, early 20th century,
cotton muslin with cotton and silk
embroidery.
Olga Getto's Collection, Turin

2 *Kurta*
Lucknow, early 20th century,
cotton muslin with cotton and silk
embroidery
Olga Getto's Collection, Turin

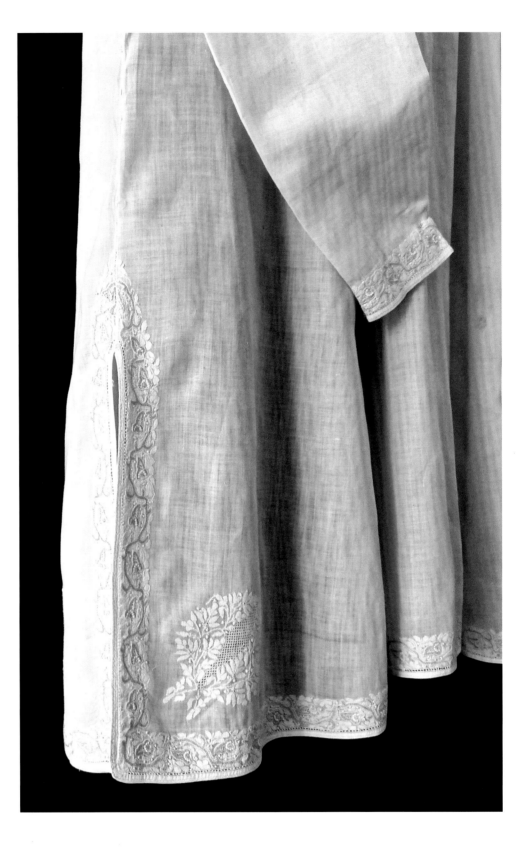

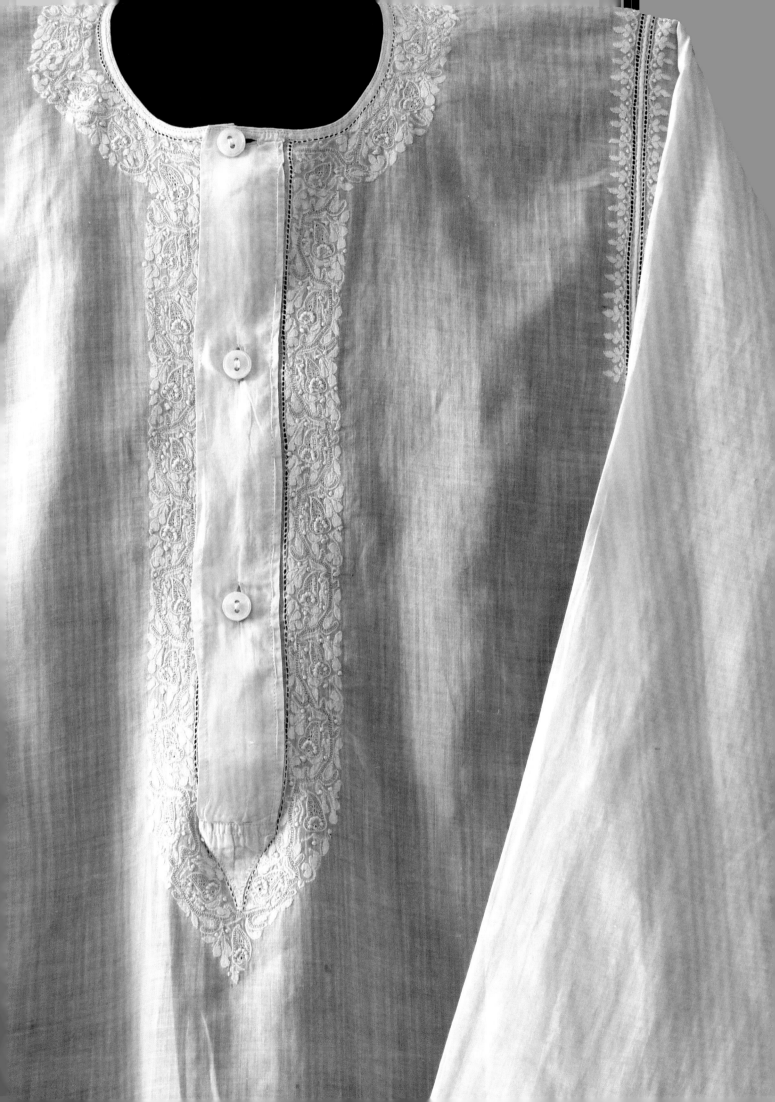

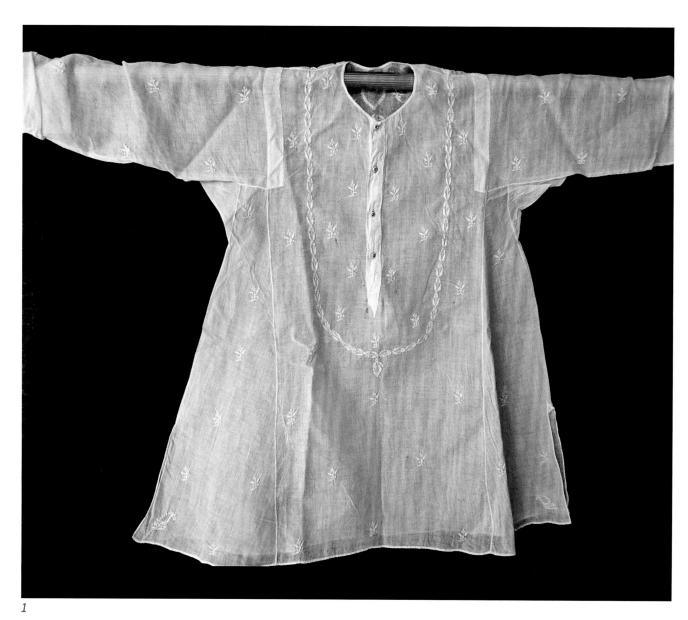

1

1 . A child's kurta
Lucknow, early 20th century,
cotton muslin with cotton
embroidery.
Rani and Raja of Oel's Collection,
Lucknow

2 Bangla kurta, side opening on
the front, dorukha chikankari
Lucknow, late 19th centuryor
early 20th century
Cotton muslin with cotton
embroidery.
Weavers Studio Resource Center
Archive, Kolkata

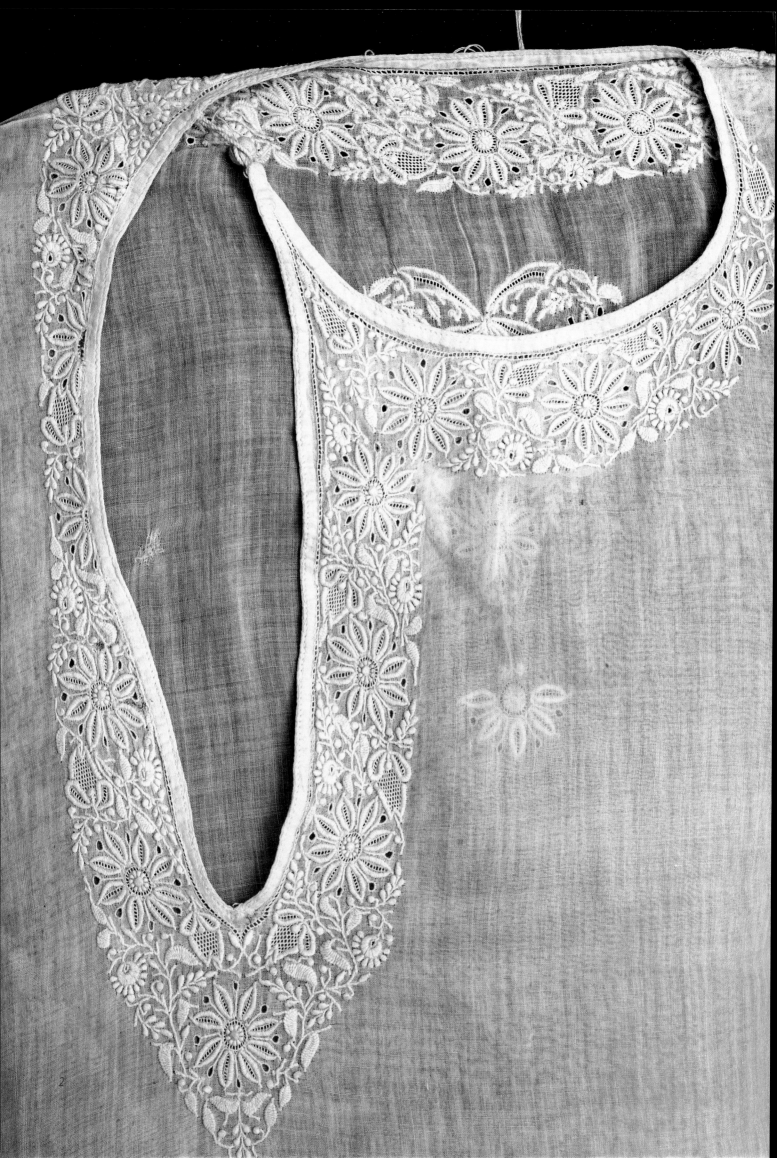

1 Kurta, front and back
Lucknow, early 20th century,
cotton muslin with cotton and silk
embroidery
Rajasthan Fabrics and Arts
Collection, Jaipur

2 Kurta with shoulder openings
and ghundi and tukuma fastening
Lucknow, late 19th or early 20th
century, cotton muslin with cotton
and silk embroidery
Rajasthan Fabrics and Arts
Collection, Jaipur

3 Paan leaf motif at kurta back
with embroidered hangings
Lucknow, late 19th or early 20th
century, cotton muslin with cotton
and silk embroidery
Rajasthan Fabrics and Arts
Collection, Jaipur

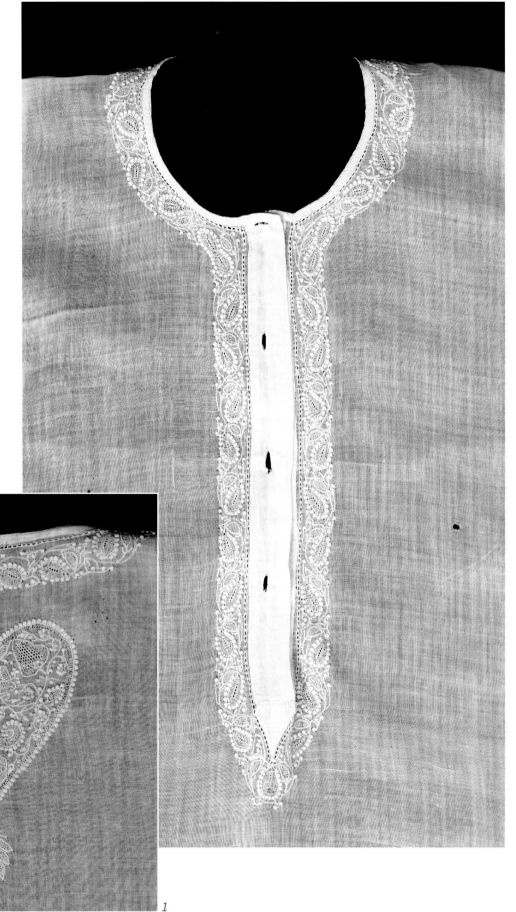

1

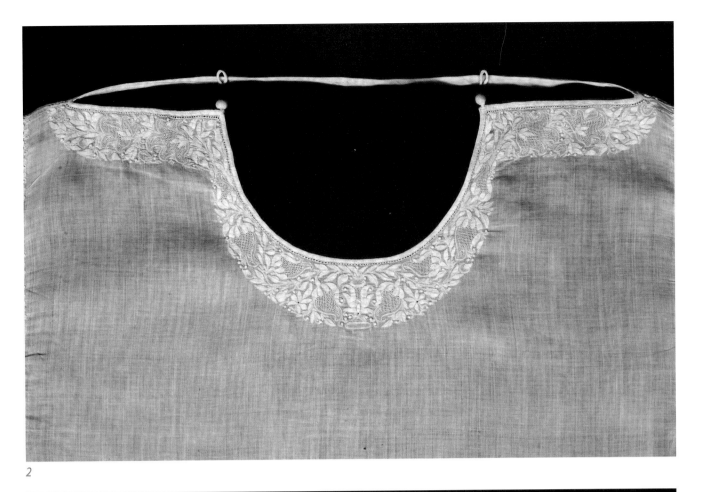

2

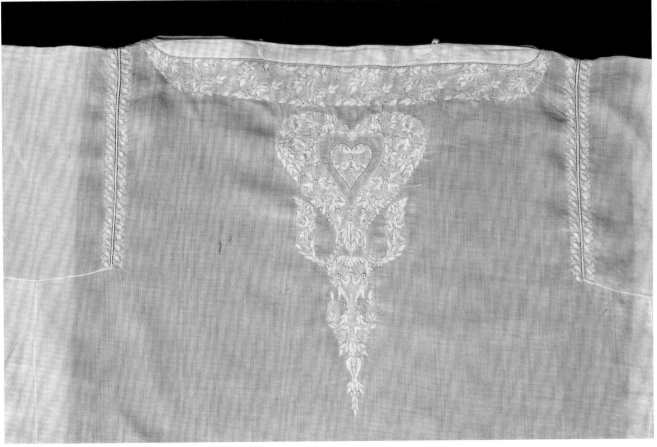

3

1 Sheer kurta with minuscule kataо

The typical delicate ripples can be seen on the sleeve
Lucknow, late 19th century, cotton muslin with cotton embroidery and appliqué work
Silver & Art Palace Textiles Collection, Jaipur

2 Kurta with rose motif
A small watch pocket with vertical opening
Lucknow, 19th century, cotton muslin with cotton and silk embroidery
Siddharth and Sangeeta Dudhoria's Collection, Kolkata

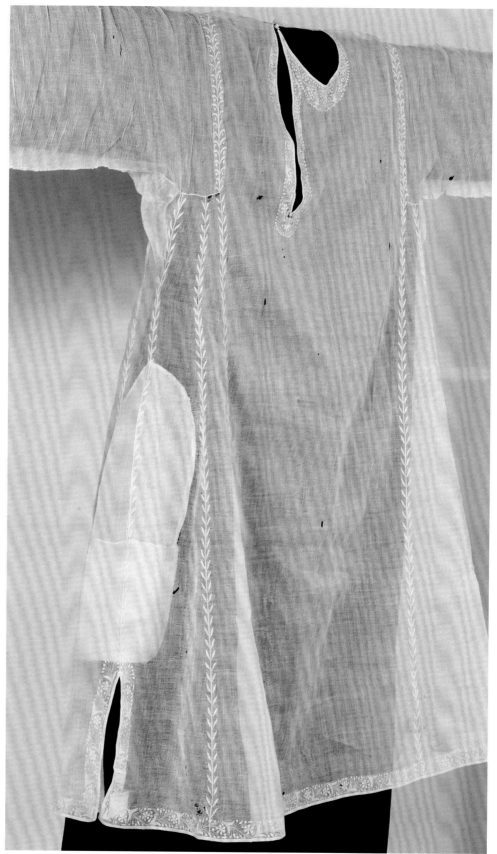

1

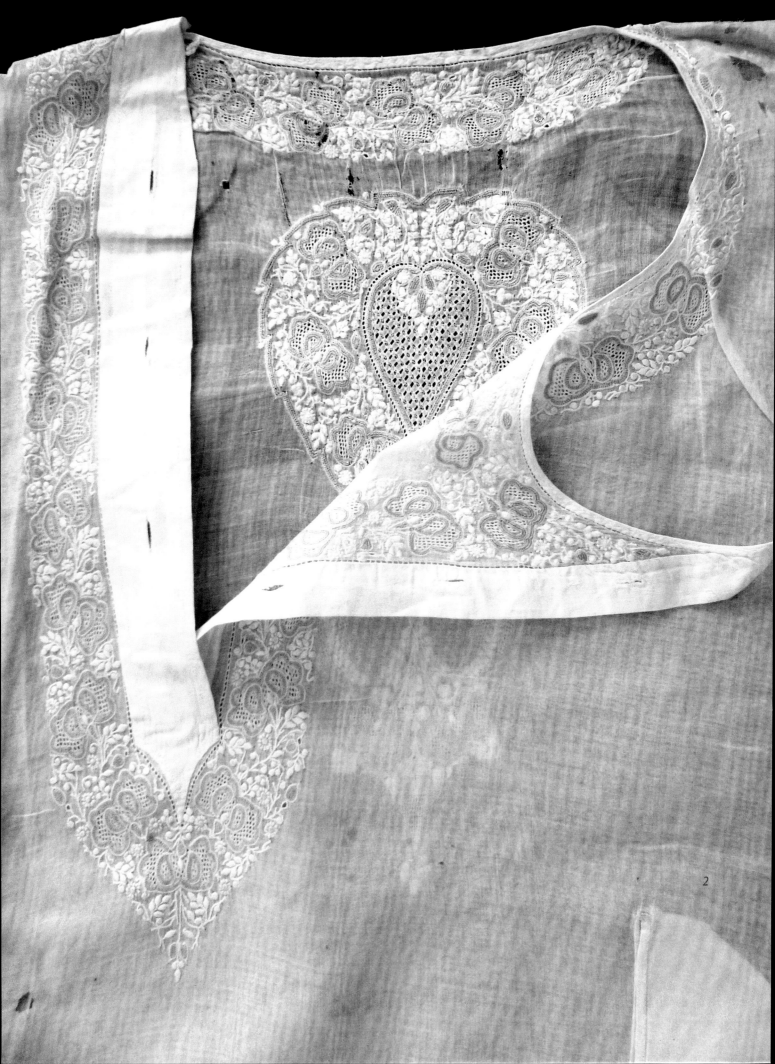

2

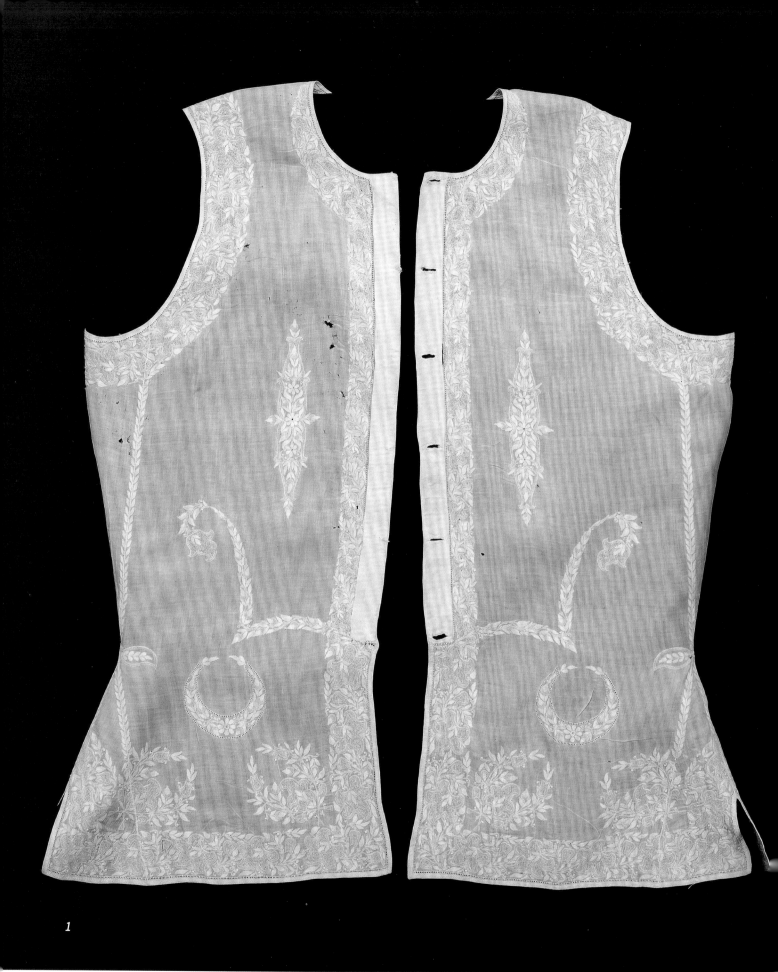

1

1 Shaluka or waistcoat
 An exceptional piece, remarkable
for the design and quality of
chikankari
Lucknow, late 19th century,
cotton muslin with cotton and silk
embroidery
Rajasthan Fabrics and Arts
Collection, Jaipur

2 Gentleman wearing a sleeveless
embroidered jacket, possibly in
velvet and zardozi. It shows a
similar design composition as
above shaluka
Rajasthan Fabrics and Arts
Collection, Jaipur

" *Towards of the end of the Nawabi rule a shaluka, a short-sleeved , tight blouse was worn (by women). This was worn over the ungia in place of the kurta and eventually did away with the necessity for the ungia. But this dress proved inadequate as it was made of very fine material and especially as the arms were left bare: it was eventually replaced by a loose kurta. However, all these garments have one by one been superseded by british-style jackets and blouses.*" [49]

From various references, is not clear if the shaluka was a costume for ladies, for men or for both, maybe with minor variations.

"In Lucknow a shaluka a waistcoat up to the neck , was worn in place of the bodice, with button in front. Buttons had just been introduced to India from Europe. Special styles were displayed in these waistcoats: People of taste wore tight waistcoats of muslins with embroidered patterns: Some people wore coloured waistcoats and the embroidery brought out the fine delicacy of the cloth"[50].

The placement of the embroidery designs on the sleeveless vest shown here follows the pattern of the ornamentations on *sadri* jackets embroidered with *zardozi* in fashion at Muslim courts. It was suggested that this design "may have had some religious significance"[51] especially the crescent moon-shaped "pockets" at the waist and the two vertical ornamental motifs, which on this sample are not real pockets but only embroidered motifs. But normally on the sadri jackets made with heavier fabrics they are actual pockets.

The catalogue of Costumes and Textiles in the Maharaja Sawai Man Singh II Museum in Jaipur lists a coat made of cotton with white embroidery with kalabattu on edges, white cotton lining has diagonal stripes embroidered with white cotton. A paper label stitched with the coat reads: "Coat one. V.S. 1930 (A.D. 1873) fourth day of the dark half of month Jyeshtha, purchased from Shivanarain, a dealer from Delhi: price 20 /- (a coat with) small leaves of tanjeb, white, with lining (which is) embroidered in chikan style – diagonal stripes, has sinjaf and magaji of white nainsukh, (coat) embroidered with golden Kalabattu – bel and turanj. L.79 cm. Acc. No. Tc/F-2"[52]

2

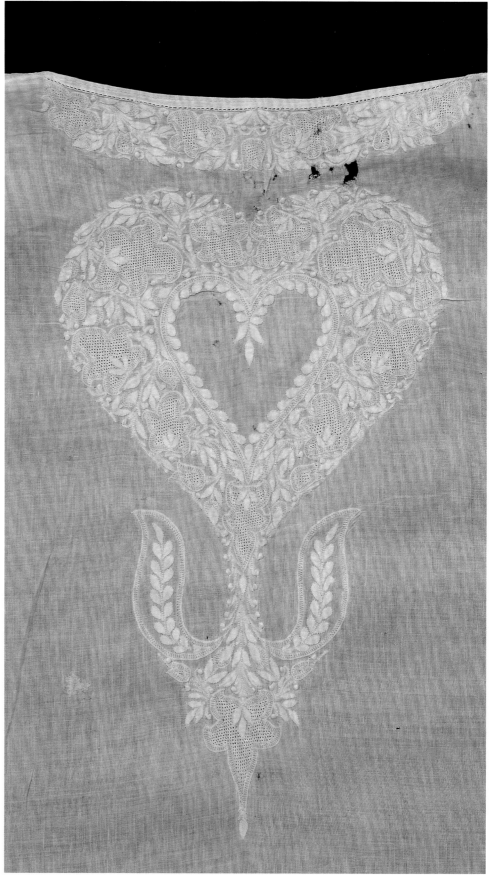

3

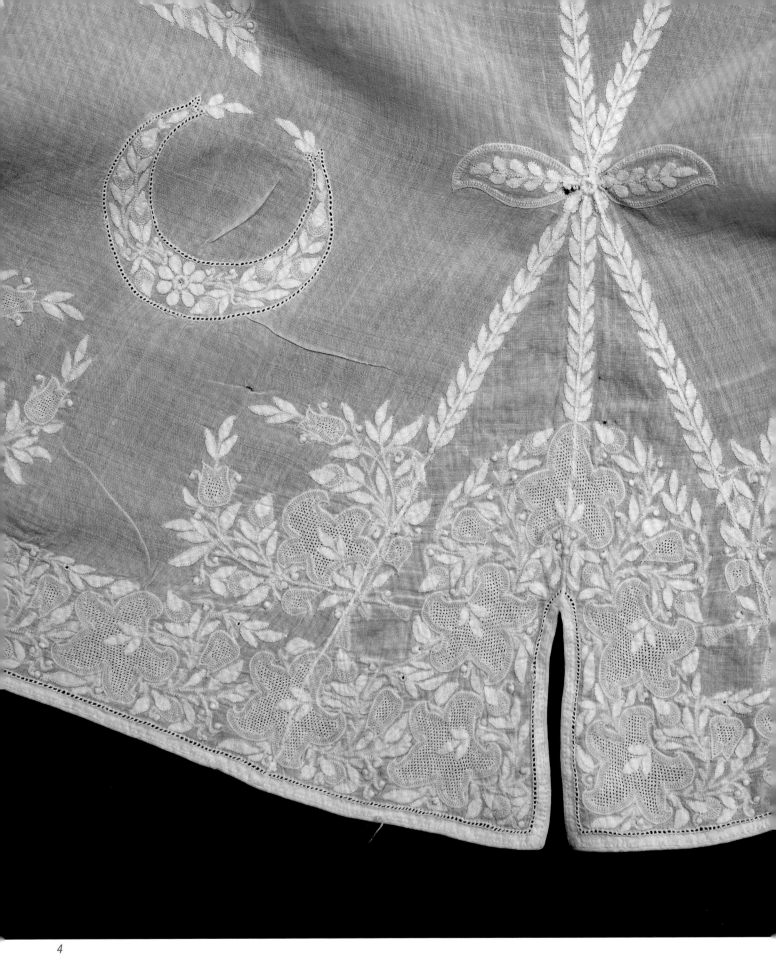

4

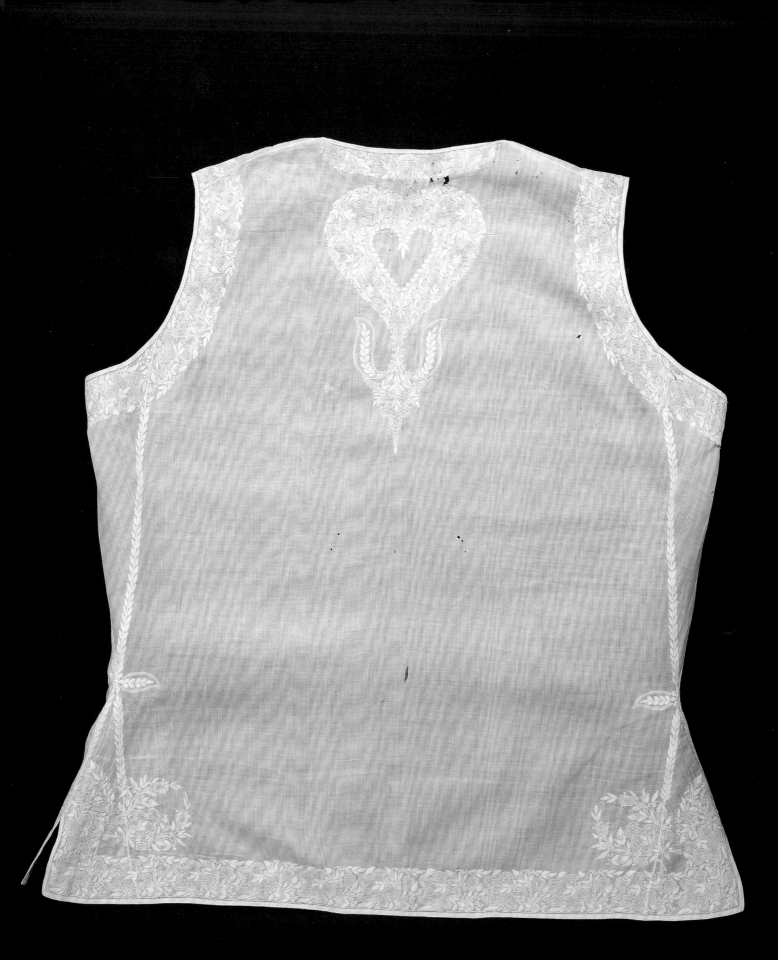

1

2

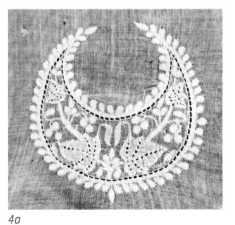

3

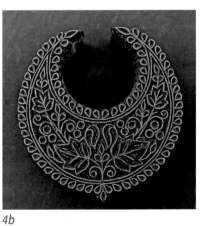

4a

4b

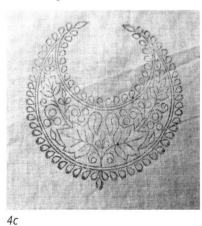

4c

1 Back of shaluka
(see previous pages 138–142)

2 Shaluka ornamented with very
fine katao or appliqué work
Lucknow, late 19th century, cotton
with cotton fabric embroidery
Musée National des Arts
Asiatiques, Paris

3 Alam, processional metal
standard finial with the crescent
motif
Nawab Mir Jafar Abdullah's
Collection, Lucknow

4 a–c Crescent motif
The embroidered piece, the
wooden block, and an impression
of the block
Kedar Nath Ram Nath
Lucknow, 19th century and 21st
century, cotton muslin, wood, and
cotton fabric

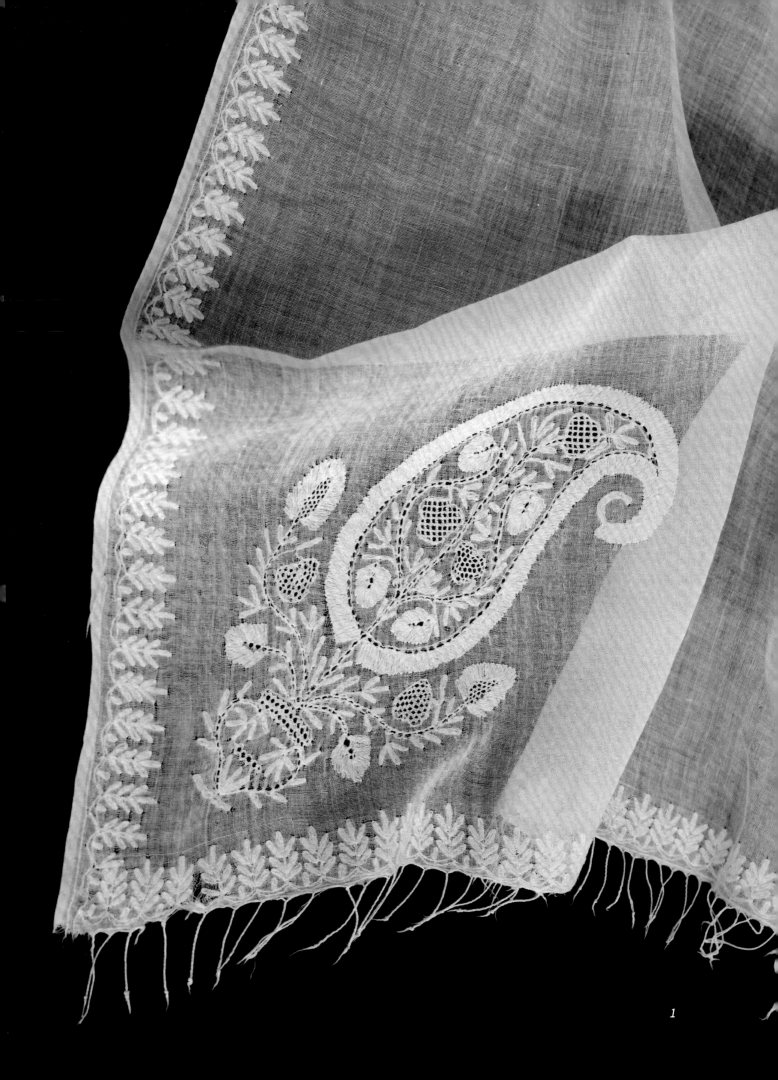

The contemporary literature with references to feminine apparel during 19th–early 20th centuries in Lucknow is rather scarce. The visual documents portraying ladies consist of very few paintings, some of which are by foreign artists working in India, and a few photographs of courtesans .

Fanny Parks was an Englishwoman who lived in India early in the 19th century and left detailed accounts of her life and travels in the country. On the way to attend a wedding in Khusgunge in 1835, she was invited to visit James Gardner's estate in Kutchowra and to meet his wife ,the Mughal Princess Mulka Begam, niece of the Emperor Akbar Shah II and sister-in-law of the king of Oudh. She was thrilled to have such chance as "I know of no European lady but myself, with the exception of one, who has ever had an opportunity of becoming intimate with native ladies of rank, and as she also had an invitation to the wedding, we agree to go together." Like most foreign travellers received at Indian courts, Fanny was overcome by the splendour of the lady's jewellery describing it in much greater details than her clothes. However, she noted that:

> "Mulka's dress was extremely elegant, the most becoming attire imaginable…A Musulmani wears only four garments :
> Firstly the angiya: a boddice which fits tight to the bosom and has short sleeves, it is made of silk gauze profusely ornamented.
> Secondly the kurti: a sort of loose body without sleeves, which comes down to the hips, it is made of net, crepe, or gauze and highly ornamented.
> Thirdly pajama: of gold or crimson brocade or richly figured silk, made tight at the waist, but gradually expanding untill they reach the feet, much after the fashion of a fan, where they measure eight yards eight inches. A gold border finishes the trousers.
> Fourthly the dopatta: which is the most graceful and purely feminine attire in the world. It is of white transparent gauze, embroidered with gold and trimmed with gold at the ends which have also a deep fringe of gold and silver.
> The dopatta is so transparent it hides not; it merely veils the form, adding beauty to the beautiful, by its soft and cloud-like folds.
> The jewellery sparkles beneath it ; and the outline of its drapery is continually changing according to the movements or coquettry of the wearer. Such was the attire of the princess!"

From the visual documents it appears that gossamer white cotton muslins and silk gauzes were the favourite choices. The painting titled 'Noblewomen playing chess' in late 18th century Lucknow (see also page 18) captures aspects of the life in the zenana or ladies' quarters. White cotton muslins of softly draped costumes and *odhnis* dominate the scene; the higher the rank of the wearer the more translucent and diaphanous appears the veil.

In our quest for antique and fine chikan embroidery, we have not found any pieces of ladies apparel such as as angiya or kurti, and particularly pieces which could be considered contemporary to the male attires. Most of the pieces shown here seem to be of more recent origin.

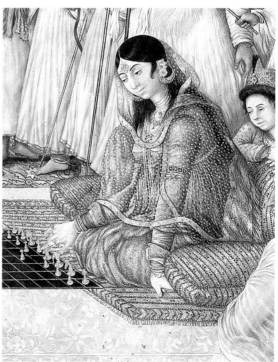

2

1 Dupatta embroidered with tepchi stitch and jali work
Lucknow 19th century, cotton muslin with cotton embroidery
Rajasthan Fabrics and Arts Collection, Jaipur

2 Detail, 'Noblewomen playing Chess' zenana at the Oudh court
Attributed to Nevasi Lal, Lucknow, c. 1790–1800, opaque watercolor and gold on paper, 47 x 62 cm, Musée National des Arts Asiatiques, Paris,
Acc. No. MA12112

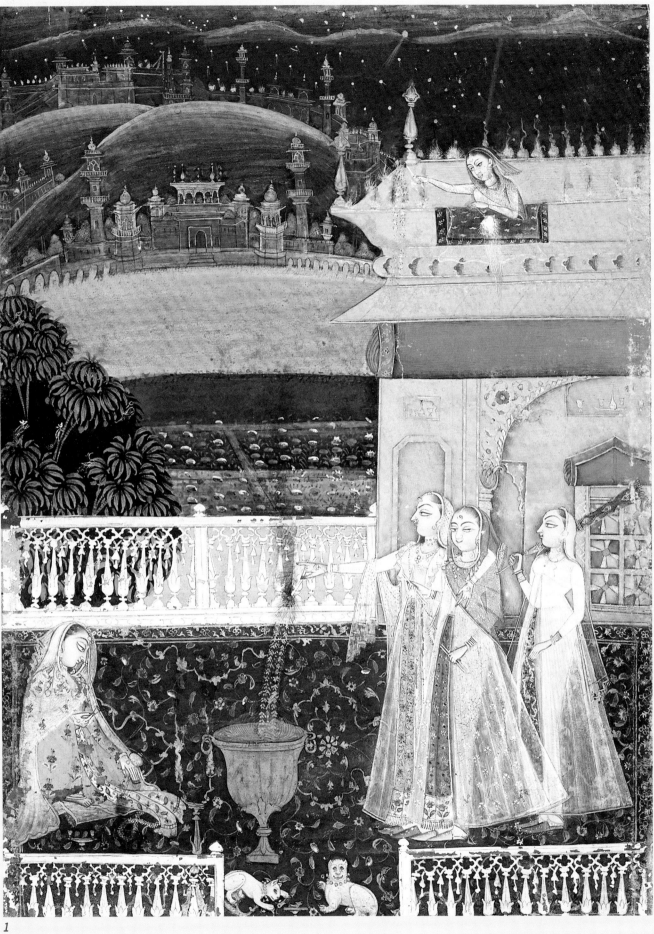

1

2

3

1 Shab-barat: Ladies with
Fireworks on a Terrace
By Mola Bagas, Bikaner, late
18th century, opaque pigments
heightened with gold on paper,
19.6 x 12.4 cm (Folio: 24.1 x 16.2 cm)
Photo courtesy Francesca
Galloway Gallery, London

2 The back of a long-sleeved
blouse piece
Lucknow, early-mid 20th century,
cotton with cotton embroidery
Crafts Museum Delhi,
Acc. No. 74/5338

3 Blouse piece
Lucknow, early-mid 20th century,
cotton with cotton embroidery
Crafts Museum Delhi,
Acc. No. 74/5339

149

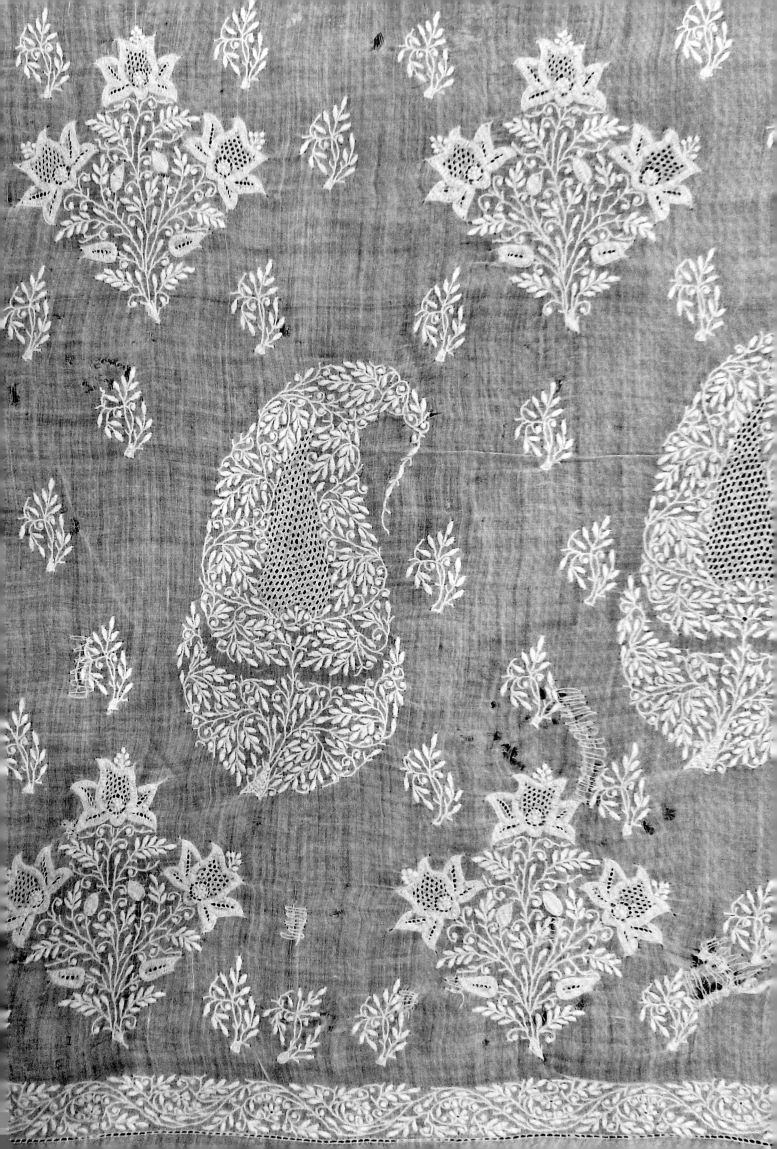

2

3

1 *Sari pallu*
Lucknow, late 19th or early 20th century, cotton with cotton embroidery
Weavers Studio Resource Center Archive, Kolkata

2 *Old block impression on paper for chikankari embroidery*
Lucknow, late 19th or early 20th century, album of old drawings and designs for chikankari embroidery
Private Collection

3 *Sari pallu*
A contemporary high quality chikankari ornamented with old keiri design. It is quite usual that old blocks are replicated when damaged, thus some motifs have survived into the present times. By the artisans from Bhairvi's Chikan, silk chiffon with cotton embroidery, Lucknow, 21st century
Bhairvi's Chikan Collection, Lucknow

1 *Detail of a fabric piece-good*
Lucknow, late 19th century or
early 20th century, cotton muslin
with cotton embroidery
Rajasthan Fabrics and Arts
Collection, Jaipur

2 *Samples of block impressions*
for chikankari
Lucknow, 2014
Kedar Nath Ram Nath, Lucknow

3 *Dupatta, border and corner*
flower motif
Lucknow, 20th century, cotton
muslin with cotton embroidery
Rajasthan Fabrics and Arts
Collection, Jaipur

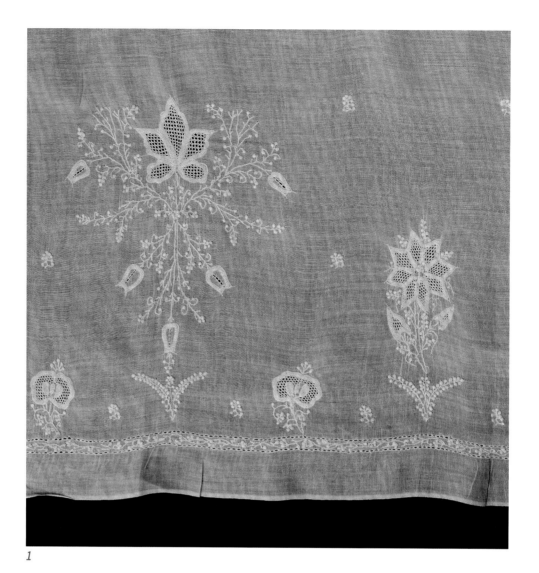

1

2

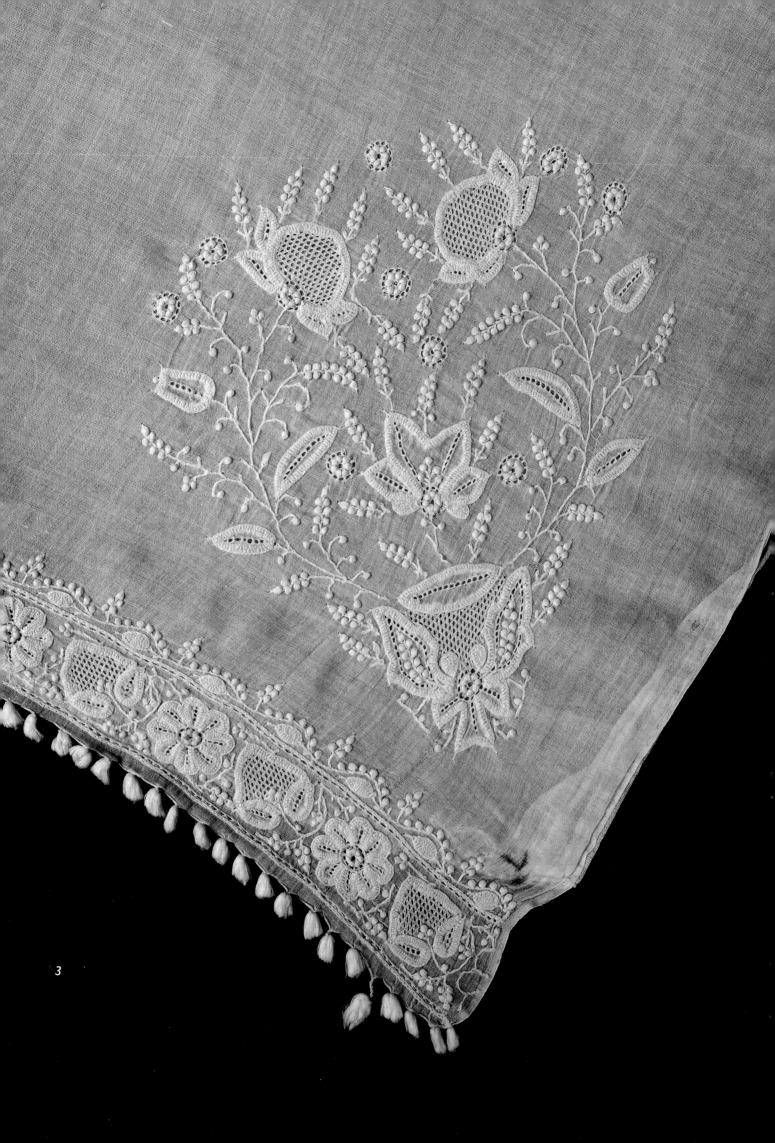

3

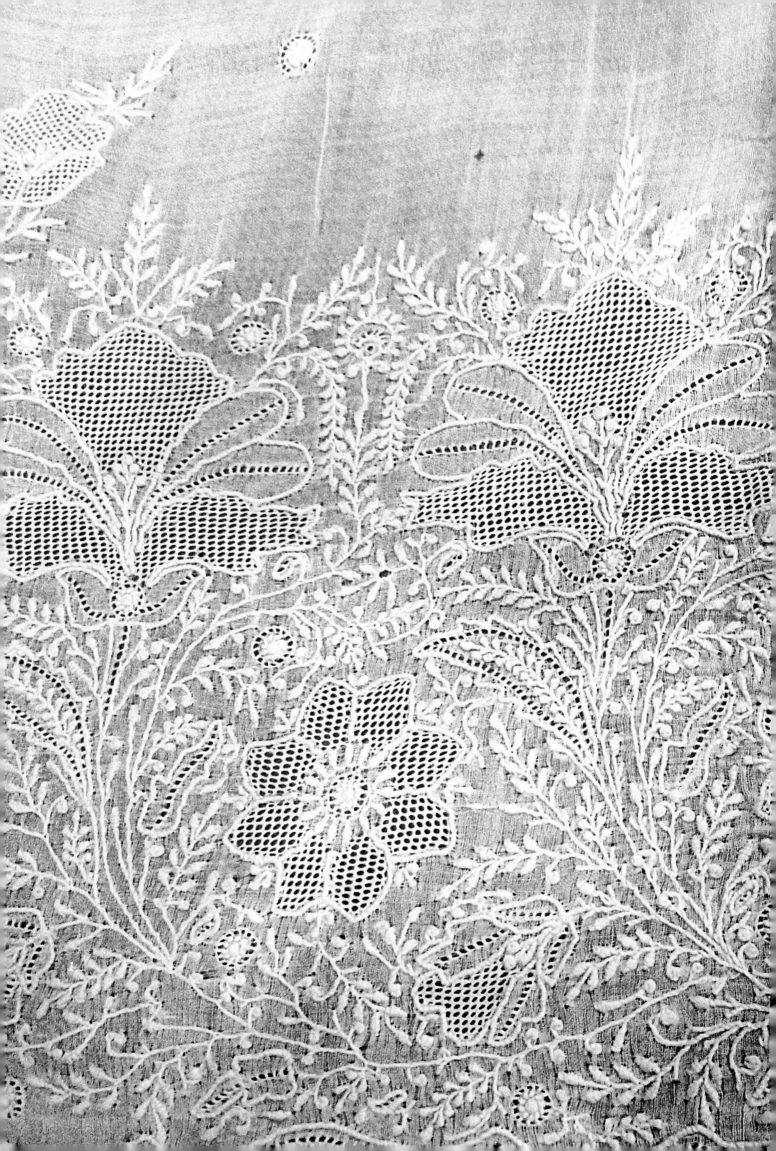

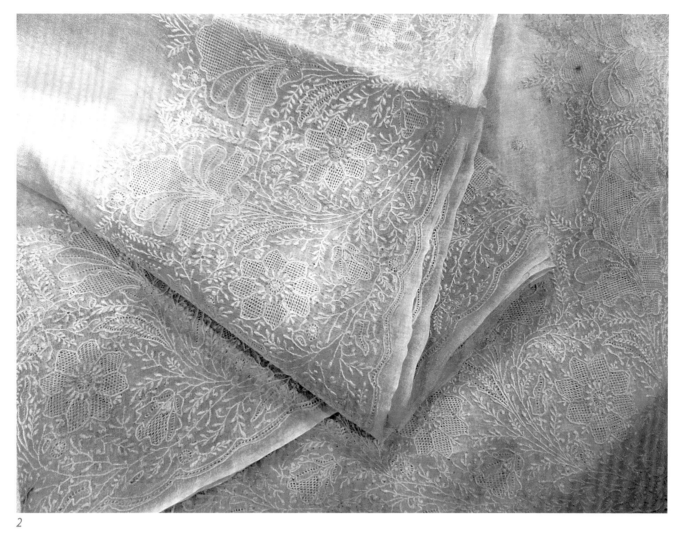

2

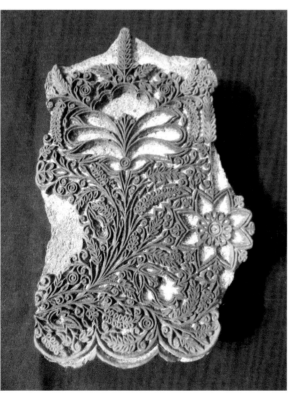

3

1 (facing page) Detail of sari
borders
*Lucknow, early-mid 20th century,
cotton muslin with cotton
embroidery
Chhangamal Chikans, Lucknow*

2 Sari
*Lucknow, early-mid 20th century,
cotton muslin with cotton
embroidery
Chhangamal Chikans, Lucknow*

3 Old wooden block
*Lucknow, early-mid 20th century
Kedar Nath Ram Nath, Lucknow*

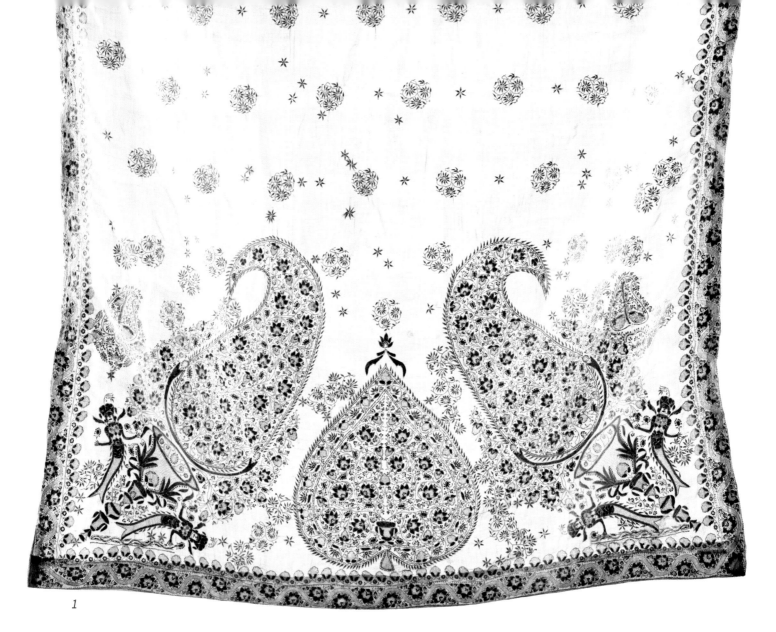

1

1 Sari
The corners' motifs display two
mermaids holding a vase with a
flowering keiri. The mermaids were
part of the royal emblem of the last
nawab of Awadh, Wajid Ali Shah
Lucknow, 19th century, cotton
with cotton and silk embroidery
and pulled-thread work , 452.12 x
104.14 cm
Los Angeles County Museum of Art,
Acc. No. M.83.105.27
From the Nasli and Alice
Heeramaneck Collection

2 Detail of the same piece with a
typical chikankari paan leaf motif,
filled with the flowering vase icon
Lucknow, 19th century
cotton with cotton and silk
embroidery and pulled-thread
work
Los Angeles County Museum of
Art, Acc. No. M.83.105.27
From the Nasli and Alice
Heeramaneck Collection

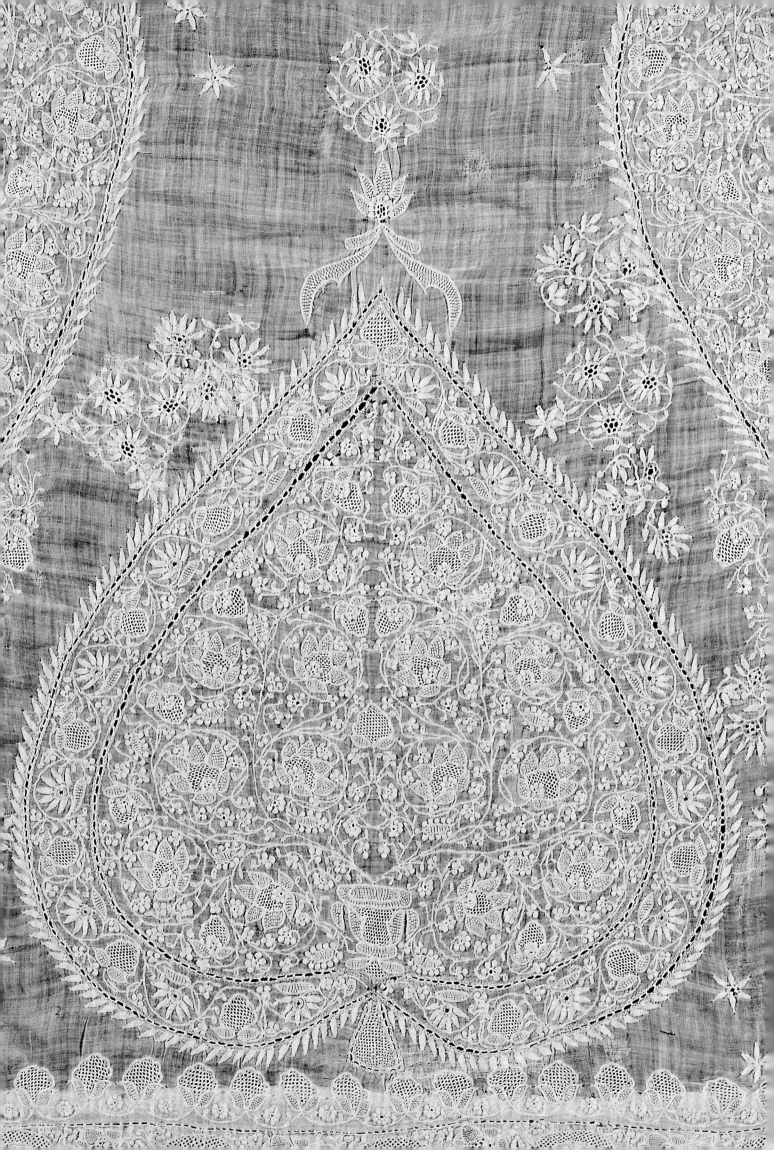

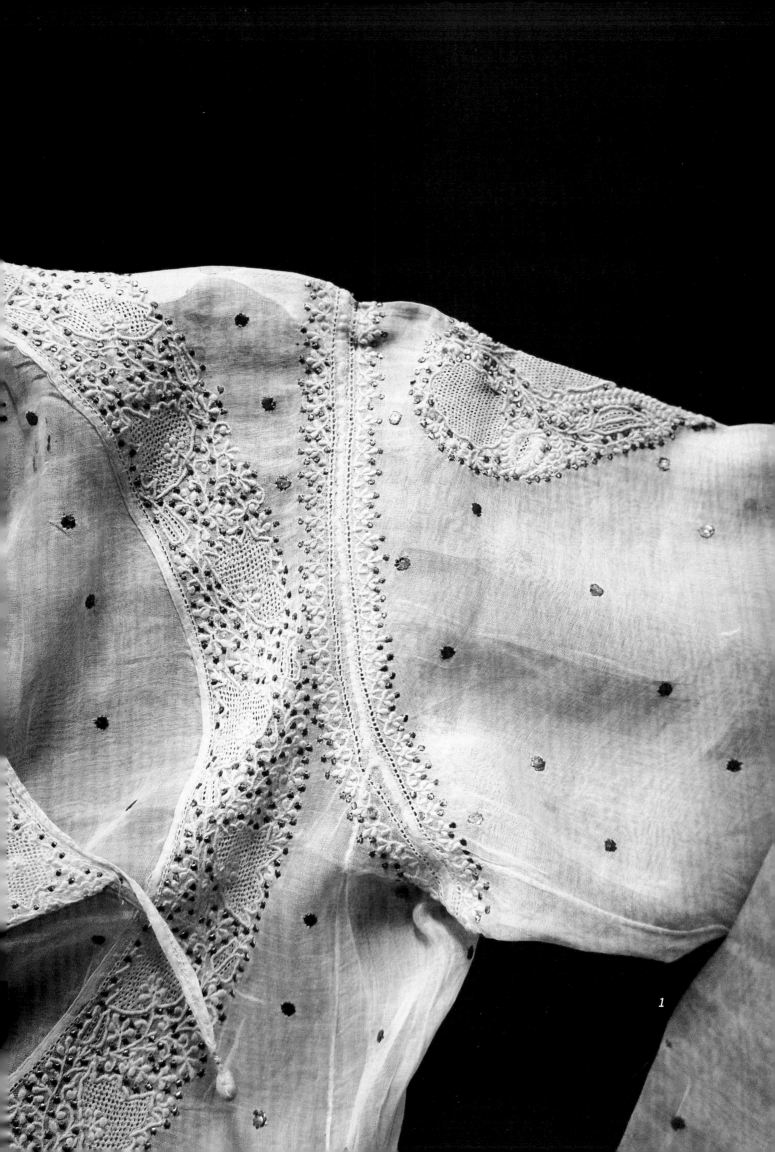

1

Chikankari is unique not just for the embroidery, but also for the detail in the dressmaking. Embroidery was essential but not just by itself; it is enhanced altogether to another level only when combined with the other structural elements of chikankari dressmaking developed by the old masters.

Shoulder seams, armholes seams and gussets

The sophisticated syntax of chikankari dressmaking is best expressed in the creative and artistic ways in which shoulders, armholes, sleeves and gussets are sewn, and the seams themselves become part of the ornamentation. Playing with the translucence of the cloth, the tailor and the embroiderer combined their virtuosity to achieve incomparable and delicate effects, utterly wonderful in their exquisite understated minuteness.

1 Short top/blouse
Lucknow, late 19th century or
early 20th century, silk with cotton
thread and silver wire (badla)
Crafts Museum Delhi,
Acc. No. 7/5212

2 Shoulder seam designed as a
stylized cypress tree
Lucknow, late 19th century or
early 20th century, silk with cotton
thread and silver wire (badla)
Crafts Museum Delhi,
Acc. No. 7/5213

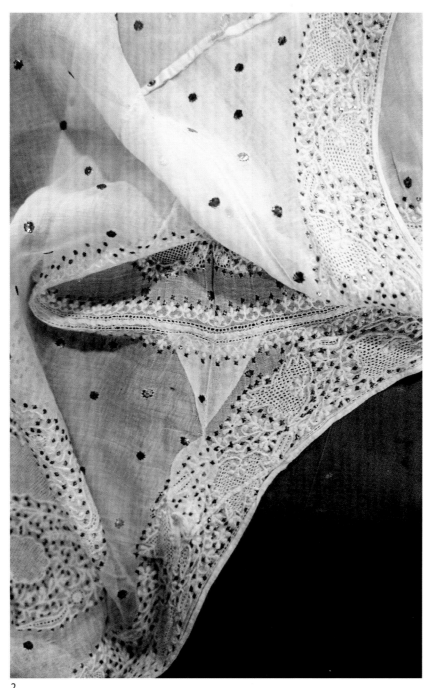

2

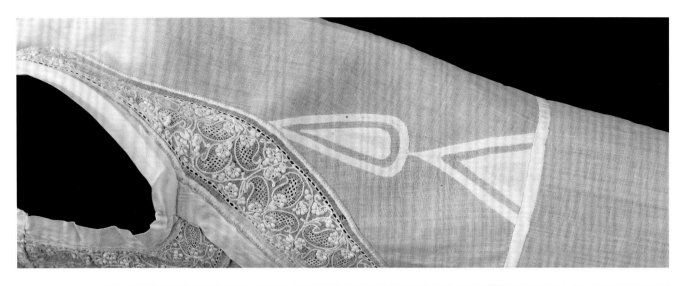

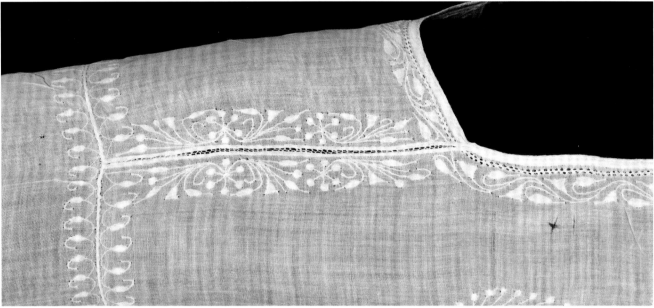

Shoulder seam in the shape of
stylized cypress tree
Lucknow, late 19th century or
early 20th century.
Rajasthan Fabrics and Arts
Collection, Jaipur

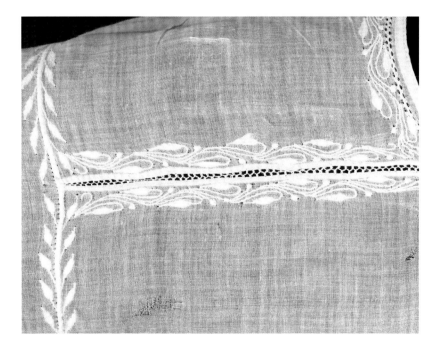

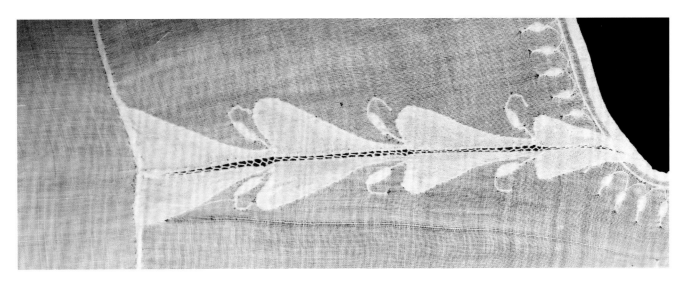

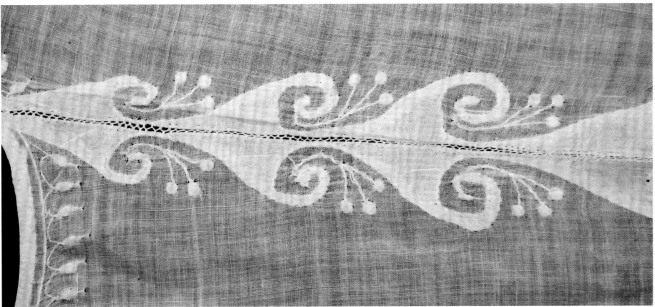

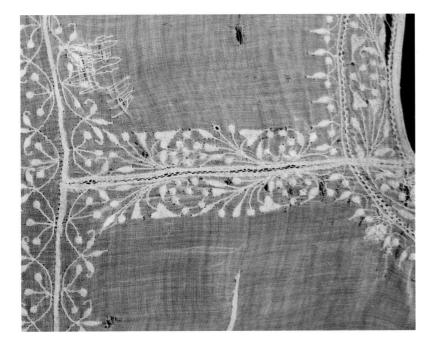

Ornamented shoulder seam joined with
twisted fagotting stitch
*Lucknow, late 19th or early 20th century, cotton
muslin*
*Rajasthan Fabrics and Arts Collection, Jaipur
and Munnu's Kasliwal Collection, Gem Palace,
Jaipur*

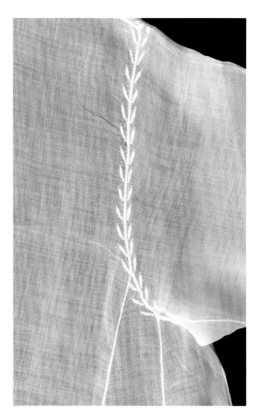

*Various types of
ornamented armhole
seams
Lucknow, late 19th or early
20th century, cotton
Various sources*

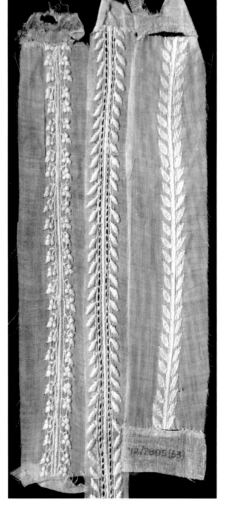
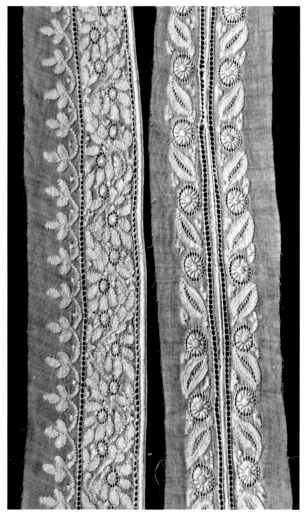

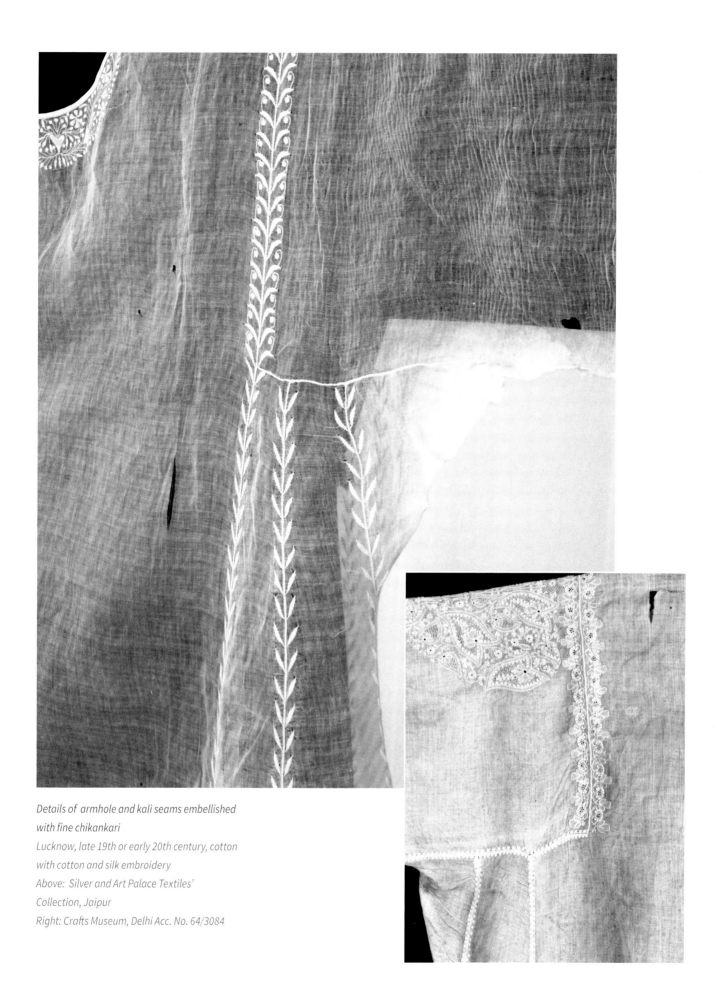

*Details of armhole and kali seams embellished
with fine chikankari*
*Lucknow, late 19th or early 20th century, cotton
with cotton and silk embroidery*
*Above: Silver and Art Palace Textiles'
Collection, Jaipur*
Right: Crafts Museum, Delhi Acc. No. 64/3084

163

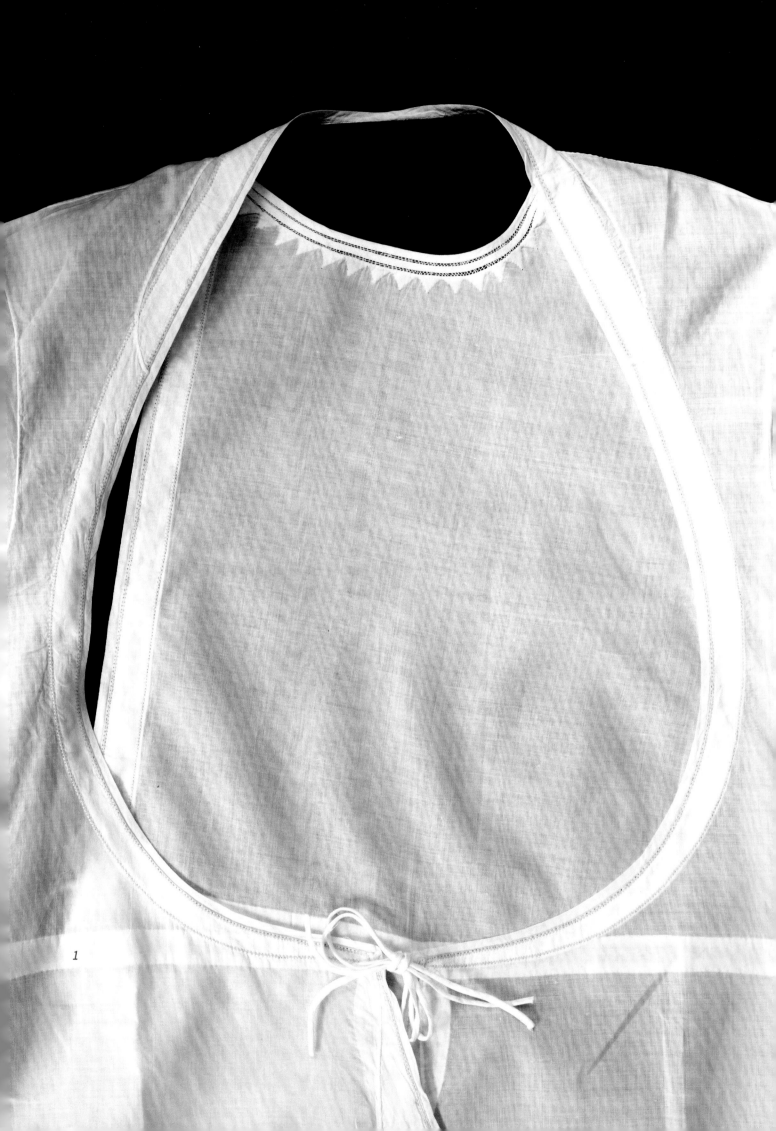

1

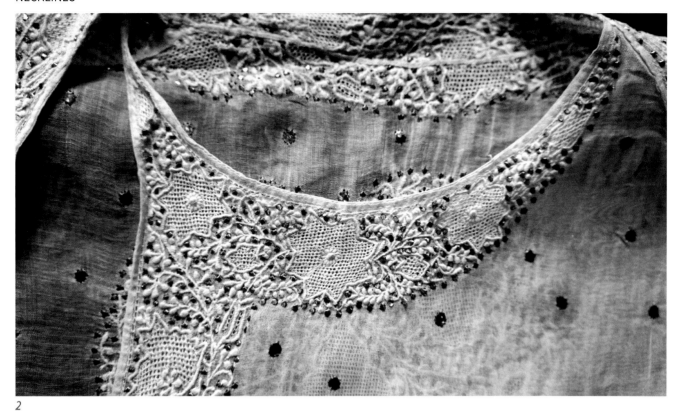

2

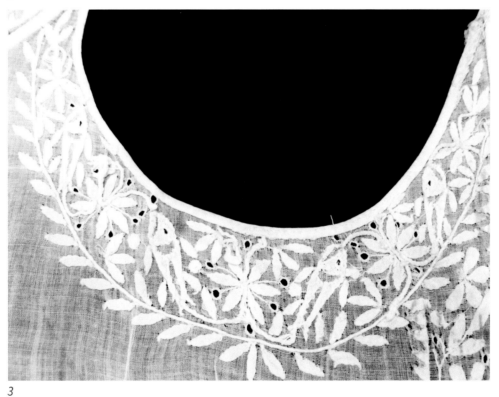

3

1 Angarkha neckline
Two pipings sewn with twisted
fagotting stitch and a dentellate
motif called jawa, and inserted
dori along the magaji piping
Lucknow, late 19th or early 20th
century, cotton
Rajasthan Fabrics and Arts
Collection, Jaipur

2 Ornamented angrakha neckline
Dense chikankari brightened with
tiny silver dots or fardi buti
Lucknow, late 19th or early 20th
century, silk with cotton thread
badla embroidery
Crafts Museum Delhi,
Acc. No. 7/5212

3 Angrakha neckline
Appliqué fish and flowers
North India, late 19th or early
20th century, cotton muslin with
cotton embroidery
Rajasthan Fabrics and Arts
Collection, Jaipur

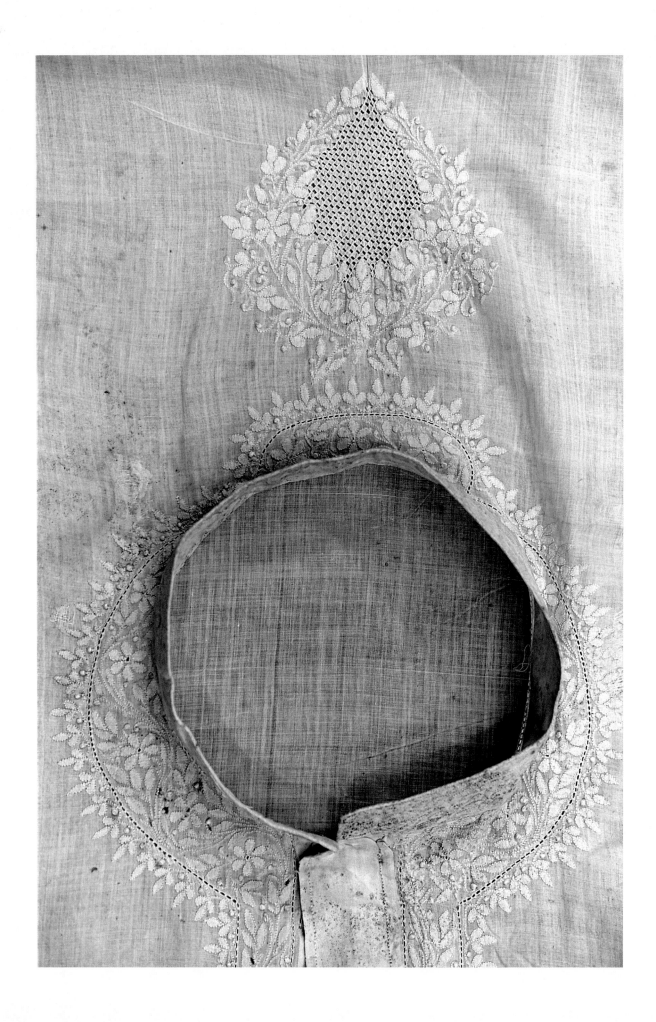

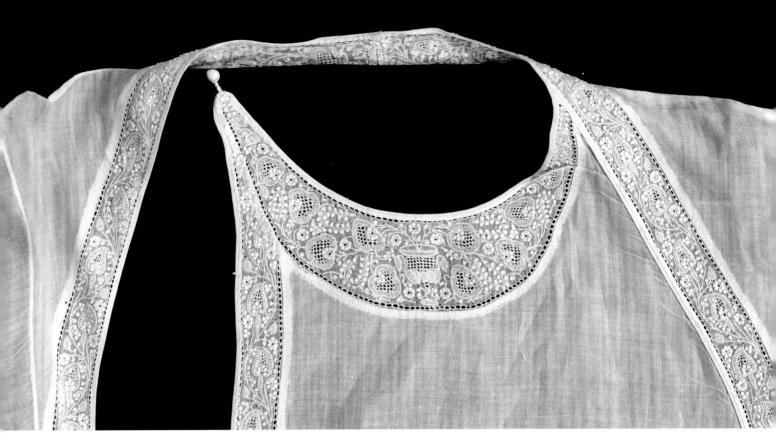

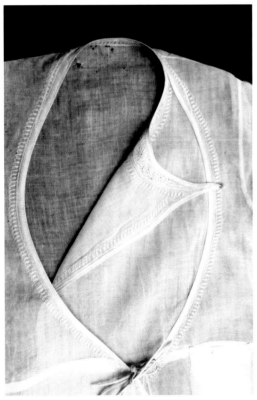

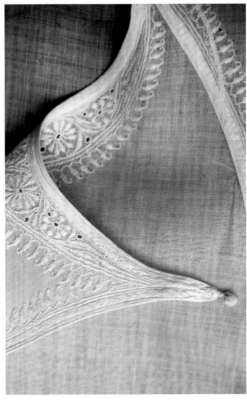

FACING PAGE: Delicately embroidered kurta with interestingly placed motifs around the collar band
Lucknow, late 19th or early 20th century, cotton muslin with cotton embroidery
Nawab Mir Jafar Abdullah's Collection, Lucknow

THIS PAGE: Necklines ornamentation for angrakha
Lucknow, late 19th or early 20th century

167

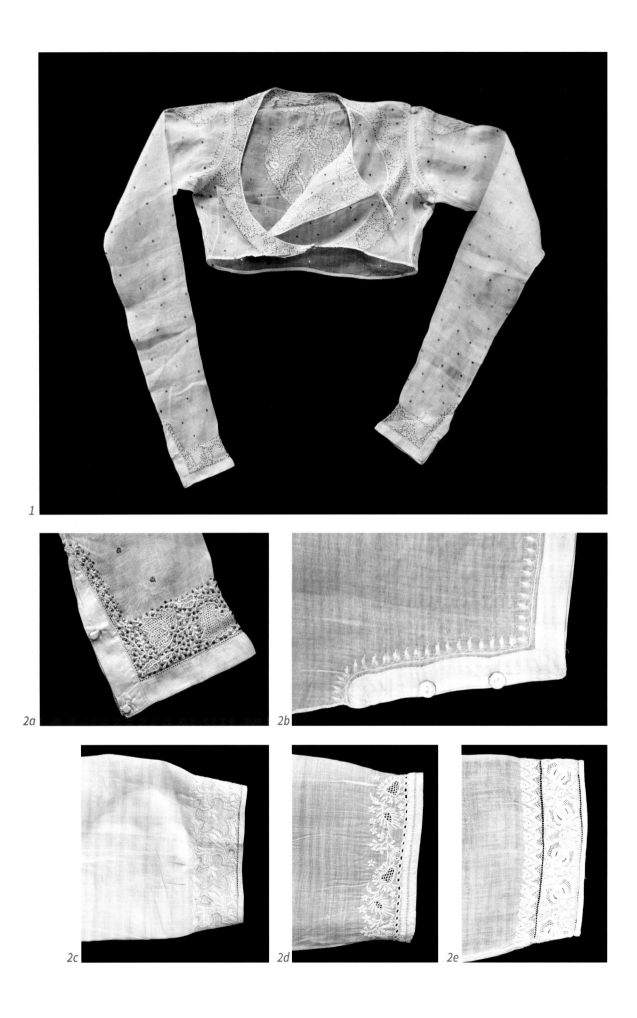

1

2a

2b

2c

2d

2e

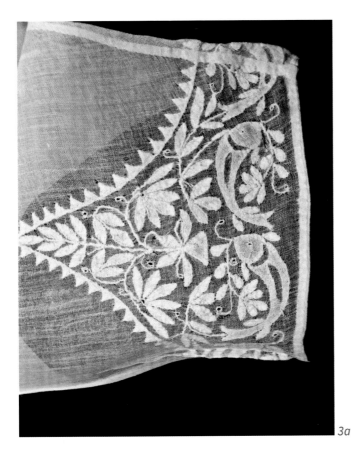

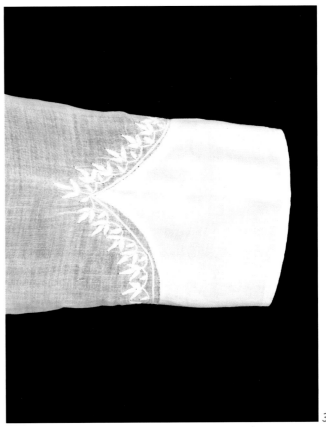

3a

3b

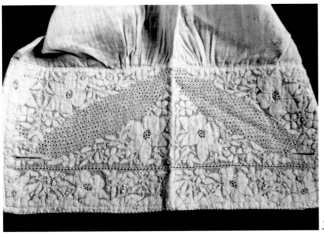

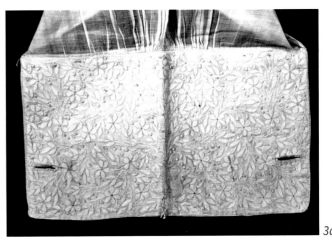

3c

3d

SLEEVES & CUFFS

*1 Top ornamented with
chikankari brightened up with
tiny silver dots or fardi buti*
*Lucknow, late 19th or early 20th
century, silk with cotton thread
and silver wire (badla)*
*Crafts Museum Delhi,
 Acc. No. 7/5212*

2a-e Sleeve ends
*Lucknow, late 19th or early 20th
century*

3a-d Cuffs
*Lucknow, late 19th or early 20th
century*

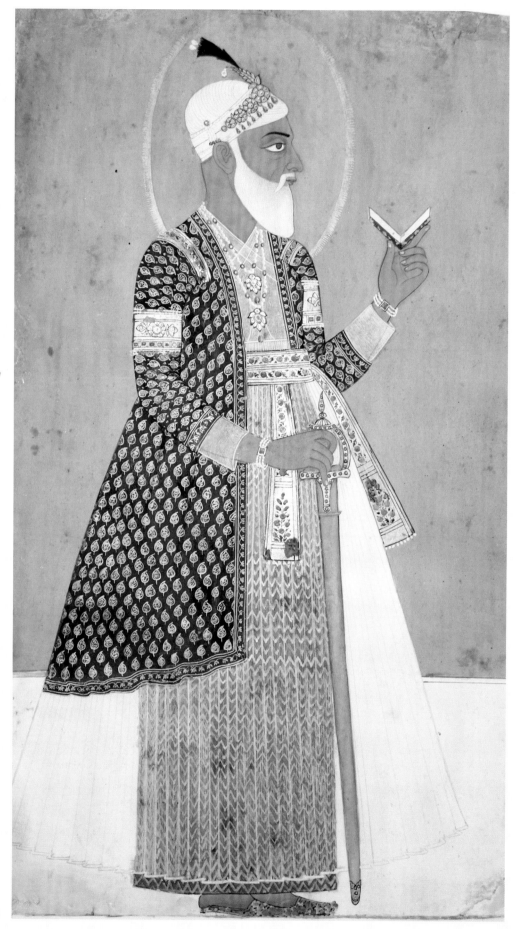

*1 Portrait of Nizam Asaf Jah I
(r.1724-48)
See the rippling effect visible
on the sleeve's end of the sheer
muslin jama
Hyderabad, c. 1800–10, opaque
watercolour with gold on wasli
28.1 x 16.9cm
Indian Miniature Paintings Ltd*

*2a– c Entada seed, the technique
of crinkling the sleeve, and the
crinkled sleeve*

*3 Ghundi and tukuma, cotton
button with loop*

*4 Choga
North India, 19th or early 20th
century, cotton with cotton ribbon
and black dori piping
Rajasthan Fabrics and Arts
Collection, Jaipur*

3

4

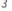

2a

2b

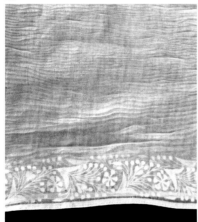

2c

Costumes were fastened with *kas*, *lappets* , tie-strings, or with *tukuma* and *ghundi*, which are loop and cloth-cased buttons in various styles.

The *lappets* were an important decorative element of the garment especially on formal *jama*, as it is seen on number of antique paintings and old costumes. They were an integral part of the dress adornment, and occurred in varying number, sizes and patterns, often further ornamented with embroidery.

The front panels of the *jama* overlapped more or less fully on each other; sometime the front panel was wide enough to reach the opposite side at the underarms. The Mughal emperor Akbar introduces the practice of tying the *jama* on the left side for the Hindus and on the right side for the Muslims. This practice persisted for a long time and on changing fashions and apparel. It is seen also on the angarkhas and the side open slit kurtas that were fastened with *ghundi* and *tukuma*, at the neckline on the right or on the left side.

On the angarkhas made with sheer muslins and *jamdani*, the *lappets* changed into thin tie-cords made with very fine fabric. These thin strings are called 'rat-tail cords' in English but in Lucknow, as Sushama Swarup mentions, they are more poetically and evocatively called *ashik-mashuq*, lover and beloved.

The *ghundi* and *tukuma* or tukma fastening, consisting of a small loop and a cotton-cased button, is typically placed on the side of the neckline on the angarkha, securing the *purdah* or front flap, and on the kurtas with the front opening on one side or on both shoulders. On chogas, the *ghundi* and *tukuma* are placed on the front between the chest and the waist, depending on the shape of the opening, at the point where the two panels meet before overlapping each other.

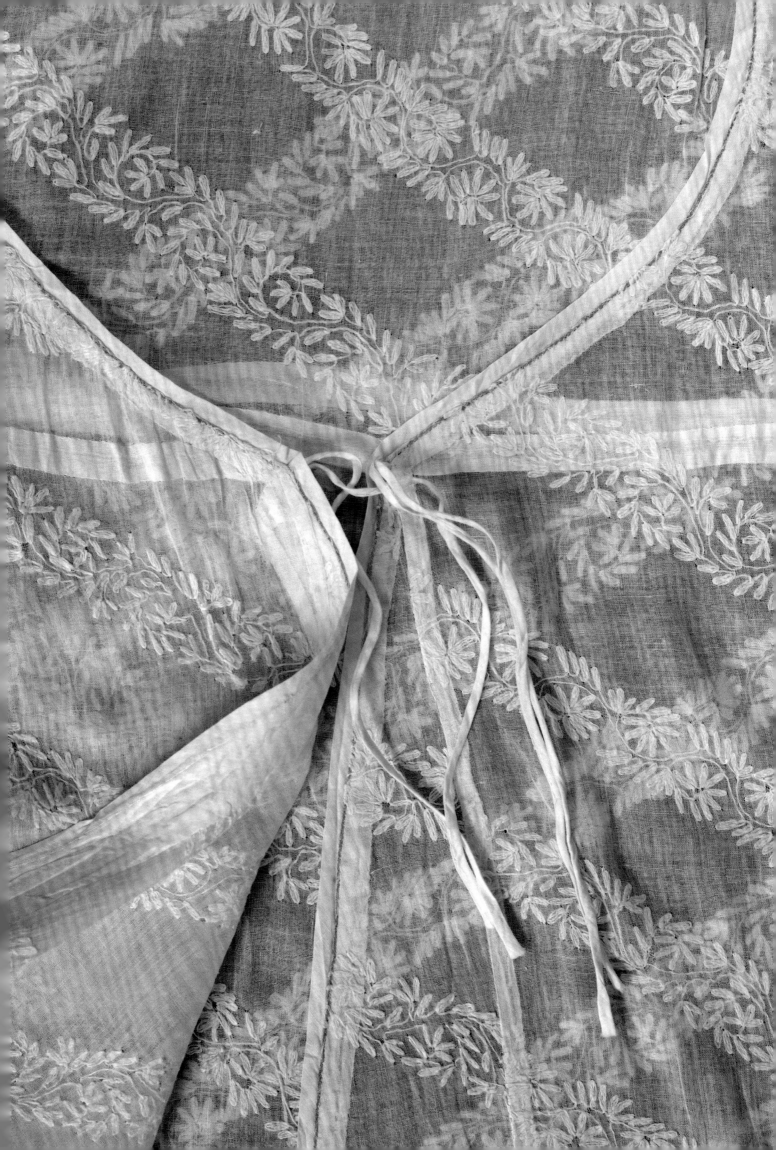

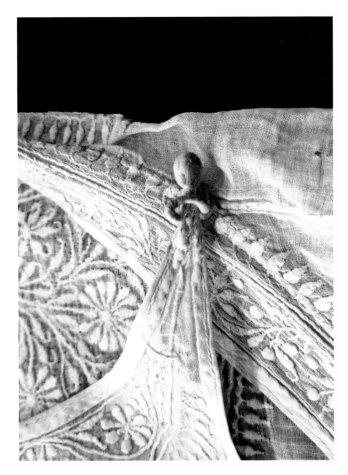
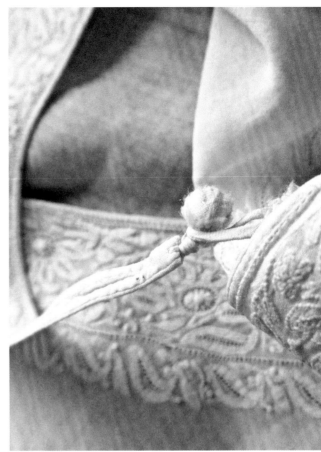

Depending on the textile used for the choga, the *ghundi* and *tukuma* can be small or rather big, and they are often elaborately decorated with cotton, silver or gold threads. They can also be attached to trimmings often shaped like *keiri,* appliquéd on the front panels. As appliqué would be too heavy on sheer muslins, two *keiri* mirroring each other were embroidered on the front panels.

Western style buttons and stitched buttonholes appear on *chapkan* and *achkan* towards the end of 19th century, at a time when traditional apparel incorporated various British influences in the cuts, patterns and styles. It is difficult to say if the buttons still attached today onto the garments are the original ones. They are made of a variety of materials like mother of pearl, or they are made of cloth or thread woven around a supporting structure. One also sees early plastic like bakelite, which was invented in the early 20th century and was used to imitate precious materials like ivory. Kurtas had no attached buttons, but only embroidered eyelets on the inner and outer front plackets to insert the detachable studs, similar to those common in Western apparel to hold detachable collars on men's shirts. The studs were often made with precious stones.

LEFT: Tie-string, red dori piping
Lucknow, 19th or early 20th
century
Cotton with tepchi embroidery
Rajasthan Fabrics and Arts
Collection, Jaipur

THIS PAGE: Fastening
Ghundi and tukuma and cotton
thread button

1 Portrait by unknown artist
Private Collection

2a & b Small pockets watch

3 a-c Side slits and corner motifs
Lucknow, late 19th or early 20th century

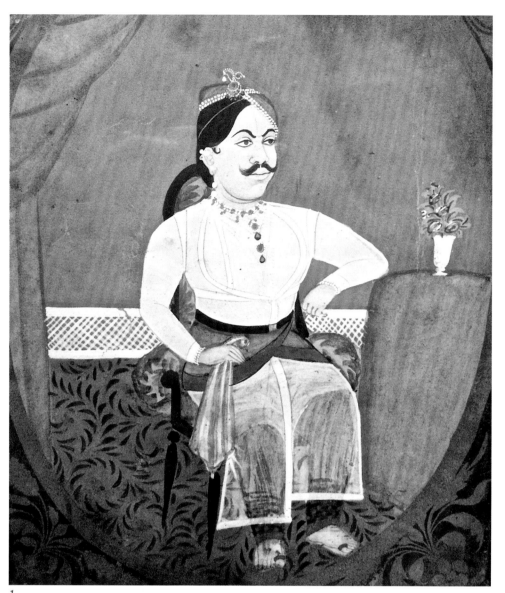

1

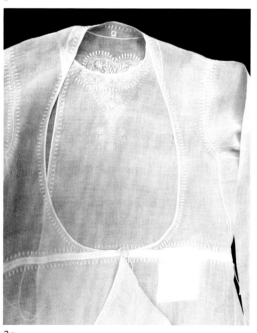

2a

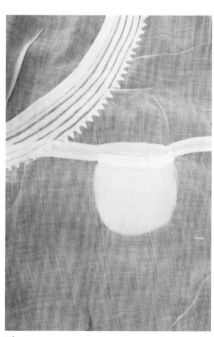

2b

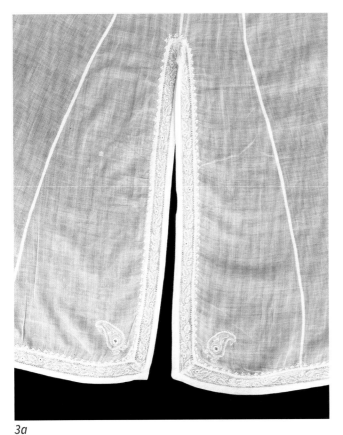

3a

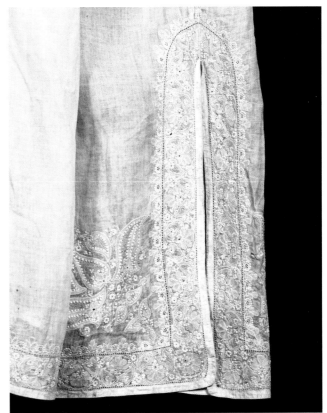

3b

POCKETS AND SLITS

Small pockets are often attached at the waist line on the angarkhas. However, flat and rather large pockets are on one or on both sides of chogas, *chapkan*, *achkan* and kurtas. The pockets are placed half on the front and half on the back of the garment. The pocket is generally constructed with a half-folded piece of fabric, partially sewn inside onto the garment. The opening is a vertical slit at the joining of the front and back panels. The bottom of the pocket is left hanging loose. Through the translucent muslin, the different shapes of the pocket tops form subtle ornamentations: round, pointed, scalloped or like an ogee arch.

The embroidered border that outlines the edging of the costume might contour the side slit and extend to include the pocket opening or the fine appliqué work that embellishes the side seams of the garment might continue on each side of the pocket opening. These are elegant details that add to the already extreme sophistication of the dress.

The length of the side slits varies tremendously, reaching up to the hips or being just a short opening, apparently without any strict correlation with the length of the costume. It probably depended on the fashion of the time, the design of the piece and the individual taste of the patron.

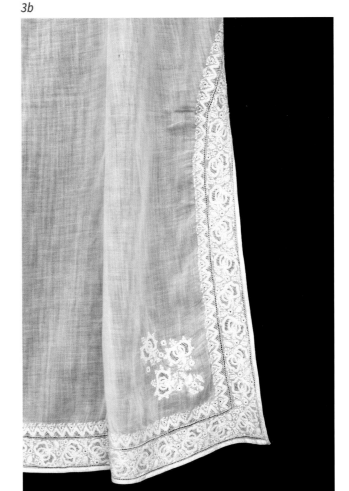

3c

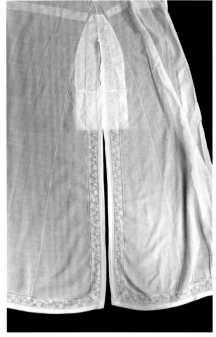

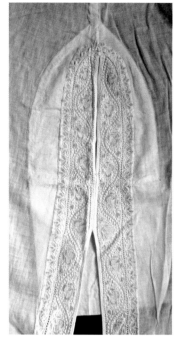

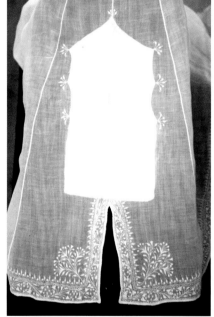

Many kinds of pockets
Through the translucent muslin, the different
shapes of the pocket: round, pointed,
scalloped, or like an ogee arch form subtle
ornamentations. Sometime the embroidered
border of the side slit frames the pocket
opening
Lucknow late 19th or early 20th century

NOTES

1 B. N. Goswami. Indian Costumes in the collection of the Calico Museum of Textiles. Ahmedabad, 1993:2

2 B.N. Goswami. Id. 1993:19

3 B. N. Goswami. Id. 1993:22

4 A.H. Sharar. 1975:228

5 B.N. Goswami. Id. 1993:20

6 Mukuta: heart shaped motif. Jhar buta : plant motif.

7 Singh, Chandramani. Textiles and Costumes from the Maharaja Sawai Man Singh II Museum. Jaipur, 1979

8 Singh, Chandramani. Id. 1979:xxiv

9 Singh, Chandramani. Id. 1979:xxiv

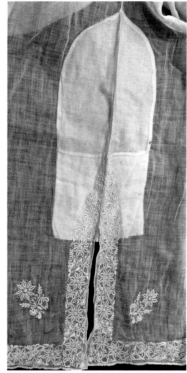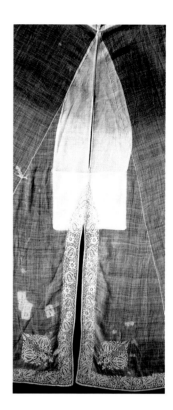

10 W. Hoey. Id. 1880:193

11 (1803 – 1837) was the second King of Oudh from 19 October 1827 to 7
 July 1837

12 A. H. Sharar, Id. 1975: 172

13 Singh, Chandramani. Id. 1979 :xxiv

14 J. Dhamija. Chikankari. In Textiles and Embroideries of India, 1965:35

15 see chapter : Fish, mermaids and crowns …

16 see also for seemingly same design the achkan at the crafts museum,
 Delhi)

17 Sharar p. 228

18 Sharar, p.175

19 Sharar, p.171

20 his reign : 19 October 1827 – 7 July 1837

21 Sharar, p. 172

22 Sharar, p.172

23 Nawab Mir Jafar Abdullah, Lucknow, personal conversation.

24 A. H. Sharar, p. 172-173

25 A. H. Sharar, p. 172, 175

26 R. Kumar. Costumes and Textiles of Royal India. 1999:165

27 R. Kumar: 1999:165

28 Sharar, A. H. Lucknow. The Last Phase of an Oriental Culture. Transl.
 & edited by E.S. Harcourt and Fakhir Hussain. 1975. Reprint 2001:189

29 Sharar, A. H. Lucknow. The Last Phase of an Oriental Culture. Transl.
 & edited by E.S. Harcourt and Fakhir Hussain. 1975. Reprint 2001:169

30 n. 502 in: Sharar, A. H. Lucknow. The Last Phase of an Oriental
 Culture. Transl. & edited by E.S. Harcourt and Fakhir Hussain. 1975.
 Reprint 2001: 274

31 S.N. Dar. Id. 1969:56

32 A.H. Sharar. Id. 1975:170

33 A.H. Sharar. Id. 1975:170

34 A.H. Sharar. Id. 1975

35 Goswamy, BN. 1993:87

36 Singh, Chandramani. Id. 1979:xxvi

37 Harvey, Janet . Traditional textiles of Central Asia. 1997:45

38 Singh, Chandramani. Id. 1979:65 : "Ca 1890, embroidered in Lucknow and
 tailored at Jaipur. L. 122.5 cm Acc. No. Tc/E-2", "Ca 1870, embroidered at
 Lucknow and tailored at Jaipur. L. 116,5 cm Acc. No Tc/E-4"

39 B.N. Goswami. 1999:136

40 A.H. Sharar. 1975:169

41 B.N. Goswami. 1999:136 "strong concern for presenting a stylish self-
 confident appearance "

42 B.N. Goswami. 1999: 19-20

43 S.N. Dar. 1969:94

44 The full name of the plant is Entada rheedii

45 A.H. Sharar, 1975 :181

46 A.H. Sharar. 1975:170

47 R. Kumar. 1999:212

48 Singh, Chandramani. Id. 1979:70

49 Parks, Fanny. Wanderings of a pilgrim in search of the picturesque during
 four and twenty years in the East with revelation of life in the zenana.
 London, 1850:379

50 Parks, Fanny. Id. 1850:384

51 Sushama Swarup. Costumes and Textiles of Awadh. Delhi, Roli Books,
 2012: 144

52 Marcel, Sarah Elizabeth. "Buttoning Down the Past: A Look at Buttons
 as Indicators of Chronology and Material Culture". (1994).University of
 Tennessee Honors Thesis Projects. http://trace.tennessee.edu/utk_
 chanhonoproj/42

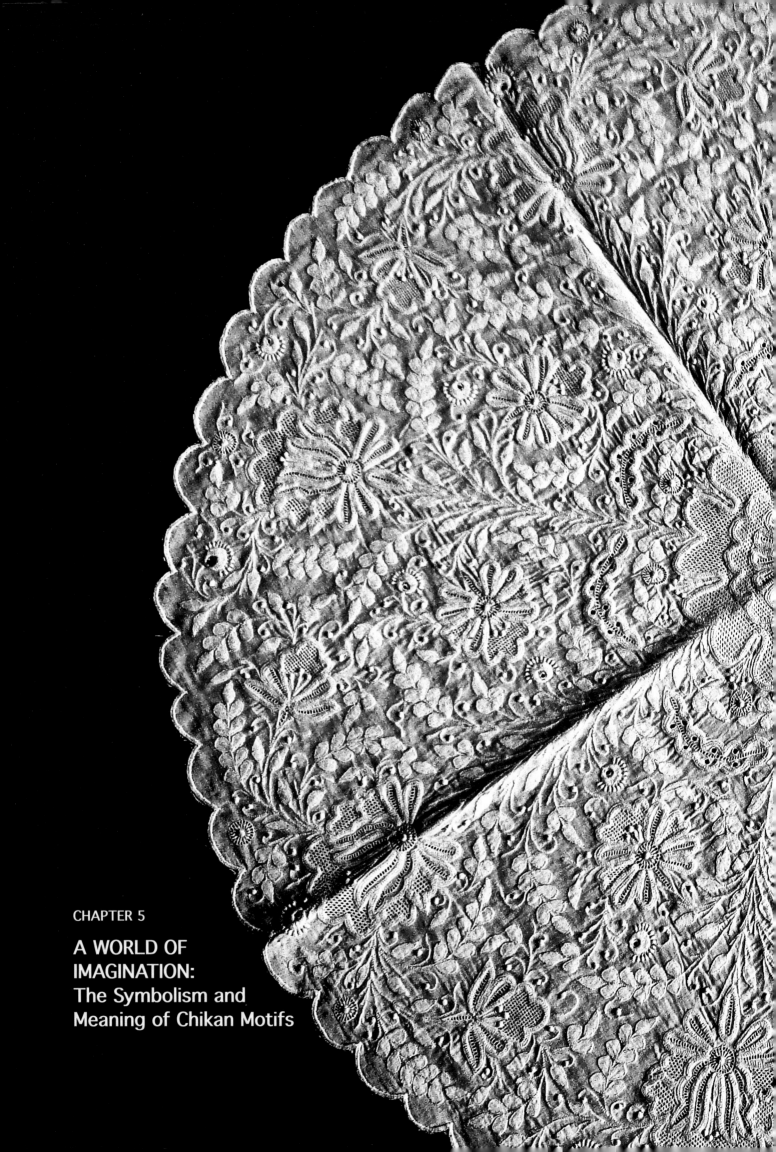

CHAPTER 5

A WORLD OF
IMAGINATION:
The Symbolism and
Meaning of Chikan Motifs

Chikan embroidery has been described as 'Indo-European' white-work[1], as it undoubtedly combines elements from the vocabulary of Indian textiles, particularly Mughal floral patterns with European white-work embroideries, which became particularly fashionable in the Western world towards the end of the 18th century. However this concise, slightly dismissive definition misses out on many dimensions that have contributed to make this craft distinctive. It does not look at its unique aesthetic codes and technical prowess strongly rooted in the ethos of Lucknow's cultural and social identity.

An Imaginary Botany

The original designs for chikan embroidery reflected the trends of other decorative arts in Lucknow "with a distinctive style of lush floral imagery," [2] that was very different from earlier Mughal arts also inspired by nature.

"The choice of motif and medium was used to achieve a unified aesthetic vision heralding the self-fashioned identity of Lucknow's ruling nawabs, leading resident Europeans, and wealthy landowners (taluqdars) in the post-nawabi era following the annexation of Lucknow by the English East India Company in 1856 and subsequent exile of King Wajid Ali Shah...Just as a codified floral imagery was developed to identify and proclaim the dynastic origin of a wide range of artworks created for the celebrated Mughal emperors and members of the nobility in the seventeenth century, a distinctive style of floral decoration that evolved in Lucknow was extensively employed for similar conceptual purposes.

Whereas the Mughals preferred a single flowering plant (often the ubiquitous poppy, but several other genera as well as hybrid and fantastic creations) or series of floral sprays formally arranged against a plain background, the luxuriant floral motifs favoured in Lucknow during the latter eighteenth and early nineteenth centuries are generally less staid and more exuberant. The vibrant, flowing floral imagery of Lucknow transmuted the orchestrated severity of Mughal flowering plants to produce a vitality of form and spirit far removed from the sombre products of the Mughal ateliers."[3]

Foliage and floral ornamentation are predominant in chikan vocabulary, with trailing curving stems, flower buds and berries. Despite their meticulous precision, the drawings belong to an imaginary botany. The identification of specific species is generally unsuccessful although the names of certain compounded stitches evoke the names of flowers like *chameli*. There are exquisite, dense compositions on rumals or handkerchiefs, and small table cloths, possibly for ceremonial use, on which it is possible to identify lotus flowers or grapevine creepers. The latter is a rather popular design in chikan also found on antique Kashmir shawls. According to some antique textiles dealers these shawls were made specifically for Lucknawi clients.

The borders with flowery scrolls, called *bel*, which are in hundreds of variations and sizes are often related to the decorative floral borders on Mughal miniature paintings, on Banaras brocades, as well as on other embroidered textiles. Some creepers, running diagonally across the width of the fine muslin attain a visual effect similar to the *tercha buti* or slanted creeper patterns on *jamdani*.

The imaginary botanical elements sets chikan embroidery apart from the romantic flowery depictions of other western white-works. More significantly, the very fineness of such imaginary botany draws a sharp dividing line between chikan embroidery produced for the general market, and chikan embroidery made for affluent patrons

Round mat
Exquisite craftsmanship that displays a variety of stitchery harmoniously balancing the densely filled composition
Lucknow, early to mid-20th century, cotton with cotton embroidery,
40 x 40 cm
State Museum, Lucknow, Acc. No. 68.2

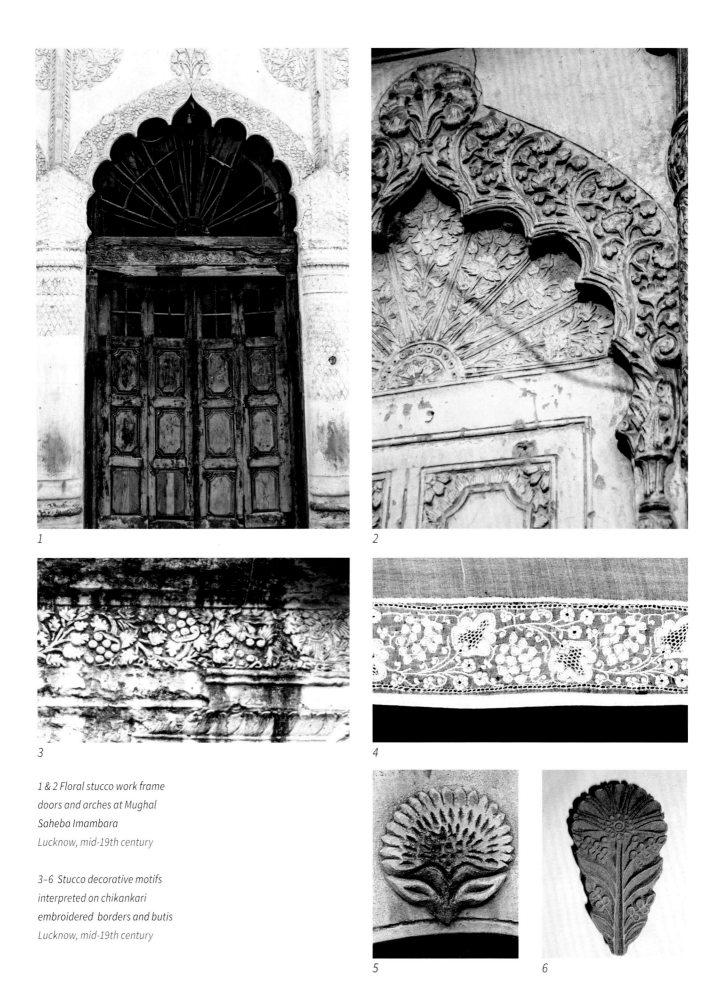

1 & 2 Floral stucco work frame
doors and arches at Mughal
Saheba Imambara
Lucknow, mid-19th century

3–6 Stucco decorative motifs
interpreted on chikankari
embroidered borders and butis
Lucknow, mid-19th century

1

2

3

4

5

6

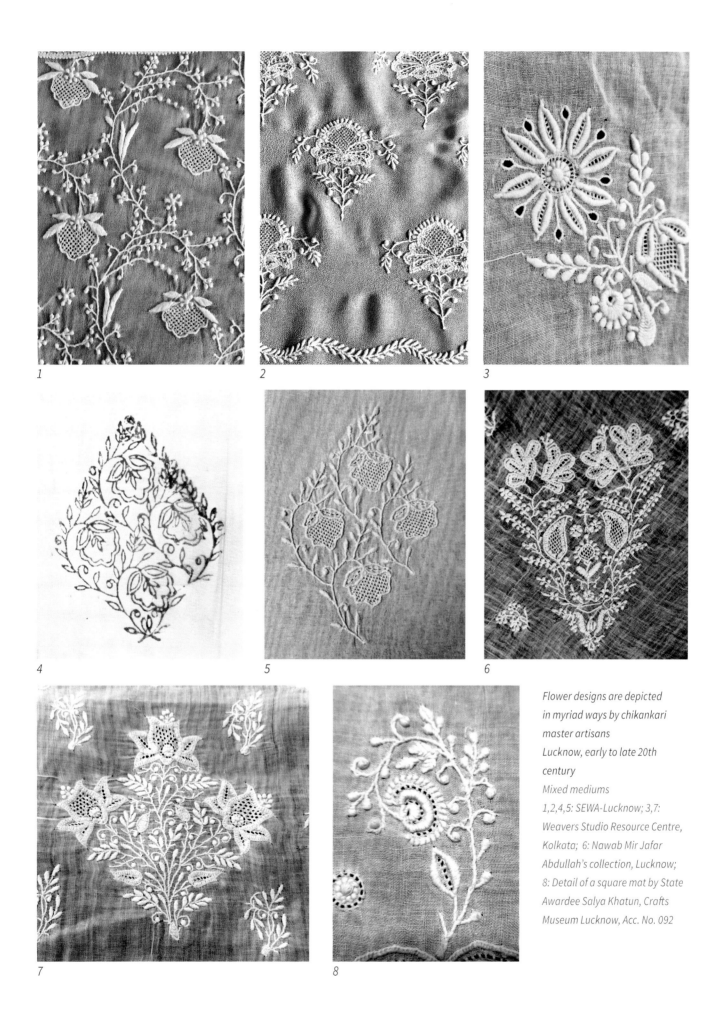

1

2

3

4

5

6

7

8

Flower designs are depicted in myriad ways by chikankari master artisans
Lucknow, early to late 20th century
Mixed mediums
1,2,4,5: SEWA-Lucknow; 3,7: Weavers Studio Resource Centre, Kolkata; 6: Nawab Mir Jafar Abdullah's collection, Lucknow; 8: Detail of a square mat by State Awardee Salya Khatun, Crafts Museum Lucknow, Acc. No. 092

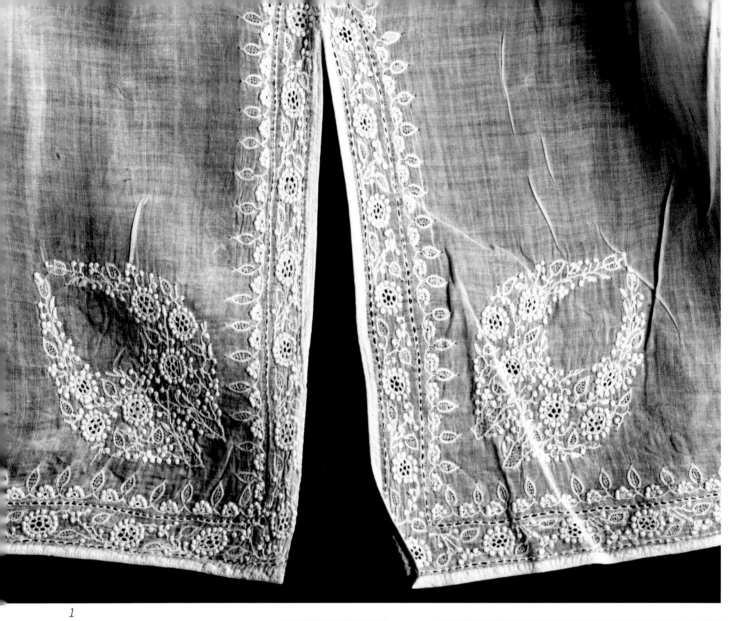

1

2

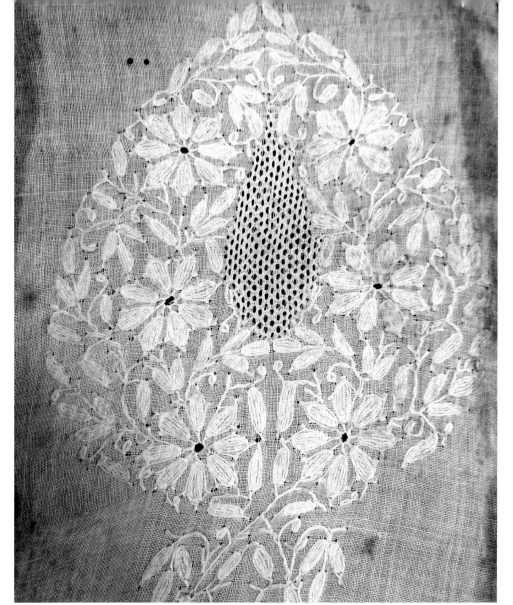

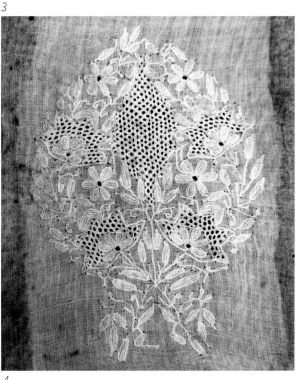

1 *Intertwined floral branches*
Lucknow, 19th century, cotton
muslin embroidered with cotton
and silk
Siddharth and Sangeeta
Dudhoria's Collection, Kolkata

2 *Drawings of intertwined floral*
branches
Album of drawings and designs
for chikankari embroidery, pencil
on paper, Lucknow, late 19th or
early 20th century
Private Collection

3 & 4 *Sample of chikan work from*
the collection of Kedar Nath Ram
Nath & Co.,Lucknow
Gold Medalist from Coronation
Exhibition, London 1911 Crafts
Museum, Delhi

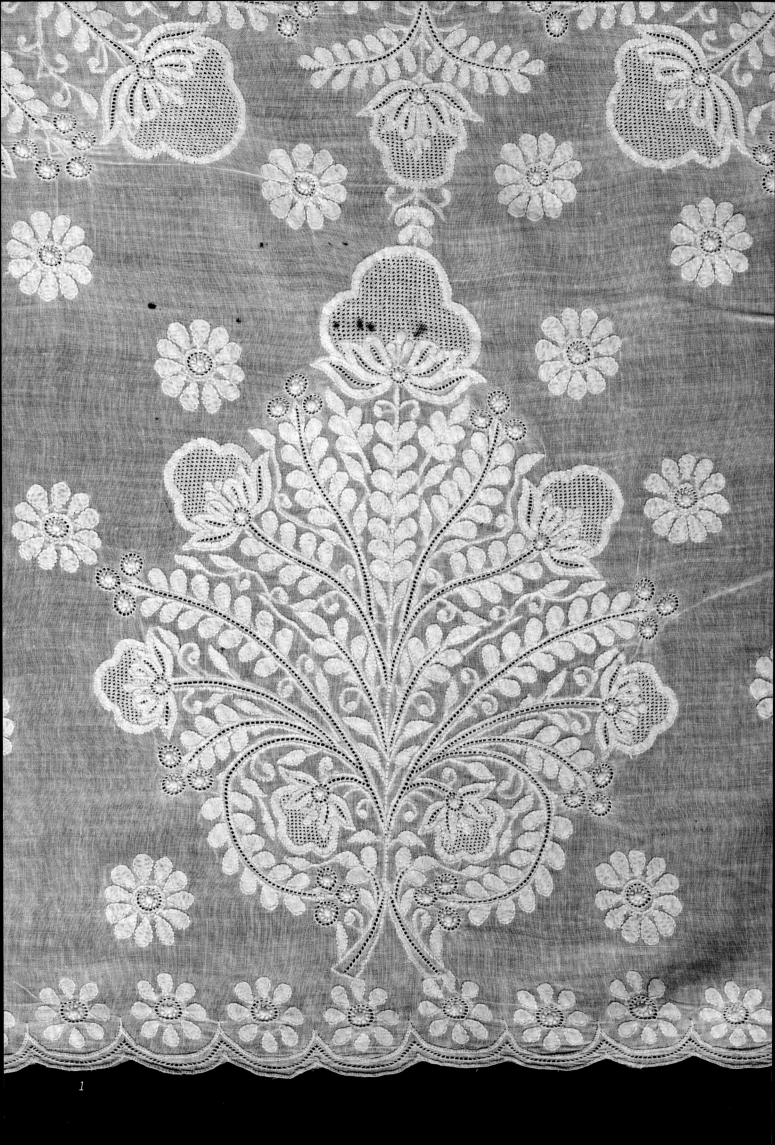

1

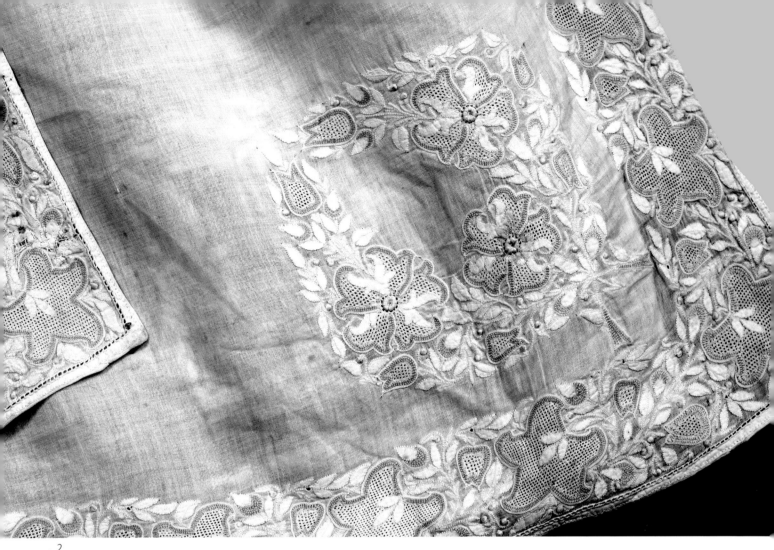

2

1 Table cloth, detail
*Bakhia (shadow work), back
stitch, and hathkati (line of open
work on the flowers' stems and
the veins of the flowers' petals).
It is interspersed with tiny kil
stitches and edged with a double
line of kat (hem stitch) with
hathkati in the middle.
Lucknow, early to mid-20th
century, cotton with cotton
embroidery
Rajasthan Fabrics and Arts
Collection, Jaipur*

2 Angarkha, lower corner motif
and border
*Lucknow, 19th century, muslin
with cotton and silk embroidery
Craft Museum New Delhi,
Acc. No.92/7804*

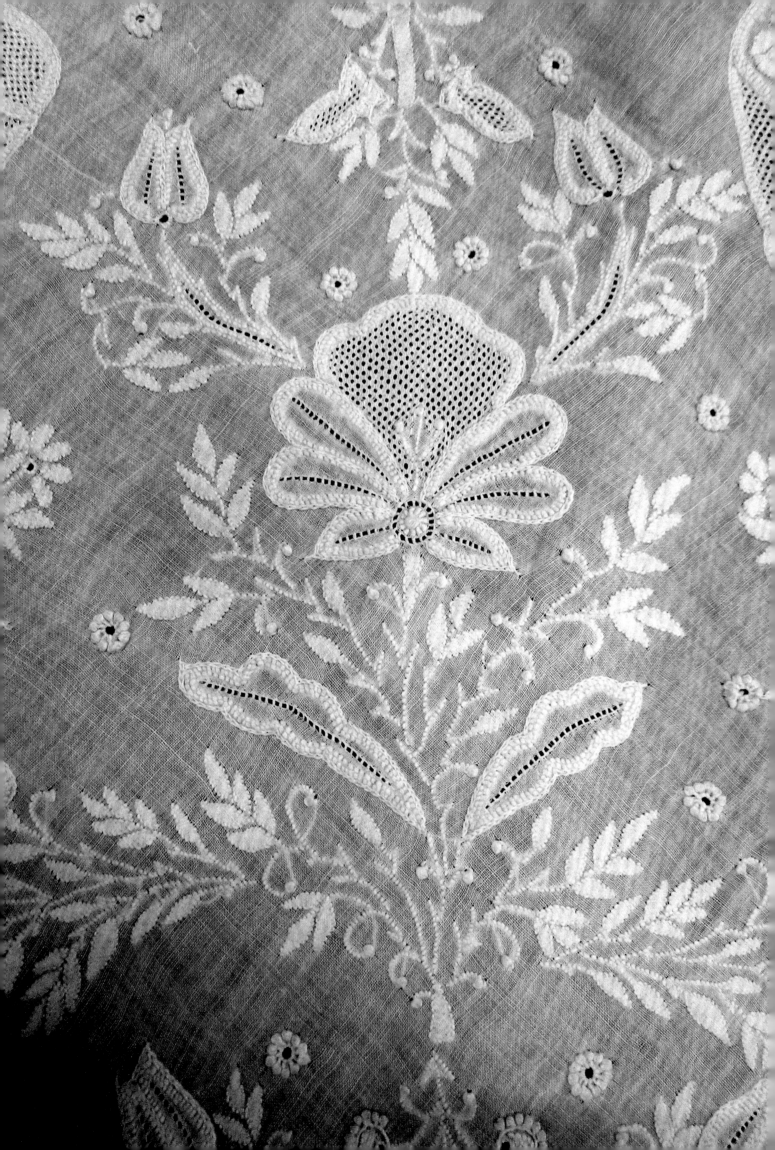

The typical motif in chikankari are the *paan* leaf, the *konia* also called *turanj,* and the *keiri* designs. All these are drawn in different sizes as matching sets for the various specific placements on the costume. Foliage and flowers are the compositional filling elements of the motif, which may have flowering branches with tiny buds, tendrils and leaves, all variously arranged to fit within the shape of the motif.

Similar intricate and luxuriant foliage, vines and floral compositions are common features in stucco work ornamentation on friezes and arches on old mansions and monuments such as the Imambaras of Lucknow, dating from the 18th to the early 20th centuries.

Paan and Betel Leaf

Older examples of choga, angarkha, **achkan**, waistcoat, kurta or a kurti, invariably contain a highly ornate heart-shaped motif called *paan*, a stylized leaf of betel, at the *pusht* or centre back of the costume.

The heart-shaped design points downwards on costumes for men but it is generally turned upwards on contemporary ladies' wear, apparently for no other special reason than just a convention "much like the difference in the left or right buttoning on a man's or a woman's shirt."[4] The same *paan* motif, maybe in a smaller size, might be repeated on the top of sleeves, pointing downwards, or at the bottom and on cuffs, pointing upwards.

The *tambul* or betel leaf is of great significance inSouth Asian cultures, and more so in India, where it is an essential offering in many religious ceremonies and rituals. At social functions, both Hindu and Muslim, offering a wrapped betel leaf containing lime, shaved areca nut and flavoured with exotic spices and silver foils, is part of basic hospitality manners. At Mughal courts, the royal gifts of *paan* were a sign of honour and imperial favour. The number of *paan* leaves offered marked the degree of the esteem in which the emperor held the visitor.[5] The acceptance of the royal gift of *paan* was also a pledge of loyalty; it sealed the recipient's acceptance of royal orders and his willingness to take on the assigned responsibilities.

In Lucknow particularly the offering of *paan* became an important elaborate social ritual, which furthered the creation of precious accessories for the keeping and the preparation of the *tambul* "jewelled boxes in which the *paan* leaves were stored, trays with compartments for lime, areca-nut, spices, camphor or other substances applied to the leaves, elaborately decorated tools to cut areca-nut in small pieces, and, of course, spittoons."[6]

The *paandan* or betel box, became a significant status symbol in Lucknow, representative of the refinement and grandeur of its owner. The prepared betel leafs, fastened with silver pegs, were served during social gatherings on the *khaasdan*. The *paan* is believed to have beneficial medicinal properties in addition to digestive and aphrodisiac effects. Chewing *paan* produces a red juice and the lips stained by its crimson colour are regarded as very attractive, while producing a fragrance of the breath that would be particularly conducive to fulfilling love relationships.

The *paan* leaf "is the symbol of auspicious beginnings, the seal on alliances and invitations. It represents the deity in religious ritual; it is the inspiration of verse, legend and painting."[7] Thus placed on the back of the dress, it is considered, a protective icon, as essential as any other part of the costume , without which the garment would be incomplete. Sometimes the same motif, in different sizes is repeated on the sleeves and at the lower corners of the costume.

1 Table cloth, detail
Lucknow, early to mid-20th
century, cotton muslin with
cotton embroidery
Crafts Museum, Delhi

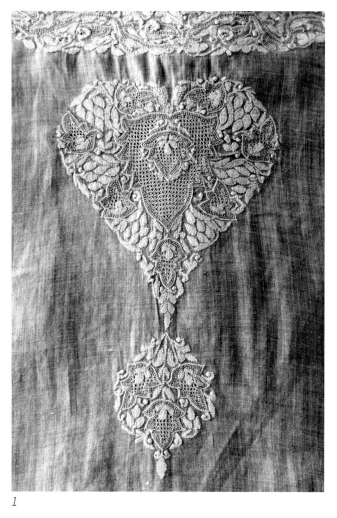

1

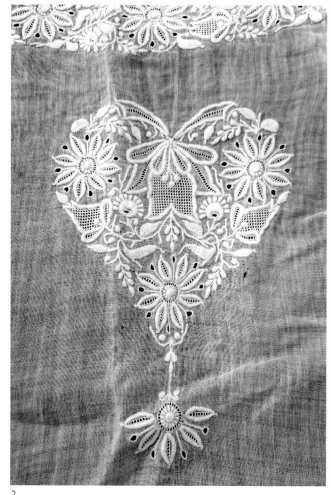

2

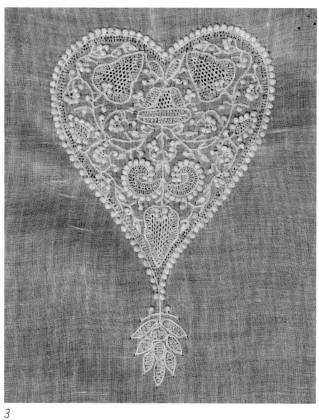

3

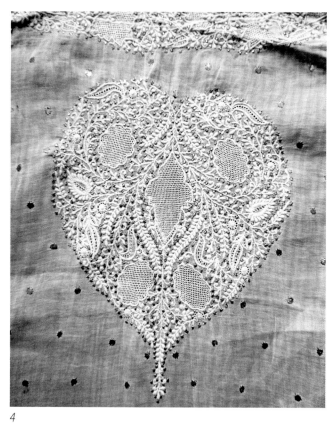

4

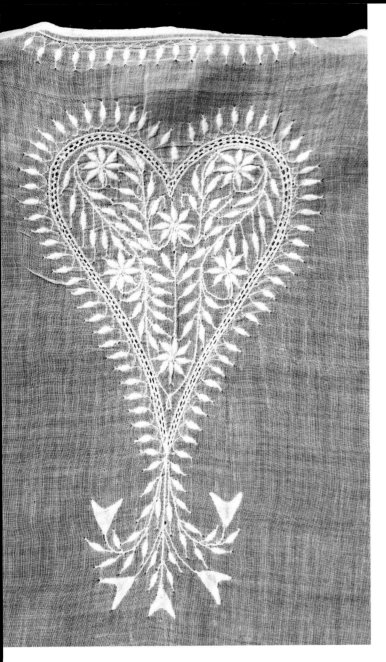
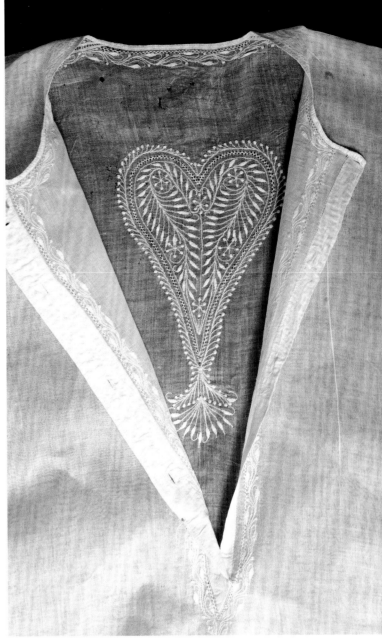

The *paan* motifs are worked with a variety of textures and *jali* work ranging from small simple heart-shaped motifs with tiny flowery ornamentations, to large and elaborate *paans* with pendants and tassels filled with flowers and foliage. They are often further embellished and made even more precious by adding gilded *kamdani* work. In chikan embroidery the *paan* leaf design has greatly inspired both the creativity of the *naqqash*[8] and the imagination of the embroiderers.

Keiri or buta design

The origin of the *keiri* design, known also as *buta*[9] (from the Persian 'boteh') or *ambi* (from the shape of the unripe mango) or as 'paisley', is shrouded in mystery and its meaning is enigmatic. Even more puzzling is how this motif in endless variations has been part of the vocabulary of decorative arts across different cultures for over thousand of years.

"The first manifestations of this ancient motif is in Scythian and Achaemenid art, mainly portrayed as the wings of Homa or Senmurv (Simorgh?), and which lasted in the same manner till the Sassanian period."[10]

FACING PAGE : Paan leaf motifs
Lucknow late 19th or early 20th century
1 O. Getto's Collection, Turin; 2 Weavers Studio Resource Center Archive, Kolkata; 3 Rajasthan Fabrics and Arts Collection, Jaipur; 4 Crafts Museum, Delhi, Acc. N. 7/5212

THIS PAGE: Paan leaf motifs on the back of two kurtas worked in miniature appliqué works
Lucknow, late 19th or early 20th century, cotton muslin with cotton embroidery
Rajasthan Fabrics and Arts Collection, Jaipur

1

2

1 Keiri motif embroidered with
cotton and with silk thread
Crafts Museum, Delhi,
Acc. No. 92/7804 (2)

2 A sample from 'Lucknow
Chikan hand Embroidery Work: A
Collection of Kedar Nath Ram Nath
& Co.'
Crafts Museum, Delhi,
Acc. No. 92/7805(4)

The *boteh* appears on textile fragments dated 6th–8th centuries AD uncovered in Akhmim, in Upper Egypt. This region was under Sassanian influence during the lagest extent of the Persian empire and it was on the Western end of the Silk Road.

"The Akhmim motifs appear to be stylized oversized leaves or fruit attached to a tree or vine. The design elements that are consistent with later (unattached) boteh are the pointed dropping tips (and at times a sprayed tip), and the border around the motif encasing an internal design."[11]

The significance of this pattern has been and still is object of many different conjectures: it has been associated with the 'Tree of Life' in Western Asia, to the "growing shoot of the date palm tree"[12] Many of its later representations, with packed compounded flowers, foliage and buds would support this theory. According to other interpretations, the boteh is symbolic of the Zoroastrian sacred flame or derives from the evergreen cypress tree[13] with its tilted tip, which in Persian traditions is associated with the Garden of Paradise and with the immortal life of the soul.

InPersia, the boteh is found on architectural details and on ceramic ornamentations since very early times, and it became a characteristic motif on rugs and textiles across Western and Central Asia. Later on it became a popular motif also in North India, no doubt through the exchanges and cross-pollination of all these different cultures.

During the Savafid period, in the mid-16th century in Persia "the botteh motif, in its original form, gains an elevated paramount status as an emblem of kingship, sovereignty and governance embellishing the headdresses of kings and princes. It is from this time onward that botteh jegheh, in a true sense, attains its exclusive status as a royal symbol."[14] In India the 'botteh jegheh' is known as *sarpech,* the precious jewelled ornament which adorned the turbans of maharajas and nawabs, symbol of royalty. The shapes of sarpech are related to the *keiri*'s endless graphic variations.

From the late 18th century the *keiri* motif, with its unmistakable yet always different shape, developed in countless styles, especially on Kashmir shawls. It became famous all over the world as 'paisley', from the small town in Scotland, near Glasgow, where during the 19th century machine-made imitations of Kashmir shawls were produced in great quantities for the European and American markets.

3

4

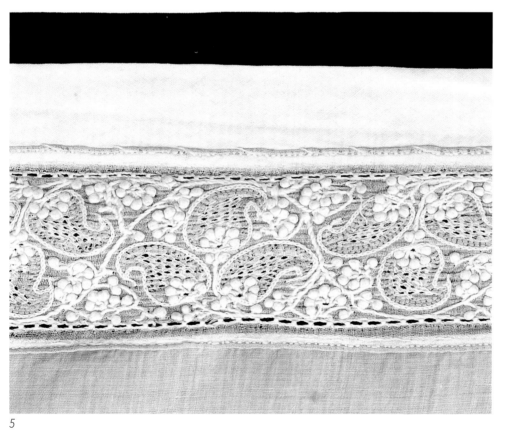

5

3 Drawing for a densely filled
keiri motif
Lucknow, early 20th century
Album of drawings and designs
for chikan embroidery, Private
Collection

4 Patterns with drawings for
chikankari embroidery
Lucknow, early 20th century
Album of drawings and designs
for chikan embroidery, Private
Collection

5 Detail of border with small keiri
motifs
Lucknow, late 19th or early 20th
century, embroidery with cotton
and pink silk thread; dori piping
in magaji
Rajasthan Fabrics and Arts
Collection, Jaipur

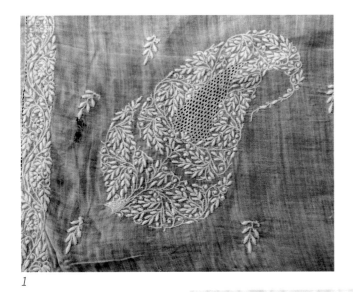

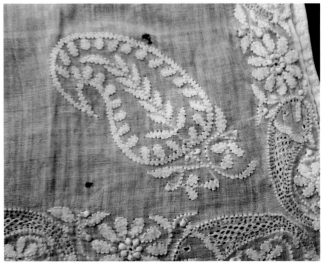

1 Keiri worked with murri stitch
and jali in the centre
Lucknow, late 19th or early 20th
century, cotton muslin with
cotton embroidery
Weavers Studio Resource Center
Archive, Kolkata

2 Keiri corner motif and border
with fish motif
Lucknow, late 19th or early 20th
century, cotton muslin with
cotton and silk embroidery
Siddharth and Sangeeta
Dudhoria's collection, Kolkata

3 & 4 Block impression and
embroidered sample for a keiri
Block: from Shekawat printing
workshop, Lucknow
Sample: from SEWA-Lucknow
Archives

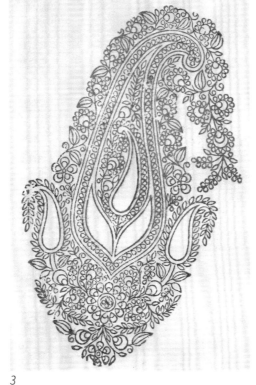

3

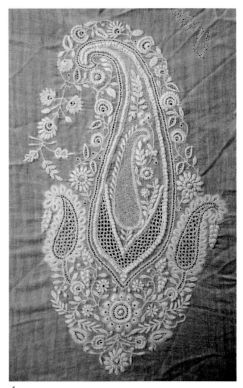

4

192

However, unlike woven shawls, where it has been possible to identify trends and date the stylistic evolution of this design, with chikankari there are too few surviving antique pieces with this motif to make this process possible. Tracings of elaborate *keiri* motifs appear among the early 20th century drawings in the Kedar Nath Ram Nath album from Lucknow, and on antique sample swatches in the Crafts Museum in Delhi.

The *keiri* or the buta (big flower), as it is more frequently called in Lucknow, does not have a specific gender connotation, but we were told that it is more common on women's wear.[15] This may be because of its connection to the 'Tree of Life' and the fertility symbolism associated with it. In many cases, the *keiri* design is constructed with a combination of different *keiri*s within the main large shape, There is also a small *keiri* emerging from the larger one, on what it is called 'pregnant *boteh*' or 'mother and child' boteh.[16] This is seen on chikan blocks as well as on oriental carpets.

Buta is the generic name for a big flower or motif while 'buti' defines a smaller one. The *keiri* on chikan embroidery is generally used as a single element either as *konia* motif, in a slanted position pointing toward the central axis of the piece, or standing in a row on the *pallu* (the decorated end portion of a sari) or on sari borders. Sometime, more rarely, it is found, in various composite forms at the *pusht*, or the centre back of the costume.

It is interesting to note that large *keiri* or buta will always be placed with the bending tips upwards, while the smaller *keiri*s also called *ambi*, especially if part of *jaal* patterns, will have their tips turned downwards, as the ambi representing an unripe mango hanging from the branches of the tree.[17]

A *keiri* can have a well-defined contour, or its shape may be suggested by the lay out of the small floral elements composing it. *Keiri* blocks are amazing in their endless variations and combinations of flowers, tendrils and buds that fill the space within, guiding and inspiring the imagination and skill of the embroiderer. The fine *jali* work often adds a grace and lightness to an otherwise dense composition. Most remarkable are *keiri*s executed in *katao* or appliqué work, in which myriads of tiny leaves, meticulously shaped and evenly sized, develop the design.

Keiri worked in *tepchi* with very fine thread, minuscule stitches and sinuous lines are among the most diaphanous and gracious embroidery works on antique chikan pieces.

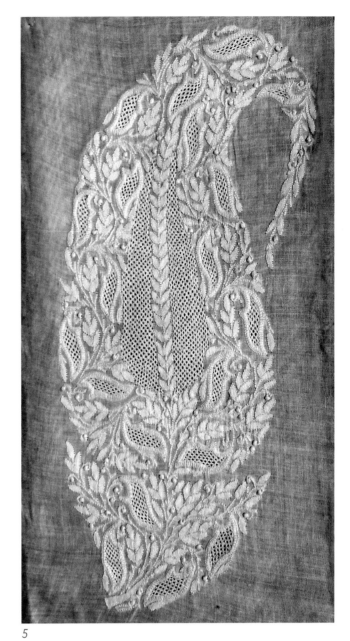

5

6

5 Sample piece of a keiri motif Bakhia, back stitch, phanda and sidhaur jali or 'straight' open work 'Lucknow Chikan Hand Embroidery Work: A Collection of Kedar Nath Ram Nath & Co', Lucknow, 19th century, cotton muslin with cotton embroidery Craft Museum, Delhi Acc. N.(37)

6 Drawing of keiri for chikankari Lucknow, 19th century, pen on paper Album of drawings and designs for chikan embroidery, Private Collection

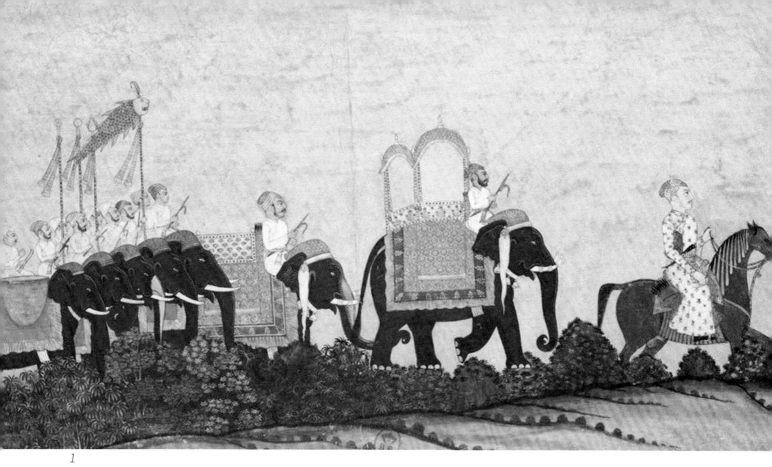

1

1 'Caravane d'elephants'
Mughal army with Fish Banner
Murshidabad, c. 1755–1760,
opaque watercolor on paper
Bibliotheque Nationale de
France, Acc. N. ark:/12148/

2 Stucco work
Mughal Saheba Imambara,
Lucknow

Fish patterns for embroidery
3 Fish design block. Sewa-
Lucknow; 4 Crafts Museum
Lucknow; 5 Rajasthan Fabrics
and Arts Collection, Jaipur;
6 Serenity by Ruth Chakravarty,
Lucknow

2

3

The distinctive insignia of the Nawabs of Oudh was a pair of fishes with curved bodies, facing each other in perfect symmetry, sometime forming a circle. Pairs of stylized fishes shaped in stucco work still survive on many of the archways of palaces, monuments and on the gateways of what remains of Qaisar Bagh, the last royal residence in Lucknow. The fish motif was placed on many precious, at times, extravagant artefacts and fine textiles of the Nawabi era. It has a strong evocative power of the past glory of the city. In fact, it survived the fall of the Nawabi rule and has become Lucknow's distinctive emblem, a nostalgic reminder of the excellence of Awadhi culture, manners and ethos.

The fish is an important symbol in different myths and religions: in Buddhism it symbolizes constant wakefulness as it never closes his eyes; in Hinduism it represents one of the incarnations of Vishnu, who saved humans as well as the sacred texts from the mythical deluge; and in Islam, the fish is associated to wealth, fertility and immortality, as narrated in the popular story and the cult of Khwaja Khizr.

In Persian mythology a giant fish supports the universe and it is depicted on a few miniature paintings as propping up the Mughul emperor Jahangir.

There is no definite documentary evidence on why the Nawabs of Oudh adopted the pair of fishes as a symbol of their dynasty. However it is generally believed that it is linked to the *Mahi-ye-Maratib*, or the 'Fish of Dignity', a prestigious ancient Persian military decoration introduced by the King of Persia Khosrau II (591–628 AD). This idea migrated to South Asia and was adopted later by the Mughals. The hereditary distinction was accorded only to "the Mughal's highest-ranking military commanders" to honour "bravery, perseverance and strength".

As per historical records, Saadat Khan (1722–39), a Mughal noble of Persian origin and a brilliant military commander, suppressed a rebellious insurrection and was awarded the prestigious *Mahi-ye-Maratib* in 1720 by the Emperor Muhammad Shah. In 1722, Saadat Khan was appointed Governor of Awadh.

4

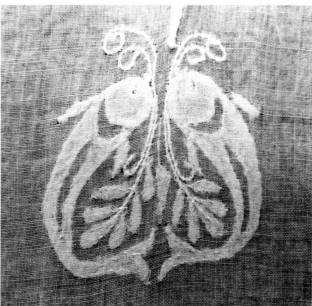

5

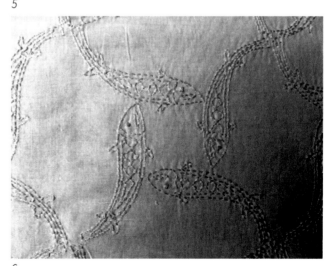

6

195

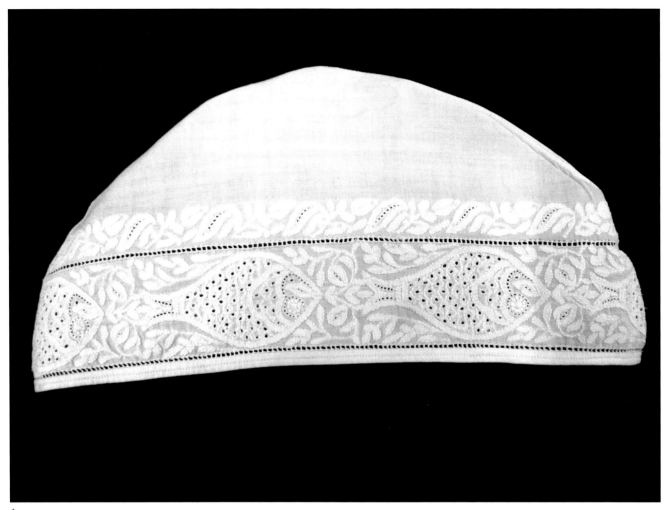

1

1 *Dopalli topi with fish border*
Lucknow, possibly mid-20th
century, cotton with cotton
embroidery
Rajasthan Fabrics and Arts
Collection, Jaipur

2 *Block impression on cotton of*
fish motif Kedar Nath Ram Nath
Lucknow, 2014

3 *Khwaja Khizir Khan on fish*
Mughal, India, 18th century
Victoria and Albert Museum,
London, IS.48:12/A-1956

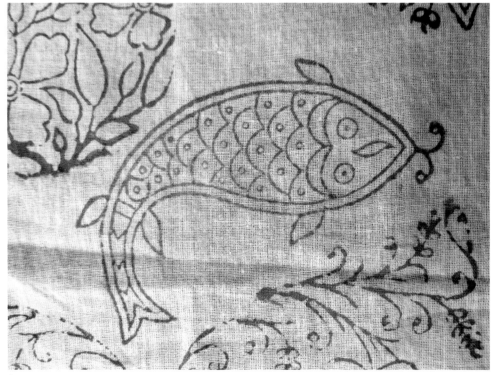

2

3

1

1 Dupatta motif with the
distinctive design of the crown of
the rulers of Awadh
*Lucknow, 19th century, cotton
muslin with cotton and silk
embroidery*
*Nawab Mir Jafar Abdullah's
collection, Lucknow*

2 Wajid Ali Shah's royal emblem
*Mermaids embroidered on a
napkin, Lucknow, 19th century*
Crafts Museum, Delhi

3 Wajid Ali Shah's royal emblem
with mermaids on a sari's pallu
*Lucknow, 19th century, Los
Angeles County Museum of Art,
Acc. No. M.83.105.27*
*Nasli and Alice Heeramaneck
Collection*

4 Mermaid Gate at Kaiserbagh,
Lucknow

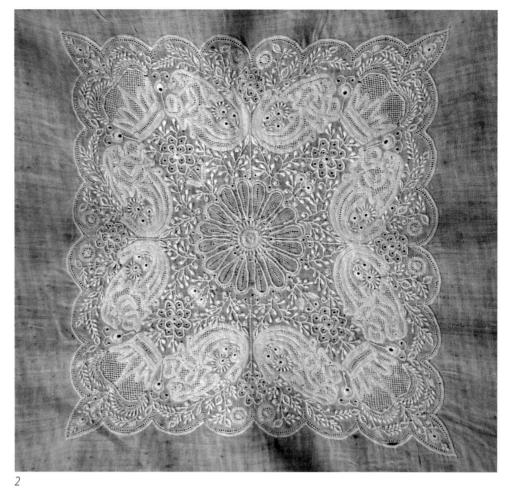

2

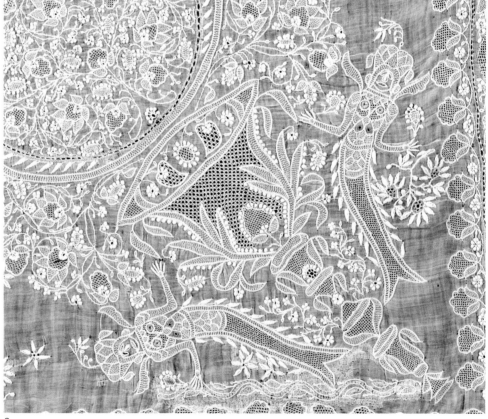

3

4

Furthermore, according to popular lore, while crossing the Ganges during the military expedition against the rebellious Shahazads, a fish leaped into the Sadaat Khan's lap. This was declared a good omen, particularly as later the expedition proved to be successful. From that time on, says popular lore, the Nawabs of Awadh endorsed the fish insigna as their dynastic brand.The Nawab treasured the fish carefully, and its skeleton was believed to have remained with his descendants till the fall of his dynasty.

Lucknows association with the fish might be even older, as it is believed that the *Mahi-ye-Maratib* honor was conferred on Sheikh Abdur Rahim, the Subedar of Awadh during Emperor Jahangir's rule. The Sheikh is thought to be the original builder of the Machhi Bhawan Fort on the banks of the river Gomti near Tila Shah Pir Mohammed (also known as Lakshman Tila). This Fort was profusely decorated with arches and paired fish.

The fascination of the Nawabs of Lucknow with the fish insignia extended to the construction of a pleasure boat in the shape of a fish which apparently could not even sail properly. The fish boat was depicted in contemporary watercolours. It was also recorded on a famous old photograph by Felice Beato taken in 1858, and in his picture the fish-shaped boat is laying tilted on the banks of the Gomti river.

The royal emblem was changed by Nawab Wajid Ali Shah, the last king of Awadh who ascended to the throne in 1847. The Awadh insignia of a pair of head-to-head fishes forming a circle were replaced by two winged creatures emerging from the open mouth of two symmetrically positioned fishes, arched outwards and upward. The winged creatures or

RIGHT AND NEXT PAGE:
Lucknow view from the Gomti
Details of a long horizontal scroll
showing the fish shaped boats
made for the Nawabs of Awadh.
Watercolor on paper, full roll 31 x
610 cm, Lucknow, 1826
Yale Center for British Art,
BA-ORB-3427397-0003-DSP

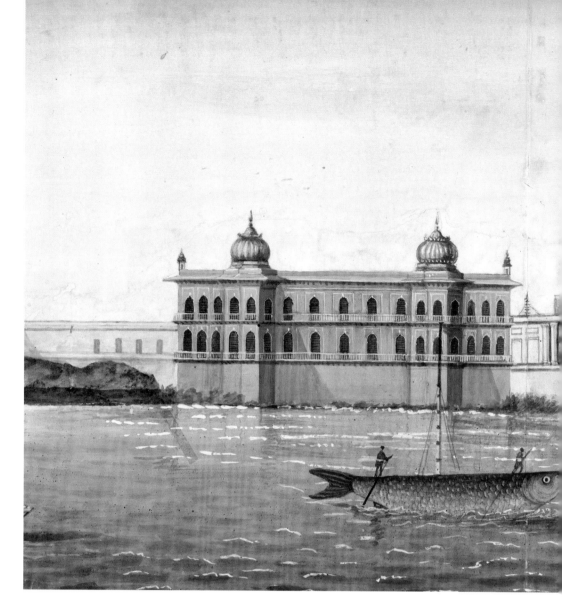

'mermaids' are holding aloft the symbol of royal power: the crown of the king protected by the ceremonial *chhatri* (umbrella) and the *morchhals* (fans). Wajid Ali Shah's insigna has been embroidered on chikan pieces and even woven on very fine *jamdani*. The images of the mermaids also survive in stucco works on the gateways of what remains of Qaiserbagh, the complex of royal palaces and gardens built by Wajid Ali Shah. This icon developed later into a single creature or mermaid. After 1857, the city suffered years of problematic economic and political situations, and social upheaval. The pair of fishes became an enduring symbol of a sophisticated and cultured, albeit decadent former Nawabi lifestyle.

Depicted in various shapes, postures and sizes, on different mediums and artefacts, the mere presence of the fish motif is often taken as proof of a Lucknowi origin. One cannot find fish motifs on older pieces, its possible they were a later introduction into chikan embroidery and integrated into borders or flowery motifs amidst foliage and tendrils. The fish is used in *keiri* motifs and heart-shaped *paan* leaf designs. It appears in all-over compositions, and is also one of the patterns used for the *daraz* seams, called the *macchli ka daraz*.

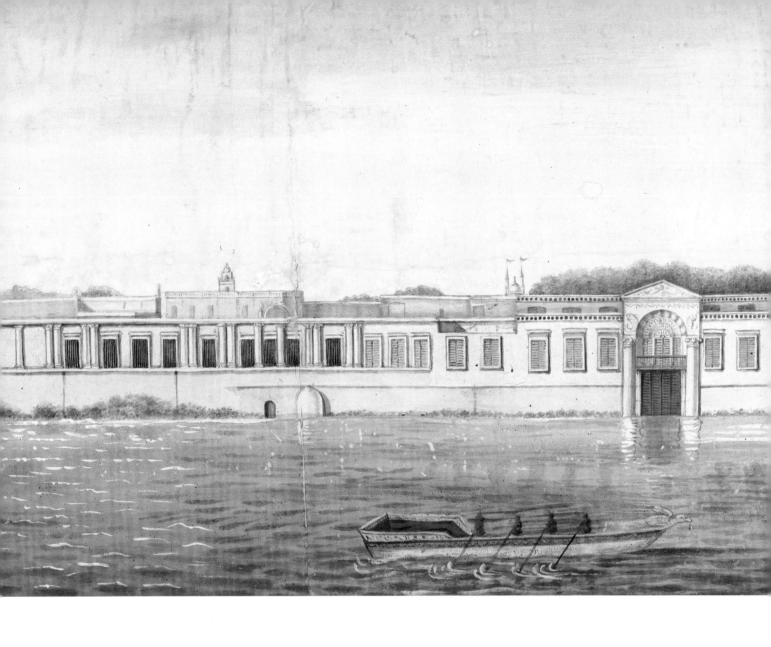

Another royal symbol was the crown of the nawabs of Awadh, which is seen on a few surviving samples of both chikan embroidery and very fine *jamdani* muslins, all possibly for use by the royal family. The crown itself was introduced in 1819 when the Nawabs, supported by the British, affirmed their independence from the Delhi Moghul court and proclaimed themselves as monarchs of Awadh.

The design and shape of the crown was consistent with the hybrid Lucknow decorative style combining western and self-styled aesthetic models adopted by the Nawabs. It was a departure from traditional Mughal-inspired turban crowns, and was designed by an European artist, Robert Home, working for the Awadhi court. It consisted of a 12-pointed diadem entirely covered with diamonds around a big ruby in the centre. It was lined with red velvet and sported a plume emerging from the centre. A stylized version of this kind of crown appears both woven on fine *jamdani* and embroidered in chikan on fine muslin.

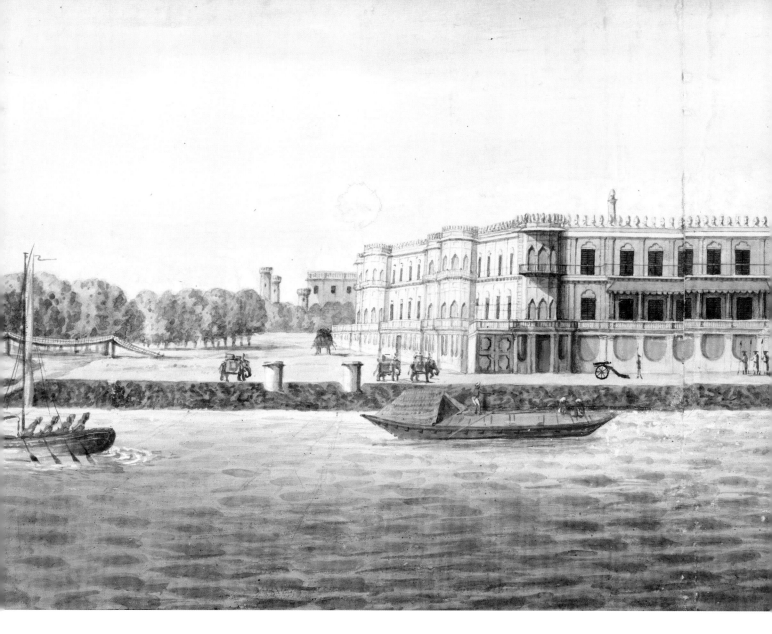

NOTES

1 See : Sheila Paine, Margaret Swain, Sonia Ashmore.

2 Markel, Stephen. "This blaze of wealth and magnificence" : the Luxury arts of Lucknow. In : *India's fabled city: the Art of Courtly Lucknow.* Los Angeles County Museum, 2010:199-200.

3 Stephen Markel. 2010 : 199-200

4 Personal communication by Mr. Muhd Ali, printer. However it is generally believed that the buttoning towards the left for man and towards the right for women is linked to ancient practices, when (well to do) ladies were helped in their dressing by maids who, standing in front, would find more convenient to have the buttons on their right side.

5 Curley, David L." Voluntary relationships and royal gifts of Paan in Mughal Bengal". In : *Robes of Honour : Khil'at in Pre-colonial and Colonia India.* Ed. by Steward Gordon. New Delhi: OUP, 2003 :52

6 Curley, David L.Id. 2003: 52.

7 http://rajakelkarmuseum.com/default/collection/c-tambool.htm

8 the pattern drawer

9 In Persian boteh means bush or shrub, it is also known as kalka or paisley.

10 Dr. Cyrus Parham, leading expert in Persian tribal history and art, published in 1999 in *Nashr-e Danesh,* vol.16, no. 4, 1378, Tehran

11 Dr. Cyrus Parham, leading expert in Persian tribal history and art, published in 1999 in *Nashr-e Danesh,* vol.16, no. 4, 1378, Tehran

12 Valerie Reilly. The Paisley Pattern. Glasgow: Richard Drew, 1987:10

13 Dr. Cyrus Parham, leading expert in Persian tribal history and art, published in 1999 in *Nashr-e Danesh,* vol.16, no. 4, 1378, Tehran

14 Personal communication by Muhammad Ali, well known printer and designer in today's Lucknow chikan industry.

15 Roger G. Cavanna. The 'pregnant botteh' mother and child. *Oriental Carpet and Textiles Studies.* 5i 1999:115-120.

16 Personal communication by Mrs Mamta Varma, Bhairvi's chikan, Lucknow.

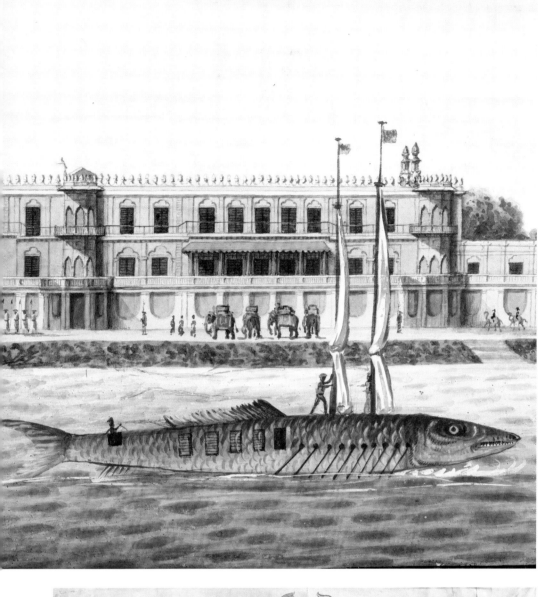

Illuminated top frame with Wajid
Ali Shah's fairy fish emblem
Lucknow, 19th century
V Thapar's Collection, Delhi

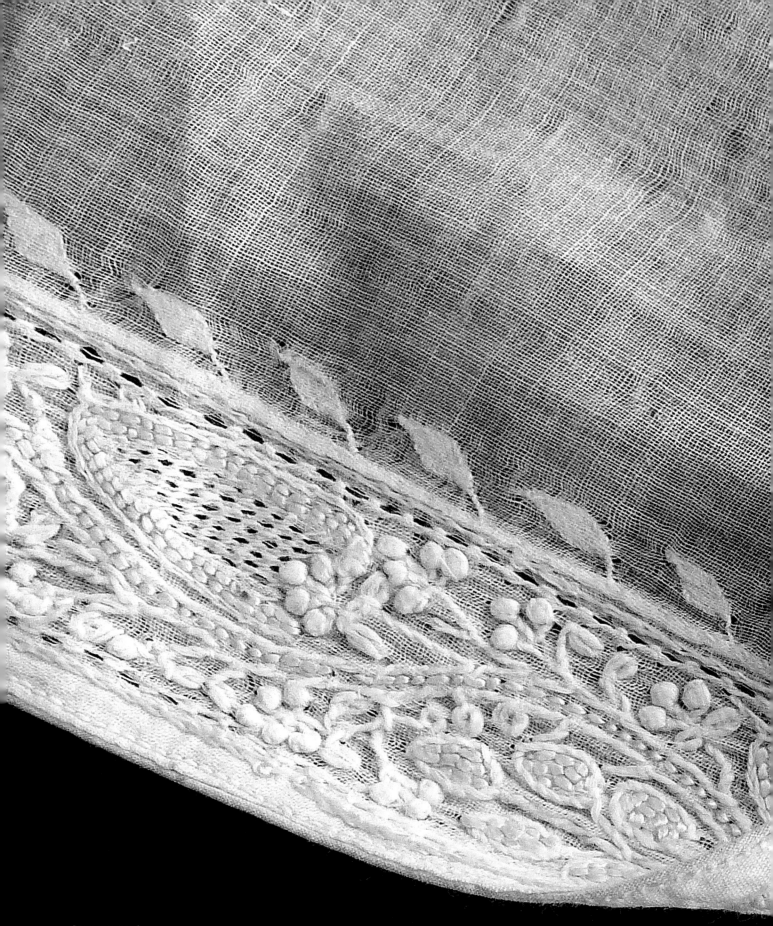

CHAPTER 6

Embroidery Stitches and other Needlecrafts

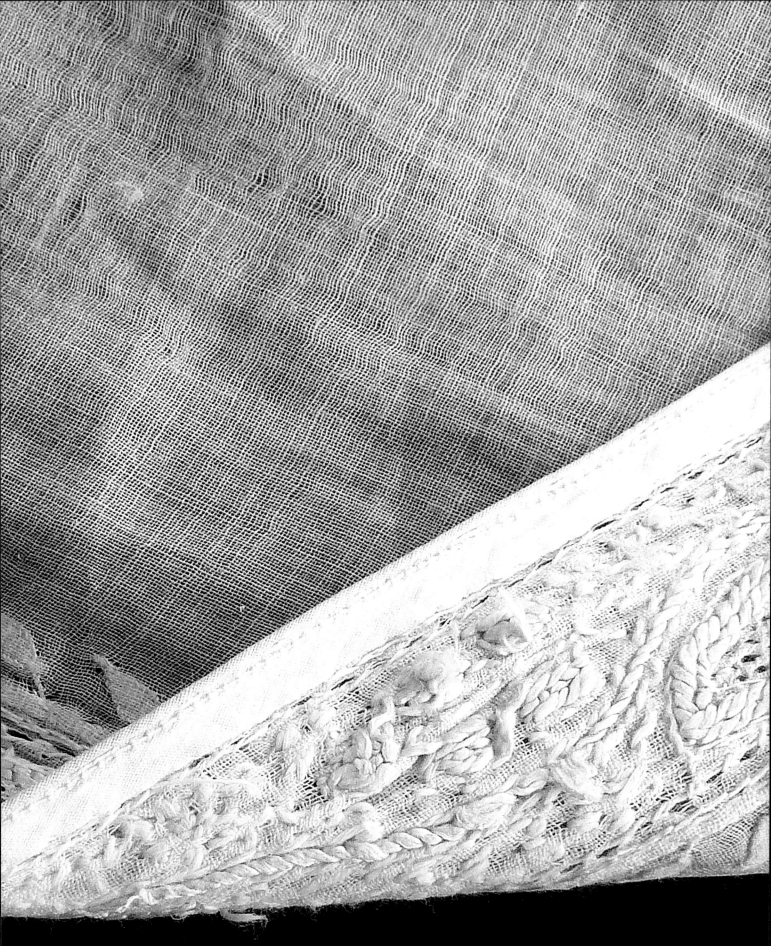

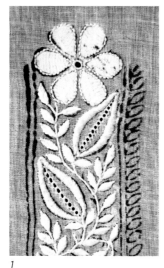

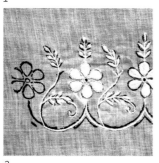

Previous page: Choga detail
A separately embroidered border
attached with a fine turpai stitch
and embellished with tiny katao or
appliqué work. At the edge, a dori
piping gives support and strength
to the fragile muslin.
Lucknow, late 19th or early 20th
century, cotton muslin with cotton
and silk embroidery
O. Getto's collection, Turin

1 & 2 Embroidery in progress on
two sample swatches by SEWA-
Lucknow
Late 20th century, cotton with
cotton embroidery

3 Keiri
A multiplicity of stitches with a
perfect balance of rythm and
textures. Excellence in chikankari
craftsmanship is still alive.
Bhairvi's Chikan, Lucknow
2014

"We tend to think of embroidery in terms of technique: stitches, needles and thread. This is surely the medium of expression. And certainly, finesse of stitch is one measure of quality. But just as good handwriting does not ensure good literature; there are other equally important concerns, particularly in tradition-based work…"[1]

The "technical" descriptions of chikan from Lucknow by and large have been focusing on the "multistage interdependent process" of this craft and each stage has been analysed in its components, leading to deep insights and appreciation of this complex tradition. However, the emphasis has generally been put on embroidery which has often failed to convey the delicate balance achieved in the combination of all its constituting elements: the fabric, the patterns, the sewing, the embroidery and the trimmings of this very distinct dressmaking style. In face all these elements together have contributed to the legend of *chikankari* from Lucknow, as an expression of that *"system of delicacy,"[2]* of *tehseeb* and *nafasat*, the sophisticated lifestyle Lucknow became so famous for.

Not just embroidery *per se* and what revolves around making it, but other needlecrafts and tailoring skills of the *darzi*, like *katao, jawa, daraz* or the delicate piping cords edging on many old costumes are also part of the chikankari tradition.

Stitches

Describing the stitches used in chikan embroidery might appear a simple and straight forward listing of technical skills, which artisans master with various degrees of competence, but actually it is more complex than that. The stitches and how well they are executed are one aspect, but others relevant factors concern the artisan/designer's choice of the blocks-designs, the placing and spacing of the blocks within a composition, and last but certainly not least, the choice of stitches and the interplay of their different textures.

The tracing on the fabric conveys hints about the suitable workmanship for that particular design in coded graphic language, but each tracing can be interpreted in more than one way. How the master embroiderer balances the opaque and the transparent elements, the different textures whether raised or flat, the nettings of the *jali*, the empty space between the designs, the tiny typical *butis* punctuating and enhancing other motifs—all these are also very important interdependent elements.

They might be dictated by the aesthetic codes of chikan craft acquired during apprenticeship, but they also reflect the personal aesthetic preferences of the individual craftsperson. Furthermore, in the last twenty five years, the Indian fashion world has been playing a crucial role in redefining the aesthetic of contemporary chikan.

Personal interpretations of a same block are particularly evident on the embroidered samples submitted for craft awards by master embroiderers since the late 1950s on which they displayed their best craftsmanship and artistry. The more skilled and artistic the embroiderer, the more she/he experimented with different stitches and textures, at times even creating new ones. However, because these pieces were meant as examples to display both the excellence and the extent of the artisan's skill on a limited space, they should be considered more as artistic 'samplers' than as samples of that 'delicate wholeness' of chikankari mentioned before.

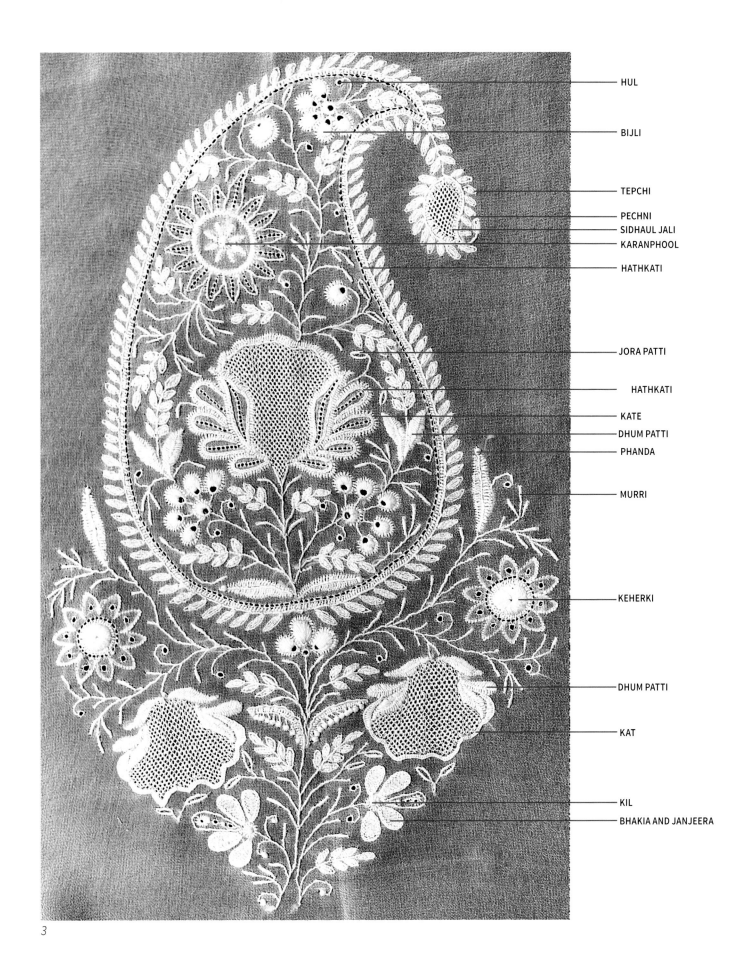

HUL

BIJLI

TEPCHI

PECHNI
SIDHAUL JALI
KARANPHOOL

HATHKATI

JORA PATTI

HATHKATI

KATE
DHUM PATTI
PHANDA

MURRI

KEHERKI

DHUM PATTI

KAT

KIL
BHAKIA AND JANJEERA

3

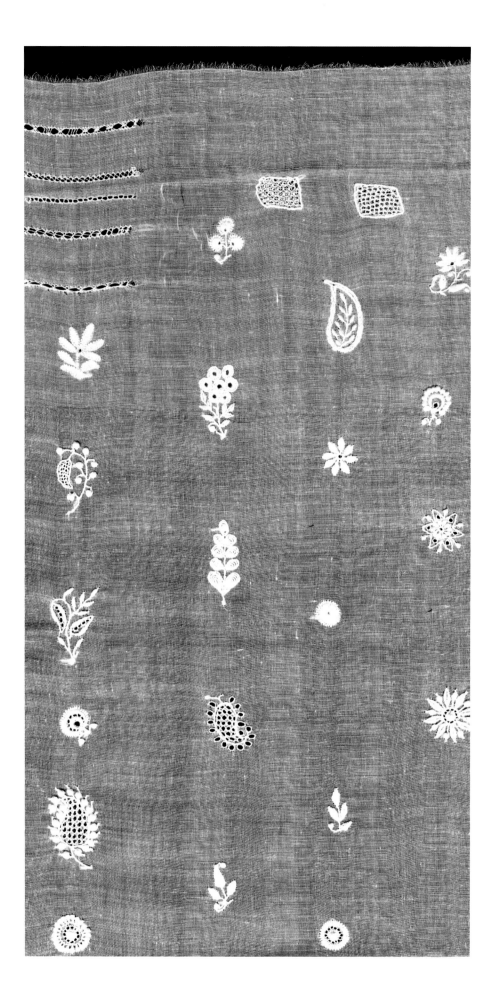

Sampler showing most of the stitches of chikankari, by the late Rukhshana, master craftsperson at SEWA-Lucknow
1992, cotton with cotton embroidery
Authors' collection, Milan

An intriguing issue is the "number of stitches" in chikan embroidery, which is also related to the discrepancies in the names given to some of the stitches. Sometimes the same name might actually correspond to different stitches or that there may be different ways to work the same stitch.

There is no codified or standardized listing of stitches with corresponding names and technical diagrams. I did one such list, for my own reference, based on the sampler made by Rukhshana for me at SEWA-Lucknow in the early 1990s, but later on I noted differences in the technicalities followed by other artisans. Eventually I began to question my own attempt to establish a 'definitive' inventory with names and diagrams. The transmission of this craft was and is done through demonstration, imitation, trials and errors and a lot of practice, more than looking at diagrams…maybe it should remain that way! The concept of diagram itself might be questioned too, as more often than not, whenever I have shown one to the artisans, they find them to be rather obscure hieroglyphs.

How many stitches…33, 40, 52, 75 or more?

Literature promoting Lucknawi chikan and some master craftpersons have a tendency to stress, as evidence of the sophistication and intricacy of the skill, on a rather considerable number of stitches proper to chikan embroidery. Some accomplished artisans claim to know up to 75 stitches,[3] while others admit to more modest repertoires of 36 or 52! The sampler made by Rukhshana, one of the most accomplished craftswomen from SEWA-Lucknow in the early 1990s, for example, includes 33 'stitches'.

However, many artisans also agree that the confusion stems from the fact that little motifs that are achieved by combining sequences of stitches and that form individual units, are actually assimilated to separate stitches. These 'compound stitches' generally follow a specific sequence, but at times on particularly creative pieces there are unusual interpretations, such as instead of the *phanda* or the little pearl like shape in the middle of the motif there is a *hul* stitch.

Some stitches have acquired distinctive names. However sometimes it is difficult to match the name with the stitch, especially in the lattice or *jali* works: as different people or literature might identify the *jalis* differently. There seems to be no consensus among the artisans on the number of *jalis* or open works that exists, the UP Crafts Council brochure, published in the '90s, has identified six *jalis* with distinct look and technical execution.

Siddhaul (or *sidhaur*) *jali* is the most common and easily identifiable open work on which there is a general consensus. But as far as other *jalis* are concerned, there are many discrepancies in their names.

C. Wilkinson-Weber suggests that the difference in numbering the stitches and their names might correspond to distinct neighbourhood traditions and she gives the example of the *phanda* stitch and the *cikan*, a very similar stitch, which can be round (*gol cikan*) or elongated (*lambi cikan*), in which case it would be otherwise referred to as *dhaniya patti*. Another reason for the discrepancies could be "related to the more informal structure of learning and practice established within the household compared to the karkhana."[4]

Although the look appears almost identical, *phanda,* often confused with the French knot stitch, can be made in two different ways. The subtle distinctions was shown to me one day by Muhammad Ali. Since there is no codification of the names, the names of less common stitches or their spelling (in hindi) might also differ.

It is interesting to look at how chikan embroidery was described at the time when some of the finest pieces shown in this book might have been made .

…It seems desirable to give the position of importance to that [chikan] of Lucknow, though in historic sequence it is probable that the craft originated in Eastern Bengal and was only carried to Lucknow during the period of luxury and extravagance that characterised the latter term of the Court of Oudh. The Kings of Oudh attracted to their capital many of the famous craftsmen of India, hence Lucknow, to this day, has a larger range of artistic workers than are to be found in almost any other town of India. Lucknow chikan work is perhaps the most artistic and most delicate form of what may called the purely indigenous needlework of India. The following is a brief enumeration of the chief stitches George Watt. *Indian Arts at Delhi,1903, pp 399-401* used by the Lucknow embroiderers:

(a) TAIPCHI
This is usually done by women and is the cheapest form of work. It consists of a sort of darn stitch in which the thread is drawn through the fabric in more or less parallel and straight lines. The design is simply outlined and it is ordinarily done on muslin.

(b) KHATAO (or KHATAWA)
This is a form of appliqué' produced on calico or linen, never on muslin. Minute pieces of the same material as the fabric are sewn to the surface, in a lavoration of the folia and floral designs, these are so minute that it requires very careful observation to detect that the design is mainly in appliqué', not embroidery. The details are then filled in by taipchi or some of the other stitches to be shortly described. Khatao is one of the two forms of what are collectively designated the flat embroidery of Lucknow, in contradistinction to the forms of embossed or knotted chikan work.

(c) BUKHIA
This is the true flat chikan work of which khatao is but a cheap imitation. It might be described as inverted satin stitch. In other words the thread is mainly thrown below and is employed in effective opaque spaces and lines on fine muslin. The needle nips the material on the upper surface by minute stitches thus outlining the petals, leaves, etc., while the thread is carried below and accumulates in compact masses, until the fine muslin on the embroidered portions is no longer transparent. It is this effect that the skilful worker desire to produce and which has received the name of bukhia.

(d) MURRI (rice-shaped)
This form is practiced on muslin only. The thread may be described as forming numerous knots or warts of a pyriform shape. These are in reality produced by a sort of minute satin-stitch but the embroidered patches rarely exceed one-eighth or even one-sixteenth of an inch in size, and thus look like French knots.

It is interesting to mention that as it has been pointed out "chikan knowledge is highly contextual"[5] and a visual reference is often essential to bring back to mind a particular stitch not commonly applied, or a combination of them. This underlines how essential it is to provide access to artisans to high quality samples and visual documentation to reference pieces illustrating the best of their own craft tradition.

Many stitches are technically similar to foreign white-work embroideries[6], but other stitches have no equivalent elsewhere and particularly most of the compounded stitches are a rather unique feature of Lucknawi chikan. According to Margaret Swain, an eminent specialist on Western white-work embroideries, and particularly on Ayrshire embroidery, the fine floral needlework on sheer muslin from Scotland shares the most similarities with chikan. Still, it is the way in which *jali* work is executed that identifies a piece unequivocally as Lucknawi chikan.[7]

Other technicalities include the side, right or reverse, on which the embroidery is executed. Some stitches are done on the right side while other are executed on the reverse, or the direction in which the embroidery develops. Some authors have emphasized that in India the needle points outwards away from the body of the artisans unlike in other western traditions.

(e) PHANDA (millet form)

(e) PHANDA (millet form)
This is simply a small and less elongated condition of murri stitch. The knots are very minute and practically spherical, that is to say, not drawn out (or pear-shaped) as in murri. The presence of phanda is the surest indication of the high class of the work. The knots are very frequently not more than one thirty-second part of an inch in size and in that case are aggregated together to form the filling of leaves and petals. This is one of the most graceful developments of Lucknow embroidery and the one that may be described as most characteristic of this great centre of needlework.

(f) JALI (fishing net)
This when met with in chikan work is commonly spoken of as drawn stitch, but as a matter of fact the Lucknow embroiderers regard the drawing out of a thread (tar) as a slovenly imitation of true jali embroidery. In true jali the strands of the warp and weft are pushed on one side by the needle and held in that position by a sort of extremely minute button-holing. There are various forms of jali in Lucknow chikan.
The chief are the following :

MADRASI-JALI
This consists of a series of minute squares usually about one-sixteenth inch in diameter. Of these one is opened, the other left closed and third broken into four still more minute openings.

CALCUTTA-JALI
(as produced in Lucknow) consists of a series of openings one-half the size of the Madrasi-jali but assorted in parallel bands with alternating bands not perforated. In neither of these forms are any threads drawn out.

SIDDHAUR JALI (simple Jali)
(usually produced by women) is drawn jali and is the form seen in all cheap work. The openings are irregularly shaped, approximately squares, but usually not bound by button-holing in any form. In Calcutta chikan work this is called box-work, especially in the larger or coarser condition as practised with calico and linen tea-table covers.

A feature of Lucknow chikan must be mentioned, namely that yellow or tasar silk is largely used in the filling of petals or leaves. Phanda work is, as a rule, done in tasar. This peculiarity instantly distinguishes the chikan work of Lucknow from that of the rest of India. " (pp. 399 – 401)

It is worthy of note the minute way in which the katao was executed in former times, and yet was considered "*but a cheap imitation*" of bhakia work. It is a nearly extinct form of craftsmanship, but one finds it an endless source of wonderment.

Although this seems to be generally the case, this shouldn't be taken too rigidly as the needle might points in various directions, though mainly upwards,[8] following the meandering of the design as well as the individual artisan's way of holding and turning the work in her hands.

The stitching techniques involve also the holding of the fabric tightly across the fingers (*cutki*) or the use of a small hoop, which is now most widespread, especially with women artisans. Wer observed the hoop is rarely used by the few male artisans we have met.

There is a tendency to glorify 'old' pieces as authentic and excellent, and the 'new' as corrupted or somehow 'degraded'. However, when one compares antique pieces of the finest *chikankari* with contemporary ones of comparable workmanship, such a statement is debatable. The variety of stitches and the combination of different textures has probably never being so rich and diversified as on contemporary designs, comparable to some antique *katao* or appliqué works whose finesse of execution defies imagination and makes one wonders about the identity of those dexterous and tiny fingers which have made such extraordinary pieces! A few antique pieces are astonishing for the even quality and minuteness of the *katao* work, further enhanced by the contrasting yet subte effect of the combination with embroidery work. These pieces are of incomparable quality.

*1a & 1b Dorukha chikan - reverse
(top) and right (below) side
Lucknow, 19th century, cotton
muslin with cotton embroidery
Nawab Mir Jafar Abdullah's
collection, Lucknow*

*2a & 2b Anokhi chikan
Front and reverse sides, by Shilp
Guru Ayub Khan, Lucknow, late
20th century, cotton with cotton
embroidery
Ayub Kan's collection, Lucknow*

The remarkable vitality of the chikan industry as well as the uninterrupted success of chikan embroidery from Lucknow for more than two centuries seems to be rooted in its ability to absorb and integrate, while reshuffling and re-interpreting into its own idiom and aesthetics, foreign elements and to make them "traditional".

The rhythm of the embroidery on the oldest surviving pieces would generally play with a limited repertoire of stitches, however their combinations and permutations are sometimes amazing. The "limited" repertoire would include the following stitches : *phanda, bhakia, kil/keal, urma/pechni, rahet/dhora bhakia, janjira, hatkati* and *jali,* or else with *teipchi, dhora bhakia, urma/pechni* or *janjira* and *jali*. Moreover the finest pieces have elaborate *jali* works, such as *madrasi, bangla* or *chataya jali,* among others.

In the oldest known technical description of the stitches typical of chikan embroidery from Lucknow dated 1903, George Watt[9] divides the stitches in three categories: flat/opaque, raised /knotted as "the most characteristic" and the *jali* works. It has often been maintained that such division corresponded to the distribution of the work among more or less skilled artisans and therefore also to different qualities of products and different markets for these products.

In thirty years experience with *chikankari*, the main division of work I noticed concerns the artisans doing *turpai* and *darz* (hand-stitch seams) and the ones doing *karhai* (embroidery), and among the latter, the more elaborate or fine works on precious textiles, like silks, will obviously be entrusted to the more experienced and skilled artisans.
The mass produced, low quality, thick thread contemporary needlework plays with a very limited repertoire of stitches and it is executed by artisans who would generally know at most five or six stitches and often they will only do one or two!
The *jali* work, even the most common *sidhaur jali*, is produced by more experienced mbroiderers.

Dorukha Chikan
Antique pieces were sometimes embroidered in dorukha style, the reverse side of the embroidery being as neatly worked as on the right side, achieving a reversible look but with a subtle different texture. Albeit rare, it is an art which has not disappeared as some remarkable samples by Sewa's and by Bhairvi's chikan can confirm.

Anokhi Chikan
A special mention should be given to "*anokhi*" chikan, an amazing accomplishment, seen more on contemporary pieces than on antique ones. The most virtuosos among the masters craft people have been embroidering only on one side of the sheer muslins, the needle not piercing fully through the light cloth! It is an extraordinary technique quite rarely seen also on antique Kashmir shawls, but it is a truly incredible accomplishment on fine textiles.

212

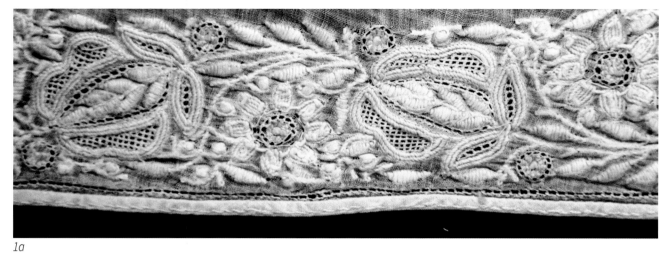

1a

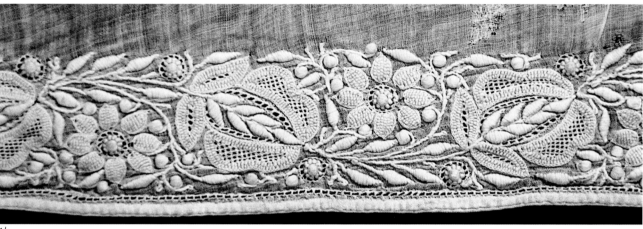

1b

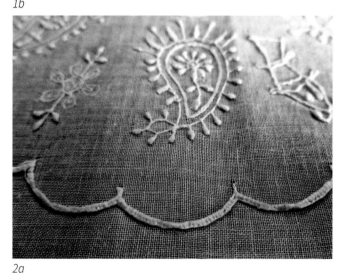

2a

2b

1

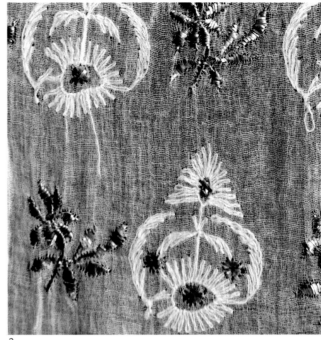

2

1 & 2 Tepchi stitch with kamdani embroidery, detail
Cotton muslin with cotton and silver wire (badla)
Tapi Collection, Surat. Acc. N. T.09.45

3 Tepchi with jali and hul
This very simple stitch may attain a variety of aesthetic effects, depending on the fineness of the cloth and of the thread playing with the spacing and the length of the stitches.
Cotton with cotton embroidery
Lucknow Chikan Hand Embroidery Work: A Collection of Kedar Nath Ram Nath & Co.
Crafts Museum, Delhi

4 Unstitched dopalli cap embroidered with tepchi and hul.
Cotton muslin with cotton embroidery
Rajasthan Fabrics and Arts Collection, Jaipur

5 A sample from the album 'Lucknow Chikan Hand Embroidery Work: A Collection of Kedar Nath Ram Nath & Co.'
Lucknow

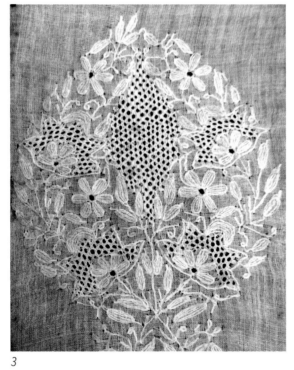

3

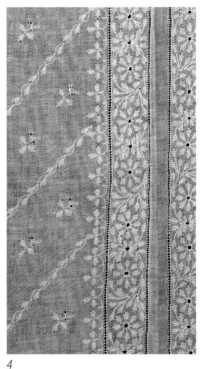

4

214

The listing of chikan embroidery stitches below will indicate the local common name (with possible variations both in the name or in the spelling) along with the corresponding English name, when it is available. There are instances when the analogy with Western embroidery might be debatable, but the corresponding English name facilitates the general identification of the stitch.

Comparing the descriptions given by a few authors with my own notes and observing the embroiderers at their needle work, it appears that there are different ways in which some stitches are executed. As mentioned above, artisans who have learnt in different environments might work slightly differently, although the final look appears identical. The intention of this chapter is not to standardize the diagram of a stich, whenever we show one it is chiefly to clarify the subtle differences of similar looking stitches.

TEPCHI [10]
Running stitch or Darning stitch

Tepchi appears as a thin line with stitches of equal length (about four threads) over the cloth, and passing below one or two threads. It is normally applied on thin mulmuls. It is used for outlining and for filling ornamental motifs.

Tepchi work is generally applied to the entire piece, but for the areas of open/*jali* work. It creates delicate and diaphanous effects against the transparency of the mulmul, a characteristic that has often approached it to *jamdani* weaving.

"There is a class of goods that neither seems to find a place as chikan work as ordinarily accepted nor under kamdani [light embroidery in which gold and silver wire are used] as just defined. These are the piece-goods that might be spoken of as hand-embroidered jamdanis. Chikan work though doubtless it includes piece-goods usually has the more restricted meaning of special embroideries, such as prepared chogas, special panels for dress, cuffs, collars, caps, handkerchiefs, etc..." [11]

Tepchi work appears on antique fragments of trade textiles dated 18th century from Bengal, [12] as shown earlier in the book and on pieces goods dated second half of 19th century for export, it is often also combined with *kamdani* embroidery.

The directions of the filling lines, the spacing or the density of the needlework are possible variations that contribute to the versatility of this stitch. *Tepchi* is used also as foundation for other stitches, like *pechni*, *balda* or *kaj*. It is a form of basting used as foundation stitch [13] for *balda* and *kat* stitches.

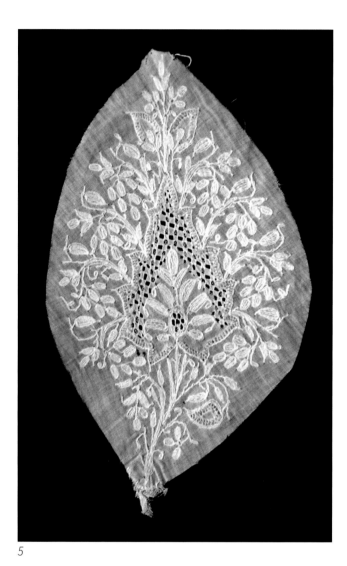

5

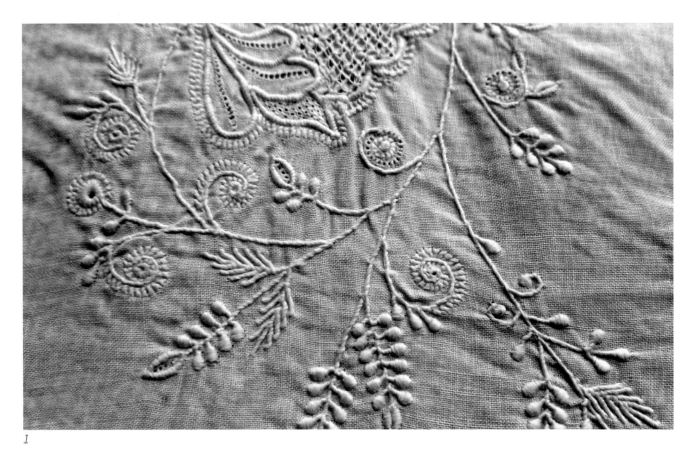

1

1 Trailing stems embroidered
with pechni stitch
Cotton with cotton thread
embroidery
Crafts Museum Delhi,
Acc. No. 69/5004

PECHNI[14] (Tepchi Pechni)
Running Stitch: Whipped or Overcast

Pechni is most widely used in chikan for depicting the trailing stems and tendrils so typical of chikan decorative idiom. It might also be used for thin outlines of motifs or as parallel lines in which case a line of *hathkati* or linear open work will be worked in the centre.

Once the *tepchi* stitch has been made, the needle travels back whipping over each stitch again, in a direction from above downwards generally without picking at the cloth underneath. There are different ways in which the needle whips around the stitch : it might always enter and exit the foundation stitch from the same direction or it might enter from the side it previously exited. At a casual glance, *pechni* might be taken for *rahet* (stem stitch).

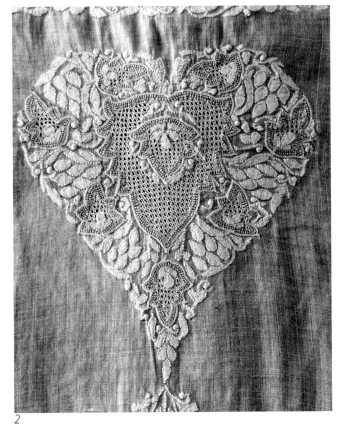

2

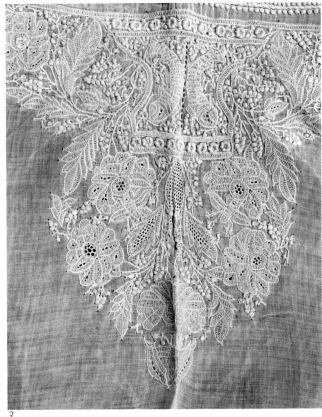

3

4

Rahet
Different visual effects and texture
of rahet or back stitch worked on
the reverse side of the cloth, as a
delicate outline, or as filling stitch.
Cotton with cotton thread and
(muga or tussar) silk thread
embroidery

2: Olga Getto's collection,
Turin; 3: Rajasthan Fabrics
and Arts Collection, Jaipur
4: Crafts Museum, Delhi,
Acc. No. 64/3084

RAHET[15]
Stem stich

"*It is a stem stitch worked with six strands of [caccha] thread on the* wrong side *of the fabric [...]*
It forms a solid line of back stitch on the right side *of the fabric and is rarely used in its simple*
form but it is common in the double form of dohra bakhya as an outlining stitch."[16]

According to some artisans, *rahet* also defines two parallel lines of back stitch with a line
of *hathkati*/open work in the middle, as described earlier with *pechni*. This combination is
often seen for the stems of flowers or for the contour of *keiri* and *paan* motifs. Widely used on
antique pieces, often worked with golden color tussar or muga silk, it is also frequently used
as a filling stitch in small motifs.

DOHRA BAKHIA
Two lines of back/stem stitch

Two compact parallels lines of rahet are sometime called *dohra bakhia*. It is a double line of
rahet stitch worked in tiny and close stitches on the wrong side of the fabric. On the right side
it appears as two lines of tiny back stitches. It is often combined with a very fine line of *janjira*
on the outer contour and with *jali* /open work inside the outlined motif. On antique and fine
quality pieces *dohra bakhia* is generally executed with golden muga or tussar silk.

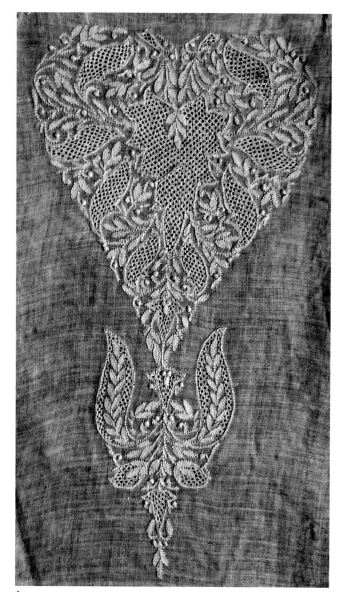

1

BAKHIA (Bakhya[17] or SHADOW)
Close Herringbone Stitch

It is the most common stitch in commercial chikan to the extent that it has often been identified with chikan embroidery itself. It is frequently called also by the English name 'shadow'. The word *bakhia* is believed to be of Persian origin meaning a 'kind of back stitching'.[18] It is worked from left to right on the wrong side of the fabric. On the right side it appears as a double row of compact back stitches defining, through the gossamer cloth, an opaque nuance like a light shadow. The crossing of the thread on the back forms a slightly raised texture on the right side.

It is predominantly used for working flowers, petals and leaves, for delicate outlines and for thin meandering stems and tendrils. On antique pieces this stitch is executed with extraordinary finesse and on the diaphanous fabric the minute stitches of *bakhia* on very small motifs, create most graceful ornamentations. On the other extreme, *bakhia* on commercial pieces is executed with long strokes and the crossing of threads on the reverse is so sparse that it bears no resemblance at all with the finest workmanship.

ULTI BAKHIA
Close Herringbone Stitch

Technically, it is the same stich as shadow, but it is worked on the right side of the fabric, the cris-crossing threads adding yet one more textural effect to the already vast repertoire of chikan, but it is not very common. It does not appears on antique pieces, it is however quite frequent on contemporary commercial and bold works with rather thick textures.

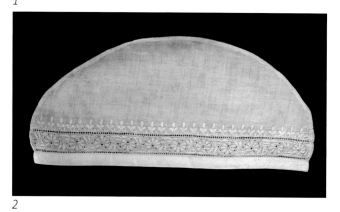

2

3

1 Bakhia or shadow work, single line of rahet for contour of sidhaul jali and phanda
Cotton with cotton thread embroidery
Crafts Museum, Delhi. Acc. N. (38)

2 Dopalli topi with a delicate border combining bakhia and hul, defined between two lines of hathkati
Rajasthan Fabrics and Arts Collection, Jaipur

3 Detail of a sari border worked with bakhia executed with silk blue thread
Lucknow, second quarter of 20th century, silk with silk embroidery, Author's collection

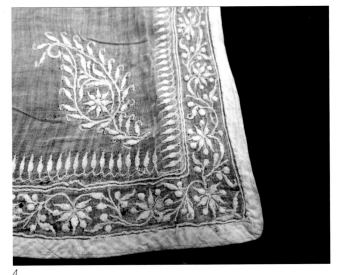

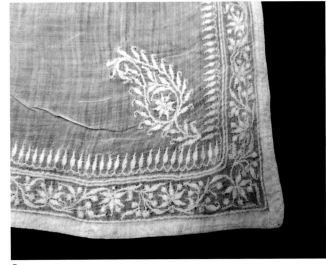

4

5

KHATAO[19]

Applique' work with blind hem stitch

Technically khatao is not an embroidery stitch but a sewing technique. It consists of tiny pieces of fabric patched on the main fabric with fine ordinary hemming. The raw edges of each tiny patch are turned under and neatly hemmed all around.

Khatao was generally done on fine calico or linen, more than on muslin. Used to interpret foliage and floral designs, the antique khatao work is characterized by the remarkable minuteness of the appliqué pieces and the precision of the almost invisible sewing. Appliquè was done on the reverse side, so that it would appear as a diaphanous shadow through the fine cloth and for this reason at a casual glance it can be confused with shadow (bakhia) work. But generally other embroidered details and trailing stems were added with stitches as teipchi, pechni, hul or hatkati to add elegance and gracefulness.

On some antique samples tiny flowers are embroidered on the right side with raised stitches, like phanda, further enhancing the complexity of the textures of these extraordinary works. Looking at the minuscule fragments of such perfectly neat appliqué work, it is difficult not to recall the observations of W. Hoey in the 1880s quoted earlier : ""*It is only when one wanders round the city enquiring about trade that one can get any idea of the extent to which the working of chikan is pushed. Little girls 5 or 6 years of age may be seen sitting at the doors of houses near Chob Mandi busily moving their tiny fingers, over a piece of tanzeb and working butas (flowers) and helping home by their earnings which are little enough, only one paisa for 100 butas...*"[20]

The artisans inspite of their talent and their artistry taken to such unbelievable aesthetic and technical virtuosity could not even make a decent living with their work. Only very few exquisite samples dispersed in private and public collections across the world bear testimony of their master craftsmanship.

4 & 5 Reverse and right sides of very minute katao or fabric appliqué ,and dori or thin cord also appliqué
Lucknow, late 19th or early 20th century, cotton with cotton fabric embroidery
Weavers Studio Resource Center Archive, Kolkata

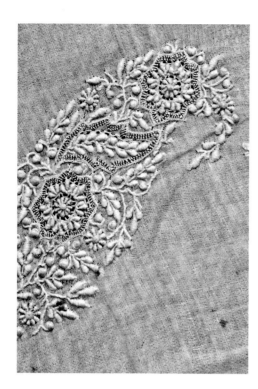

JANJIRA
Chain Stitch

It is a tiny chain stitch worked on the right side of the fabric. *Janjira* is used to outline leaves or flower shapes, and on antique pieces, it is worked with such thin thread and such tiny stitches that it becames hardly decernible to the naked eyes. *Janjira* is also used as foundation/padding stitch for *kauri* stitch.

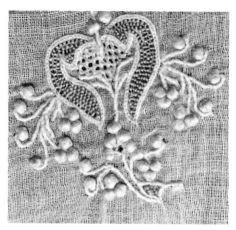

Janjira
FAR LEFT: A n exquisite keiri, with combination of lambi and gol murri, phanda, janjira and rahet in golden color silk, with kils and pechni stitches
Lucknow, late 19th or early 20th century, cotton muslin with cotton and silk embroidery
Crafts Museum, Delhi, Acc No.92/7804(2)

LEFT: A small buti

KATE or BANARSI[21]

It is a simple twisted stitch which has no corresponding stitch in English. It is a fairly common stitch worked on the right side of the fabric. It is used as a decorative outline in various composite stitches such as *kangan, keher ki, bijli, kil*, etc. In recent works, *kate* or *banarsi* stitch is often seen as an ornamental 'spiky' outline on various motifs like leaves, flowers or *keiri* following the creative inspiration of the embroiderer.

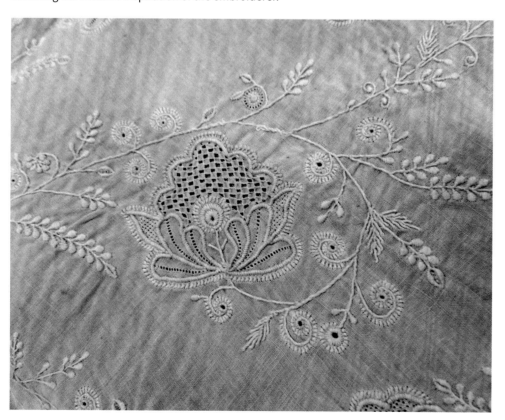

Kate
Kate is here applied to express convoluted tendrils with a little hul in the centre, and the tiny rays of the bijli inside the flower motif
Crafts Museum, Delhi.
Acc. No. 69/5004

HUL [22]
Detached Eyelet Stitch
It is a tiny hole punched in the fabric with the needle, teasing apart the warp and weft of the cloth. The hole is held in place by tiny straight compact stitches all around and it is worked on the right side of the fabric. It often forms the centre of a flower[23] or it is part of various composite stitches.

Hul

By breaking the consistency of the cloth with tiny dots, hul punctuates the embroidered compositions in endless different ways

Lucknow, late 19th or early 20th century, cotton with cotton embroidery

Rajasthan Fabrics and Arts Collection, Jaipur

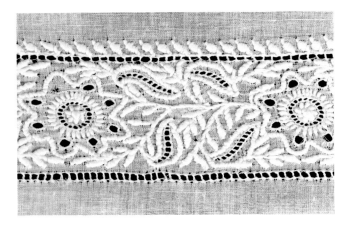

KAT [24]
Button-hole Stitch with the variations of Wheel Stitch or Blanket Stitch

"This stitch is worked like ordinary buttonhole stitch but in circular form, each stitch being taken into the same central hole. In this way the fabric is pulled apart and leave quite a large hole in the centre of the buttonholing. It is generally used for tiny flowers."[25]

In this stitch, according to C. Wilkinson-Weber and in my own experience too, a couple of threads at the centre might actually be broken, to ease the open effect. *Kat* is also used to embroider the scalloped edge of a piece, especially on contemporary table and bed linens, in which case the interlocking of the stitch will be towards the outer edge. When it is used within a motif, the interlocking of the stitch might be towards the center of the motif.

Kat

Kat is another versatile stitch, used creatively for edgings and fillings. It forms dots if worked in circle or it fills little leaf motifs if worked back to back

LEFT: Crafts Museum Delhi
RIGHT: SEWA-Lucknow

Shakeela, from Bhairvi's Chikan, has been using kat in a rather unusual way on leaves, working two lines, back to back, so that the interlocking of the stitch forms the central spine of the leaf.

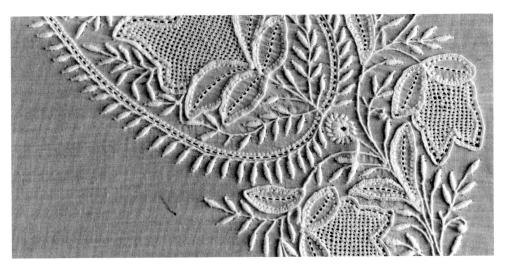
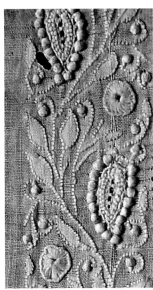

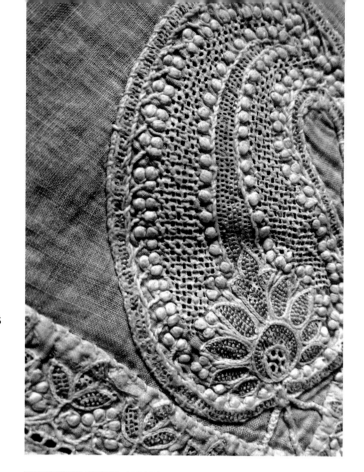

MURRI -PHANDA WORK

Murri-Phanda generally defines a category of chikan embroidery characterized by embossed or *mota* stitches, like *murri* and *phanda*, but it might also just define the embroidery work with a variety of textural effects achieved through the combination of many different stitches. Considered to be a more intricate and difficult needlework than the *bakhia* or shadow work, *murri-phanda* work supposedly identifies higher quality workmanship by the more skilled artisans. Unfortunately, in today's context, the above is not necessarily true as the required fine and painstaking workmanship is often often circumvented by using thick threads, at times with up to sixteen or even more strands of *caccha* cotton, so that the thick embossed stitch is done with a single stroke of the needle.

On antique pieces, the tiny delicate *phanda* are often combined with very fine *bakhia* and *dohra bakhia*, or with *murri, hul, kil* and a variety of extremely fine *jali* works.

PHANDA[26] -

Phanda looks like a tiny round pearl studded on to the cloth, and it has often been wrongly compared to the French knot stitch. There are different ways to do the *phanda*: S. Paine describes it as "a blanket stitch [is] made with a long left arm and two small ones are worked close to it on the right[27], from this point one horizontal stitch and two vertical stitches are made, repeated three to four times to form a small round, compact pearl like shape. The long base of the first stitch is then whipped."

Another way consists of several tiny satin stitches, overlaid on top of each other, each stroke entering and exiting through the same opposite holes. In yet another variation, at each stroke the needle might pass through a kind of loop, like superimposed *janjira* or chain stitches. The *kacca phanda*[29] is made with less overlaid stitches and therefore it appears more flat than the otherwise pearl-shaped *phanda*.

DHANIYA PATTI [30]

Dhaniya patti is technically like the *phanda* stitch but it has a little stem protruding out at the top. It is not a very commonly used stitch.

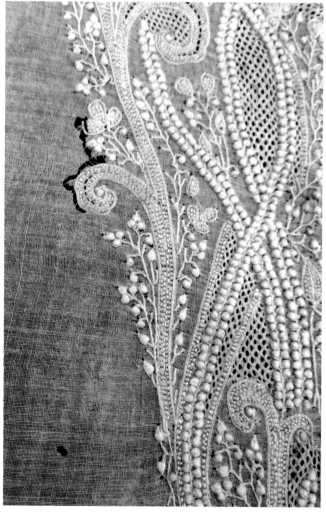

Phanda

Like strings of tiny precious pearls or like a delicate flower bud. It might be sparsely scattered among other stitches, or it might impress a strong identity on the entire chikankari work, Lucknow, 19th or early 20th century, cotton with cotton and silk thread, Crafts Museum, Delhi

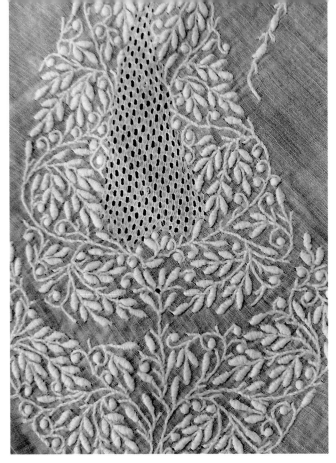

MURRI, LAMBI MURRI and GOL MURRI
Satin stitch, padded

Murri is made with a criss-cross foundation stitch which is then overcasted horizontally with close and tight satin stitches. *Murri* are mainly used to interpret the small leaves and buds of tendrils and flowers. The most common form, *lambi murri*, has the elongated and pointed shape of a rice grain, while *gol murri* ends with a round tip.

The *phanda* and the *murri* stitches are worked on the right side of the fabric. Sheila Paine adds two other kind of *murri* stitch: *nukili murri* and *mundimMurri.* [29]

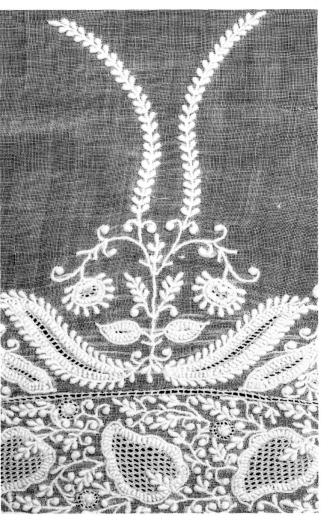

Murri
A very interesting and highly textured chikan embroidery worked almost exclusively with murri stitch
Lucknow, 19th or early 20th century

ABOVE: Cotton with cotton embroidery
Weavers Studio Resource Center Archive, Kolkata

LEFT: Sari border with gol murri
Lucknow, 19th or early 20th century
Cotton with cotton embroidery
SEWA-Lucknow archives

223

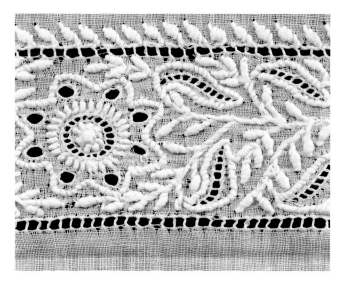

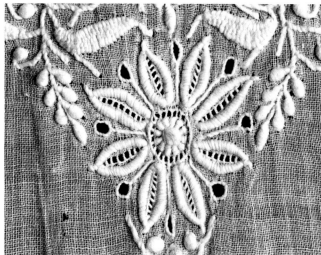

OVERCAST STITCHES

BALDA
Overcast Stitch (on tepchi or pasuj)
Balda is worked on a foundation of running stitch, oversewn by tiny and very compact vertical satin stitches. It appears like a very tight and sligtly raised line and it used for stems and mostly to outline certain motifs. The stitches " are pulled tight and rubbed with the thumb to ensure that they are close."[31]

KAURI [32] or Kori
Overcast Stitch (on *janjira* stitch)
The name of this stitch identifies simultaneously both the shape of the motif similar to the small *cowrie* shell and the technique of the making. It is worked on *janjira* used as padding stitch oversewn by tiny and compact vertical stitches.

Kauri is formed by two patti united and pointed at both ends but with the central portion slightly apart to allow further embellishment, a line of hathkati in the middle.

Badla (top left)
Badla stitch outlines the main motifs on this border for dopalli
Lucknow, 19th or early 20th century, cotton with cotton embroidery
Rajasthan Fabrics and Arts Collection, Jaipur

Kauri (top right)
The corolla of the flower is embroidered with kauri stitch
Lucknow, 19th century, cotton with cotton embroidery
Weavers Studio Resource Center Archive, Kolkatta

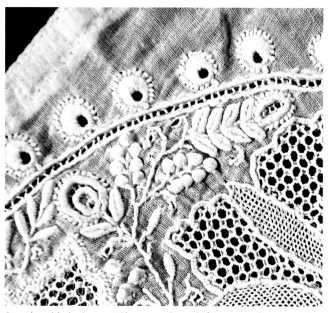

Sampler with tiny jora patti leaves at the end of a stem on this composite embroidery, SEWA-Lucknow,cotton with cotton embroidery
SEWA-Lucknow archives

JORA PATTI[35]
Satin Stitch (or flat stitch ?)
This stitch is basically a satin stitch used to fill tiny leaves or petals, working it alternatevely on half petal or leave and creating a neat thin hollow line in the middle of the double pointed oval shape, a little bigger than the similar shape for *murri* stitch.

The thread is carried across half of the leaf and returning underneath the material to the point immediately next to the previous one. The whole art is in making the stitches lie evenly and closely packed so as to creating a neat firm edge of the shape to be filled. Some times jora patti is confused with *kauri* stitch, but in the codified language of chikan blocks the difference between the two is very clear.

STITCHES AND TEXTURES

Traditionally chikan embroidery is characterized by a combination of trailings stems, tendrils, flowers motifs worked with *jalis* and a profusion of foliage and small leaves embroidered with different stitches. Inspired by nature, Lucknawi chikan has fashioned a fantastic botany with a vocabulary of imaginary textures, as each element of the design can be worked in different ways within a distinctive codified language. In particular, the leaves and the flowers are worked in seemingly endless combinations and permutations to compose closely packed and yet delicate ornamentations, harmoniously alternating the dense and open work, or raised and flat stitches. The perfect balancing of textures is as important in chikan embroidery as the quality of the execution.

For the embroidery of the leaves, the experienced artisan has number of options to choose from, with such subtle distinctions that at times it might be difficult to discern the difference. At times the workmanship is so minute that it is possible to appreciate it only through a magnifying glass.

GHAS PATTI [33]
Inverted Fish Bone Stitch

Most common stitch in chikan, *ghas patti* is generally employed as a leaf filling stitch. It can be differentiated from the *chane ki patti* stitch, looking at the reverse side. This stitch is worked along a central long foundation stitch. The needle is brought out on the right edge of the leaf close to the bottom, it enters then at the left edge to reenter the fabric slightly at the right of the central line. Each stitch crosses the previous one at the centre and so it forms an 'A', overlapping at the centre. From the back the stitches appear horizontal under a vertical thread.

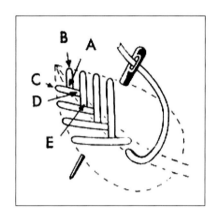

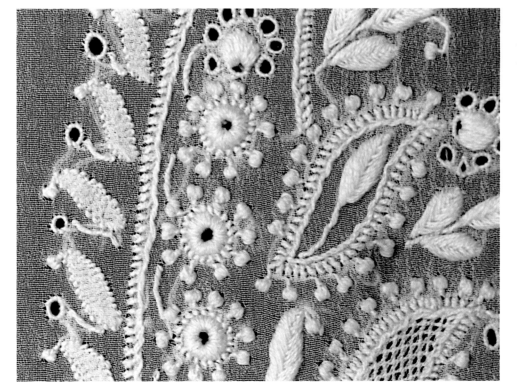

Ghas patti in the leaves
Silk with cotton embroidery
Bharvi's Chikan, Lucknow

225

Jali
A multi-petalled compact flower
motif, worked with four different
styles of jalis
Lucknow, late 19th and early
20th century, cotton with cotton
embroidery
Rajasthan Fabrics and Arts
Collection, Jaipur

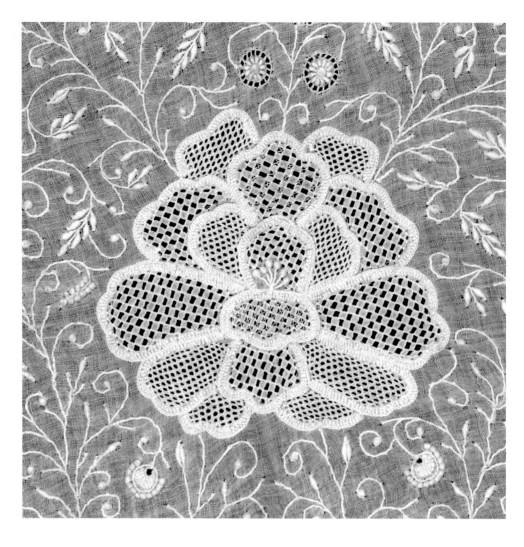

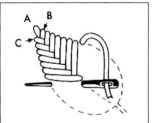

CHANE KI PATTI
Leaf stitch /Fish bone stitch

It is generally considered similar in look to *ghas patti*, but for the fact that the stitches are slanted towards the centre of the leaf both on the top as well as on the reverse side, and there is a slightl overlapping at the centre. However, on Sewa-Lucknow's sampler *chane ki patti* appears with a sort of plait as a central spine of the leaf.

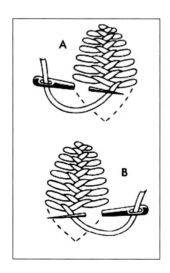

DHUM PATTI[34]
Cretan Stitch

It is a stitch that forms a sort of plait at the central spine of the leaf. The difference with *chane ki patti* stitch is in the interweaving at the centre. The shape of the leaf is first outlined with *pasuj* stitch, it is worked from the bottom to the top. At the top of the leaf, the thread is brought back from the reverse side.

226

No authentic Lucknawi chikan can be without some form of openwork or *jali* and the quality of the *jali* is the chief criteria to assess the excellence of the workmanship. Describing *jalis* in chikan embroidery is quite challenging as we are again confronted with various inconsistencies about their names.

According to Margaret Swain[39], the eminent expert on white-work embroideries and specifically on Ayrshire embroidery, the Scottish needlework which shares most similarities with chikankari, *jali* is the parameter of geographical indication. In Lucknawi chikan *jali* is executed by pulling apart the warp and weft of the fabric and securing the lattice effect with tiny and tight stitches, while in other traditions the open work is created on a grid of drawn out threads. Generally the *jali* or lattice work decorates the inner portions of flowers, which is usually marked as an empty space in the codified chikan tracings.

On an exceptional angarkha dispayed at the State Museum in Lucknow *jali* has been worked all along the borders as background net for embroidered calligraphy, executed in very fine *bakhia*. On antique pieces *jali* was sometimes done on scalloped borders of napkins, hankerchiefs and collars as a lace trimming.

Jali is generally worked from the back of the fabric with a fine twisted thread strong enough to withstand the tension of pulling apart the fabric grid or warp and weft. Technically speaking, as explained by Shilp Guru Ayub Khan, there are two basic different ways to work the jalis: one jali is executed on a straight line (although worked diagonally),[40] and two points in the fabric are pulled and 'tucked' with the thread. This is known as *siddhaur jali*.[41] It is the most common form of *jali* in chikan embroidery, its lattice effect might vary tremendously: the holes have a roundish shape, their number, evenness and size are the main indicators of its quality.

A different *jali*, variously called *mandrasi jali* (or *bangla* or *chataya jali)*, is executed along a zig-zag progression on a diagonal direction and the fabric texture is pulled apart and tucked at four corners. This *jali* has the appearance of a chess board. It is reversible, as the neat succession of the small squares of cloth and the square holes looks the same on both sides of the cloth.

On these two technically as well as visually very different *jalis*, there are variations constructed by adding within the tiny holes of the pulled fabric, interlocks of the stitching thread or intersections of the warp and weft. The rhythm and the patterns created within the open spaces define their difference, on whose names there isn't always a consensus.
However they are listed here under what seems to be the more commonly accepted name, though perhaps not everyone would agree with the nomenclature.

To stress or add to the *jali* confusion, here is an extract from an official report on *Art and Artifacts of Lucknawi Chikankari*:

There are various kinds of jali, but the technique is the same, each jali is made in different patterns. The most common and popular are Bengali and Madrasi jalis.

5.8.16 Bangala Jali: It is popularly believed that the Bengali and Madrasi [also known as Mandrazi] jali were clearly bought from Bengal and Madras and probably modified to suit chikankari. In Bangla jali the square holes are smaller than Madrasi jali and the holes are alternately opened and unopened in parallel bands.

5.8.17 Chattaiya Jali: In Chattiya, the jali is opened in the same style by holding the weft and the waft apart, but mat like patterns are formed in the net.

5.8.18 Makra Jali: Or the spider web, the jali is opened about 1 \16th of an inch in a circular pattern and the centre is left unopened giving it a look of a web. This is repeated till the open spacing of the flower is filled with this Makra jali.

5.8.19 Mandrazi Jali: This jali is the most intricate among the others. Here one hole is opened' about 1 \ 16th of an inch another is left unopened, another is opened in four parts and the next is again left unopened. The pattern is thus repeated. In the next line on top of the fully opened hole a jali with four parts is worked out. The next hole is left unopened which comes on top of the four that has been opened below and this is again repeated thus creating an interesting texture.

5.8.20 Siddaur Jali: Siddaur jali is the most common jali in Lucknow; except siddhaur jali in which the stitches are worked diagonally the warp and the weft threads, in rest of the jalis the stitches are worked on the weft and the warp. Other kinds of jalis which are sparingly used are, Tajmahal, Phool jali, Satkani, Tabar, Chitegul and Kanthmahal.

5.8.21 Bulbul Chashma: This jali seems to be compound of the siddhur and the makra jali. In the alternative rows there are the siddhur like opening ascending vertically. In the other rows are square holes with diognally intersecting threads. This jali also appears very delicate. [All the jalis are worked from the reverse side of the fabric]

5.8.22 Hathkati: Another form of jali stitches to form a row of square holes is known as hathkati. This can be seen around the borders of handkerchiefs, centers of flowers and petals,in gents kurtas on the neck and the shoulders. Hatkati is of two types, the single, when the jali is made from one side only and the second type is when the jali is worked from both the sides. Also known as Bank jali There is a slight difference in their look but double jali takes more time and gives a finished look.

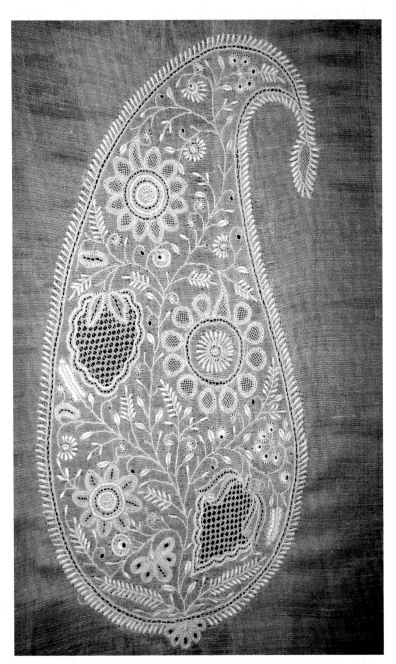

Elaborate keiri sample, with a wide choice of chikan stitches among which there are three different styles of jali
SEWA Lucknow, 2008, silk with cotton embroidery

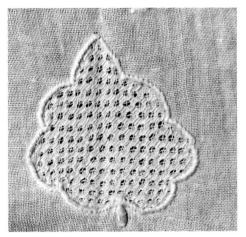

From the sampler of chikankari stitches made for the Tapi Collection of Indian Textiles by an unidentified master artisan Lucknow, cotton thread on cotton Tapi Collection, Surat. Acc. no. T.99.164

Chasm I / Bulbul Jali[42]
Every open hole has an intersection of threads

Makra Jali, sometimes also called bank jali, is like a spider web, each open space has a warp thread in the middle

VARIATIONS ON MANDRASI OR BANGLA JALI

Taj Mahal jali (?): in this variation every alternate line of open spaces has an intersection of threads, the other line being left empty

Phool or kattam jali. The tiny intersections fill the open spaces according to different patterns

This particular jali is at times called Chasm-i-bulbul (as the previous sample on siddhaur jali) at other times it is called Madrasi (or mandrasi or makri) jali

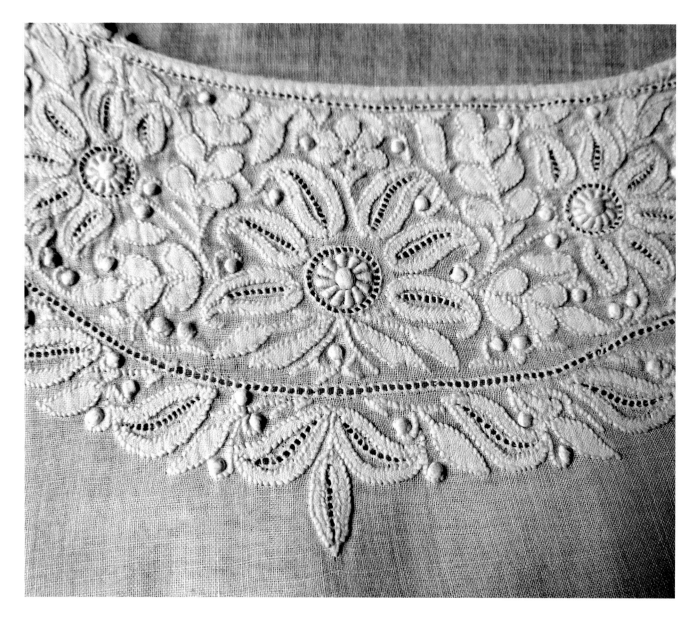

Hathkati

Hathkati is used to define the embroidered border, to interpret the texture of bakhia petals and leaves, and to emphasize the kils motifs.

Lucknow 19th or early 20th century, light cotton with cotton embroidery

Author's collection

HATHKATI

The single line of open work in chikankari is called *hathkati* [44] and it is similar to the hem stitch, As in *jali* work, it is executed pulling apart the fabric and not drawing threads from it. Very fine *hathkati* is generally done in the middle of *kauri* stitch, around *kil* and *kangan* stiches. It often defines the grains of leaves and flowers. On fine pieces, *hathkati* might delineate contours and borders or it creates graceful openwork next to the *turpai* stitch at armholes or delicate underlines along the front opening and neckline.

Hathkati is also executed on *katao* or appliqué work as a thin line of openwork on the top layer, so that the stitch binds together the upper and lower cloth.

In the sampler from SEWA-Lucknow Rukhshana did a few variations of hathkati and for some of them she drew out a few warp threads, suggesting possible incorporations of foreign techniques. However on old chikan pieces, I never observed any such variations.

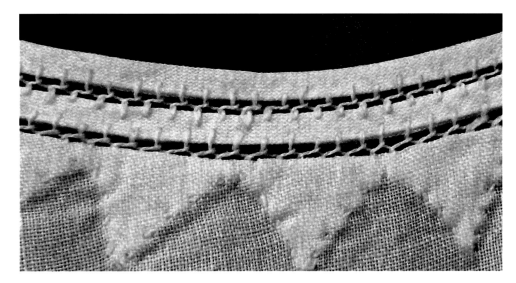

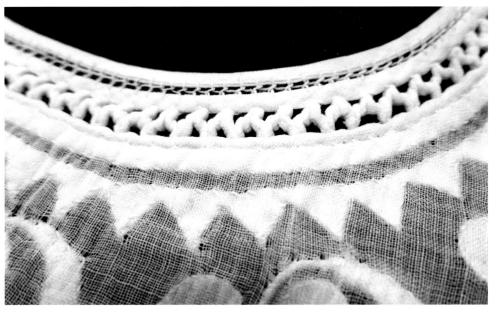

Jawa jali
LEFT: *Jawa jali stitch holding
together the separate pipings on
the neckline of this angarkha
Lucknow 19th or early 20th
century, light cotton with cotton
embroidery
Rajasthan Fabrics and Arts
Collection, Jaipur*

BELOW: *A twisted tie string
attached at the neck line, forming
a zig-zag pattern*

JAWA JALI

A special mention should be given to the *jawa jali* stitch corresponding to the Fagotting/
Insertion stitch-twisted.[45] *Jawa jali* is an artistic stitch mostly used to join the edges of two
panels, each one hemmed with *turpai*, with *jawa* or with other decorative motifs. It appears as
a delicate openwork seam.

Hathkati (Bank or Kate Wale Jali)

It is a hem stitch worked in serpentine or zig zag pattern in the *hathkati*.

Hathkati (Madrasi Jali)

The *hathkati* is worked tieing together two weft threads. Four bundles are subsequently tied
together in the middle of the open work.

Makra Wale Jali

Eight warps are drawn. The *hathkati* is worked bundling together two weft threads. Two
bundles are subsequently tied togetherin the middle, the bundling thread is carried over from
one bundle to the next one.

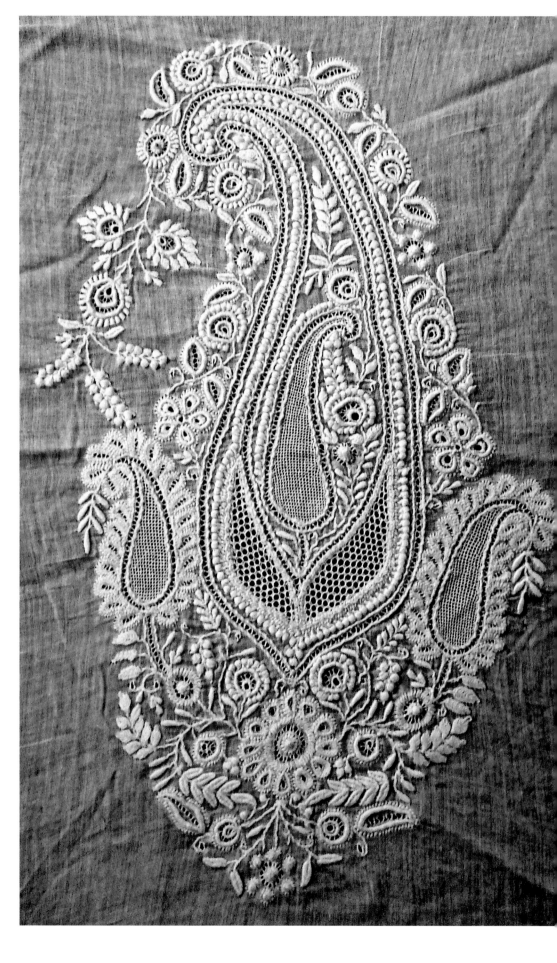

Embroidered keiri
An outstanding sample by SEWA-
Lucknow, displaying a wide range
of chikankari stitches. Particularly
noteworthy are the unusual
bank hathkati with its zig-zag
texture, and the variations of the
composite stitches like bijli, kil,
kangan, karn phool
SEWA-Lucknow Archives

232

Kapkapi

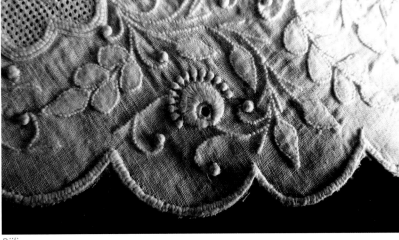

Bijli

THE COMPOSITE STITCHES OF CHIKAN : Jewels and flowers

The creative genius of chikankari artisans has codified sequences of stitches to form a few composite stitches. Their designs and complex textures remind of jewels and flowers, from which they sometimes take their name.

With the exception of *kil* or *bijli, most* of these composite stitches, considered characteristic of chikankari today, seem to be more recent developments in the embroidery vocabulary, as they rarely appear on antique pieces. Most of them are found on the samples produced in the 1950s and 1960s by mastercraftsmen for State or National craft awards.

KIL or KEAL : PHANDA/ KATE/HATKATI

Kil is the name of a nose pin, thus described by A.H. Sharar: "Lucknow women discarted *nath* [gold ring habitually worn in Lucknow on the left nostril] and replaced them by *kils*, jewel-studded gold pins worn on the side of the nostril, a very delicate and attractive piece of jewelry. Because of the desire of daintiness the goldsmiths of Lucknow fashioned this pins in such a manner that no other jewellers culd imitate them."[46]

It is a tiny motif frequently interspersed within tendrils and foliage. *Kil* is often placed in the centre of a flower.

Kil

BIJLI

It is not clear if the name of this stitch comes from the gold or silver bijli earring worn on the ear lobes, or from the lighting. It is a stitch with number of variations, some of which are identified by a separate name. The innumerable ways in which this tiny motif is integrated in bigger motifs make it deliciously versatile.

SADHI BIJLI
Eye Stitch (Kate)

Although *sadhi bijli* stitch is obtained with the same stitches as *keher ki*, the shape of these two motifs are different. *Keher ki* is round and comparatively larger, like a dot with a central little hole, whether in *sadhi bijli* the hole is worked at the base of the motif that is smaller and with a slightly oval look.

CHAND BIJLI

The sequence of this stitch is *Hul-Cauri-Hatkati-Cauri-Kate* or *Hul-Cauri-Kate-Murri*

PHANDA WALE BIJLI

The sequence on this variation of *Bijli* stitch is *Hul-Cauri-Kate-Murri*

KANGAN
Phanda /Kate /Hatkati /Kate

Kangan is a bangle. In chikankari, it is a round motif with many variations and it can be worked in different sizes by adding more circles of *kate* stitch around it.

KAPKAPI

The seqence of this stitch is *Bijli-Hathkati-Balda-Hathkati-Kate-Balda-Gol Murri*

1 A Portrait of Emperor Shah Jahan (r. 1628–58)

The Emperor is wearing a transparent jama showing joints of the panels and ornamented seams on the armholes. The sleeves ends, the neck band and the hanging lappets are also decorated with tiny floral motis.

India, Mughal, 17th century
Gouache on paper, 20 x 11.4 cm
Courtesy Sothebys

2a–2c Details of phool daraz or seam of flowers
Late 20th century, cotton
SEWA-Lucknow

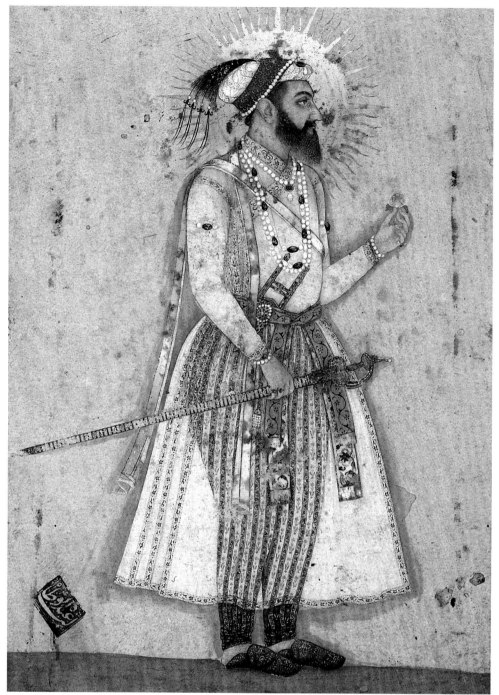

1

2a

2b

2c

In chikankari, the fabric, the embroidery, the designs and the cutting, the way the different portions are assembled together, blending aesthetic with functional into a whole, each step being further enhanced by the others. It is said that Lucknow is a place where "the largest range of artistic workers are to be found than in almost any other town of India." [47]

Antique costumes were entirely stitched by hand, the seams themselves being part of the ornamentation discreeetly visible in the translucence of the thin muslins.

TURPAI

This refers to the hand made, self-bound, thin seam, obtained by rolling and hemming together into thin lines the seam allowances inside the garment. *Turpai* underlines the cuts and the pattern of the dress and in chikankari, particularly, it often dialogues delicately with the embroidery. The needlework encompasses the seams and structures itself around the thin lines.

JAWA HEMMING & APPLIQUE

Jawa is a most exquisite way of hemming or finishing the inner fabric allowance in costumes, saris or dupattas. It shows through the transparency of the fine muslin as a string of small triangles worked with the margin of the fabric itself. The smaller the triangles, the finer is the effect they create.

The string of small triangles is also found on old pieces as appliqué work, especially at necklines or at the gussets inserted at the underarm or at the sides of the body on angarkha or kurtas. On some old pieces, the hemming of the margin inside the garment is worked in decorative and unusual designs, particulary at the shoulder seams.

Turpai, jawa and sometimes string pipings are joined together with an open lattice stitch work, already described earlier as twisted insertion stitch or faggoting.

DARAZ

Daraz is a charming figurative way in which chikan work joins together the different pieces of the garment. It is a reversible stitch in which the seams themselves are worked so as to create in the transparency of the fabric an ornamental effect that perfectly blends in with the embroidery. The seams and joints are disguised with figurative patterns.

Though not frequently seen on antique pieces, a similar effect is depicted on some early portraits of the Moghul Emperors Jahangir and Shah Jahan. They wear translucent muslin *jamas* with a decorative motif running along the seams, the armhole and the collar similar to the *phul ka daraz.*[48] It is very tempting to draw an association between the costumes of the Mughal Emperors and the *daraz* as it is executed even today, and to imagine an uninterrupted transmission of this exquisite needlecraft technique . Unfortunately, by general consensus in Lucknow, *daraz* is seen to be a dying art, with an ever shrinking group of artisans proficient in this technique.

There are several common patterns of *daraz.* B*akri daraz* is a fine zig-zag line sometimes also called *tikona* or *pahari. Macchli daraz* (or *macchli ka daraz*) is a line of small fishes, generally with a *hul* at the place of the eye and with a line of *hathkati* along the central spine. In a

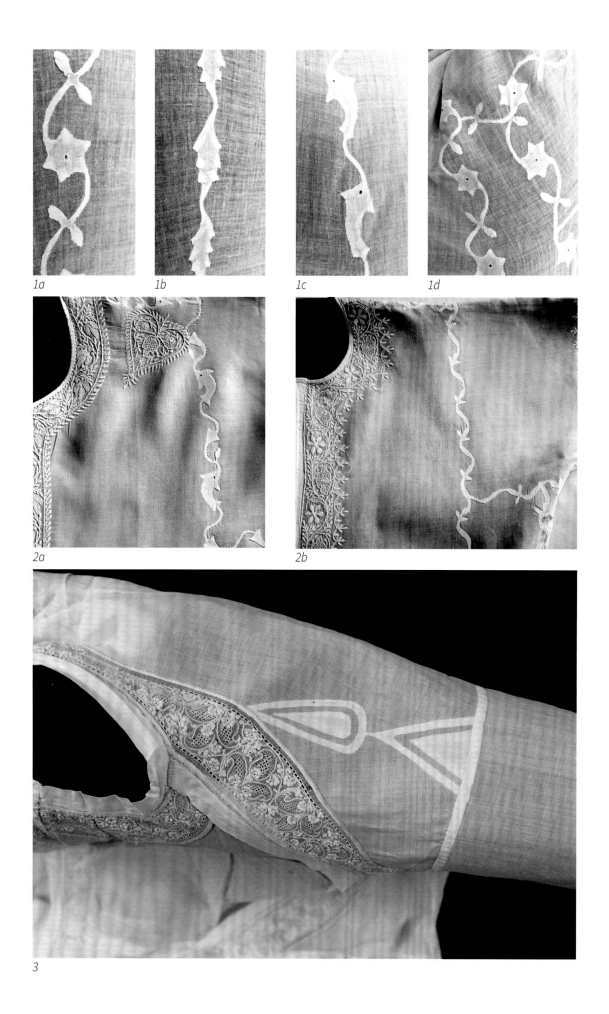

1a

1b

1c

1d

2a

2b

3

variation of this motif, the fish and a bell flower are alternating. *Phul ka daraz* is like a string of flowers and tiny leaves, often enhanced with a *hul* at the centre of the flower, sometime this pattern is called *tara patti*. *Salemi daraz* is like a string of bell flowers and the *neem ka daraz* or *neem patti* is a scroll of dentelate leaves.

These patterns are generally stamped with blocks on the superimposed edges or extra cloth margins of the two panels; the motif shows on both sides through the translucent fabric .
The edges are kept in place with a loose stitch that tucks them together. The fabric is then cut leaving a small margin along the contour of the pattern. Turning under the narrow margin, the two fabrics are joined together as for *katao*, with tiny hem appliqué stitches.
The seam first follows one side of the printed pattern. When one side being completed, the work is turned on the reverse side and it proceeds in the same way. The decorative motif comprised within the double layers of the fine muslin stands out, creating a beautiful opalescent effect. The final stitch is reversible and the join is invisible.

A special mention should be given to an interesting and technically more complex joining seam than the *daraz*. It is a technique that appears on some old costumes in various stylized shapes such as that of a cypress tree.

1a –1d Intersection of different
daraz seams
Phool ka daraz, patti ka daraz,
macch ka daraz
20th century, cotton
SEWA-Lucknow

2a & 2b Samples of contemporary
work on kurtas
20th century, cotton
SEWA-Lucknow

3 Cypress motif joining seam with
appliqué work
Late 19th or early 20th
century,cotton
Rajasthan Fabrics and Arts
Collection, Jaipur

4 Angarkha with the join of front
and back body in the shape of a
stylized cypress tree
Lucknow, late 19th or early 20th
century,cotton muslin
Rajasthan Fabrics and Arts
Collection, Jaipur

4

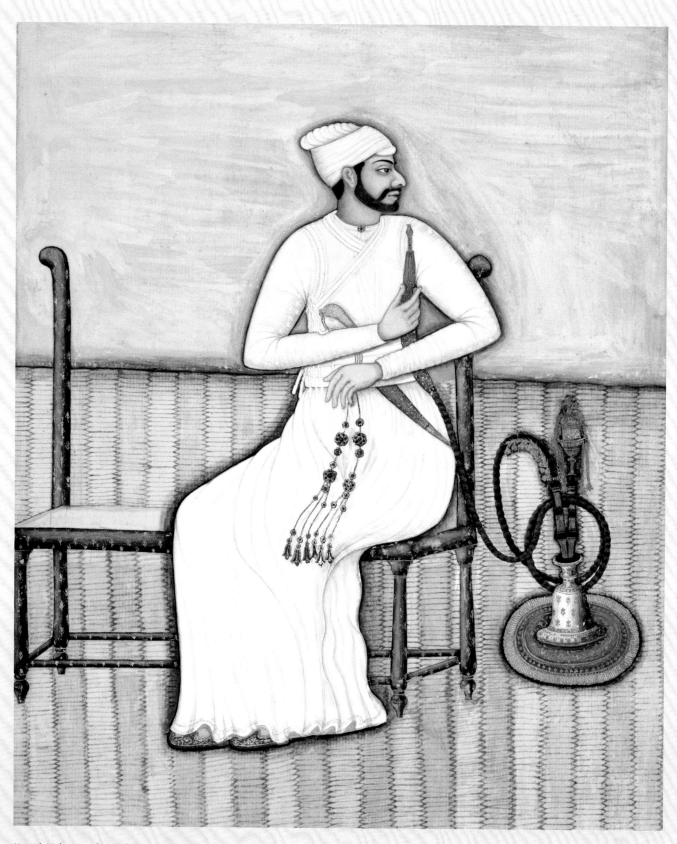

Nawab Muhammad Riza Khan smoking a Huqqa
Concentrations of tiny dots of paint reveals a discreet
embroidered pattern on the white jama, and long rivulets of
paint suggest the clinging folds of the transparent garment
India, Mughal style at Murshidabad, c.1780–90
Watercolor and gold on paper, 30.6 x 24.7 cm
Philadelphia Museum of Art, Acc. No. 2004-149-70
Alvin O. Bellack Collection,

SINJAF, MAGAJI and PIPING CORD

On some antique costumes the edges are finished with a tiny bias facing and a piping, called *sinkia magaji*. The facing and the pipings are both a decorative element but they are also functional, adding strength to the frail muslin costume.

On a few old garments, the piping is sometimes filled in with a thin and almost invisible piping cord, and at times the cord is of a contrasting colour, red, blue or black, which shows as a delicate nuance through the sheer fabric.

Red dori pipings showing through the diaphanous muslins
LEFT: 19th century, Nawab Mir Jafar Abdullah collection, Lucknow

RIGHT: Rajasthan Fabrics and Arts Collection, Jaipur

CORDED QUILTING WORK

A similar technique of filling up portions of the embroidery with piping cords of contrasting colours[49] is found also on a *panchgoshia* topi, with a typical decoration of crescent moon and stylized cypress trees at the joining of each panel. It is also seen on other pieces like chogas or bedcovers. The origin of this needlecraft art has been variously attributed to Bhopal, Gujarat and to Bengal.

Corded quilting
LEFT: Two layers of light cotton fabric with cotton embroidery and woollen filling, Rajasthan Fabrics and Arts Collection, Jaipur

RIGHT: Corded trapunto or quilting embroidery work filled with coloured woollen thread, 19th century, Nawab Mir Jafar Abdullah Collection, Lucknow

1 Judy Frater. In the Artisan mind: concept of design in traditional Rabari Embroidery. In : *Sui Dhaga*. New Delhi, 2010:85

2 As Nawab Mir Jafar defines the ethereal, waiflike

3 Reference to the discussions with master artisans : Akhtar Jahan, Rehana Begum, Sultana Begum, Ayub Khan, related by C. Wilkinson-Weber. *Embroidering lives*.1999:127

4 C.Wilkinson-Weber, 1999:129

5 C. Wilkinson-Weber. 1999. p. 127

6 Ayrshire, Plumetis,

7 Personal communication. 2000

8 and avoiding the face of the embroiderer bowed on her work!

9 G. Watts. *Indian Art at Delhi 1903*, reprinted in Delhi, 1987

10 also spelled *taipchi* in G. Watt.1903:399. V. Singh mentions also the name "do roha" for this stitch. V. Singh Romance with chikankari 2004:53

11 G.Watt. Indian Art at Delhi, 1903. 1903:406

12 S. Paine. 1989:35

13 C. Wilkinson-Weber. 1999:209

14 also spelled : "*pencni* ("penc" – twisting, weaving) is constructed on the base of a running stitch, which is then "oversewn" by the thread winding under and over the base stitches" C. Wilkinson-Weber. 1999: 209. It is also called: *urma* or *pashni* : "*Pashni* is a fine version of tepchi pechni worked with one thread on the right side of the fabric. A row of short running stitches is made on the edge of a motif and the thread is then looped back through them but without picking up the fabric. This forms a laced running stitch. Pashni is used as a fine finish on the inside of a motif, as zanzeera is on the outside, after the normal outline stitches have been worked. It is not common" (S. Paine, 1989:38)

15 It is a very common stitch on antique pieces, but I could not get it on my original sampler at SEWA's

16 S. Paine. 1989:36

17 also spelled Bakhia V. Singh. 2004

18 "*There are names of two types of stitches which were essentially of Persian origin! they are bakhyah and ajidah! they had different costs attached to them! the ones with the bakhyah stitch cost rupees eight and the ones with ajidah stitch was half the price of the former! Here Blochmann notes that the bakhyah was a kind of back stitching and the adijah was similar to buttonhole stitching.*" In : Rajrupa Das, MUGHALIA LIBAAS, The trans migration of Central Asian fashion to the Indian sub continent in the 16th and 17th Century . Dissertation - MLitt Art History: Dress and Textile Histories, University of Glasgow. 2013

19 Also called khatav, V. Singh 2004 or Katawa, G. Watt. 1903:400

20 W. Hoey. 1880:59

21 S. Paine calls this stitch Banarsi. 1989:37

22 Also called *Rojan* or *Rozan* : "The hole in the cloth is made as in bijli it is sealed with small overwrapping stitches that are only visible underneath the cloth. Rojan normally appears as a circular hole in the middle of an open patti…" C. Wilkinson-Weber. 1999:210 or called Hool rozan by V. Singh.[in Bijli "one of the three stitches made by breaking threads in the cloth. Bijli is made by picking up two threads in the cloth with the tip of the needle. The needle is then twisted round and round until the threads break. The resultant hole is enlarged and its edges sealed with stitches fanning out about 270° around the hole like spokes, the ones at the apex being longer than those at the sides. A final corona of overwrapped stitches like those found aound kil completes the bijli". 2004: 205-207

23 S. Paine spells it "hool". S. Paine 1989:36

24 Sometime called Kaj: "*similar to "blanket stitch", the stitch was also used to "seal" the edge of material where it would be cut, to prevent fraying. Another name for the stitch was, in fact, kat. Kaj was almost always done upon a scalopped design, and was made of two elements, pasuj and the covering stitch*". (W-W. 1999: 208)

25 M. Thomas. Dictionary of Embroidery Stitches.

26 also spelled *phunda* and C.Wilkinson-Weber calls it also cikan. "*Gol cikan (round cikan) is made by creating a raised knot (gol) at the end of a stem. Lambi cikan (long cikan) is made like gol chikan, except a single stitch is placed at its apex to make it seem pointed*" p. 209 (see : Dhanya patti)

27 S. Paine. 1989:39

28 V. Singh. Id. 2004:56

29 "*Tepchi is worked from right to left and at the left end is oversewn with two or three straight stitches, keeping the thread to the left with the thumb, and then one or two narrower ones*"S. Paine 1989:39

30 Also known as Dandi dar Phanda or as Lambi Cikan. C. Wilkinson-Weber. 1999:207

31 S. Paine. 1989:38

32 S. Paine Id. p. 40 "*Kauri is used to form a leaf in the shape of a cowrie shell. Two stitches are worked to three-quarters of the length of the leaf side and thread is then looped back under the first stitch from the inside without picking up the fabric. It is then taken back through the stitch so formed, finishing with a small stitch at the tip of the leaf. This make a base down one side of the leaf which is thicker in the centre and which is oversewn with small straight stitches. The work is repeated down the other side of the leaf. It is worked with twelve threads on the right side of the fabric.*"

33 Ghas ki patti (grass): a complex stitch, ghas appears as angled, tapering stitches, wide at the base of the patti, and pointed at the top. Theneedle emerges from the cloth in the central"line" of the leaf,

and defines the "frond" to the left edge first. The needle passes under the cloth to the right side, where the corresponding "frond" is traced from outer edge to center". p.207

34 S. Paine mentions a stitch called Boot Patti, which, from the description appears to be closer to Ghas patti stitch: "Boot Patti is used to form a pointed spined leaf. Three large stitches are worked up the spine of the leaf to beyond its tip. The needle is brought out by the side of the point and is reinserted near the centre. Criss-cross stitches are made, picking up the fabric down the spine and keeping very close together on the outside edge. The stitches slant steeply on the right side of the fabric and are straight across the back. Boot Patti resembles European Open Fishbone Stitch and is worked with four threads on the right side of the fabric". p. 40. W-W. describes Dhum as "*a complex interwoven stitch, underlain by running stitches defining the leaf, and then a cross-hatching done on top of them, creating closely spaced, angled stitches with a central spine, like a plait*". p.207

35 Jora patti means "pairing"

36 S. Paine, 1989:40

37 C. W-W. 1999:208

38 S. Paine, 1989:40

39 personal communication in 1997.

40 however, according to others scholars, sidhaur jali is executed also on a diagonal.

41 M. Thomas: "A Drawn fabric stitch. Commencing in the top right corner, bring the needle out at A, insert it at B (four threads to the right) and bring it out at C (four threads to the left and four down). From C, insert the needle at A again, bring it out at D (four threads to the left and four down). The needle will then enter at C again and continue in this way, each stitch being pulled tightly, until the row is finished. For the second row, turn the work upside-down and repeat the same process again, using some of the holes made on the first row."

42 C. W-W: Bul-bul chasm. "Made in similar fashion to sidhaur except perpendicular to the base of the phul. The holes are more squarish in appearance and each alternating hole has two threads from the fabric remaining , in the shape of an X. As each line is worked, first two open triangles in the base of a hole are made, then the remaining triangles, and with them, the presence of the "crosshair" is revealed". 1999:208

43 as named by late Rukhshana from Sewa-Lucknow

44 S. Paine."The common stitch known as hatkati is a straight row of pulled holes worked vertically over six to eight threads and is used for the spine of leaves, to encircle flower heads or to divide and edge areas of fabric. Variations of it are *dohra hatkati*, when a double line is made by repeating the stitch on return, and *maheen hatkati*, when is finely worked over four threads." 1987:43

45 M. Thomas : Half Cretan Stitch .

46 A. H. Sharar. 1987:184

47 G. Watt. Indian Art at Delhi 1903. 1903:399

48 A. H. Sharar. 1987:184

49 Nawab Mir Jafar of Lucknow calls this work "dough", personal communication.

ACKNOWLEDGEMENTS

Years of research work on chikan craft and this book have only been possible thanks to the support of many friends, so unconditional and generous in sharing knowledge, suggestions, embroidered treasures, hospitality and last but not least in encouraging me at difficult times of stumbling blocks that I have no words to express my immense gratitude to all of them.

This book owes its existence specially to the warm welcome over many years by all the ladies in SEWA-Lucknow and the patient and generous assistance of all their members in sharing with me their secrets and allowing me to mess around, digging deeply in search for unique blocks and embroidered samples. I am also deeply appreciative for more than generous assistance of Mrs Mamta Varma the sensitive and passionate owner of Bhairvi's Chikan in Lucknow, who led me through the discovery of chikan industry in Lucknow outside the world of SEWA.

Without them this book would not have been possible, my gratefulness is beyond description.

In Delhi, my special thanks go to the unfailing encouragement and the generous knowledge of my friend and mentor Jasleen Dhamija, to Laila Tyabji who first set me on this journey, to Chote Bharany, to Nalin Tomar and Kaka Singh who allowed me to explore thier wonderful textiles collections, to Pramod Kumar KG, to Ruchira Ghose, former Director of Crafts Museum, Delhi, with Mr. Ansari (Textiles Section, Crafts Museum - Delhi) and Mr. Mustak Khan (Crafts Museum – Delhi), to Divya Singh, to Jenny Housego, Asaf Ali and Sameena Zaidi of Kashmir Loom, to Ritu Kumar, to Rajesh Pratap Singh and to Sapna Mehra , to Jaspal Kalra, to Veena Talwar Oldenburg, to Mayank Kaul, and to Prabeen Singh, to Sholeh and Ravi Sikri, to Seemi and Sayed Zaidi always very supportive when I needed! Last but not least very special thanks to my dear friends in Delhi with their generous hospitality, affection and encouragement : Christine and Aman Rai, Valmik Thapar with Sanjna and Hamir and Jivi Sethi.

In Lucknow my special thanks to all the people who have helped me in my quest: first of all to Runa Bannerjee and Sehba Hussein with SEWA's team, and particularly late Rukhshana, Umar, Nasreen, Ansari, Kurshida, Shahnaz, Shabana, Farida and all the other wonderful ladies in SEWA who for many years put up with my inquisitiveness with patience, warmth and affection, to Salim Kidwai, Sufia Kidwai, to Mamta Varma and her team from Bhairvi's Chikan , to Madhovi Kukreja , Askari and to all the Sanatkada's team, to Ruth Chakravarty, Sahar Hasan, Mita Dass, Nawab Mir Jaffar, Nawab Masood Abdullah, Begum Vijaya Khan of Mahmudabad, Asha Hussein, Lucknow State Museum's Assistant -Director (Dr. S.N. Upadhyaya) and Numismatic Assistant (Dr. Anita Chaurasia), Director U.P. Institute of Design and ITTUP Kanpur – Lucknow (Crafts Museum) Dr. K.P. Mishra, District Industries Centre – Lucknow, Mrs Asha Nigam, Mrs. Mohini Manglik, Meera and Muzaffar Ali, Rani Sudha Oel, Begum Jyotsna Kaur Habibullah, Abdullah Badla works, Ashu Tandon, Pankaj Arya with Shilp Sadhana , Muhammad

Ali, Rehana Begum (Shilp Guru) , Ayub Khan (Shilp Guru), Mohd Kalam Khan, Iqbal Hussain, Aamina Katun, Rani Siddiqi, Hata Suleman Qadar, Chhangamal, Vani Anand, Prem Kohli and Vineet Kohli from Kedar Nath Ram Nath & Co., Shekhawat Printer. My apologies if my failing memory has omitted to mention any one!

In Kolkata my special thanks go to Sangeeta & Siddharth Dudhoria, Amrita Mukherjee, Bashobi Tewari, to Dr. Bhargaviamma Venugopal, Director of the Indian Museum and to Dr. Nita Sen Gupta, Curator at the Indian Museum, to Ruby Palchoudhuri, Honorary General Secretary and Executive Director of the Crafts Council of West Bengal, to Darshan Shah, Ushma Savla and all the Weavers Studio team, to Dr. Cesare Bieller, General Consul of Italy in Kolkata.

In Jaipur it was wonderful to see the exceptional textiles collection at Rajasthan Fabrics and Arts and to meet Subash and Jatin Sharma. While Meenu and Romi Tholia generously lent some family heirloom. The Gem Palace's and the Silver and Art Palace kindly allowed me to look at their precious textiles pieces, thank to Nur Kaoukji and a very special thanks to Brigitte and Lilah Singh who are my family and my home there.

In Mumbai: Shilpa and Praful Shah and the Tapi Collection and to Munira Akikwala, Abu Jani & Sandeep Khosla showed me some very special chikankari designs, and Monisha Ahmad as always generous with contacts and suggestions. Thanks to Apeni and Himman Dhamija.

Many others people over the world have contributed to enrich my knowledge and opened their store rooms, special thanks to Rosemary Crill, Asian Textiles Curator at the V&A Museum, London. Aurelie Samuel, Asian Textiles Curator at the Oriental Art Museum, Musée Guimet in Paris, to Dr. Clare Wilkinson-Weber, whom I met in Delhi in the '80s at the times of her PHD field work, to Dr. Tereza Kuldova, to the collectors : Joss Graham, Sushama Swarup, Renzo Freschi, Olga Getto, Roberta Sommi Picenardi and Vannozza Della Seta with Comitato per SEWA. Last but not least thank you to my supportive family.

My deep gratitude to Bikash and Tultul Niyogi who immediately supported this project and to Malini Saigal, editor of this book, for her invaluable contributions and patience.

The fine photographs of this book are by: Najeeb Aziz (Lucknow), Jonas Spinoy (Jaipur), Bish Mohitra (Delhi), Jaspal Kalra (Delhi) and Tommaso Manfredi.

Thanks to all!

Paola Manfredi
Milan

BIBLIOGRAPHY

Arya, Pankaj & Shilp Sadhana. *Diagnostic study, Artisan, the Chikan Embroidery Cluster*, Lucknow.

Art and Artifacts of Lucknowi Chikankari. by : P. Nayak, T.K. Rout, S.Krishna Kumar, Rakesh Dwivedi. Ministry of Commerce & Industry, UNCTAD and DFID. Study organised by Textiles Committee, Mumbai. 2007

Ashmore, Sonia. *Muslin*. London: V & A Publ. 2012

Asian Costumes and Textiles from the Bosphorus to Fujiyama: the Zaira and Marcel Mis Collection. Milan: Skira, 2001

Barnes, Ruth, Stephen Cohen, Rosemary Crill. *Trade, Temple and Court: Indian Textiles from the Tapi Collection*. Mumbai: India Book House Pvt. Ltd., 2002

Bernier, François. *Travels in the Mughal Empire (1656-1668)*. Reprint. Delhi, 1989

Chattopadhyaya, Kamaladevi. Origin and development of embroidery in our land. In Marg : *Textiles and Embroideries of India*. Bombay, 1965

Chouhan, Dr. Omar Prakash, Om Prakash . *The Dutch East India Company and the Economy of Bengal, 1630-1720*. Princeton University Press, 1984

Cowan, Rex. "Shipwreck, dye stuff and the India Trade" in Rosemary Crill, ed. *Textiles from India*. Kolkata, Seagull Books, 2005 : 374-388

Crill, Rosemary. *Indian Embroideries*. London, 1999

Crill, Rosemary. "Textiles and Dresses in Lucknow in the Eighteenth and Nineteenth Centuries". In : Stephen Markel with Tushara Bindu Gude and al. *India's Fabled City: The Art of Courtly Lucknow*. Los Angeles County Museum, 2010.

Curley, David L. "Voluntary relationships and royal gifts of paan in Mughal Bengal". In : *Robes of Honour: Khil'at in pre-colonial and colonial India*. Ed. by Steward Gordon. New Delhi: OUP, 2003:42

S.N. Dar. *Costumes of India and Pakistan: a historical and cultural study*. Bombay, 1969

Dhamija, Jasleen. Chikankari. In : Marg : *Textiles and Embroideries of India*, 1965

Dhamija, Jasleen. Ed. *Asian Embroideries*. Craft Council of India, 2004

Dongerkery, Kamala S. *The Romance of Indian Embroidery*. Bombay: Thacker, n.d.

Forbes Watson, *The Textiles Manufacturers and the costumes of the people of India*. London, 1866

Foster, William ed. *The Embassy of Sir Thomas Roe to the Court of the Great Moghul, 1615-1619 as narrated in his journal and correspondence*, edited from contemporary records. London, 1899.

Gordon, Stewart, ed. *Robes of Honour: khil'at in Pre-colonial India*. Delhi, 2003

Goswamy, B.N. *Indian Costumes in the Collection of the Calico Museum of Textiles*. Ahmedabad, 1993

Graff, Violette (ed). *Lucknow: memories of a city*. Delhi: OUP, 1999

Handler, Richard and Linnekin, Jocelyn . "Tradition, Genuine or Spurious". *Journal of American Folklore*, Vol. 97, No. 385, 1984, pp. 273-290

Harvey, Janet . *Traditional Textiles of Central Asia*. London, 1997.

Hoey, William. *A Monograph on Trade and Manufactures in Northern India*. Lucknow 1880

Hunter, William Wilson Sir. *Imperial Gazetteer of India*. (Vol. 3). 1885:221

Jain, Rahul. *Rapture: The Art of Indian Textiles*. Delhi: Niyogi Books: 2011

J. Irwin & M. Hall. *Indian Embroideries*. Calico Museum, Vol. II, 1973

Kalra, Jaspal. *Variety of Chikankari Stitches*. (2013) Documentary. Produced by Jaspal Kalra. Demonstrated by Ayub Khan. [DVD] Lucknow.

Kalra, Jaspal (2014). "Ethical and Organic Innovation in the Handicraft Industry: Perpetuating the Essence of Heritage in Chikankari." *International Journal for Design in Society*. vol 7 (2), p 67-86. Illinois, Common Ground Publisher.

Knighton, William. *The Private Life of an Eastern King*. New York, 1855

Kumar, Ritu. *Costumes and Textiles of Royal India*. London: Christie's Books, 1999

Llewellyn-Jones, Rosie. *Engaging Scoundrels : True Tales of Old Lucknow*. Delhi, 2000

Llewellyn-Jones, Rosie. *The Last King in India*: *Wajid Ali Shah*. Delhi, 2014

Llewellyn-Jones, Rosie. *Lucknow : then and now*. Mumbai, 2003

Manfredi, Paola. In Search of Perfection: Chikankari from Lucknow. In : Laila Tyabji, *Threads and Voices*. Marg Publications. 2007

Markel, Stephen et al. *India's fabled city: the Art of Courtly Lucknow*. Los Angeles County Museum, 2010

Mrs Meer Hassan Ali. *Observation on the Mussalmauns of India descriptive of their manners, customs, habits and religious opinions made during a twelve years residence in their immediate society.* 1832. Second Edition, 1917. Edited with Notes and an Introduction by W. Crooke,n late of the Indian Civil Service.

Mehta, Rustam J. *The Handicrafts and Industrial Arts of India.* Bombay, 1960

Morrell, Anne. *Technique of Indian Embroidery.* Batsford, 1995

Morrell, Anne . *The migration of stitches and the practice of stitch as movement.* Ahmedabad, 2007

T. N. Mukharji. *Art Manufactures of India.* Calcutta,1888

Oldenburg, Veena Talwar, ed. *Shaam-e-Awadh : writings on Lucknow.* Delhi, 2007

Oldenburg, Veena Talwar. *The Making of Colonial Lucknow, 1856-1877.* 1984

Paine, Sheila. *Chikan Embroidery: the Floral Whitework of India.* Shire Publ. 1989

Parlby, Fanny Parks. *Wanderings of a pilgrim in search of the picturesque during four and twenty years in the East with revelation of life in the zenana.* London, 1850:379

Rai, Ashok. *Chikankari Embrodery of Lucknow.* Ahmedabad, NID,1992

Reilly, Valerie. *The Paisley Pattern.* Glasgow: Richard Drew, 1987

Samuel, Aurelie. *Les jamdani et chikankari de Lucknow dans la collection Krishnâ Riboud au Musée Guimet.* In: *Orientalisme, Mélanges offerts à Jean-François Jarrige,* Paris, 2012

Sandhu, Arti. *Indian Fashion: Tradition, Innovation, Style.* Bloomsbury Academics, 2015

Sharar, Abdul Halim. *Lucknow : the Last Phase of an Oriental Culture.* Delhi: OUP, 1989

Singh, Chandramani. *Textiles and Costumes from the Maharaja Sawai Man Singh II Museum.* Jaipur, 1979

Singh, Divya. *White on white. Design Intervention for the craft of chikankari.* Ahmedabad, NID, 2012.

Singh, Veena. *Romancing with Chikankari.* 2004

Swain, Margaret. *The Flowerers: The Story of Ayrshire White Needlework.* 1955

Swain, Margaret. *Ayrshire and Other Whitework.* Shire Publ., 1983

Swarup, Sushama. *Costumes and Textiles of Awadh.* New Delhi: Roli Book. 2012

Tarlo, Emma. *Clothing Matters.* 1996

Taylor, James Cooke. *A Descriptive and Historical Account of the Cotton Manufacturers of Dacca, in Bengal by a Former resident of Dacca.* London: J Mortimer, 1851

Thomas, Mary. *Dictionary of Embroidery Stitches.* London, 1934

Tyabji, Laila. Hand-crafting a culture. In : *Seminar Magazine*

Tyabji, Laila. White on white : Stitches and Shadows.

Watt, George. *Indian Art at Delhi 1903.* Reprinted in Delhi, 1987

Wilkinson-Weber, Clare M. *Embroidering Lives: women's work and skill in the Lucknow embroidery industry.* New York, State University Press, 1999.

Wilkinson-Weber, Clare M. Skill, Dependency, and Differentiation: Artisans and Agents in the Lucknow Embroidery Industry. *Ethnology*, Vol. 36, No. 1 (Winter, 1997), pp. 49-65

Wilkinson-Weber, Clare M. Women, work and the imagination of craft in South Asia. *Contemporary South Asia* 13(3), (September 2004) 287–306

Wright, Elaine ed. *Muraqqa' : Imperial Mughal Album from the Chester Beatty Library, Dublin.* Dublin, 2008

GLOSSARY [1]

Achkan : a fitted coat with band collar, also known as a bandgala (see shervani)

Adhi or addhi: a variety of handloom muslin

Adi bel or Ari bel : a flowering creeper pattern in diagonal stripes

Ambi : (lit. unripe mango) a mango-shaped motif – one of the many names of the keiri or paisley pattern

Angarkha : a long-sleeved, full skirted tunic for men, generally open at the chest and tied in front with tie-strings. It has a typical an inner flap (purdah) covering the chest.

Angarkhi : a short version of angarkha.

Anokhi : unique[2], it is given to a style of chikan embroidery worked only on one side of the cloth.

Ari : hooked needle, used for chain-stitch embroidery

Ari bel : diagonal stripes of creeper motif

Bagalia : gusset, the diamond or triangular piece added under the armholes

Balabar : An outer garment, worn by men, related in shape to the coat-like achkan .[3]

Banka : dandy, elegant people of Lucknow

Bel : a stylized creeper pattern, used on borders and specially around the neck line and the front opening on kurtas

Bel patti : floral vine design

Buta : a large motif of a stylized flowering plant, used also sometimes for keiri motif

Buti : a smaller version of buta, the term is used also to denote stylized animal motifs printed in block repeats

Butidar : flowers scattered all over the surface

Chaapakhana : printing workshop

Chak : slit

Chameli : jasmine flower

Chanda : moon shaped motif

Chapkan : a long-sleeved coat fitted to the waist / lower part resembles an angarkha

Chapwala or chhipi : block printer for chikan embroidery

Chaugoshia : four-cornered cap

Chogha : loose cloak

Choli : woman's blouse or bodice, usually tight-fitting

Churi : glass bangles

Chutki : the ripple effect on the long sleeves, obtained with the help of a seed from the entada pod.

Chutki : pinching of the cloth between the fingers which ensure the right tension of the cloth while doing chikan embroidery.

Chutki-wala gota : crinkled gota ribbon

Daccai : it is an adjective often applied to fabrics (usually muslins) from Dacca

Dalal : Middleman, agent

Daman/Daaman : the lower part of a garment

Dant : (tooth) the crenellated border edge or crenellated design, like jawa

Daraz /Daraj : reversible ornate stitch used in chikan dressmaking.

Darzi : tailor

Dhobi : washerman

Dogh work : trapunto work filled with red and blue dori on panchgoshia caps[4].

Dori : a cord

Dorukha chikankari : embroidery worked as to be double sided

Dupalli /Dopalli/Dopalri : a close fitting cap, made of two or more identically cut pieces of muslin, stitched together with a curve at the top

Dupatta/doputtah : an unstitched length of material for the upper body, traditionally worn by both sexes, but now mainly worn by women as part of a salwar kameez ensemble (see also odhani)

Fardi buti : tiny dots

Farji : a short coat / worn over a jama or angarkha

Gheru : a brownish or red clay, often in the form of a stone that dissolves in water. Used in the old times for printing tracings' outlines.

Ghundi : a round button made of silk or cotton, sometimes covered with gold or silver wire, to be tied with a loop (tukuma)

Jaal : an all-over pattern printed or embroidered (lit. net or web)

Jali : in chikan it define open-work stitching or netting

Jamdani : a weaving technique traditional to the towns of Tanda, Jais, Dacca used to produce figured muslins with discontinous supplementary-weft threads

Jawa : a dentellate hemming or appliquè

Jhoomar : pendent, a jewelled hair ornament worn on the side of the head, also used to define certain motifs in chikan embroidery

Jolaha : weaver

Keiri buti : mango motif

Kalga buta : mango or cypress-shaped motif with a bended tip, synonymous of keiri

Kali : gored panel

Kaliondar/kalidar paijama : a wide-bottomed paijama made up of several panels

Kalidar Kurta : kurta with side panels

Kalka : an oval, almond or mango shaped motif with many variations.

Kamdani : embroidery using badla thread

Kangan : ear-ring, name of a stitch and a motif in chikan embroidery

Kantha : moon-shapd design at the neck – name of block with lune-shape for angarkha, bangala kurta…

Karan/karn : flower

Karigar : artisan

Karkhana : workshop

Karnphool : ear-ornament, shaped like a flower, the name of a stitch and a motif in chikan embroidery

Karchikan : fine metal embroidery done on silk or muslin.

Kas : fastenings made of cloth, tailored like ribbons or lappets (lit. to tie) / strings

Khillat : robes of honour

Konia : a corner pattern or motif

Kurta : loose tunic with or without panels (kali) on the side

Kurti : a short tunic usually worn by women

Libaas : an ensemble or dress

Magaji or Magazi : piping. Sinkia (very fine) magaji (very fine piping defining borders) between the garment and the wider magaji (bias cut also 1 " wide)

Mahajan : businessman, entrepreneur

Mahepusht : fish scales and the fish scale motif

Mahi Maraatib : The Mughals' dynastic ceremonial fish standard. This came in two forms: single golden fish on a pole (as illustrated at the beginning of chapter 1) or two golden fish hanging from a bow (as illustrated in the plate section)[5].

Mandel : round cap, like a tambourine

Mohri : the opening at the end of the sleeve or leg of a garment

Muga : the natural rich gold silk of Bengal and Assam

Mulmul : cotton, usually in reference to India muslin, particularly the muslin woven in Bengal

Mulmul khas : muslin of the finest quality

Naqqash : pattern drawer

Nazakat : delicacy

Nazar : generally gold coins, offered to the ruler as a symbol of submission.

Odhani : a veil worn by women: it covers the head and the right shoulder, is drawn across the body and either tucked into the waistband or left hanging in front

Paan : a preparation made of betel leaves and other ingredients

Paan daan : receptacle for the ingredients of the betel leaf preparation

Paan Buta/buti : the heart shaped motif like the leaf of the paan in various sizes

Paisley : the English name with which became globally known the keiri / ambi / kalga motif.

Pallu, Pallav : the decorative border at one or both ends of a length of fabric usually of a sari, odhani, or patka

Panchgoshia : headgear having five corners /panels

Patka : sash or waistband

Patti : a border but also used to indicate a small leave

Patti ka kam : appliqué work on fine cloth.

Peshwaz : the peshwaz is generally defined as a woman's robe, closing in front

Phoonda : tassels

Purdah : the practice of sequestering women, also the name of the front bodice flap on the angarkha, also the pieces of fabric used to make up the cups of a choli (lit. curtain or to conceal)

Pusht : back of a garment

Rafoogar : master darner

Rumal : large scarf used by men in Avadh, kerchief

Sadri : a waistcoat / a sleeve-less jacket worn over a shirt or a kurta

Shabnam : dew (a name for fine muslin)

Shaluka : a tunic opened in front

Shervani : a formal knee-length coat fitted to the waist (see achkan and bandgala)

Sinjaf : the facing inside the hem of a garment

Sinkia : very fine

Sinkia magaji : very fine piping or magaji

Tabeez/ tabeej : front opening of kurta / kamiz

Tanda jamdani : fine jamdani fabric woven in Tanda, U.P.

Tanzeb : handloom muslin

Tatariyat : a gown

Tawaaif : a courtesan

Tepchi : running stitch used in chikankari

Topi : a cap

Tukuma/Tukma : a loop made of cord used to fasten the ghundi

Tukri ki gote : gote made of tukri (patchwork): a special textile tradition of Awadh

aari chariyon ki gote – gote in diagonal stripe

gilloriyon ki gote – triangular shaped gote

katari ki gote – semi circular shape

namak pare ki gote – diamond shape gote

patake ki gote – square shaped gote

sitare ki gote – star shaped

Turanj : mango motif, often used as a corner motif[6]

Turpai : "a self-bound seam which is achieved when both the seam allowances on the inside are finely rolled together and hemmed very close to the seam" (in Goswamy. 1993:277)

Ungheeah : bodice – generally "made of gauze, net or muslin (ref. Mrs Ali), the more transparent in texture, the more agreeable to taste. Ornamented with spangles and silver trimmings, the ungheeah was made "to fit the bust with great exactness" and fastened behind with strong cotton cords. Their sleeves, which were short and tight, were invariably finished with some fanciful embroidery or silver riband. Over the ungheeah was worn a transparent courtie (shirt) of thread net which covered the waistband of the paijama butdid not screen it".[7]

Zardozi : gold-thread embroidery, using metallic elements and thread, sometimes mirrors, precious or semi-precious stones

Zari : metal wrapped yarn used for zardosi embroidery

NOTES

1 This Glossary has been compiled from various sources, references including: R. Kumar 1999, S. Swarup 2012, C. Singh 1979, B.N. Goswamy 1993, P. Manfredi 2007

2 Sushama Swarup. p.156

3 http://www.hainsworth.co.uk/textile-glossary/b

4 personal communication by Nawab Mir Jafar, Lucknow

5 W. Dalrymple : The Last Mughal.

6 Charu Smita Gupta. Zardozi.

7 In Nevile, Pran. Beyond the veil. Indian women in the Raj. New Delhi: nevile Books, 2000:131

INDEX

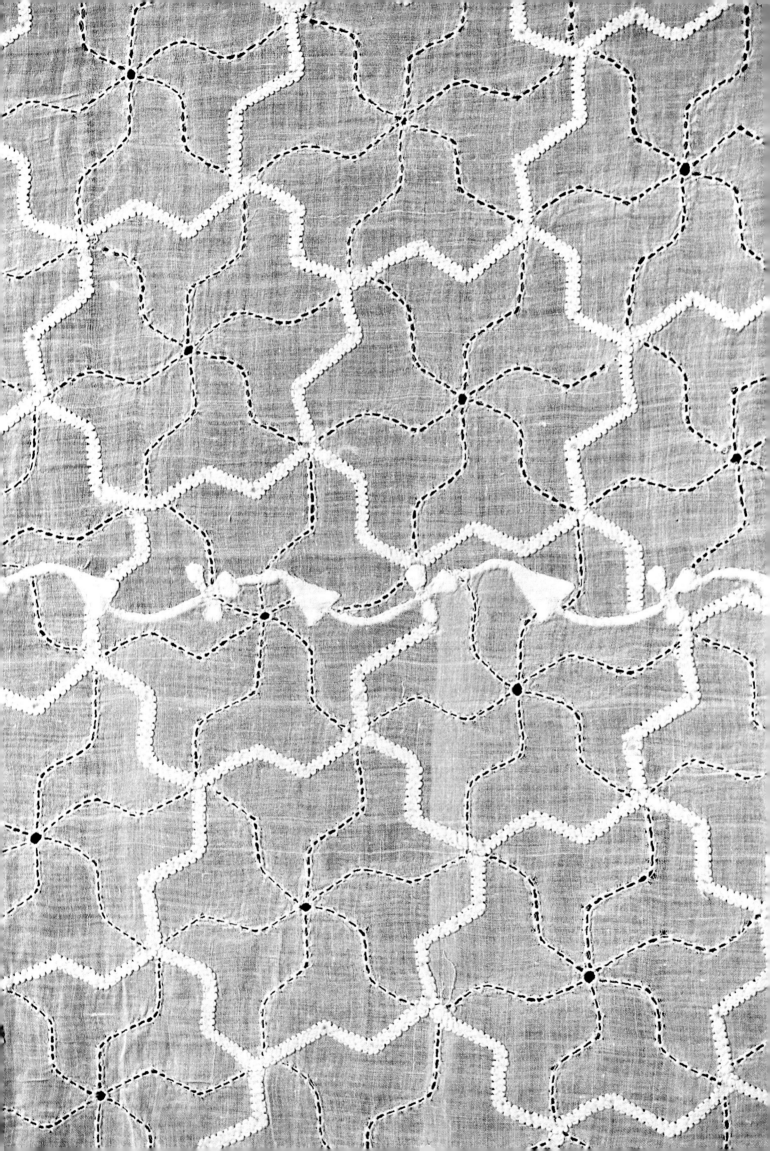